Ceramics in America

CERAMICS
IN AMERICA
2002

Edited by Robert Hunter

Published by the CHIPSTONE FOUNDATION

Distributed by University Press of New England

Hanover and London

Cover Illustration: Detail of earthenware pitcher, American, possibly Medford, Massachusetts, ca. 1840. (Chipstone Foundation; photo, Gavin Ashworth.)

Design: Wynne Patterson
Copyediting: Alice Gilborn
Printing: Meridian Printing
Type: Aardvark Type

Published by the Chipstone Foundation, 7820 North Club Circle, Milwaukee, WI 53217
© 2002 by the Chipstone Foundation
All rights reserved
Printed in the United States of America 5 4 3 2 1
ISSN 1533–7154
ISBN 0–9724353–0–1

Contents

Book Reviews 233
Amy C. Earls

Editorial Statement

Ceramics in America is an interdisciplinary journal intended for collectors, historical archaeologists, curators, decorative arts students, social historians, and contemporary studio potters. Authors are encouraged to submit articles on the broad role of historical ceramics in the American context including essays on ceramic history, archaeological research, ceramic technology, social history, studio pottery, and ceramic collecting. Short illustrated notes on new ceramic discoveries are particularly wanted. References to be compiled in an annual bibliography, including electronic sources, may also be submitted. Manuscripts must be typed, double-spaced, illustrated with high-quality color transparencies, and prepared in accordance with the *Chicago Manual of Style*. Computer disk copy is requested but not required. The Chipstone Foundation will offer significant honoraria for manuscripts accepted for publication and reimburse authors for all photography approved in writing by the editor.

Robert Hunter

Robert Hunter

Introduction

▼ THE RESPONSE TO the inaugural issue of *Ceramics in America* has been highly favorable with comments coming from a varied audience. As anticipated, historical archaeologists and decorative art students have acknowledged the importance of the journal for their respective disciplines. Surprisingly, though, reaction from contemporary potters and academics has been particularly enthusiastic. This suggests that *Ceramics in America* may indeed function as a vehicle for supplying historical context to an audience not otherwise routinely exposed to this material.

Certainly the overall response to the journal confirms that interest in ceramic topics is continuing to grow and expand. Beyond professional societies, there are a number of small, special interest groups that form a large constituency of ceramic devotees in this country. One case in point is the Wilson Pottery Foundation, descendants of nineteenth-century stoneware potters Hiram, James, and Wallace Wilson. The Wilson pottery was established by these former slaves and produced a wide range of products in Texas. An article on their story is planned for a future issue of *Ceramics in America*.

Meetings and conferences also continue with astounding frequency. The lecture series associated with *The New York Ceramics Fair* sponsored by the Chipstone Foundation and *Ceramics in America* is of particular interest, as many of the journal authors speak at this annual event in January. For the highest level of enthusiasm and sheer volume, the National Council for Education in the Ceramics Arts (NCECA) annual conference, held this year in Kansas City, had the feeling of a revival meeting with several thousand participants. A notable special focus conference, sponsored by Historic Deerfield and organized by curator Amanda Lange, brought together an international cast to discuss the topic of delftware. The symposium, which coincided with an exhibit and publication of a book, achieved the commendable goal of attracting an audience of curators, collectors, archaeologists, auction house specialists, dealers, students, and working potters.

This second issue of *Ceramics in America* continues its interdisciplinary approach. Ivor Noël Hume again leads off with an eclectic essay offering the latest insights into his diverse collection of pottery. If one uses the jigsaw puzzle as metaphor, Noël Hume has found more pieces of the picture he painted in his first article and his recent epic *If These Pots Could Talk: Collecting 2,000 Years of British Household Pottery*. Noël Hume's critical evaluation of previous research, whether long-held notions or his own published statements, demonstrates how so-called definitive conclusions in ceramics research can be as fragile as the subject matter itself.

It has been said there is as much archaeological analysis to be done in the drawers and storage cabinets as can be done in the ground. Certainly, the image of the vast warehouse in the closing scene of *Raiders of the Lost Ark* clearly reminds us of this potential for rediscovering bureaucratically buried treasures. In her article, Merry Outlaw opens the cabinets to a special group of ceramics, which had been excavated in the 1930s by archaeologists working at Jamestown. Known as North Devon sgraffito slipware, this assemblage is unparalleled in the quantity of virtually compete vessels and the diverse representation of vessel forms and decoration. Although bits and pieces have been reported on throughout the years, this is the first comprehensive survey of this important archaeological collection.

Ceramic enthusiasts can generally be lumped into two distinct groups: pottery people and porcelain people. And, for the most part, never the twain shall meet. This dichotomy is an interesting sociological phenomenon. Leading authorities on English pottery often dismiss the thought of studying anything else, while porcelain "connoisseurs" have opined that pottery is nothing but a second-rate pretender. Regardless, at the heart of all porcelain or pottery stories are the materials and technology. Unfortunately for most of us, hard science or chemistry and physics are prerequisites for truly understanding the "alchemy" of the art. Toward this end, Victor Owen presents a forensic look at the ingredients of the early recipes of eighteenth-century British porcelain manufacturers. Careful reading of his paper will underline the importance of implementing material science in the identification of porcelain bodies along with the long-held connoisseurship approach.

A century after the introduction of porcelain table and tea wares for the English market, a new technological breakthrough permitted the mass production of another aspect of ceramic art previously reserved for the dilettante. Ellen Denker traces the use of Parian porcelain by English and American sculptors to create affordable commodities for the increasingly art conscious world. For the first time in America, ceramic bodies were being used for strictly decorative purposes for an upwardly mobile, domestic market.

Ceramics have been used since antiquity to convey social, political, and religious messages. Indeed, we know more about the imagery of Greek and Etruscan mythology from their pots than any other single source. One of the most potent symbolic uses of the ceramic medium in recent history was its association with the abolition of slavery in the Anglo-American world. While relatively rare, this class of ceramics reflects one of the most far-reaching social ills of modern Western civilization. In his thoughtful narrative, Sam Margolin explores the images and slogans used in the abolitionist movement. Illustrated with extraordinary and poignant objects from the collection of Americana specialist, Rex Stark, Margolin frames the historical context for these important political wares.

As the antislavery ceramics bring a harsh reminder of yesterday's social ills, other types also prompt us into recalling cultural heroes who have faded from public consciousness. One such figure is Toussaint L'Ouverture. A

household name in early nineteenth-century America, he was immortalized when his portrait was reproduced on earthenware pitchers made ostensibly to champion the antislavery cause. Jonathan Prown, Glenn Adamson, Katherine Hemple Prown, and this writer combine social and art historical methods to interpret a fascinating but previously unrecognized American-made ceramic object. The resulting evidence not only provides a compelling basis for more research into the diversity of American-made ceramics, it also gives new life to L'Ouverture's legacy as the commander of the only successful slave rebellion in the Western hemisphere and his subsequent influence in the abolitionist cause.

When conducting material culture research, where hard evidence is often fleeting and conjecture is required, archaeologists usually have the firmest footing in opening windows to the past. Al Luckenbach's excavation of a large cellar associated with Rummey's Tavern in now-forgotten London Town, Maryland, offers a crystal clear snapshot of a circa 1725 Anglo-American ceramic assemblage. No reading of inventories or travelers' descriptions can substitute for the physical remains of the actual pots and dishes used to store, prepare, and serve food and drink in an early colonial American tavern.

In a radical departure from the analysis of ceramics at the historical level, American decorative arts scholar Robert Trent gives us a personal look at living potter Richard Schalck. The field of contemporary studio pottery is an amazingly dynamic arena with tensions among the artist potters, art critics, museum curators, gallery owners, ceramics writers and publishers, and ultimately collectors. *Ceramics in America* intends to enter the arena to seek insights that can be applied to age-old issues of patronage, marketing, technological innovation, and ceramic aesthetics and design.

The response to the first "collector's essay" was particularly rewarding as many readers expressed their affinity with Troy Chappell's thoughts and motives. In this issue, James Glenn presents another opportunity to examine what drives a die-hard collector of ceramics. Besides his interest in assembling the types of eighteenth-century English and German stonewares used in everyday colonial America, Mr. Glenn also spends his spare time at the blacksmith's anvil, exploring and forging ironwork in eighteenth-century styles. Quite a contrast, given the delicate nature of the ceramics medium and brute force required for blacksmiths' work!

The "New Discoveries," compiled and edited by Merry Abbitt Outlaw, provides another broad view of recent ceramics "finds." Based on the response from potential submitters, this section of the journal promises to have tremendous popularity for years to come. Although *Ceramics in America* does not have an open forum for the exchange of comments and ideas, the inclusion of contact information for New Discoveries submissions is intended to encourage readers to contact the authors directly with their thoughts and ideas.

The book reviews and annual bibliography, edited and compiled by Amy C. Earls, contains a list of electronic resources this year. Although these websites may have limited life, they do serve as a starting point for

researchers. In the future, the electronic resources may appear as links on the Chipstone Foundation's website www.chipstone.org.

With the completion of the second volume of *Ceramics in America,* future topics are being compiled. Several thematic issues are planned covering American redware and stoneware. More articles on ceramic technology, including engine-turning and the manufacture of agateware, will be forthcoming as well. At present ceramic scholarship is alive and well. *Ceramics in America* and the Chipstone Foundation will continue to provide a forum for the exchange of new information and ideas about historical ceramics in the American context.

Ceramics in America

Ivor Noël Hume

A Pot Potpourri

▼ NATHANIEL BAILEY'S ever helpful early eighteenth-century *Etymological English Dictionary* defined collecting as a "gathering together or picking up," suggesting, perhaps, that the lexicographer had garbage in mind. A hundred years earlier, essayist John Earle had described an antiquarian collector as one who "loves all things (as Dutchmen do cheese), the better for being mouldy and worm-eaten."[1] Both Bailey and Earle would have been rendered speechless had they been told that their own cast offs, be they old clothes or kitchen crockery, would today be vied for and puzzled over by collectors.

For my part, puzzling has been the driving force; finding out being the ultimate purpose of finding. Its corollary, however, is that the need to find out implies ignorance and a willingness to be deceived. In his book *The Portrait of a Scholar* (1920) Robert William Chapman put it best. "A collector," he wrote, "should not be too careful to be sure of what he buys, or the sporting spirit will atrophy."[2] There is no denying, however, that the prospect of securing a bargain by knowing more than the seller creates an adrenaline rush matched only by its reverse when you discover to your cost that you didn't.

As my recent book *If These Pots Could Talk* makes clear, my late wife and I were eclectic collectors of ceramics (and much else from armor to mummified hands) and happily gathered together a collection of the kinds of earthen and stone wares that specialist collectors of *Keramics* considered unworthy of cabinet space. When we began, the remains of the relatively recent past were no better respected, but over the last half century such studies have been legitimized. In America, historical archaeology is now as established a discipline as prehistory, while in England, post-medieval archaeology vies with Roman or Saxon sites for academic attention and funding. Rarely a month goes by without new information being un-earthed, some of it making nonsense of old assumptions and conclusions.

Unfortunately, potentially valuable ceramic information from excava-tions can go unrecognized and unpublished, while much that does get into print does so in journals undiscovered by many who might profit from them. That certainly is true of older collectors unable to keep abreast of current research. Their loss is nobody else's unless the aging collector is rash enough to publish what he believes to be sound information thereby sticking his errors to the brows of his readers like used flypaper.

Even as my *If These Pots Could Talk* was in press, I discovered that I had unnecessarily devoted more than a page to debating the identification of an

English stoneware gin flask in the shape of a hump-backed woman who might or might not have been Judy, the wife of Mr. Punch. The undeniable proof was about to come under the auctioneer's hammer—too late for me to do anything but place the winning bid. A pair of flasks coupling the deformed woman with an equally deformed man was impressed E. M. SHEPPARD / FRENCH HORN TAVERN / CRUTCHED FRIARS. There could be no doubting the figures' identities. More often than not, the Judy figures were unmarked, but another in my collection that is, was made for J.BROWN / Wine & Spirit Merchant / ADAM & EVE / 144 CHURCH STREET / BETHNAL GREEN (figs. 1, 2). More on these marks anon.

Perhaps because earlier English stonewares are increasingly hard to find, interest in once common nineteenth-century wares has greatly expanded. One might suppose that examples scarcely 150 years old would retain few secrets worth pursuing. Makers' marks are common and attributions carved in stone—or are they?

Why, for example, does a Doulton of Lambeth ink bottle carry an impressed "21" that some collectors have believed to indicate the year of manufacture as 1921, and alongside it a registry letter for 1876 using the diamond-shaped combination that ceased to be used after 1879 (figs. 3, 4)? Royal Doulton historian Louise Irvine has pricked the dating bubble saying that the numbers within Doulton's oval mark are "some sort of refer-

Figure 1 Gin flasks, Staffordshire, ca. 1840. Stoneware. H. of tallest: 8⅝". (All objects from the Noël Hume collection unless otherwise noted; photography by Gavin Ashworth unless otherwise noted.) In collections of English brown stoneware gin flasks, a hump-backed hag is relatively common, but whether or not she represented Judy, wife to Mr. Punch, has been cause for prolonged speculation. Identifying Punch, himself (center), had never been an issue. Now husband and wife are unequivocally united by the paired flasks impressed with the name and ownership of the same London Tavern (see fig. 2).

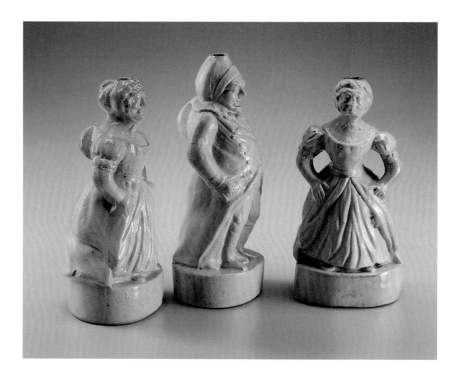

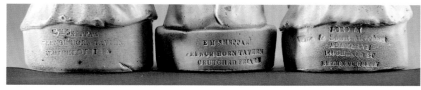

Figure 2 Detail of impressed marks on flasks illustrated in figure 1.

Figure 3 Ink bottle, Doulton, Burslem, Staffordshire, ca. 1899. Stoneware. H. 8". Doulton ink wells and bottles are a collecting field on their own. This example of a Stephens sheered-neck bottle has wider interest, serving as a reminder that diamond-shaped registry marks were applied to ceramics of all kinds across more years than the marks state. This example was registered in 1876, but the inclusion of the word LIMITED in the Doulton factory mark puts the bottle no earlier than 1899.

Figure 4 Detail of mark on ink bottle illustrated in figure 3.

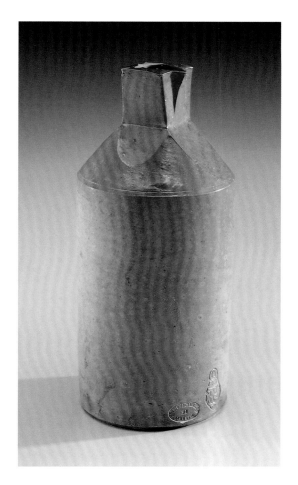

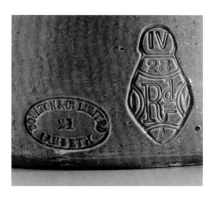

ence number for the bottle, although it is not known exactly what it signifies."[3] She has added that the oval inscription reading DOULTON & CO. LIMITED / LAMBETH postdates 1899 when Doulton became a limited company. Clearly, therefore, the 1876 registry mark was being used long after its accepted three-year expiration date. The registration had been filed by Doulton in 1876 on behalf of the famed ink manufacturer Henry Stephens of Aldersgate, London, who had designed this sheered neck and lipped bottle that would be made in fifteen different sizes.[4]

Another of my pot book's half truths provided grist for an illustrated essay explaining why a silver-gilt mounted brown stoneware mug (or jug?) was not German of the seventeenth century as the auction catalog had stated.[5] There is no need here to review all the reasoning leading to the conclusion that the mug was really made by Doulton around 1910. Suffice it to say that I was convinced that it was as recent as its mounts which bore a Chester date letter for 1911 and the mark for silversmiths G. Nathan and R. Hayes. However, that posed another problem. Why would a reproduction made by Doulton at Lambeth be shipped to a Chester silversmith to be finished?

With the question still unanswered my book went to press. Shortly thereafter another identical mug was brought to auction at Christie's, but this time with no seventeenth-century attribution (fig. 5).[6] The mounts'

Figure 5 Jug, Doulton, Burslem, Staffordshire, ca. 1911. Stoneware. H. 11¾". This Rhenish-type stoneware drinking vessel with 1911 silver mounts was auctioned as dating from the seventeenth century, but when Colonial Williamsburg's master silversmith George Cloyed temporarily removed the base, its true identity was revealed.

decoration was the same save for its Chester hallmarks for 1912. So here were two mugs, both with Chester mounts—yet apparently shipped all the way from London's Lambeth. It would make much better sense, I thought, for the pots to have been made about thirty miles away in Burslem. Although Doulton had begun purchasing Staffordshire factories in 1877, the standard books did not indicate that brown stonewares were among its products.[7]

Commenting on the then still-unsolved mystery, Ms. Irvine noted that "around 1910, Doulton artists Harry Simon and Francis Pope modeled a range of shapes inspired by early Rhenish stoneware and these were salt-glazed to recreate the distinctive 'orange skin' texture of the 16th century." Quoting previous Doulton historian Desmond Eyles, she added that "The mottled surfaces recall the Rhineland stoneware used by Elizabethan silversmiths as a foil for silver and silver gilt mounts."

Were it not that a leading expert on German stonewares remained reluctant to accept this Doulton evidence without unequivocal proof, I would have been content to go along with the Doulton attribution. But thus challenged, I decided that the only means of providing the proof would be to have the base mount removed to see whether or not it concealed Doulton marks. That delicate task was performed by Colonial Williamsburg's master silversmith George Cloyed who found the base packed with pitch, but which, after careful separation, revealed an impressed Royal Doulton mark and the number 796 (figs. 6, 7).[8]

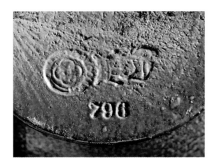

Figure 6 George Cloyed with the Doulton jug and removed silver base.

Figure 7 Detail of the revealed Doulton mark.

Among other carved-in-stone verities is the knowledge that around 1750 personalized English brown stoneware tankards, bottles, and pitchers ceased to be scratch-inscribed and that thereafter printers' type was substituted. But what is meant by thereafter and how did it differ from the hereafter's evermore? While pondering that, we may also pause to ask at what point did Toby Fillpott and a supporting cast of rustic topers begin to substitute for the earlier sprig-applied trees, houses, convivial panels, and the signs of taverns and shields of craft-related companies?

The answer to these questions is around 1800,[9] although the applied stag-chasing scenes characteristic of the eighteenth-century "Hunting Jugs" persisted throughout the nineteenth century, and indeed, into the twentieth.[10] The combined design's longevity is demonstrated by two pitchers of graduated sizes bearing the mark DOULTON & CO. / LIMITED / LAMBETH, both with type-impressed identifications as having been made for Mr & Mrs J. Reddick / Old Windsor / 1911 (fig. 8).[11]

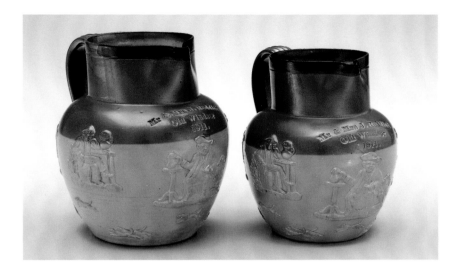

Figure 8 Jugs, Doulton, Burslem, Staffordshire, ca. 1911. Stoneware. H. of tallest: 6". Although Doulton's fine wares have received much collector attention, the factory's once common domestic and tavern lines have only recently begun to earn the interest they deserve. These examples made for Berkshire public house owners in 1911 illustrate the longevity of Doulton's nineteenth-century "hunt jug" designs.

The spacing of the lettering on both the Reddick pitchers is identical, strongly indicating that the type was set in blocks and thereby applied as one. But had this always been the method of applying type-impressed names of people and places? It certainly was true of initialed seals applied to glass wine bottles of the second half of the seventeenth century.[12] Eccentricity of alignment is not in itself proof of one-letter-at-a-time application. To be sure of that, one needs two examples of one inscription, both applied at approximately the same time. The previously discussed Punch and Judy flasks provided such an opportunity and left no doubt that the letter dies were individually applied. Another example is provided by a beer beaker marked *DOULTON*/ LAMBETH and impressed below the rim with the name GERALD (fig. 9).[13] The same "A" die had been impressed

Figure 9 Beaker, Doulton, Burslem, Staffordshire, ca. 1880. Stoneware. H. 5½". This personalized Doulton beaker has had the name impressed with individual letter dies, the "E" of which touched the wall before being applied, evidence of the continuing use of single-letter stamped inscriptions.

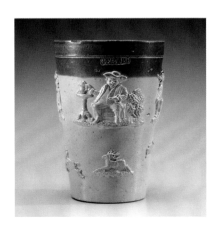

on the base and the "E" had touched the upper wall while being moved into place. Such beakers were being made by Doulton in the 1870s providing a *terminus post quem* for the transition from separate letters to inscription-impressing blocks.

In their book *English Brown Stoneware 1670–1900,* the late Adrian Oswald and Robin Hildyard began a partial analysis of sprig ornamentation on hunting jugs and mugs, but limited their illustrations to windmills, trees, and handle terminals.[14] Much more remains to be done. Among devices characteristic of the late Doulton wares, for example, are a barrel-seated toper with a cat-eared dog beside him, and on the other side of the vessel, a sprig usually paired with a snoozing sot curiously accompanied by an owl in the bush behind him (fig. 10). Both are present on the 1911 Reddick

Figure 10 Examples of sprigged "toper" ornaments characteristic of Doulton's Lambeth brown stonewares throughout the second half of the nineteenth century: *left:* the owl in the bush; *center:* a standard Toby Fillpot; and *right:* the cat-headed dog.

pitchers and go back at least to the 1870s. An assessment of the use and iconography of the Toby Fillpott sprig has been begun by Massachusetts collector Nicholas Johnson, and it is to be hoped that he will expand his studies to embrace the hat waver, the sleeping toper, the homeward reveler, and many other once familiar brown stoneware images.[15]

Although, for me, looking beyond the pots in search of connections to the social history of their time is the most rewarding part of collecting, the quest can all too easily lead to wrong conclusions. Mercifully not voiced in print, my great "piggy-bank" revelation was another of them.[16] Discovering that on eBay an Australian dealer was auctioning a brown stoneware box cast with a panel showing a boy stealing a pig, I saw in it an allegorical warning that one's savings (the pig) should be kept in a place safe from plunderers (figs. 11, 12).

Made in the honey-colored brown stoneware characteristic of Brampton in Yorkshire, the box is impressed on the base S & H BRIDDON, a mark used ca. 1840–1860.[17] Stamped in single-letter type around the money-box's shoulder is the name of its owner MARY SUSANNA DODD. Presumably it was she who broke off the finial to extract her loot.[18] Cast in two parts, the lower wall is relief-decorated on one side with a smoking toper and somebody who strongly resembles the previously mentioned "befriended owl" pose (albeit sans owl) and on the other with a lively scene showing a boy stealing a piglet and being pursued by the sow while watched by an assortment of yokels. It seemed to me that this rustic drama

Figure 11 Bank, Samuel and Henry Bridden, Brampton, Derbyshire, 1840–1860. Stoneware. H. 3⅞" (lacking finial). Front and back of a personalized, honey-brown stoneware money box. The purloined pig scene was thought to be a metaphor for

piggy bank savings until it was discovered that the Briddens used similar molds for tobacco and butter jars. Broken off when the box was emptied, the finial may have been a sitting hen, a chimney stack, or a shell-shaped ornament.

Figure 12 Reverse of the bank illustrated in fig. 11.

was allegorically related to the idea of keeping one's money safe from theft—thereby a mid-nineteenth century manifestation of the American piggy bank. I subsequently discovered, however, that Samuel and Henry Briddon used the same mold to make tobacco jars whose upper element became the removable lid.[19] No amount of allegorical legerdemain could link tobacco and purloined piglets.

The mold used to create the money box was old, and the details of the scene consequently eroded. One can barely see, for example, that along with the two male observers, a women holding a child stands by the gate to the right of the scene. Nor can one see that the gate is open. But on examining more crisply molded Briddon examples, it is evident that only the sow sees the event as larcenous, the people having instructed the boy to bring home the bacon.[20] The Aesopian moral to this story is simply stated: reading much into little is an exercise best kept private. It is equally true that in the study of stonewares a little knowledge is rarely enough. A case in point: Another eBay auction yielded a group of five very small jugs or costrels, all wasters from a stoneware kiln dump at Raeren (fig. 13). Their

Figure 13 A group of German stoneware wasters, Raeren, Germany, ca. 1550. Stoneware. H. 2¼". Said to have been intended to contain thread-lubricating oil to be hung around the necks of Flemish weavers, further investigation showed that these miniature costrels had many more uses.

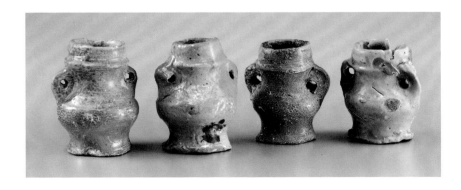

necks were consistent with a mid sixteenth-century date, but their little ear-like handles were unlike any I had seen. Their capacities being inconsistent, they could not be measured. So what were they?

A friend wise in stoneware matters promptly provided an answer: "I know exactly what they were for," he assured me. They were used by Flemish weavers as containers for thread lubricants and were hung on strings around the workers' necks. When asked for documentation, my friend referred me to a London dealer who said he obtained the information from another dealer in Holland who informed him that the mini-costrels were often seen in European paintings—but failed to be specific. Nevertheless, I was now in a position to respond with self-satisfied authority if asked how the pots were used. Although the question was unlikely to be asked with any frequency, I thought it best to seek a Netherlandish weaver illustration of my own.

I failed to find one, but somewhat disconcertingly, I came up with several engravings by Peter Bruegel the Elder showing what appeared to be squatting scholars with little blobs dangling by strings from their belts. Another Bruegel engraving showed the blob hanging from the side of a basket containing books. It seemed reasonable to deduce, therefore, that Bruegel's blobs were actually personal ink pots.[21] More clearly depicted, however, was his engraving titled *The Land of Cockaigne*, depicting three slumbering loafers: soldier, laborer, and clerk, the last with open quill case and ink pot hanging at his side (fig. 14).[22]

It was David Gaimster who pointed me in yet another direction. In an article titled "Oil Pot or What?", Ian Reed of Trondheim in Norway cited several instances where these little bottles had been found buried in churches and other Norwegian religious buildings, each pot containing small fragments of bone, and in one instance with a sealed piece of parchment identifying it as a reliquary dating to the year 1476.[23] In sum, therefore, it would seem that these small costrel-style pots were made for several purposes and were exported from Raeren to Scandinavian countries rather than to England.[24]

But even that assumption may be false. In her seminal publication *Border Wares,* Jacqueline Pearce illustrated another of these scriveners' pots, this one having been found in London (fig. 15).[25] Puzzled as I was when I first saw them, she concluded that "it could hardly have been intended for practical use and may well have been a toy." Ms. Pearce added that it was brown glazed and "unknown in the standard form." But having since examined this tiny pot, I have no doubt that Ms. Pearce is correct in attributing it to a Border Ware kiln and to a date in the late sixteenth century.[26]

The persistent probing or looting of Rhenish kiln dumps is no less an archaeological hot potato than is shipwreck salvage, but the resulting availability of the factories' more mundane wares has served to generate student and collector interest in an aspect of the industry that has hitherto merited little extra-European attention. Just as decorative arts museums have concentrated on masterpieces and have deliberately avoided the second rate, thereby creating a false impression of the average individual's

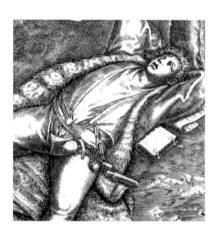

Figure 14 Detail from Peter Bruegel's *The Land of Cockaigne*, 1567. This engraving illustrates a mini-costrel hanging beside a pen sheath at the waist of a sleeping scholar. There can be no doubt that the little bottle contained his ink or that such was its primary use.

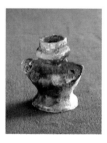

Figure 15 Ink pot, England, late sixteenth century. Earthenware. H. 1⅞". (Courtesy, Jacqueline Pearce and the Museum of London; photo, Ivor Noël Hume.) A lead-glazed Border Ware copy of a Rhenish stoneware scriver's ink pot.

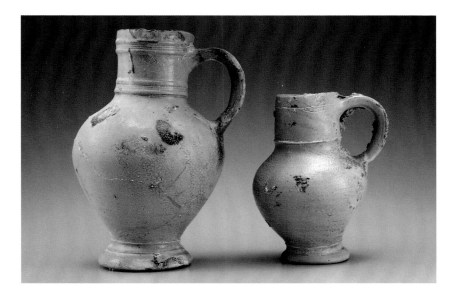

Figure 16 Examples of stoneware wasters, Raeren, late sixteenth century. H. of tallest: 9". From a Raeren kiln dump illustrating pear-shaped drinking vessel profiles that rarely found their way into the export market.

possessions, so the survival of relief-decorated German stonewares has left us oblivious to the run-of-the-mill wares that were staples of the industry in the fifteenth, sixteenth, and seventeenth centuries.

We tend to think of Rhenish mugs (or drinking jugs) being gray in the first half of the sixteenth century and iron-washed brown in the later years. Kiln wasters demonstrate that both were in production toward the century's end, and that the late wares were more elegant than their predecessors and were sometimes carefully cordoned at their necks to emphasize the simplicity of their profiles (fig. 16). Having no claims to beauty, but also coming from Raeren kiln dumps, is a class of small mugs or cans, slightly conical in shape and markedly ribbed (figs. 17, 18). Tapering mugs with and

Figure 17 Mugs, Raeren, late sixteenth century. Stoneware. H. of tallest: 4⅛". These semi-conical mugs from a Raeren kiln dump are another type uncommon in the export trade. The difference in their bases demonstrates the fallacy of drawing stylistic conclusions from too little evidence. One mug exhibits wire pulling marks and the other the result of seating on a sanded wheel.

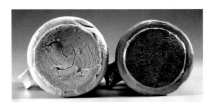

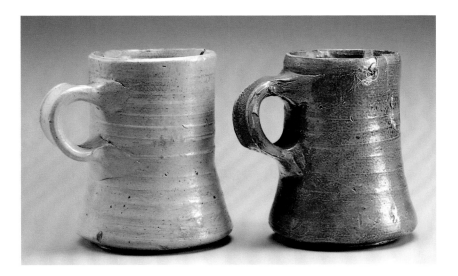

Figure 18 Bottoms of the mugs illustrated in figure 17.

without applied decoration are relatively well known, but these two differ in that their walls are offset above pad-like bases—bases which themselves differ one from the other.[27] That on the left exhibits the wire pulling marks common to most Rhenish stonewares, but its companion had been stood

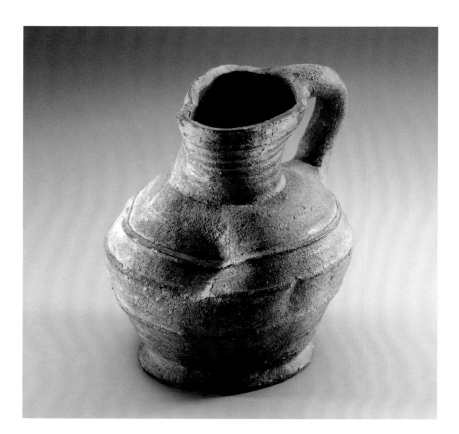

Figure 19　Jug, Germany, thirteenth century. Stoneware. H. 7". Collectors of Rhenish stonewares have hitherto shown little interest in the evolution of the ware through the medieval centuries. This example of Rhenish proto-stoneware, in spite of being wildly distorted and a potential waster, was reported to have been excavated in London.

in sand on the wheel and was therefore left with what might be described as a rusticated bottom. I confess that in publishing the latter mug, I had suggested the possibility that if it was not a Raeren product, it might have come from a lesser known factory such as that at Bouffioulx in Belgium.[28] When, however, the second mug turned up to parallel every construction detail but the sandy bottom, the "obscure kiln" theory collapsed. So did any thought that there might be a dating difference between gray and brown. Another example, one sufficiently distorted in firing that it should have been discarded as a waster, has been dredged from the River Wensum near Norwich, leaving us to wonder at the craftsmen's lack of pride in their work.[29] The possibility exists, of course, that this warped mug was not deliberately exported, but was lost overboard from a visiting Dutch trading or fishing vessel.

Not as easily dismissed, however, is a much earlier Rhenish proto-stoneware jug reputed to have been found in London (fig. 19). Though severely distorted in firing, this is a type well known in the Low Countries in the mid-thirteenth century.[30] Exhibited in a museum case alongside perfect examples of medieval pottery, this stoneware jug cuts a pretty sorry figure. However, in many ways it is infinitely more interesting—if only in that it raises questions worth asking. When it emerged spoiled from the kiln, who made the decision not to toss it onto the waster heap? Was it sold at a cut price to some poor soul who could not afford a better jug? Or was it cynically exported in the belief that the undiscerning English would buy anything they could get? And what was going on in London at the time the jug arrived?[31]

This we do know: Henry III was on the throne. His French marriage encouraged French emigration into the city which was resented by its inhabitants. The king's self-serving relationship with Rome and his approval of his brother Richard to stand for election as Holy Roman Emperor led to civil war after Richard proposed turning over a third of the country's revenue to the Pope. London merchants joined with country nobles to oppose the king, and the resulting popular rebellion led by Simon de Montford ended with the capture of the king at the Battle of Lewes in 1265. In short, these were uncertain and dangerous times, jug pourers not knowing from one week to the next what calamity might disrupt their lives. This, of course, is not the page to embark on a history of thirteenth-century England. My point is simply that when one studies the Rhenish jug, a door opens—just a little—to the life and times of the people who made, transported, and used it.

To collectors of German stonewares whose interests focus on the great relief-decorated vases and jugs from Raeren (and subsequently from the Westerwald) in the late sixteenth century, the notion that the industry's history began centuries earlier is often of small concern. If it isn't decorated and shiny it has no place in a collection of ceramic art, they say. But what about collections of ceramic history? To better appreciate the best, surely it is necessary to climb the ladders that lead up to it? Thus, for example, the story of Germanic stonewares began in the late twelfth century at centers with odd sounding names like Brühl-Pingsdorf and Brussum-Shinveld where the development of increasingly hard and liquid-impervious fabrics would lead to the more smooth-surfaced wares that became the trademark of Siegburg stoneware in the fifteenth century (fig. 20). I would argue that a teaching collection is incomplete without a leavening of such early wares, no matter how unappealing they may be to the connoisseur.

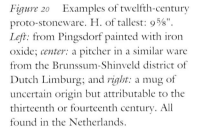

Figure 20 Examples of twelfth-century proto-stoneware. H. of tallest: 9⅝". *Left:* from Pingsdorf painted with iron oxide; *center:* a pitcher in a similar ware from the Brunssum-Shinveld district of Dutch Limburg; and *right:* a mug of uncertain origin but attributable to the thirteenth or fourteenth century. All found in the Netherlands.

Figure 21 Jug, Sieburg, ca. 1400–1460. Stoneware. H. 8¾". Plentiful in the fifteenth century were the stonewares of Siegburg, one of whose shapes sports a curious and rarely explained name : Jacobakanne. The apocryphal association with the Countess Jacoba van Beijeren commemorates a remarkable lady around whom fairy tales could have been spun.

When writing about or cataloging post-medieval and earlier ceramics, the problem of acceptable and correct nomenclature is ever present. We see it, for example, in the ubiquitous mask-decorated German bottles of the sixteenth to eighteenth centuries. Every collector is now aware that associating them with Cardinal Roberto Bellarmino is a mistake. But in spite of revisionist writers (myself included) who prefer the German Bartmankrug or the English Graybeard, dealers and auction houses continue to call them Bellarmines. Another popularly used German term is Jacobakanne to describe the tall-necked stoneware drinking vessels from Siegburg common in the fifteenth century (fig. 21). But who was Jacoba and why did she give her name to a jug? Dutch collector Marco Maas has provided an answer.

The four-times married Countess Jacoba van Beijeren (also known as Jaqueline of Holland) was born in 1401 and was first married when she was six years old. Her tempestuous life included imprisonment in the castle at Ghent in Flanders, where she passed the time making pottery which she tossed into the moat after each piece was finished. When, in the eighteenth century, examples of the tall Siegburg pots were dredged out of the moat, they were hailed as the products of Jacoba's hobby.[32] Ludicrous though it is to accept that the incarcerated countess was firing stoneware in her prison cell, the name has stuck simply because it serves to identify a particular shape. It also provides a springboard for the romantically inclined to dig deeper into the life of the reputedly beautiful young woman who married the Dauphin of France, her cousin the Duke of Brabant, the Duke of Gloucester, and trigamously Frans van Borsselen, Lord of the province of Zeeland. But back to pots.

The lesser known and under-appreciated Rhineland stonewares were matched in Normandy where, in the mid-eighteenth century, kilns at Martincamp and elsewhere were competing with those of their northern neighbors.[33] Much of what we know about these wares comes from French Canada, specifically at Louisbourg (1713–1758), and from a shipwreck off the coast of Bermuda known (for want of specific documentation) as "*The Frenchman*" that sank around 1760 (fig. 22). From the latter came strap-handled pitchers similar to others from Louisbourg as well as a series of gray-bodied and unglazed pharmaceutical ointment pots in several sizes,

Figure 22 Examples of Normandy gray stoneware pharmaceutical pots and a bottle recovered from an unidentified shipwreck off the coast of Bermuda, ca. 1760. H. of bottle: about 3½ ". (Collection of E. B. Tucker, Bermuda; photo, Ivor Noël Hume.)

Figure 23 Plates, Staffordshire or Yorkshire, 1775–1785. Creamware. D. 9¾". English creamware plates in the Royal shape decorated with an unusual version of the ubiquitous Chinese House pattern, their significance enhanced by their backs exhibiting the ghost images of two more from the same batch. Together, the four examples demonstrate the degree of painting freedom exercised between one plate and the next.

Figure 24 Backs of plates illustrated in figure 23. (Photo, Ivor Noël Hume.)

and a small bottle in the same ware recovered still corked, the latter containing an unidentified oil.[34] I know of no published examples of such pots and bottles being found in England, but it is entirely possible that if and when fragments have been unearthed, they have gone unidentified and therefore ignored.

As long as there have been druggists there has been a need for pots wherein to pack their potions. Although, in studying the seventeenth and eighteenth centuries we tend to think of drug pots and jars as having been the monopoly of delftware potters, in reality they were made in every available ware from lead-glazed Staffordshire earthenwares to creamware and white salt-glazed stoneware. Recently reported excavations at the site of a circa 1774–1787 stoneware manufactory near Trenton, New Jersey, have yielded several examples.[35] Described by project director Richard Hunter as "condiment pots," they nevertheless derived their shape from contemporary delftware pharmaceutical containers.

Now for something entirely different.

In *If These Pots Could Talk,* I illustrated a creamware plate that had been sold cheaply because, as the dealer explained, "it was dirty on the back."[36] The dirt proved to be a ghost impression of the cobalt-painted "Long Eliza" pattern from the next biscuit plate in the stack. I described this manifestation as a "rare demonstration," and nobody came forward to say otherwise—until I did so myself.

I was to find not one, but two matching Royal pattern creamware plates in a rural Virginia antique shop, both dirty on their backs (figs. 23, 24). There could be little doubt that they came from the same prematurely stacked batch and had miraculously remained together for more than two hundred years. The backs of each exhibited ghost images of the design my late wife and I had facetiously dubbed the "Chinese TV house pattern," but neither exactly matched the fronts.[37] It was evident, therefore, that several more "wet ones" had been part of the batch and that the newly acquired plates had not been stacked directly one on top of the other. Nevertheless, they provide documentary evidence of the scope of a single painting session for one design.

In the first volume of *Ceramics in America* (2001), ceramic historians George Miller and Robert Hunter provided a pioneering assessment of the development of "china glaze" earthenware (pearlware) and in the process demonstrated the enormous diversity of designs based on the so-called *pagoda* and *Long Eliza* themes. The same year saw the publication of Lois Roberts' paper "Blue Painted Creamware and Pearlwares" which, for the first time, attempted to analyze and attribute individual elements in the pagoda pattern.[38] Significantly, perhaps, the newly found pair of Royal pattern creamware plates is paralleled by none of the examples illustrated or discussed by either Miller and Hunter or Roberts. Instead, the design includes details of its own, notably the tall chimneys at front and back of the house, and the crosses at the junctions of the flanking fence lattices.[39]

Minor differences, notably in the foreground rocks and flights of birds, might suggest that more than one painter was involved in decorating these four house designs, and that rather than viewing the leisurely work of a single happy paintress, one is seeing the products of sweatshop mass-production that had short-circuited the drying process.

Be they brown stone gin flasks, mystery jugs, squashed mugs, or dirty-bottomed creamwares, these widely disparate specimens are yet more examples of the intellectual fun to be derived from pursuing the people behind the pots.

ACKNOWLEDGMENTS

The author is indebted to British Museum curator David Gaimster, dealer Garry Atkins in London, Doulton historian Louise Irvine, collector Marco Maas in Holland, Jacqueline Pearce at the Museum of London, stoneware collector Nicholas Johnson, ceramic historian George Miller, Colonial Williamsburg's master silversmiths James Curtis and George Cloyed, and friend and scholar Robert Hunter of the Chipstone Foundation for their willingness to share their skill and answer dumb questions.

1. John Earle, *Microcosmographie or A Piece of the World Discovered in Essays and Characters* (London, 1628) as quoted by Ronald Jessup, *Curiosities of British Archaeology* (London: Butterworth, 1961), p. 10.

2. Chapman added that "he who collects that he may have the best collection, or a better than his friend's, is little more than a miser."

3. Louise Irvine to Ivor Noël Hume, personal communication, January 20, 2002.

4. Colin Roberts, *Doulton Ink Wares* (London: Bee Publications, 1993), pp. 109–11.

5. See also "Potsherds and Pragmatism: One Collector's Perspective," in *Ceramics in America,* edited by Robert Hunter (Hanover, N.H.: University Press of New England for the Chipstone Foundation, 2001), pp. 16–17.

6. Christie's, London, September 25, 2001, Sale no. 9199, lot 18.

7. Doulton began manufacturing stoneware drain pipes at Rowley-Regis near Birmingham before 1877. At Lambeth, Henry Doulton had opened a ceramic pipe factory in 1846. The company's history by Desmond Eyles, *The Story of Royal Doulton 1815–1965* (London: Hutchinson, 1965), p. 15, notes that "If Henry Doulton had never done anything else but help to pioneer the general use of stoneware drainpipes he would have earned a secure place in the social history of the Victorian era." Doulton's fine ware production began at Burslem around 1882.

8. The standard lion-topped crown over the Royal Doulton roundel was in general use

between 1902 and 1922. Jeffrey A. Godden, *Encyclopaedia of British Pottery and Porcelain Marks* (New York: Crown Publishers, 1964), p. 215.

9. Robin Hildyard, *Browne Muggs, English Brown Stoneware* (London: Victoria and Albert Museum, 1985), p. 80, nos. 204, 205.

10. Messrs. Doulton and Watts in their 1873 price list offered "Hunting Jugs (Common clay)" in capacities from ¼ pint to 1 gallon, as well as in "Fine Clay"; Chris Green, *John Dwight's Fulham Pottery, Excavations 1971–79* (London: English Heritage, 1999), p. 367.

11. Old Windsor is a Berkshire village and parish on the River Thames two miles south east of Windsor.

12. Ivor Noël Hume, "A Seventeenth-Century Virginian's Seal: Detective Story In Glass," *Antiques* 72, no. 3 (September 1957): 244–45.

13. This Doulton mark began to be used ca. 1858.

14. Adrian Oswald, R.J.C. Hildyard, and R. G. Hughes, *English Brown Stoneware 1670–1900* (London: Faber & Faber, 1982).

15. Nicholas Johnson, "The Man in the Middle: Toby Fillpott as a Sprig on Brown Stoneware," *The Web of Time* 4, no. 2 (Internet history magazine <www.theweboftime.com>).

16. Ivor Noël Hume, *If These Pots Could Talk: Collecting 2,000 Years of British Household Pottery* (Hanover, N.H.: University Press of New England for the Chipstone Foundation, 2001), p. 424, note 15, cites references demonstrating that in England money boxes in the shape of pigs go back at least to the fifteenth century. According to Webster's *Ninth Collegiate Dictionary,* however, in American usage the term "piggy bank" was first applied to money boxes as recently as 1941. The *Oxford English Dictionary,* on the other hand, leaves no doubt that as early as ca. 1440 the word "pig" was applied to any earthenware pot that lacked any other more specific name. That dictionary does not list "piggy bank" among its definitions.

17. Samuel Briddon was in the stoneware business at Brampton as early as 1834, continuing a tradition established by William Briddon in 1790 (Oswald et al., *English Brown Stoneware,* p. 164). That source associates Samuel with William Briddon at the Walton Pottery along with the S & H Briddon mark and dates it to ca. 1840–1860. On the other hand, Derek Askey, *Stoneware Bottles from Bellarmines to Ginger Beer 1500–1949* (Brighton, U.K.: Bowman Graphics, 1981), p. 164, has Samuel and Henry at an independent factory in 1848 that would be purchased in 1881 to become part of the Barker factory. However, Llewellynn Jewitt, *The History of Ceramics Art in Great Britain,* 2 vols. (New York: Scribner, Welford, and Armstrong, 1878), 2: 122 had Henry Briddon owning the Barker Pottery prior to 1878, and makes no mention of a partnership between him and Samuel Briddon. Yet another S & H Briddon pig-decorated tobacco jar is in the Glaisher Collection at the Fitzwilliam Museum, Cambridge, there cataloged as a "box with Lid" and erroneously attributed to the "Late 19th century." Bernard Rackham, *Catalogue of the Glaisher Collection,* 2 vols. (Cambridge, Eng.: The University Press, 1935), 1: 162, no. 1254 (not illustrated).

18. Robin Hildyard, *Browne Muggs,* p. 113, no. 326, ca. 1840. Finials for Brampton tobacco-jars with pig panels came both in the form of a fleur-de-lis or a bricked chimney stack, and so there is no way of knowing which was used on the illustrated money box. It seems possible that tobacco jars had smoke stacks finials and that versions intended for other purposes did not.

19. One might expect that the two parts of the Briddon money box would have been luted together while in their leather hard state. It appears, however, that they were not joined until after their salt-glazed firing—and then with glue.

20. That phrase is not in the *O.E.D.,* but "to save one's bacon" was in use by 1691.

21. H. Arthur Klein, *Graphic Worlds of Peter Bruegel the Elder* (New York: Dover Publications, 1963). "Temperance" (1560), no. 54; "The Ass at School" (1557), no. 30.

22. Ibid., (1567), no. 32.

23. Ian Reed in *Medieval Ceramics* 16 (1992): 71–72 and p. 69, pl. 2.

24. John Hurst, David S. Neal, and H.J.E. van Beuningen, *Pottery Produced and Traded in North-West Europe, 1350–1650* (Holland: Museum of Boymans-van Beuningen, 1986), pp. 197–98, no. 308, illustrate an example found at Raeren-Born in Belgium, its exterior glaze a mottled brown with gray patches, and attributed to the sixteenth century.

25. Jacqueline Pearce, *Border Wares* (London: Her Majesty's Stationery Office, 1992), pp. 32, 66; fig. 37, no. 288.

26. These pots being so small and virtually unbreakable, it is surprising that others have not been reported from English archaeological contexts.

27. H.J.E. van Beuningen, *verdraaid goed gedraaid* (Rotterdam: Museum Boymans-van

Beuningen, 1973), pp. 49–50, no. 287, second half of sixteenth century. Also Hurst, Neal, and van Beuningen, *Pottery Produced and Traded in North-West Europe,* p. 199, nos. 310–12, ca. 1575–1600.

28. Hume, *If These Pots Could Talk,* p. 97, fig. V.3.c.

29. Sarah Jennings et al., *Eighteen Centuries of Pottery from Norwich,* East Anglian Archaeology Report No. 13, Norfolk Museums Service, 1981, pp. 113–14, no. 760. Described as "Dark grey fabric; shiny brown glaze on all surfaces." No mention is made of basal markings.

30. Gisela Reineking-von Bock, Steinzeug (Cologne: Cologne State Museum, 1971), no. 85, n.p.; found at Cologne.

31. E. M. Ch.F. Klijn's *Lead-glazed Earthenwares in The Netherlands* (Arnhem: Nederlands Openluchtmuseum, 1995), p. 27, noted: "The material's value was even so high that the potters of the Middle Ages sometimes tried to mend a waster, so that, after a necessary second firing, it was serviceable again and ready to be sold."

32. It surely must be a coincidence that a fifteenth-century playing card illustrated in David Gaimster's *German Stoneware 1200–1900* (London: British Museum Press, 1997), pl. 2.1, depicts a woman making Siegburg pots! Nevertheless, the citation allows me to make a correction to *If These Pots Could Talk* (p. 99, fig. V.5) wherein I illustrated the card and associated it with an example in the collection that I attributed to Siegburg when it should have been to Raeren.

33. North Normandy lies at the southern extremity of the Rhineland stoneware industry, its industrial and pharmaceutical wares reaching America by 1585. Ivor Noël Hume, *The Virginia Adventure* (New York: Alfred A. Knopf, 1994), p.76.

34. Ivor Noël Hume, *Shipwreck! History from the Bermuda Reefs* (Hamilton, Bermuda: Capstan Publications, 1995), p.22.

35. Richard Hunter, "Eighteenth-Century Stoneware Kiln of William Richards Found on the Lamberton Waterfront, Trenton, New Jersey," in *Ceramics in America* (2001), ed. Robert Hunter, pp. 238–43.

36. Hume, *If These Pots Could Talk,* pp. 221–22, fig. X.1.

37. Most authorities refer to the central structures as *pagodas,* a term defined in *Webster* as "a Far Eastern tower usu. with roofs curving upward at the division of each of several stories and erected as a temple or memorial," a description far removed from a single-story hut with two chimneys.

38. *Northern Ceramic Society Journal* 18 (2001): 1–37.

39. There are small differences between the footrings of these plates, one being sharper than the other. But rather than pointing to diagnostically significant variations, they are a further reminder of the fallacy of reading much into little.

Merry Abbitt Outlaw

Scratched in Clay: Seventeenth-Century North Devon Slipware at Jamestown, Virginia

▼ I N 1 9 3 5 , W H E N historical archaeology was in its infancy, National Park Service archaeologists working at Jamestown, Virginia, made a remarkable discovery. They found an astonishingly large assortment of decorated slipware vessels in a meandering drainage ditch on the periphery of a seventeenth-century site known as the May-Hartwell property. The feature that produced the artifacts was a formal brick drain built over an older U-sectioned ditch from which over 600 fragments were cataloged. Although the archaeologists could not identify all of the wares at the time of their recovery, the collection was recognized as significant by the sheer quantity of restorable slipware vessels.

The restorable ceramics include not only sgraffito-decorated wares but also many other gravel-tempered coarse earthenware utilitarian vessels as well as seventeenth-century English delftware objects. Soon after excavation, the slipwares were mended and restored by technicians at Jamestown (fig. 1). At least forty-seven slipware vessels and many more large fragments were cataloged. Almost seven decades since its recovery, the assemblage remains a prominent component of the archaeological collections at the National Park Service's Colonial National Historical Park (fig. 2).[1]

Four years after they were unearthed, the slipwares were finally identified as having been made around 1670 in the coastal region of North Devon in southwestern England.[2] Representing a wide range of shapes, most of them are scratched, or sgraffito-decorated, with bold motifs that cut

Figure 1 National Park Service technicians assembling ceramics recovered from Jamestown, Virginia, with some of the May-Hartwell collection in the foreground, 1938. (Courtesy, National Park Service, Colonial National Historical Park. Photo # 7030.)

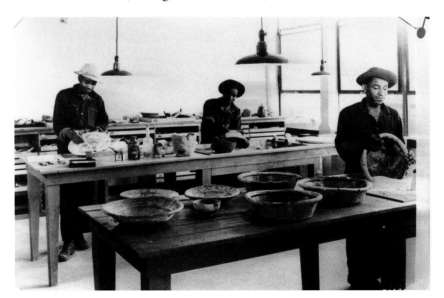

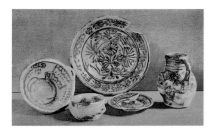

Figure 3 A collection of small plates from the May-Hartwell ditch. Sgraffito decorated with a variety of floral and geometric motifs. (Courtesy, National Park Service, Colonial National Historical Park; photo, Gavin Ashworth.)
Clockwise from bottom: COLO J 7343; COLO J 7371; COLO J 7341; COLO J 7298; COLO J 7372.

through a white slip into leather-hard pinkish-red clay.[3] They are glazed with transparent lead, which appears bright amber over the white slip. The glaze over the red body, particularly in the lines of the carved designs, appears brown. Because of the sizable number of vessels represented, their completeness, and their wide-ranging forms and decorative motifs, this assemblage has remained the most significant collection of seventeenth-century North Devon slipware in Britain or America. These wares provide a unique insight into the bold, stylistic trends of the period, and their graphic qualities still appeal to a wide audience today (fig. 3).

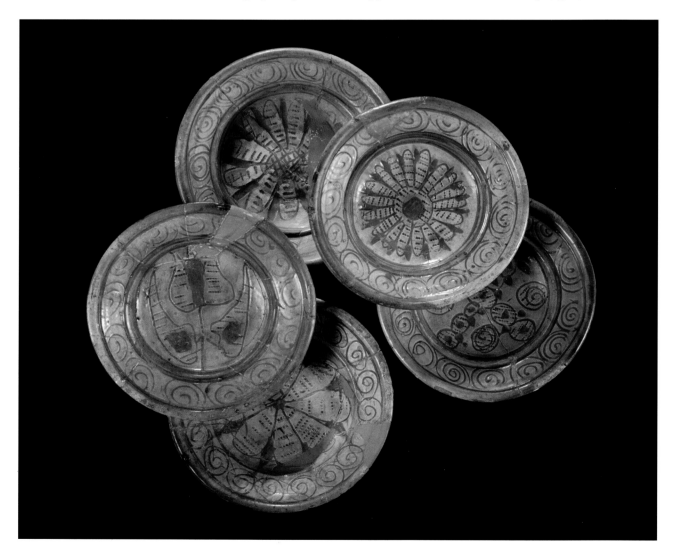

Figure 4 Detail of map depicting the North Devon region in southwestern England. Sgraffito-decorated slipware was produced in the region from the seventeenth until the nineteenth centuries, most notably in Barnstaple and Bideford. (Chipstone Foundation.)

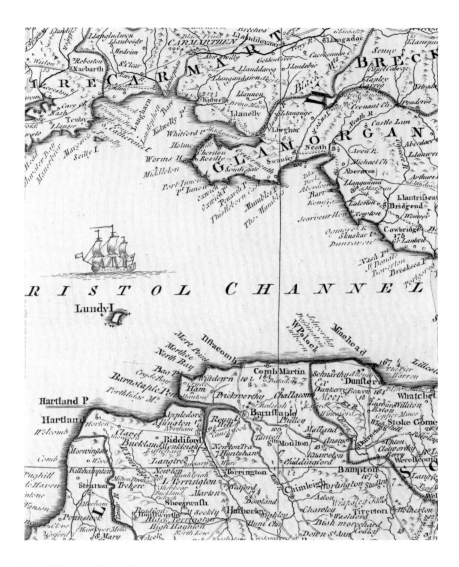

North Devon Ceramics

In 1960, C. Malcolm Watkins published the pioneering study of North Devon wares, focusing on the May-Hartwell collection from Jamestown. His research laid the groundwork for documenting the considerable seventeenth-century trade and familial connections between North Devon and America. In 1983, Alison Grant published a complete history of the seventeenth-century North Devon pottery industry, expanding on the Devon and American connections. Both researchers used the Devon Port Books to provide evidence of an active ceramic trade with America beginning as early as 1635. However, not only does the archaeological record of the New World provide evidence of the actual product, it also demonstrates that these wares arrived before 1635.[4]

From medieval times, pottery was being produced in North Devon, but in the seventeenth century, it flourished as an industry. Its success was closely related to the prosperous shipping trade that originated in the sixteenth century from the port towns of Barnstaple and Bideford (fig. 4). Ceramics could be transported far more economically by sea than by land,

thus they were promoted and shipped in great quantities to ports in England, Wales, Ireland, and America during the seventeenth century.[5]

Contributing to this booming production in the seventeenth century were the readily available local resources used in pottery manufacture. These included clays from Fremington; water worn gravel for temper from the Rivers Torridge and Taw; and white ball (or tobacco-pipe) clay for slip from Peters Marland. Most lead ore for glaze was brought in, and large imports of coal into North Devon suggest it was the primary fuel for firing the kilns.[6]

Pottery production was Bideford's most important seventeenth-century industry, adding considerably to the wealth of England during that century. The nearby market town of Barnstaple also was a major production center during the era. To a lesser extent, earthenware was made in and near other towns in the region, such as Great Torrington.[7]

Although sgraffito slipware was the most decorative pottery type manufactured in seventeenth-century North Devon, other earthenwares were produced in a vast range of shapes to fulfill consumer needs. For example, baluster-shaped jars, in a fabric known as North Devon Plain, were made in enormous quantities from the late sixteenth century and into the seventeenth century as containers for foodstuffs such as fish and butter. Thus, filled with provisions, they were carried in 1585 with the first British colonists to the New World, only to be discarded at the short-lived North Carolina coastal settlement of Fort Raleigh. These shapely jars represent the principal North Devon earthenware form found on Anglo-American sites from the first quarter of the seventeenth century.[8]

Another ware that North Devon potters began making in the early seventeenth century is the distinctive gravel-tempered coarse earthenware, by far the easiest of all coarse earthenwares to identify. Water worn gravel from fresh waters was used to temper the utilitarian coarse earthenware products, thereby strengthening the fabric, and enabling the ware to be used on the hearth and in bake ovens. Although this ware type has been found as early as circa 1620–1622 on Anglo-American sites, it is most commonly recovered from sites dating after circa 1640. This type of ware was manufactured well into the eighteenth century, and is found in archaeological contexts in America until the Revolutionary War. Forms of gravel-tempered vessels exported to America include pipkins, cooking pots and lids, three-legged cauldrons, large dome topped ovens, storage jars, and most frequently, milk pans.[9]

The most ornamental of the North Devon ceramic wares is, of course, slipware. Three types of slip decoration can be identified: plain slip coating; trailed slip; and sgraffito designs that are cut through a plain slip. Although this later category encompasses many highly decorated forms, surprisingly few seventeenth-century examples have survived as antiques. This suggests that their prominence in the archaeological record is a function of their basic utilitarian nature.

The wares of Northern Europe, where the sgraffito technique had been used since the sixteenth century, clearly influenced North Devon slipware

Figure 5 Sgraffito-decorated slipware dish fragments showing Continental influence on North Devon. *Top:* Beauvais, France, sixteenth century; *bottom:* North Devon, ca. 1620–1660. (Courtesy, Ivor Noël Hume.)

Figure 6 Harvest jug, North Devon, Barnstable, 1764. Sgraffito slipware. H. 14½". (Courtesy, Colonial Williamsburg Foundation.) This highly ornamented vessel is typical of scratch-decorated forms produced in the eighteenth century and later.

potters. Some evidence also suggests that immigrant potters may have directly influenced the products of North Devon. Like Continental potters, and unlike others in England, North Devon potters fired their slipware twice: the first, a biscuit (unglazed) firing after slipping and sgraffito decorating, and the second, a glost (glaze) firing after the application of the liquid lead glaze. Furthermore, the vessel forms, decorations, and the technique of scratching a design through a white slip are evocative of pottery from Germany and the Low Countries. Also, they bear an uncanny resemblance to the double-slipped wares made from the early sixteenth century onward in Beauvais, Northern France, strongly suggesting these wares influenced seventeenth-century North Devon potters (fig. 5).[10]

Slipware manufacture by North Devon potters reached its peak in the third quarter of the seventeenth century, and began to wane at the end of the century. By that time, potters faced competition from the delftware industry and the well-organized Staffordshire potters who were producing more sophisticated wares in larger quantities, in a wider range of shapes and decoration, and more economically because of their location and resources. Thereafter, and until the late nineteenth century, North Devon slipware potters specialized in the production of more ornately sgraffito-decorated forms, such as the well-known ceremonial "harvest jugs" (fig. 6).[11]

At least one North Devon amber-colored sgraffito slipware dish had made its way to America by 1622. It was retrieved from a site of that date at Martin's Hundred near Jamestown, Virginia. A few more dish fragments have been recovered from other nearby sites dating to the second quarter of the seventeenth century. The early examples are deeply sgraffito-decorated by a single, wide implement. The decoration appears on the interior, with a running S-scroll device on the rim, and all but the earliest examples display a bird and leaf motif in the center (fig. 7).[12]

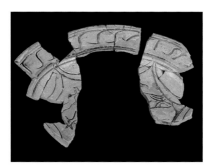

Figure 7 Dish, North Devon, ca. 1620–1640. Sgraffito slipware. (Courtesy, Association for the Preservation of Virginia Antiquities; photo, Gavin Ashworth.) Excavated from the Richard Buck site near Jamestown, this example is decorated with an S-scroll rim device and a bird and leaf central motif. This decoration is commonly found on North Devon slipware from the second quarter of the seventeenth-century Virginia sites.

In the second half of the seventeenth century, North Devon slipware is represented on most Chesapeake archaeological sites of all socio-economic levels by at least one or two vessels. Stylistically, their designs are more sophisticated and well executed than the earlier examples, and a wider range of forms is represented. Mirroring the industry-wide decline in production, North Devon slipware disappears from the Anglo-American archaeological record around the end of the seventeenth century.

The May-Hartwell Collection

Although North Devon slipware is regularly encountered on sites in America in the second half of the seventeenth century, it is rarely found intact or in large quantities. The extraordinary exception to this is the May-Hartwell collection. The property within the spreading settlement of Jamestown was patented by attorney William May in 1661, and was owned by four different title-holders in the remainder of that century, ending with Henry Hartwell who died in 1699. Colonel William White, a highly successful merchant and planter, may have been living there as early as 1673, and he owned the property from 1677 until his death sometime before August 1682. Since White was the only merchant among the four owners, it is very likely that the North Devon ceramics were part of a shipment intended for sale in the marketplace, arriving circa 1673–1682 during his tenure on the property.[13]

The shipment of ceramics appears to have been broken in transit. When it arrived, the dishes, jugs, and mugs were used to line a ditch to promote drainage of White's low-lying property.[14] Although victim to an unfortunate shipping mishap, the assemblage serves as an unique time capsule demonstrating the range of North Devon slipware forms available to Virginia consumers in the 1670s. In this respect, it differs from the large ceramic assemblages that are commonly recovered from kiln excavations, because those illustrate discards and forms made over a longer period. In contrast, the May-Hartwell group shows the kinds of ceramics sent to the colony and the sorts of choices available to colonial consumers.

Included in the wide range of slipware forms are: porringers; large dishes; plates; shallow piecrust-edge plates (pie plates); wavy edge dishes (possibly meat pie dishes); handled bowls; a milkpan; mugs; jugs; chamber pots; and candlesticks. The fabric of most of the vessels is fine, chalky earthenware, appearing in tones of pinkish- to brownish-orange to gray because of both oxidizing and reducing firings. The broken edges are laminated and some display gravel inclusions.

All of the May-Hartwell slipware vessels were wheel-thrown. The flatware was covered on the interior with a white slip, as was the exterior of hollow ware. Some were simply covered with a plain white slip, but most were sgraffito-decorated. None of the vessels were slip-trailed.

The sgraffito decorations were quickly and skillfully scratched through the slip with single- and/or multi-pointed tools while it and the underlying fabric were still damp. The use of stippling augmented the primary scratched lines. The potters were clearly influenced by popular designs on furniture, metalwork, embroidery, and other ceramics such as imported slipware, and English and Continental tin-glazed earthenware (fig. 8). Emulating the prevailing tastes of the day, geometric principles prescribed the position of the flowers, leaves, zigzags, chevrons, curlicues, s-scrolls, and other motifs on the vessels.[15]

No two objects are decorated identically, but the same stylized floral and/or geometric devices are often repeated. Similarities in motifs, the standardization of forms, and the visual quality of the pieces suggest that

Figure 8 Detail of a carved box, England, 1671. Oak. H. 8¾", W. 26", D. 16½". (Private collection; photo, Gavin Ashworth.) The stylized geometric and foliage decoration on this box are elements shared in other decorative arts of the period.

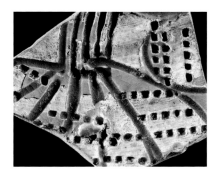

Figure 9 Detail of a North Devon sgraffito slipware fragment illustrating that the same multi-pointed tool was used to incise parallel lines and to punch patterns of indentations on individual vessels. In this case, the tool had five points or prongs. The glaze is missing in several areas on this example. (Courtesy, National Park Service, Colonial National Historical Park; photo, Gavin Ashworth.)

they were products of the same kiln, and that the same person or just a few individuals decorated them. The multi-pointed tool used to create the parallel striped lines and stippling varied from vessel to vessel, as their numbers ranged from three to five points. On each individual vessel, however, the same multi-pointed tool generally was used to draw the parallel lines and to punch the stippled lines (fig. 9).

Sgraffito-Decorated Flatwares
Well represented in the May-Hartwell assemblage are sgraffito-decorated flatwares, including large dishes, small plates, and one shallow plate with a piecrust rim. Most numerous of all of the reconstructed vessels in the collection are twenty large plate-form dishes that range in diameter from eleven and one-half to fifteen inches (fig.10). They are slipped, incised, and glazed on the interior only. Each has an upturned marly (flanged section between the rim and bouge, the cavetto, or curved section) with a thickened rim, rounded and tooled on the interior edge (fig. 11). A prominent, tooled ridge appears on the interior at the marly/bouge junction. The

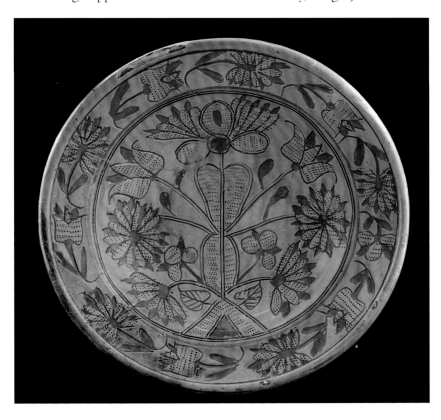

Figure 10 Dish, North Devon, ca. 1670–1680. Sgraffito slipware. D. 13". (Courtesy, National Park Service, Colonial National Historical Park; photo, Gavin Ashworth.) COLO J 7367.

Figure 11 Section drawing depicting North Devon slipware dish and plate nomenclature.

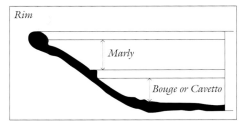

Rim

Marly

Bouge or Cavetto

Figure 12 Reverse of dish, North Devon, ca. 1670–1680. Sgraffito slipware. D. 14". (Courtesy, National Park Service, Colonial National Historical Park; photo, Gavin Ashworth.) COLO J 7354. Note the knife trimming on walls above the base, and the numerous drips of slip and glaze indicating the importance of production speed.

Figure 13 Dish, North Devon, ca. 1670–1680. Sgraffito slipware. D. 12½". (Courtesy, National Park Service, Colonial National Historical Park; photo, Gavin Ashworth.) COLO J 7339. This dish is decorated with an elaborate floral motif on the marly and in the center.

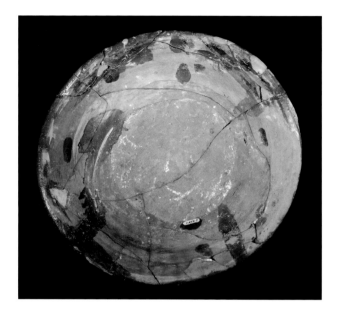

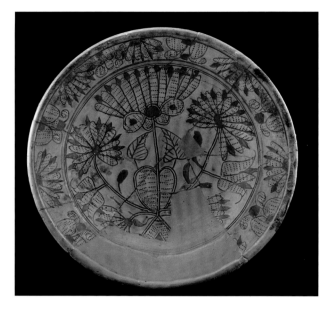

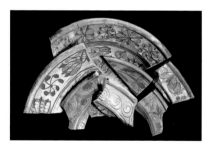

Figure 14 Dish fragments displaying a variety of marly decorations, North Devon, ca. 1670–1680. Sgraffito slipware. (Courtesy, National Park Service, Colonial National Historical Park; photo, Gavin Ashworth.) *Bottom to top, left to right:* COLO J 53725; COLO J 53639; COLO J 53707; COLO J 53794; COLO J 53797; COLO J 53570.

Figure 15 Dish, North Devon, ca. 1670–1680. Sgraffito slipware. D. 12". (Courtesy, National Park Service, Colonial National Historical Park; photo, Gavin Ashworth.) COLO J 7330. Note swag and tassel motif on marly.

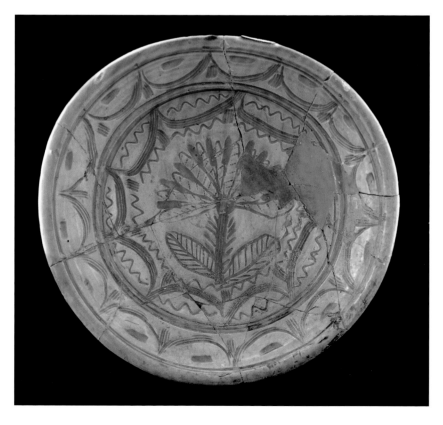

Figure 16 Dish, North Devon, ca. 1670–1680. Sgraffito slipware. D. 12½". (Courtesy, National Park Service, Colonial National Historical Park; photo, Gavin Ashworth.) COLO J 7581. A floral spray on the bouge encircles the small floral medallion in the center of this dish.

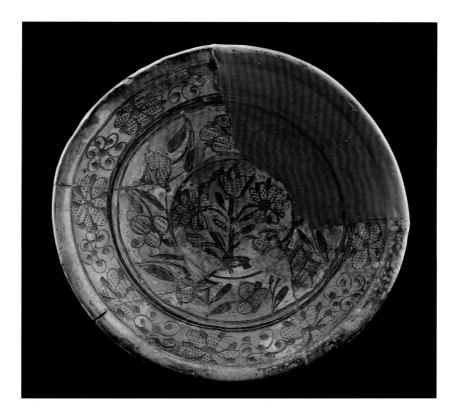

Figure 17 Dish fragments inscribed with grape clusters, North Devon, ca. 1670–1680. Sgraffito slipware. (Courtesy, National Park Service, Colonial National Historical Park; photo, Gavin Ashworth.) COLO J53475; COLO J 53481; COLO J 53495.

bouge curves inward gently to a flat base. In contrast to the detailed decoration of the interior surface, the unglazed exteriors exhibit hasty knife trimming above the bases, numerous kiln scars, elongated drips of slip and glaze, wipe marks, and finger impressions in the fabric, indicating the importance of speed in production (fig. 12).

Of all the sgraffito-decorated slipware, the most elaborately decorated are nine large dishes with floral motifs (fig. 13). The marlys of six reconstructed examples are incised with combinations of spiral asterisks, daisies, hanging flowers, tulips, and floral swags (fig. 14). One marly, however, bears a chain device; another, a swag and tassel motif (fig. 15). Seven dishes are adorned with large symmetrical floral and foliate designs that cover the interior base and bouge, and include flowers such as daisies, carnations (or thistles), and tulips. Two, though, are ornamented with smaller central floral medallions on the base that are encircled on the bouge, a swag on one, and floral sprays on the other (fig. 16). One unusual dish represented only by fragments is decorated with bunches of grapes on the marly/ bouge/base (fig. 17).[16]

Eleven large dishes are incised on the interior with geometric patterns in three zones. With one exception, they have curlicues on the marly; the exception has chevrons (fig. 18). Drawn with multi-pointed tools, the bouge decoration varies from straight-sided squares to U-shaped swags, and frames the central motif.[17] One dish is centrally adorned with alternating rows of wavy lines and dots. The circular-shaped central medallions of

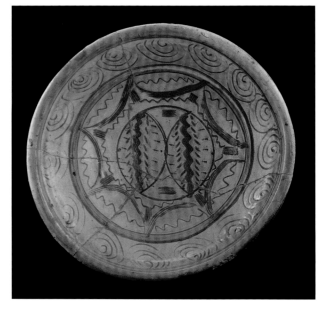

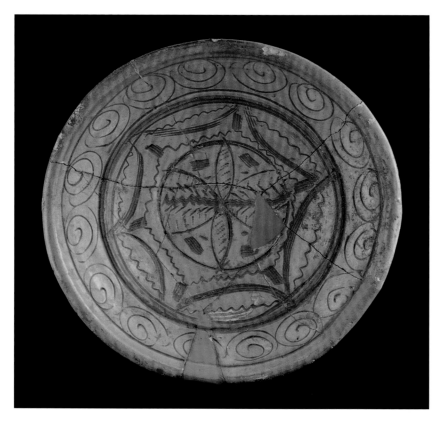

Figure 18 Dish, North Devon, ca. 1670–1680. Sgraffito slipware. D. 11½". (Courtesy, National Park Service, Colonial National Historical Park; photo, Gavin Ashworth.) COLO J 7336. This is the only marly decorated with a chevron motif. It resembles a dish with a cross-hatched design recovered from a ca. 1673 context during excavations at Colony of Avalon at Ferryland, Newfoundland.

Figure 19 Dish, North Devon, ca. 1670–1680. Sgraffito slipware. D. 14¾". (Courtesy, National Park Service, Colonial National Historical Park; photo, Gavin Ashworth.) COLO J 7348. This dish is centrally decorated with a stylized so-called "Chinese butterfly" motif.

Figure 20 Dish, North Devon, ca. 1670–1680. Sgraffito slipware. D. 20". (Courtesy, National Park Service, Colonial National Historical Park; photo, Gavin Ashworth.) COLO J 7329. A compass was used to draw the six-pointed star in the center of this dish.

Figure 21 Dish, North Devon, ca. 1670–1680. Sgraffito slipware. D. 15". (Courtesy, National Park Service, Colonial National Historical Park; photo, Gavin Ashworth.) COLO J 7366. Pre-glost firing damage is displayed in the center of this plate.

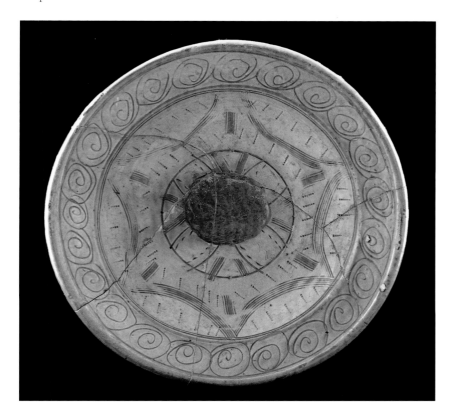

ten others are filled with compass drawn geometric decorations. Three are highly ornamented variations on the "Chinese butterfly" motif with two large lozenge-shaped, wing-like devices (fig. 19).[18] The remaining dishes are decorated with four- to six-pointed stars or flowers adorned with curlicues, stippled lines, dots, and wavy lines (fig. 20).

Areas on the interior surfaces of two dishes were damaged prior to the glost firing. Apparently, a vessel, such as a jug or porringer was placed in one dish while still damp. When the object was removed, so too was a circular portion of the decoration (fig. 21). It and the other damaged dish were glazed anyway, and their presence confirms that these "seconds" were sent to America.

Eight small plates, and fragments of many more, were recovered from the ditch. Only about seven to seven and three-fourths inches in diameter, their shape is comparable to that of the large dishes. Similar to the dishes, the plates are slipped, decorated, and glazed only on the interior, and the decoration occurs in zones. The marlys of the intact examples have curlicues, but fragments of several others are incised with swags (see fig. 3). Covering the interior base and bouge, the central motifs include stippled

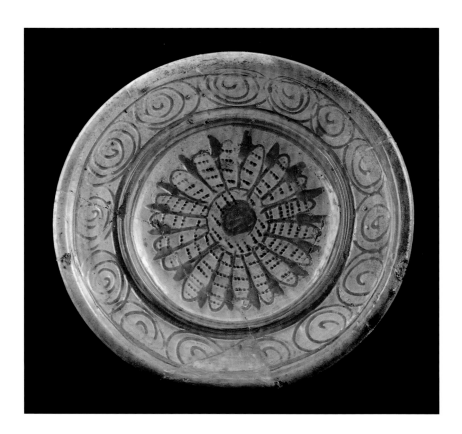

Figure 22 Plate, North Devon,
ca. 1670–1680. Sgraffito slipware. D. 7½".
(Courtesy, National Park Service, Colonial
National Historical Park; photo, Gavin
Ashworth.) COLO J 7298.

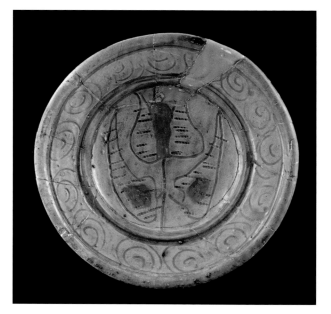

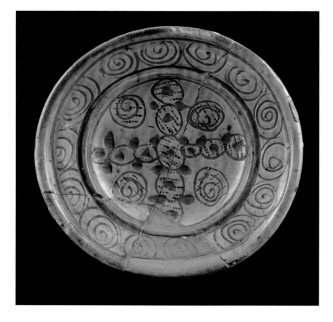

Figure 23 Plate, North Devon,
ca. 1670–1680. Sgraffito slipware. D. 7½".
(Courtesy, National Park Service, Colonial
National Historical Park; photo, Gavin
Ashworth.) COLO J 7371.

Figure 24 Plate, North Devon,
ca. 1670–1680. Sgraffito slipware. D. 7½".
(Courtesy, National Park Service, Colonial
National Historical Park; photo, Gavin
Ashworth.) COLO J 7372.

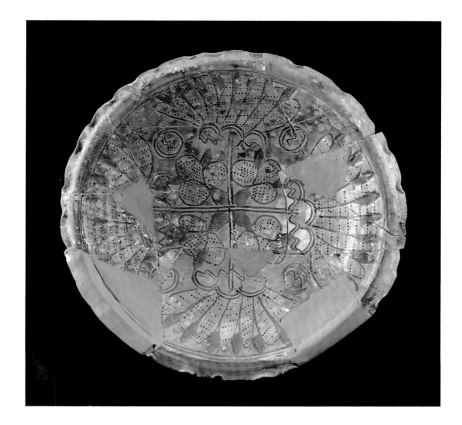

multi-petaled flowers (fig. 22), a tulip (fig. 23), and a cruciform device made up of overlapping circles (fig. 24). Like their larger cousins, the exteriors display evidence of knife trimming, fingerprints, and glaze drips.

One shallow sgraffito-decorated plate (fig. 25) is slipped and geometrically inscribed on the interior with crossed stems terminating with elaborate carnations (or thistles). The rim has a piecrust edge, and it is glazed on the interior only (fig. 26). Like the dishes and plates, the unglazed exterior was knife trimmed above the base and displays a wealth of fingerprints.

Sgraffito-Decorated Hollow Wares

Sgraffito–decorated hollow wares are represented by mugs, jugs, and deep handled-bowls. All about three and one-half inches in height, four mugs in three different shapes were restored. Each has a single, vertical handle. The

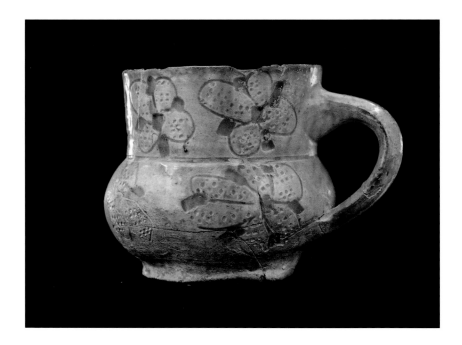

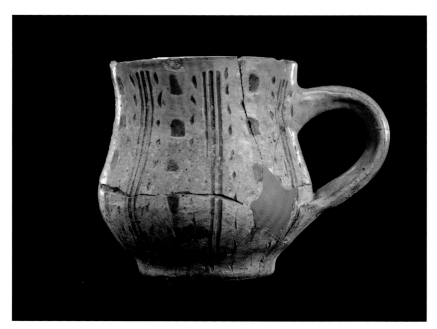

mugs are slipped and incised on the exteriors with stylized floral or abstract designs. Lead glazes cover the interiors and exteriors. Two gorge-shaped (globular with tall vertical rims) mugs are adorned with floral motifs (fig. 27). A third mug, bulbous in form, is incised with vertical rows of combed lines alternating with vertical rows of dots and dashes (fig. 28). The fourth example has concave sides and is ornamented with quatrefoil flowers, curlicues, and stippled lines (fig. 29).

Ranging from six and three-fourths to eight and three-fourths inches in height, six sgraffito-decorated jugs are included in the assemblage of mended vessels. Each jug has a single vertical handle made of gravel-

Figure 29 Mug, North Devon, ca. 1670–1680. Sgraffito slipware. H. 3¾". (Courtesy, National Park Service, Colonial National Historical Park; photo, Gavin Ashworth.) COLO J 7297. This stylized quatrefoil flower is found on many other hollow and flat forms.

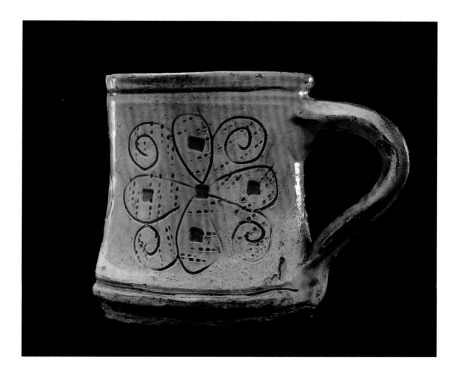

tempered coarse earthenware. Their vertical necks are horizontally ribbed and grooved, and their bodies are bulbous. They are slipped on the exterior, and glazed on the interior and upper exterior. The bodies are incised on the upper half with stylized motifs. Decorations include stippled multi-petaled flowers and vertical lines (fig. 30), stippled quatrefoil flowers and tulips

Figure 30 Jug, North Devon, ca. 1670–1680. Sgraffito slipware. H. 6¾". (Courtesy, National Park Service, Colonial National Historical Park; photo, Gavin Ashworth.) COLO J 7346. A combination of wavy lines and multipetaled floral devices decorate this example.

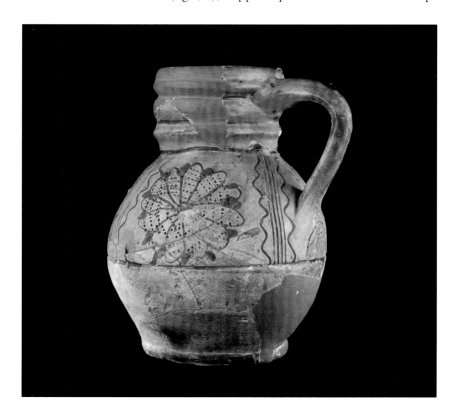

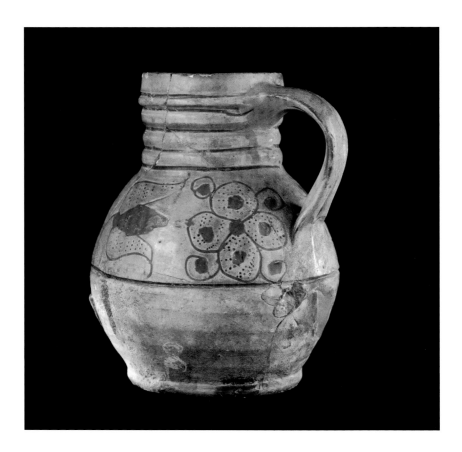

Figure 31 Jug, North Devon, ca. 1670–1680. Sgraffito slipware. H. 6¾". (Courtesy, National Park Service, Colonial National Historical Park; photo, Gavin Ashworth.) COLO J 7296. Quatrefoil flowers and tulips are incised on this jug.

Figure 32 Jug, North Devon, ca. 1670–1680. Sgraffito slipware. H. 6¾". (Courtesy, National Park Service, Colonial National Historical Park; photo, Gavin Ashworth.) COLO J 7347. This jug is ornamented with a quatrefoil flower and carnations.

Figure 33 Jug, North Devon, ca. 1670–1680. Sgraffito slipware. H. 8½". (Courtesy, National Park Service, Colonial National Historical Park; photo, Gavin Ashworth.) COLO J 7368.

(fig. 31), carnations (or thistles) with leaves flanking a central quatrefoil flower (fig. 32), and a vertical pattern of stippled horizontal lines, wavy lines, and combed vertical lines (fig. 33).

Two deep bowls recovered from the ditch are the only hollow wares decorated on the interior (fig. 34). Both are the same size and have a single horizontal loop handle on the rim. One is incised on the central base with a quatrefoil flower, and on the interior walls with spirals and elaborate hanging flowers. The other is decorated with an abstract design consisting of horizontal wavy lines and vertical stippled lines separated by vertical combed stripes.

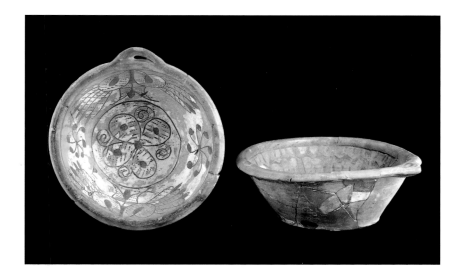

Figure 34 Bowls, North Devon, ca. 1670–1680. Sgraffito slipware. H. 4", D. 8¾". (Courtesy, National Park Service, Colonial National Historical Park; photo, Gavin Ashworth.) *Left:* COLO J 7352; *right:* COLO J 7344. Both have a single horizontal loop handle on the rim exterior, and are sgraffito-decorated on the interior.

Figure 35 Chamber pot, North Devon, ca. 1670–1680. Sgraffito slipware. H. 5½". (Courtesy, National Park Service, Colonial National Historical Park; photo, Gavin Ashworth.) COLO J 7369. The exterior of this chamber pot is decorated with chevrons, wavy lines, and dashes.

Figure 36 Fragments of two incomplete chamber pots, North Devon, ca. 1670–1680. Sgraffito slipware. (Courtesy, National Park Service, Colonial National Historical Park; photo, Gavin Ashworth). COLO J 53452; COLO J 53459; COLO J 53469; COLO J 53472; COLO J 53636.

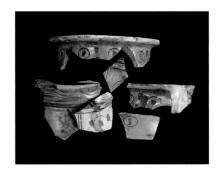

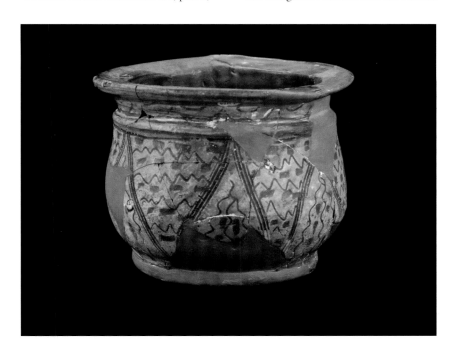

Sgraffito-Decorated Comfort Wares

Not all of the decorated forms in the assemblage were for food preparation or serving; two were made to meet daily needs: chamber pots and candlesticks. One almost complete bag-shaped chamber pot (fig. 35) was recovered, along with fragments of two others (fig. 36). They are incised on the exterior with motifs including stippled multi-petaled flowers, rows of dotted circles, and chevrons separating horizontal rows of wavy lines alternating with rows of dashes. Slip and lead glazes cover the interiors and exteriors.

Figure 37 Detail of the rim of the chamber pot illustrated in figure 35. (Courtesy, National Park Service, Colonial National Historical Park; photo, Gavin Ashworth.) The initials are possibly those of William Berkeley, governor of Virginia during the period in which the pot was manufactured.

Figure 38 Candlestick, North Devon, ca. 1670–1680. Sgraffito slipware. H. 6 5/16". (Courtesy, National Park Service, Colonial National Historical Park) COLO J 12342. Because of its rarity, this is one of the most important ceramic objects in the archaeological collections of the National Park Service at Jamestown.

The most intact of the three chamber pots has a rim diameter of six and three-fourths inches and is inscribed "WB 16__" (fig. 37). Could this pot have been made for William Berkeley, the governor of Virginia until his death in 1677, thereby providing a terminus ante quem for the collection? White and Berkeley were linked, as shown in a 1674 court record documenting that one of Berkeley's indentured servants was obligated to serve White for a year and a half for boat stealing.[19] Did White specifically order the inscription to show his appreciation, or later to demonstrate his loyalty to Berkeley during a period of civil unrest leading up to Bacon's Rebellion in 1676? Although these questions can probably never be answered with any certainty, they demonstrate the potential for linking forgotten artifacts with historic people or events.

One of the most important of all the North Devon slipware forms recovered is a handled candlestick with a flared base and mid-section drip tray (fig. 38). Fragments of a least one other example were also found (fig. 39).

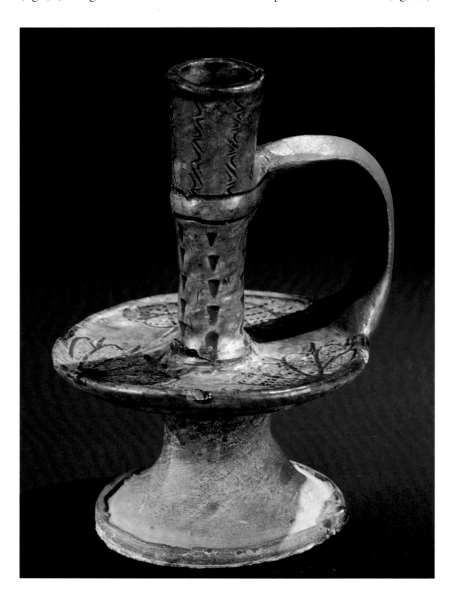

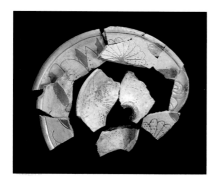

Figure 39 Fragments of incomplete candlestick, North Devon, ca. 1670–1680. Sgraffito slipware. (Courtesy, National Park Service, Colonial National Historical Park; photo, Gavin Ashworth.) COLO J 53453; COLO J 53454; COLO J 53460. This candlestick is decorated on all exterior surfaces with floral devices.

These mid-drip candlesticks have parallels in delft and metal forms. Their top half exteriors are slipped and decorated with stylized stippled floral motifs.

Undecorated Slipware

Slipped but undecorated vessels include a shallow plate with a piecrust rim, large dishes, porringers, dishes with wavy edges, and a milkpan. Paralleling the decorated example, the shallow plate exhibits a pinched piecrust rim and is nine and three-fourths inches in diameter. It is glazed on the interior only, and displays knife trimming on the exterior above the base.

Three large dishes, eleven and one-half to twelve inches in diameter, are slipped and glazed on the interior only. They are similar in form and size to the sgraffito-decorated examples. And like the incised dishes, all exhibit knife trimming on the exterior above the base.

Ranging in height from two and one-half to three and one-fourth inches, six porringers appear in two forms, carinated and bulbous (fig. 40). Bearing a single horizontal loop handle applied at the waist, two carinated examples are slipped and glazed on the interior and just over the rim. Resembling delftware forms, the four bulbous porringers each have one horizontal loop handle just below the rim. They are slipped and glazed on

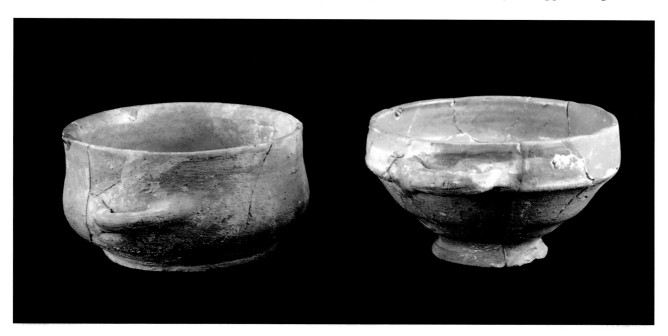

Figure 40 Porringers, North Devon, ca. 1670–1680. Slipware. *Left:* H. 3"; *right:* H. 3¼". (Courtesy, National Park Service, Colonial National Historical Park; photo, Gavin Ashworth.) *Left:* COLO J 7331; *right:* COLO J 7333. These examples represent the two porringer forms found.

the interior, and are unglazed on the exterior. Rough on the exterior bases, the porringers appear to be lightly gravel tempered.

Four wavy-edged baking dishes are represented in the assemblage. In graduated sizes, their rim diameters range from eight to ten and one-half inches (figs. 41, 42). Flat based, their tall vertical sides were pinched when the clay was damp to form corners and seven, eight, nine, or eleven sides. They are slipped and glazed on the interior and just over the rim exterior, and are horizontally grooved just below the rim exterior and/or interior.

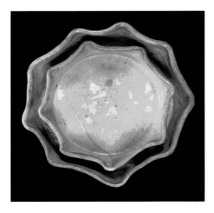

Figure 41 Dishes, North Devon, ca. 1670–1680. Slipware. D. 9", 10½". (Courtesy, National Park Service, Colonial National Historical Park; photo, Gavin Ashworth.) *Smaller:* COLO J 7337; *larger:* COLO J 7300. These wavy edge dishes occur in graduated sizes.

Figure 42 Dish, North Devon, ca. 1670–1680. Slipware. D. 9½". (Courtesy, National Park Service, Colonial National Historical Park; photo, Gavin Ashworth.) COLO J 7340.

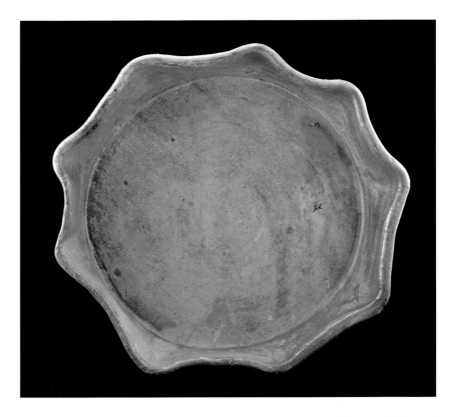

Sherds of a unique slipware milkpan also survive. The fabric and form of this fragmentary object are typical of North Devon gravel-tempered coarse earthenware, but a white slip under a lead glaze covers the interior below the rim. This example, along with the handles on the six incised jugs and the porringers, show that gravel-tempered earthenwares and slipwares were produced at the same kiln.

Conclusion

Somewhere between the coastal North Devon region of England and Jamestown, Virginia, a large ceramic shipment was broken. The fragmented vessels were discarded in a ditch dug to provide drainage for flat, low-lying property at Jamestown, which in the twentieth century was named May-Hartwell for its first and last seventeenth-century owners. The sheer number and range of forms indicate that they were intended for more than one household. Since Colonel William White was the only merchant owner of the property, it is extremely likely that the parcel was shipped to him during his occupancy, which may date as early as 1673.

This fortuitous accident, while disastrous for the owner at the time, has provided a legacy of the most complete example of North Devon sgraffito-decorated slipwares in the world. With forty-seven restored vessels represented, and fragments of many, many more, the May-Hartwell assemblage also gives us a unique view of everyday life in Virginia during the 1670s. As we examine these ceramics intended to fulfill the colonists' daily needs and activities, doorways to their kitchens, bedchambers, dairies, taverns, and even their minds, are opened. Skillfully scratched in clay, the decora-

tion gives us a firsthand look at the stylistic trends and tastes of the time. We may also contemplate the potters who threw and decorated these remarkable vessels over three hundred years ago. Could they possibly have imagined the fate of their work and the enduring effect of their creations?

ACKNOWLEDGMENTS

I would like to thank Curator David Riggs and Museum Technician William Calhoon of the National Park Service's Colonial National Historical Park for always making the collection and other research materials available to me. Also, for generously sharing their thoughts on the collection, I extend my appreciation to colleagues and fellow ceramics enthusiasts Beverly Straube, Taft Kiser, Robert Hunter, Michelle Erickson, Richard Coleman-Smith, and last, but in no way least, Alain Outlaw.

1. John L. Cotter, *Archeological Excavations at Jamestown, Virginia*, 2nd ed. (Richmond: Archeological Society of Virginia, 1995), pp. 68–74. H. Summerfield Day, "Preliminary Archeological Report of Excavations at Jamestown, Virginia," 1935, typescript, Colonial National Historical Park. J. C. Harrington, "Summary of Documentary Data on the William May-Henry Hartwell Property Preparatory to its Excavation," 1938, typescript, Colonial National Historical Park. J. C. Harrington, "Archeological Report: May-Hartwell Site, Jamestown, Excavations at the May-Hartwell Site in 1935, 1938, and 1939 and Ditch Explorations east of the May Hartwell Site in 1935 and 1938," 1940, typescript, Colonial National Historical Park.

2. Although the potter or potters and place of manufacture of these vessels have yet to be identified, examples uncovered in Barnstaple are similarly sgraffito-decorated. Many marly motif parallels have been recovered from kiln excavations in North Devon. Linda Blanchard, *Archaeology in North Devon 1987–8* (Barnstaple, Eng.: North Devon District Council, 1989), pp. 16–19. Alison Grant, *North Devon Pottery: The Seventeenth Century* (Exeter, Eng.: A. Wheaton & Co. Ltd, 1983), plates 8–15, 17. C. Malcolm Watkins, "North Devon Pottery and Its Export to America in the Seventeenth Century," *United States National Museum Bulletin* 225 (Washington, D.C.: U. S. Government Printing Office, 1960), p. 20.

3. Michelle Erickson and Robert Hunter, "Dots, Dashes, and Squiggles: Early English Slipware Technology," in *Ceramics in America*, edited by Robert Hunter (Hanover, N.H.: University Press of New England for the Chipstone Foundation, 2001), pp. 98–101.

4. Watkins, "North Devon Pottery and its Export to America in the Seventeenth Century." Grant, *North Devon Pottery: The Seventeenth Century*.

5. Port records indicate that only fifteen percent or less of North Devon's overseas exports was to America. Grant, *North Devon Pottery: The Seventeenth Century*, p. 114.

6. Ibid., pp. 35–46.

7. Ibid., pp. 1–33.

8. Ivor Noël Hume, "First Look at a Lost Virginia Settlement," *National Geographic Magazine* 155, no. 6 (June 1979): 735–37. Ivor and Audrey Noël Hume, *The Archaeology of Martin's Hundred Part I: Interpretive Studies* (Philadelphia: University of Pennsylvania Press, 2001), pp. 166–68. Alain Charles Outlaw, *Governor's Land: Archaeology of Early Seventeenth-Century Virginia Settlements* (Charlottesville: University Press of Virginia, 1990), pp. 105–8.

9. Ivor and Audrey Noël Hume, *The Archaeology of Martin's Hundred Part I: Interpretive Studies*, pp. 166–68.

10. Sgraffito decoration of ceramics passed from China, through the Middle East, and then to Italy in the Middle Ages. From the sixteenth century on, the technique spread to Switzerland, Germany, France, and the Low Countries. Double slipping, or the application of a white slip over a red slip before sgraffito decorating, was used in Northern Europe. European sgraffito decorated wares are well represented on post-medieval archaeological sites in southwestern England, therefore serving as prototypes. In addition, techniques, forms, and designs may have come into southwestern England by way of refugee Huguenot and Netherlands Protestant artisans, who may have included potters. Grant, *North Devon Pottery: The Seventeenth Century*, p. 2; Leslie B. Grigsby, *English Slip-Decorated Earthenware at Williamsburg*

(Williamsburg, Va.: Colonial Williamsburg Foundation, 1993), p. 19. John G. Hurst, David S. Neal, and H. J. E. Van Beuningen, "Pottery Produced and Traded in North-West Europe, 1350–1650," *Rotterdam Papers 6* (Rotterdam: Museum Boymans-van Beunigen, 1986), pp. 30–33. Hans van Gangelen, Peter Kersloot, Sjek Venhuis, *Hoorn des Ouervloeds: De Bloeiperiode van Het Noord-Hollands Slibaardewerk, Ca. 1580–Ca. 1650* (Stiching Noord-Hollands Slibaardewerk Oosthuizen: Stiching Uitgeverij Noord-Holland Wormerveer, 1997). Ivor Noël Hume, *If These Pots Could Talk: Collecting 2,000 Years of British Household Pottery* (Hanover, N.H.: University Press of New England for the Chipstone Foundation, 2001), pp. 35–36.

11. Grant, *North Devon Pottery: The Seventeenth Century,* pp. 131–34.

12. Ivor and Audrey Noël Hume, *The Archaeology of Martin's Hundred Part II: Artifact Catalog* (Philadelphia: University of Pennsylvania Press, 2001), pp. 237–39, 300–303. Seth Mallios, *Archaeological Excavations at 44JC568, The Reverend Richard Buck Site* (Richmond: Association for the Preservation of Virginia Antiquities, 1999), p. 32.

13. Analysis of the ditch artifacts has always been difficult because of the lack of excavation field notes, drawings, and photographs. Because of the presence of glass wine bottle seals bearing the initials of Henry Hartwell, who patented the land in 1689, the deposit has always been related to him, thus post-dating 1689. Various explanations include rebuilding activities during Hartwell's occupation, discarding out of date ceramics, a household or shipping accident, and destruction at the end of Hartwell's residency in 1695. It is this author's opinion, however, that the restorable vessels, including North Devon gravel-tempered earthenware, North Devon sgraffito slipware, and English delftware, were broken in shipment to merchant Colonel William White, and the large ceramic fragments were used as drainage fill for the earlier U-sectioned ditch. Later, the very fragmentary domestic artifacts, including the "HH" bottle seals, bone combs, delft tiles, roofing tiles, turned lead, window glass, and flooring tiles, were discarded. This later material is very different in character from the large ceramic sherds, and it does suggest house-remodeling activities. Interestingly, White's widow married Hartwell. Harrington, "Summary of Documentary Data on the William May-Henry Hartwell Property Preparatory to Its Excavation." Cotter, *Archeological Excavations at Jamestown, Virginia,* pp. 68–74.

14. Archaeological parallels demonstrating the use of ceramic sherds for fill are common. For example, pottery waste was used as fill for drainage in the "soakaway" trenches and pits at John Dwight's late seventeenth-century Fulham pottery near the River Thames. Chris Green, *John Dwight's Fulham Pottery: Excavations 1971–79* (London: English Heritage, 1999), p. xii. In the early eighteenth century, stoneware wasters from the Southwark Bankside Kiln in London were used to line drainage channels and to strengthen the River Thames' shoreline. Saggers and wasters from the William Rogers pottery factory were used to surface roads in Yorktown, Virginia, in the second quarter of the eighteenth century. Ivor Noël Hume, *Here Lies Virginia* (New York: Alfred A. Knopf, 1963), pp. 221–22. Remarkably, whole vessels were used to fill a ravine at the Baynham stoneware pottery factory near Trenton, South Carolina, in the 1880s. Mark M. Newell, "A Spectacular Find at the Joseph Gregory Baynham Pottery Site," in *Ceramics in America* (2001), ed. Robert Hunter, pp. 229–32.

15. Grant, *North Devon Slipware: The Seventeenth Century,* pp. 58–59.

16. Grapes are common motifs on Germanic and Low Countries slipwares. Anton Bruijn, *Spiegelbeelden: Werra-Keramiek uit Einkhuizen 1605* (Zwolle: Stiching Tromotie Archeologie, 1992), pp. 259–62. van Gangelen, et al., *Hoorn des Ouervloeds,* figs. 85, 105, 124, 128, 129. Hurst, et al., "Pottery Produced and Traded in North-West Europe," pp. 244–45.

17. The use of scalloped medallions to frame the central motifs was common on German and Low Countries slipware dishes, and emulated similar decorative devices on Chinese porcelain dishes of the period. Bruijn, *Spiegelbeelden,* pp. 64–84. Hurst, et al., "Pottery Produced and Traded in North-West Europe," pp. 243–44. C. L. Van der Pijl-Ketel, ed., *The Ceramic Load of the "Witte Leeuw" 1613* (Amsterdam: Rijksmuseum, 1982), pp. 53–80.

18. Grant, *North Devon Slipware: The Seventeenth Century,* p. 59.

19. Martha W. McCartney, *James City County: Keystone of the Commonwealth* (James City County, Va.: Donning Company, 1997), pp. 111–13.

J. Victor Owen

Antique Porcelain 101: A Primer on the Chemical Analysis and Interpretation of Eighteenth-Century British Wares

▼ THE WESTERN WORLD HAS been fascinated by Chinese porcelain since its existence was first revealed to Europeans by Marco Polo 800 years ago. Monarchs collected it, the landed gentry coveted it, and ordinary folk imitated it with inexpensive coarse earthenware. It was the ultimate status symbol. All of this ensured that it was only a matter of time before entrepreneurs—some sponsored by their regents— would seek and eventually find the secret of manufacturing their own porcelain.

In Europe, the first pseudo-porcelain was manufactured in Italy in the late sixteenth century. True porcelain was first made in Germany in the early eighteenth century, several decades before any type of porcelain was made in Britain. Early British porcelain, however, is of particular interest, not only because many different types were produced, but because large quantities of it were exported to colonial North America. As such, it can be found on many archaeological sites on this continent, even French settlements such as the Fortress of Louisbourg, in Cape Breton.[1]

The road to a domestic British porcelain industry took many turns (table 1) because those experimenting with the manufacture of these wares only knew what the end-product should look like but had no real idea how

Table 1 Evolution of porcelain pastes used at representative British factories in the eighteenth century.

Artificial porcelains
 bone ash
⋯⋯ flint glass frit ⎫ hybrid
■■ Silicious/aluminous wares
✦✦ Silicious/aluminous/calcic wares
⌣ bone ash - frit
·•· soapstone - frit

True porcelain
 No symbols

		1740	1750	1760	1770	1780	1790	1800
Pomona	c. 1744–1754	⋯⋯⋯⋯⋯						
Limehouse	c. 1744–1748	■✦✦						
Chelsea	c. 1745–1748	⋯⋯⋯⋯⋯						
Bow	c. 1747–1776	?_____						
Longton Hall	c. 1750–1760		⋯⋯⋯⋯⋯					
Lund's Bristol	c. 1749–1751		•					
Worcester	c. 1751–1840		•—•·•·•·•·•·•·•·•·•·•·•·•·•·•·•·					
Derby	c. 1748–1848		⋯⋯⋯⋯⋯⋯⋯ _____					
Brownlow Hill	c. 1755–1767		?■✦✦✦✦✦✦✦					
Lowestoft	c. 1757–1799		_____					
Plymouth/Bristol	c. 1768–1781							
Caughley	c. 1772–1799				•·•·•·•·•·•·•			

to achieve this goal. Porcelains are white and translucency. Their translucency results from the ware partly melting (vitrifying) in the kiln. Its white color reflects the use of suitable clay and other ingredients. Identifying these ingredients was a major obstacle to those attempting to produce porcelain. As a result, their trial-and-error experiments made use of a remarkably wide range of paste mixtures. Some of these had the unfortunate property of promoting wholesale melting, and hence sagging, of the ware at peak firing temperatures. Thus, the control of kiln conditions was as much an issue as paste recipes. Fortunately for porcelain enthusiasts, all early porcelain factories created extensive waster piles in the course of their operations, and these are a fertile source of research material.

This article summarizes the character of the diverse raw materials used in porcelain pastes and glazes and the effect that these have on their chemical composition, and hence their classification. Methods by which porcelain can be analyzed are briefly discussed, after which the use of compositional fingerprints in porcelain provenance studies is considered. In order to further highlight the significance of these analytical data, a porcelain analysis is recast into a paste recipe. Using historical information concerning the amount of a key ingredient consumed by its manufacturer, recipe data are then manipulated so that an annual production rate can be estimated. Features indicative of kiln firing temperatures are also reviewed. Finally, the broad issue of collecting analytical data on archaeological ceramics is considered by citing some real-life examples.

The Raw Materials of Porcelain

Based on their experience with making coarse earthenware, early potters attempting to "reinvent" porcelain knew they had to base their experiments on mixtures of clay (for plasticity), quartz-rich sand or flint (an aplastic), and fluxing agents (to promote melting at achievable temperatures). Here consensus ended. Indeed, one of the most contentious issues for modern researchers concerns the type and source of the clay used in eighteenth-century British porcelain. It is therefore instructive to review the main types of this and other ingredients that manufacturers included in their porcelain pastes. The mineral formulae and chemical compositions of

Table 2 Compositional formulae for selected porcelain paste ingredients.

Kaolinite:	$Al_4(Si_4O_{10})(OH)_8 = 2Al_2O_3 \cdot 4SiO_2 \cdot 4H_2O$
Talc:	$Mg_6(Si_8O_{20})(OH)_4 = 6MgO \cdot SiO_2 \cdot 2H_2O$
Flint glass:	$Pb_{0.8} K_{0.9} Si_{4.4} = 0.8PbO \cdot 0.45K_2O \cdot 4.4SiO_2$
Potash:	$K_2CO_3 = K_2O \cdot CO_2$
Soda ash:	$Na_2CO_3 = Na_2O \cdot CO_2$
Bone ash:	$Ca_3(PO4)_2 \cdot Ca(OH)_2 = 3CaO \cdot P_2O_5 \cdot (CaO \cdot H_2O)$
Calcite:	$CaCO_3 = CaO \cdot CO_2$
Quartz:	$SiO_2 = SiO_2$

Notes: the flint glass was recovered from the Caughley site (Owen et al., 2000, Table VI). For the purposes of recipe calculations, it is treated here as a stoichiometric phase. The bone ash is low-fired (T<1000 \cdot C), so has a CaO/P_2O_5 ratio of 4.

	SiO_2	Al_2O_3	MgO	CaO	Na_2O	K_2O	P_2O_5	PbO	H_2O	CO_2
Kaolinite	46.55	39.49							13.96	
Talc	63.36		31.89						4.75	
Flint glass	53.52	0.72			0.50	8.32		36.96		
Potash						68.16				31.84
Soda ash					58.48					41.52
Bone ash				58.37			36.94		4.69	
Calcite				56.03						43.97
Quartz	100.00									

Notes: Data are in wt.%
The flint glass was recovered from the Caughley site (Owen et al., 2000, Table VI) and excludes minor components.
The bone ash is assumed to have been low-fired (T<1000C) before being incorporated into the ceramic paste.

Table 3 Composition of selected porcelain paste ingredients.

most of these ingredients are summarized in tables 2 and 3, respectively, and these raw materials are briefly described below.

CLAY comprises a group of hydrated aluminum silicate minerals that form minute crystals with a flaky (sheet-like) character. Clays tend to have an electrical polarity that allows positively charged ions to bond to their surface. This affects their composition.

Clays can be subdivided according to the mode of their formation, as well as their compositional and crystallographic characteristics. Primary (residual) clays form by the in situ degradation of aluminous minerals (principally feldspars) in bedrock. If transported and redeposited some distance from their source, they are considered to be secondary (sedimentary) clays. Primary clays include china clay (kaolinite) and bentonite; secondary clays include ball clays, fireclays, stoneware clays, and red marls. In terms of their composition and crystal structure, clays can be subdivided into five groups: kandites (including kaolinite), illites (e.g., illite and celadonite), smectites (e.g., montmorillonite and saponite), palygorskites (e.g., sepiolite), and vermiculite. Of these, the kandites are the most important in the preparation of porcelain pastes: kaolinite is a principal ingredient in true porcelain. Furthermore, ball clays, which are widely used in different types of ceramics and even glazes (to improve the adhesion of the glaze to the body), mostly consist of kaolinite, although detrital grains of other minerals are invariably present, giving ball clays a very wide range of compositions.[2] Early porcelain manufacturers washed these clays to remove impurities.

QUARTZ (a form of crystalline silica) in one form or another is invariably added to ceramics. To ensure the whiteness of the fired ware, it is advantageous to have a source of pure white, quartz-rich sand, although in some instances flint or chert was used instead. The presence of this mineral strongly influences the firing behavior of ceramics because it undergoes several crystallographic inversions in response to changing temperature (and/or pressure, in geological settings). Quartz gradually expands as it is heated, but there is an abrupt increase in its volume when it transforms into another silica mineral (polymorph) such as tridymite or cristobalite. These inversions are reversible, so the silica minerals contract during cooling.

These crystallographic inversions can lead to cracking of the body of the ware and crazing of the glaze.

CHERT (flint) is a form of cryptocrystalline silica. It commonly occurs as nodules in limestone and chalk deposits. Rarely pure silica, it generally contains small amounts of calcium carbonate (e.g., calcite) and water. Although naturally gray, it whitens when heated (calcined), and this process also allows the chert to be easily crushed for use in ceramic pastes.

BONE ASH is made by calcining animal bones, a source of both calcium and phosphorus. Not all bones are useful in this regard—some animal bones contain impurities such as iron, rendering them less suitable for the preparation of porcelain. Cattle bones are usually used. The use of bone ash dates back to the early days of British porcelain, but it is unclear why this is the case. One possibility is that animal bones are white and readily available (and therefore inexpensive) from the knackerman. A more intriguing reason centers on the notion that adding bones to ceramic pastes would give them strength in the same manner that skeletons support vertebrate animals. Although within the realm of folklore, there is a tradition in Britain for this explanation.[3] Whatever the reason for its initial use, bone-ash is a principal ingredient in modern bone china.

Bone ash is known to influence the melting behavior of porcelain. A key issue in the investigation of historical bone-ash wares (*sensu lato*) is the temperature at which the bones are calcined. If "burned" at temperatures below about 1000°C, bone ash contains parts calcium oxide (CaO) for each part phosphorus oxide (P_2O_5) (and one part water).[4] But when added to ceramic pastes and fired at temperatures above 1000°C, the bones progressively dehydrate and lose about 25% of their calcium, which reacts with clay to form calcium-rich silicate minerals, including anorthite (calcium plagioclase). The bulk CaO/P_2O_5 ratio (expressed in terms of molecular proportions, see below) of eighteenth-century British phosphatic porcelains generally ranges between about 3.2 and 3.84, indicating that the bone ash at the time was high-fired, so it had already lost some of its calcium. This inference is supported by the analysis of calcined bones from the Longton Hall site, which have a CaO/P_2O_5 ratio of 3.3 to 3.5. Caution should be exercised in interpreting these data, however, because it is known that unglazed (biscuit) sherds from this site have had calcium leached from them, probably by circulating groundwater during 250 years of burial.[5] Bones from this site might also have been leached. Clearly, the analysis of calcined bones from other sites in which this leaching process has not occurred would be useful in better understanding the character of this ingredient and its effect on the mineralogy and composition of the wares in which it is found.

SODA ASH, a highly soluble sodium carbonate, was used as a fluxing agent in many early porcelains. Traditionally, it was made by burning kelp.

POTASH, a highly soluble potassium carbonate, was also used as a fluxing agent. It was made by burning plants.

FLINT GLASS, or lead crystal, was used as a fluxing agent in some early porcelains (e.g., Longton Hall, Worcester; see table 1 for the dates for these and other factories). Its lead content can vary considerably. Blue flint

glass (smalt) from the Caughley site proved to contain about 37 wt.% lead oxide (PbO). It also contains significant amounts of potassium. Smalt from America's first known porcelain works, the Bonnin and Morris factory in Philadelphia, however, contains about 61 wt.% PbO.[6]

BARITE is a barium sulphate mineral. It was used in the paste of some experimental porcelains (e.g., Bovey Tracey). Substantial amounts of the element barium are also present in the glaze on some of the nineteenth-century porcelains produced at the Grainger (Worcester) works. This glaze is very low in sulphate, so unless all of the sulphur was dissipated as sulfur dioxide (SO_2) during firing, the barium must originate in a source other than barite (e.g., perhaps a barian feldspar such as celsian).

STEATITE, a talc-rich rock (soapstone), was used to partly replace clay as the plastic ingredient in some early porcelains (e.g., Worcester). Steatite is the major source of magnesium in these wares. When fired, steatite can break down to yield enstatite, a magnesium-rich pyroxene-group mineral that has a low coefficient of thermal expansion. These wares therefore resisted breaking when immersed in boiling water, a definite selling point to a nation of tea drinkers. If calcite was also included in the paste, then steatite can break down to form diopside, a calcium-magnesium pyroxene group mineral. At one time, it was thought that diopside was rare in "soapstone" porcelains. Analysis of these wares from a variety of sites, however, have shown that it actually is very common, having been identified to date in all such analyzed wares except the low-calcium porcelain produced in Worcester and its Vauxhall counterpart.[7]

During the eighteenth century, soapstone porcelain manufacturers quarried their steatite from the Lizard peninsula, where this material forms narrow veins in serpentinite, a magnesium-rich rock derived from the hydration of mantle peridotite. These were small-time mining operations (figs. 1, 2), only a few tons of steatite being removed from the ground annually. It is very likely that the steatite used was adulterated by the host

Figure 1 Gew Grange soapstone quarry. (Photo, Victor Owen.)

Figure 2 A view of the bay at the end of the Gew Grange quarry. The pale band in the cliff is a shear zone in which soapstone formed at the expanse of the dark host rock (peridotite). (Photo, Victor Owen.)

rock. Indeed, so-called ground "talc" recently purchased at a pottery supply store proved to have this mineral only as very a minor constituent; serpentine and other magnesium-rich minerals comprised most of the powder.

CALCITE, a calcium carbonate mineral, is the principal mineral in limestone and marble. Powdered calcite is now often referred to by potters as whiting.

DOLOMITE, a calcium-magnesium carbonate mineral, is the principal mineral in dolostone. It forms as magnesium-bearing brines circulate through and react with limestone. Thus, many limestones can be dolomitic. It may be a source of magnesium in some porcelains, although it is clear that this component generally originates in steatite.

CHINA STONE is granite that has had the feldspars altered to clay minerals by the action of hot water (hydrothermal solutions) circulating through the bedrock. It is used in true porcelain and bone china. Traditionally, British manufacturers of these wares used Cornish china stone, which tends to be extremely aluminous (i.e., is derived from peraluminous granite, which contains concentrations of aluminum in excess of that residing in feldspar group minerals in the rock).

GYPSUM is a hydrated calcium sulphate mineral. It is the likely source of small amounts of sulphur that can occur in some porcelains, especially phosphatic ones. In these wares, the sulphur seems to get trapped in phosphate minerals during firing, although some may be liberated from the paste in a gaseous state (e.g., as SO_2) as the mineral breaks down. If this is the case, then paste recipes calculated from compositional data will underestimate the amount of gypsum that actually was used in the ware. In rare instances, other sulphate minerals such as barite were used by some manufacturers.

Glaze Raw Materials

Two main types of glazes were used on eighteenth-century British porcelain. Artificial porcelains were coated with lead-bearing glazes after an initial,

high-temperature firing. In contrast, many true porcelains were coated with alkali-lime glazes that could withstand the very high temperature of the biscuit kiln, so only a single firing was required prior to the application of on-glaze decoration (e.g., enameling). Some true porcelains, however, have lead glazes, and so were manufactured using the traditional, two-stage soft-paste firing sequence. The lead content of the glazes on early porcelains can vary enormously (from about 10 to 55 wt.% PbO). Since typical flint glass contains in the order of 35 wt.% PbO, then clearly, at least some glazes must have made use of another source of this component (e.g., red lead or another lead oxide).

As health problems emerged in those charged with the task of dipping biscuit wares into lead glazes, alternate glazes were developed for artificial porcelains. In the 1820s, John Rose of the Coalport works won a gold medal for introducing a feldspathic glaze that contained borax as a fluxing agent. Surprisingly, analysis of the glazes on some modern British bone china shows that the use of lead has not entirely disappeared from the industry.[8]

Glaze recipes required the presence of three types of ingredients: glass forming compounds (e.g., silica, which upon solidification allows the glaze to retain the amorphous character of the molten state), stabilizers (e.g., alumina, which stiffen—increase the viscosity of—the molten glaze), and fluxes (e.g., alkalis and lead compounds to lower melting temperature). Insofar as glazes are glassy coatings on ceramic bodies, it is inherently difficult to ascertain the ingredients used in their manufacture, because virtually none (tin oxide is a rare exception) are preserved as relict grains in the glaze itself. However, compositional data suggest that early glazes were prepared from some of the same ingredients used in the paste, but in much different proportions. For example, the glazes on many soapstone porcelains can contain significant amounts of magnesium, a component generally lacking (or present only in minor concentrations) in the glazes on other types of wares.

Analytical Methods
British porcelain has been analyzed for many decades (figs. 3–11). In 1922 Eccles and Rackham published dozens of analyses of early wares that are still useful today.[9] However, over time, developments in instrumentation have allowed ever-smaller pieces of porcelain to be analyzed with greater accuracy and precision and with lower detection limits. There are many analytical tools that can be used for this purpose, but my own preference is the electron microprobe. This method has several advantages: only a small (mm-scale) piece of sample is required, and the sample does not have to be crushed. Once the sample is prepared for analysis, the microprobe can be used to determine its bulk composition, as well as the composition of individual mineral or glass grains within it. If equipped with a backscattered-electron imaging system (which generates and measures features in "compositional snapshots" of the ware), the microprobe can accurately determine the proportion of its constituent minerals. This can prove to be invaluable in studies that focus on the potential melt fertility of different types of paste, a

Figure 3 Teapot, Lowestoft, ca. 1770. Soft-paste porcelain. H. 6". (Courtesy, Roderick Jellicoe.)

Figure 4 Plate, William Reid, Liverpool, ca. 1757. Soft-paste porcelain. D. 9". (Courtesy, Roderick Jellicoe.)

Figure 5 Coffee can, William Reid,
Liverpool, ca. 1758. Soft-paste porcelain.
H. 2¼". (Courtesy, Roderick Jellicoe.)

Figure 6 Coffee cup, Derby, ca.
1758. Soft-paste porcelain. H. 6".
(Courtesy, Roderick Jellicoe.)
This enameled example has an
unusual ear-shaped handle.

Figure 7 Vase, Derby, ca. 1760.
Soft-paste porcelain. H. 6". (Courtesy,
Roderick Jellicoe.)

Figure 8 Coffee can, Samuel Gilbody,
Liverpool, ca. 1758. Soft-paste porcelain.
H. 2½". (Courtesy, Roderick Jellicoe.)

Figure 9 Mug, Samuel Gilbody, Liver-
pool, ca. 1758. Soft-paste porcelain.
H. 3½". (Courtesy, Roderick Jellicoe.)

feature that can also be addressed on more theoretical grounds using phase
diagrams, as discussed below.

The microprobe uses a narrowly focused (micron-scale) electron beam
to irradiate a prepared sample of porcelain (or another medium). The irra-
diated part of the sample emits secondary X-rays that are indicative of its
composition. The sample is generally prepared for analysis by being sawn

Figure 10 Breakfast cup, Pennington's, Liverpool, ca. 1785. Soft-paste porcelain. D. 4½". (Courtesy, Roderick Jellicoe.)

Figure 11 Plate, Bow, ca. 1756. Soft-paste porcelain. D. 8". (Courtesy, Roderick Jellicoe.)

and ground flat, glued to a glass slide, and polished to a highly reflective, smooth finish. A skilled lapidary technician can successfully prepare a sample as small as 2 mm in diameter. In the case of intact objects, powder scraped from the base can be mounted in epoxy, and then polished. In this instance, however, only the composition of its constituent grains can be accurately determined, but this alone may serve to identify the ware. Sample preparation and subsequent analytical costs can vary considerably, but typically a single sherd can be analyzed for as little as fifty dollars. Furthermore, the same prepared sample (particularly if ground to a 5-times normal 150 microns thickness) can also be analyzed by other microbeam methods, such as the laser ablation microprobe, which can provide more accurate trace element data than the electron microprobe for samples containing

low concentrations of these components. A more recent development is the hard X-ray microprobe, which can not only be used to measure the concentrations of trace elements, but also their oxidation state. The use of these alternate methods, however, can add substantially to analytical costs.

Categories of Early British Porcelain

There are two end member categories of early British porcelain and one intermediate variant. Artificial (soft paste) porcelains are so-named because they contain some man-made ingredients, such as fritted (melted, quenched, and ground) mixtures of various compounds. These wares are first fired in an unglazed state in the biscuit kiln (T~1250°C), and subsequently, after glazing, at lower temperature in the glost (glaze) kiln. The glaze lies thickly on the body. In these regards, these wares are fundamentally different from true (Chinese-type) porcelains, which only contain "natural" ingredients (e.g., china stone and china clay), and are given a single high temperature (T~1400°C) firing during which the glaze fuses to the body. Of course, the addition of colored decoration requires additional firing. For example, a "hardening-on" firing of the ubiquitous underglaze blue designs was introduced to minimize bleeding of the cobalt pigment into the glaze, a characteristic that plagued some manufacturers (e.g., Lund's Bristol).

Glazes on early artificial porcelains contain lead. True porcelains usually have an alkali-lime glaze, but as already noted, some British manufacturers made use of lead glazes instead. In Britain, true porcelains were first manufactured in 1768 by William Cookworthy (Plymouth porcelain), and subsequently at Bristol. Artificial porcelain is thought to have first been made in the mid-1740s at the Pomona (Staffordshire) and Bow (London) factories (table 1).

The classification of British artificial porcelains has traditionally been based on key paste ingredients. These categories are therefore mirrored by the composition of the wares they represent. Thus, bone-ash porcelains are phosphatic, soapstone porcelains are magnesian, and frit ("glassy") porcelains contain lead, which in most instances likely originated in the use of flint glass. The latter grouping, however, is somewhat of a misnomer, because most, if not all, artificial porcelain manufacturers fritted some of their ingredients before grinding them to a powder and mixing them with clay and water. They were very secretive about their methods, but some historical documents record their procedures, albeit often in code. William Billingsley, who during the first quarter of the nineteenth century operated a bone-ash porcelain factory in the Welsh hamlet of Nantgarw, fritted bone ash and other ingredients, ground it, mixed it with water and clay to form a fluid slurry, and then slip cast his wares.

The analysis of sherds from factory sites has revealed new types of porcelaneous wares. For example, the dominant type of ware recovered from the Limehouse works (London) is a non-phosphatic, silicious, aluminous and calcic porcelain that contains small amounts of lead. A compositionally similar ware was found among abundant bone-ash porcelain sherds at the Brownlow Hill (Liverpool) site; both have an unusual, lead-rich, tin-bearing

glaze. There are, however, some notable differences between the Limehouse and Liverpool samples: those from Limehouse may contain relict bottle glass, which served as a source of calcium. In contrast, limestone was the likely source of calcium in the Liverpool samples. In addition, the tin-bearing glaze on the Brownlow Hill sherds is crystalline (i.e., it contains quartz crystals) and in this regard is perhaps unique among early British porcelains. This feature, however, likely reflects differences in the cooling history in the glost kiln rather than inherent contrasts between the character of the Limehouse and Brownlow Hill glazes. Both glazes contain particles of refractory tin oxide that would have served as nuclei on which quartz crystallites could have formed given suitable environmental conditions.[10]

There are also hybrids between the more traditional groupings of British porcelains. Most early Worcester porcelain (fig. 12) was made from pastes that contained both flint glass and soapstone; they are thus soapstone/frit porcelains. The earliest wares from this factory lacked soapstone—an ingredient previously used by the Lund's Bristol factory, which was acquired by Worcester's proprietors in February 1752. Prior to this, experimental Worcester pastes included flint glass and bone ash. These novel wares can be considered to be a frit/bone ash hybrid. The most important porcelain hybrid was invented in the mid-1790s by Josiah Spode, who combined ingredients of true porcelain and bone-ash porcelain pastes. In so doing, he created bone china, still an industry standard in Britain.

Figure 12 Sauceboat, Worcester, ca. 1754, Soft-paste porcelain. H. 2¾". (Courtesy, Victor Owen.)

Compositional Signatures of British Porcelain and Their Use in Provenance Studies

Many different factories produced phosphatic, soapstone, or frit porcelains. Some even produced more than one type of ware, as they switched recipes in response to various technical difficulties that they encountered (table 1). In some instances, recipe changes coincided with the annexation of a competing factory (e.g., Derby abandoned frit porcelain pastes in favor of bone-ash pastes after they acquired the Chelsea works in 1770). Thus, identifying the type of porcelain simply narrows the field of factories responsible for an object's creation. However, no two factories used identical recipes that incorporated exactly the same composition of all ingredients. Consequently, within each category of porcelain, there are compositional differences that serve to distinguish the products of particular porcelain works. These compositional signatures can be identified by analyzed bona fide wasters excavated from factory sites. Furthermore, the same analytical approach advocated here for porcelain can be applied to pottery, and preliminary results show that redware produced at various factories can have as distinctive compositional and mineralogical signatures as their more refined, porcelaneous counterparts.

Analytical data for both porcelain and pottery can be portrayed graphically as discrimination diagrams based on key components diagnostic of important ingredients (e.g., aluminium oxide [Al_2O_3], which reflects the amount of clay used in the paste). This approach is particularly useful for artificial porcelains, which can have a wide range of compositions within

Figure 13 Identification of eighteenth-century porcelain factories based on bulk alumina contents (Al_2O_3).

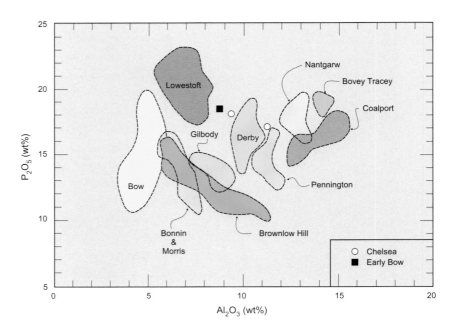

each category. Among phosphatic wares, bulk alumina contents can range from about 5 to 15 wt.% for porcelains produced at various factories (fig. 13). Distinction between true porcelains produced at different factories, however, is more equivocal, partly because few data are available for these wares, but also because they are produced from mixtures of relatively few ingredients that mostly originated from the same general area (e.g., Cornwall).[11]

Manipulating Analytical Data
Analytical data for early porcelain can be used for much more than simply identifying wares. Bulk compositional data can be recast into paste recipes, or used to predict the amount of melt that should form in the ware during kiln firing. The composition of the former melt phase in the ware provides an indication of firing conditions. These objectives will be considered in turn in the following sections.

1) Recipe Calculations
For many archaeologists, analytical data are more readily appreciated if they are expressed as proportions of paste ingredients (i.e., recipes) rather than their chemical constituents (e.g., expressed as cation oxides). Analyses of individual samples can be recast into a paste recipe provided that some information is available about which ingredients were used by the manufacturer. Historical factory records can provide detailed information about these ingredients, but the mineralogy of the samples themselves also provides important clues. In principle, recipe calculations are straightforward, but some uncertainty is introduced when the ingredients have variable compositions (e.g., sand, china stone). In contrast with earthenware, however, the ingredients used in porcelain pastes tended to be rather pure, and this both simplifies the calculation and minimizes errors associated with it.

At the heart of the recipe calculation presented here is the fact that many components in the ware originated in specific ingredients. For example, virtually all of the magnesium in soapstone porcelain has its source in steatite, whereas almost all of the phosphorus in bone-ash porcelain originates in bone ash. Since both soapstone and bone ash have predictable, well-known compositions (i.e., are stoichiometric) that vary little from sample to sample, the proportions of other elements within them are governed by the amount of magnesium and phosphorus, respectively. Thus, the proportions of these ingredients in the paste is the given by the sum of the signature element and other components in them, weighted according to stoichiometry (i.e., mineral formulae). Other types of ingredients such as rock (e.g., Cornish stone) or glass (e.g., flint glass) can be analyzed, and then treated as stoichiometric media. The only wrinkles in this type of calculation are introduced by the fact that mineral formulae are expressed as molecular proportions rather than by weight (as analytical data generally are), and some ingredients contain volatile substances (e.g., water and carbon dioxide) that are driven off during kiln firing. The first problem is readily solved by dividing through the wt.% analytical data by the molecular weight of each cation oxide (tables 3, 4). The second problem is remedied by adding back volatile components to their respective sources (e.g., water in steatite; carbon dioxide in calcite). The sample calculations in tables 4 and 5 show how an analysis of Worcester porcelain can be converted to a plausible paste recipe. Such recipes can be calculated by other means as well (e.g., least-squares calculations, as are commonly used to calculate the modal mineralogy of crystalline rocks), but the approach advocated here has the advantage that it can be readily undertaken with a hand calculator or spreadsheet.

Calculated paste recipes are useful for comparing and contrasting the compositions of wares in a tangible, meaningful way. They can also be used to calculate annual porcelain production rates provided that the yearly

Table 4 Conversion of a mineral formula to a wt.% recipe ingredient.

In the case of kaolinite, the proportion of silica to alumina is given by the weighted (according to mineral stoichiormetry; table 2) ratio (molecular proportions) Of $SiO_2:Al_2O_3$ (= 2:1). The molecular weight of silica is 60.09, and of alumina is 101.94. Each part alumina is therefore matched by $(2 \cdot 60.09)/101.94 = 1.18$ parts silica. It likewise is matched by $(2 \cdot 18)/101.94 = 0.35$ parts water (molecular weight = 18). Multiply the silica and water data by these coefficients, respectively, and add to the alumina value to determine the amount of kaolinite in the recipe. Thus, in the case of Worcester sample W44C (see text and table 5), which contains 3.6 wt.% alumina:

$$\text{alumina contribution} = 3.6 \text{ wt\% } Al_2O_3$$
$$\text{silica contribution} = (1.18 \cdot 3.6) = 4.25\% \text{ } SiO_2$$
$$\text{water contribution} = (0.35 \cdot 3.6) = 1.26 \text{ } H_2O$$

The total amount of kaolinite in the paste is therefore 9.11 wt.%. A running tally must be kept of the residual silica and other components shared by two or more paste ingredients during the rest of the recipe calculation. Note that volatiles such as water are driven off early in the firing history of porcelain, so measured porcelain compositions (W44C, table 5) do not include the water and carbon dioxide contained in the original paste ingredients.

	SiO_2	Al_2O_3	MgO	CaO	Na_2O	K_2O	P_2O_5	PbO	H_2O	CO_2	Total	(Recipe %)
Kaolinite	4.25	3.60							1.26		9.11	8.5
Talc	32.83		16.50						2.46		51.79	48.3
Flint glass	7.70					1.25		5.20			14.15	13.2
Potash						0.95				0.45	1.40	1.3
Soda ash					2.30					1.63	3.93	3.7
Bone ash				6.00			3.80		0.3		10.10	9.4
Calcite				0.80						0.63	1.43	1.3
Quartz	15.22										15.22	14.2
Total (=W44C)	60.0	3.6	16.5	6.8	2.3	2.2	3.8	5.2	[4.02]	[2.71]	107.13	99.9

Notes: The analysis is for a transitional period (c. 1752–53) Worcester dish.
Bone ash is assumed to be low-fired.
Cation oxide data for paste ingredients are expressed to two decimal places to reduce rounding errors in the final calculated recipe.

Table 5 Calculated soapstone paste recipe.

consumption of a key ingredient is known for the factory in question. The only other information that is required is a reasonable average weight for typical wares from the factory. The analytical data and calculated recipes are given in weight percent. Therefore, if the amount of a key ingredient consumed annually at a given factory is known, then an annual production rate can be calculated from proportion of that ingredient in the paste. During the 1750s, approximately eighteen tons of soapstone from quarries on the Lizard peninsula were purchased annually by Worcester's proprietors. It is likely that nearly all of this soapstone was used in Worcester pastes, because it was expensive (about £5/ton).

Given a typical soapstone content of about 37 wt.% in Worcester pastes and assuming an average weight of 250 grams per piece of porcelain, then in the order of 180,000 objects could have been produced annually at this factory.[12] If Worcester produced more teabowls and saucers (which weigh comparatively little) than, say, dinner plates and teapots, then this value could be about half the actual production rate. Factory manifests likely provide a clear idea of the proportion of different types of wares produced at any given factory for which records have been preserved. Representative examples from the period could then be weighed, and a weighted average determined, so that a more accurate idea of this factory's production could be calculated.

What is clear from this type of calculation is that only a few firings would have been necessary even at large factories, because kilns were stacked to roof with porcelain-laden saggars, to the extent that a large bottle kiln could easily accommodate over 20,000 objects. It is no wonder that a failed firing was financially devastating for these enterprises. It is likewise not surprising that the kiln operator was one of the most highly paid workmen at porcelain works.

2) Estimation of Kiln-firing Temperatures and Melt Fertility
Archaeologists have long been interested in reconstructing the firing conditions used in the manufacture of ceramics. In the case of coarse earthenware, this can sometimes be determined from the identity and composition of certain minerals in the ware such as iron oxides.[13] Other workers have directly

measured firing temperatures associated with the burning of certain types of fuel, in everything from open fires to updraft kilns, although the application of these results to ethno-thermometric studies can be controversial.[14]

In the case of porcelain, the fact that kiln temperatures, by definition, were sufficiently high to promote partial melting of the biscuit places close constraints on firing conditions. This is because of the availability of experimental data that relate different compositions of pastes to the amount of melt that can initially form in them, and its composition at different temperatures at and above the vitrification point. The analytical data are usually presented graphically in what are referred to as phase diagrams. Phase diagrams portray the results of experiments designed to simulate natural and synthetic systems. The data are plotted either as weight percent or molecular proportions; if this information is not given explicitly, the position on phase diagrams of compounds of intermediate composition indicates which form of data is appropriate. For example, if the composition of compound "AB" plots exactly halfway between components "A" and "B" on the edge of an "A-B" (two component, or binary) or "A-B-C" (three component, or ternary) diagram, then the data should be plotted as molecular proportions. If not, weight percent data are used. The only exception to this rule occurs where A and B have the same molecular weight, a rather unlikely scenario. Both bulk and phase compositional data can be plotted on these diagrams.

The term phase refers to a physically discrete substance (solid, liquid, or gas) within the system being investigated. The diagrams can be based on

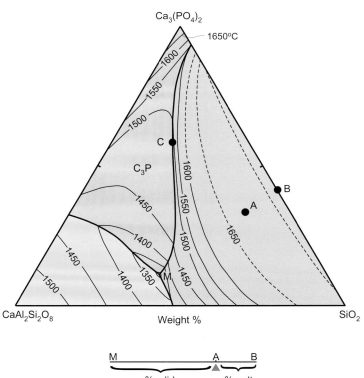

Figure 14 Phase diagram of how porcelain pastes melt in kiln temperatures.

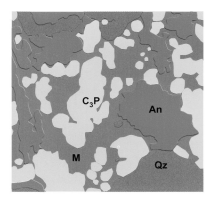

Figure 15 Diagram showing the shape (morpohology) during heating.

one or more chemical compounds (components) that dominate the ware being studied. Binary diagrams are portrayed as simple X-Y plots, wherein the vertical axis is temperature, and the horizontal axis is composition. Ternary diagrams are triangular; each apex represents a different component. Each side of ternary diagrams represents a binary system. The vertical axis, extending perpendicular to the page, represents temperature. Thus, in essence, ternary diagrams have a thermal topography. Thermal valleys (called cotectics) extend down-temperature, and can meet at what is referred to as a thermal (ternary) minimum (point "M" in fig. 14). The position of the ternary minimum (there may be more than one) dictates the composition of the first-formed ("minimum") melt that will form during kiln firing. The closer the bulk composition of the ceramic paste being fired is to the ternary minimum, the larger the amount of melt that will form at that temperature. Therefore, if by happenstance the paste has a minimum melt composition, then the ware will completely melt at the thermal minimum, provided that the system remains at that temperature for a sufficiently long period of time.

The example shown here (fig. 14) is pertinent to phosphatic porcelains that are sufficiently aluminous that calcium-rich plagioclase feldspar (anorthite: $CaAl_2Si_2O_8$) can form. On this diagram, the bulk composition of a typical bone ash ware is represented by point A. The amount of melt that can be formed in this ware once the minimum melt temperature (point M; a temperature slightly less than 1300°C) has been reached is determined by the lever rule. To apply this rule, a line is drawn from point M, through A, to the side of the diagram (point B). The proportion of minimum melt is given by the ratio of the distances AB/AM. Of course, this system excludes alkalis, which were used as fluxing agents in these wares. Their presence lowers the minimum melt temperature and can increase the melt fertility of the paste. In this regard, phase diagrams represent only a simulation of how ceramic pastes will actually behave in the kiln.

It is important to understand the significance of the minimum melt. Regardless of the temperature of the kiln, the ware being fired will remain at the minimum melt temperature and generate a melt of fixed composition until one of the minerals in the system is completely reabsorbed. In the example used here (point "A" in fig. 14), anorthite will be the first mineral to be dissolved. Until this happens, the minerals in the paste melt in the proportions dictated by the ternary minimum. Once a phase has dissolved, however, the temperature of the ware can rise, and the composition of the melt steadily changes. It does so in a predictable way, because the melt composition tracks a thermal valley up-temperature. In the case of the phosphatic ware shown in figure 14, once anorthite has dissolved, the melt will track the cotectic, separating the phosphate and silica fields until it reaches point C, whereupon the last of the calcium phosphate will dissolve. As temperature continues to rise, the melt will follow a compositional pathway along a line connecting C and A. Silica polymorphs will continue to dissolve until the liquid has a composition corresponding to the bulk sample (point A) which will then, of course, be entirely molten.

Figure 16 Diagram showing crystallized mineral grain.

How can these diagrams be used to reconstruct peak kiln temperatures? Temperatures on these diagrams are represented by lines of equal temperature (isotherms) that resemble contours on a topographic map. It is from these that the peak kiln temperature can be surmised. In general, however, this will be a maximum temperature, because, as already noted, the ware will often contain small amounts of a fluxing agent(s) not included in the chemical system represented by the phase diagram.

Provided that the system closely simulates the bulk composition of the ware (e.g., if it represents >90 wt.% of its bulk composition), then the composition of the melt phase (now a glass) can indicate whether or not melting was restricted to the thermal minimum. In many instances, however, the former melt phase in porcelain is adulterated by minute (submicron scale) crystallites that cannot be seen even at extreme magnification (e.g., X20,000). However, if the analyzed melt (inclusive of crystallites) compositions are plotted on the phase diagram, they can define a linear array of points between the thermal minimum and the position of the contaminating phase on the diagram. If the melt compositions instead extrapolate to a point on a thermal valley, then there should be one fewer phase present in the system (unless it started to crystallize out from the melt during cooling, and melting occurred above the thermal minimum).[15] Isotherms indicate the temperature corresponding to this point on the cotectic. The shape (morphology) of mineral grains (crystals) helps to distinguish between relict minerals that have not been completely dissolved during heating (fig. 15) and those that have subsequently crystallized from the melt during cooling (fig. 16).[16] Thus, informed interpretation of the ware requires more than simply identifying the presence of each phase: the origin of each mineral should also be considered where observations allow.

Discussion

Connoisseurship of early British porcelain has come a long way over the past few decades. Fifty years ago, some reference books on the subject advocated distinguishing between true and artificial porcelain by scratching the base of such objects with a steel file. This would now be considered unjustified vandalism, although it is altogether a different matter if unobtrusive scrapings from the object were being taken for the purpose of microchemical analysis.

Although previous generations of researchers often relied on ultraviolet lights to help link porcelain objects to specific factories, UV lamps should not be considered a reliable tool in attribution studies because vastly different types of porcelain can fluoresce in a similar manner.[17] For example, the body of phosphatic Nantgarw porcelain and some early Worcester soapstone wares can generate very similar pinkish-brown to brick red tones when illuminated by a long-wavelength black light.[18] Furthermore, unless they are pristine, the unglazed parts of porcelain objects (e.g., the base) can fluoresce differently than a fresh broken surface. The manner in which these surfaces fluoresce can be difficult to observe because of the intense colors that can be generated by the adjacent glaze. Neither should the

colors generated by the irradiated glaze be considered diagnostic, because small variations in glaze compositions can strongly influence how they respond to UV light. Furthermore, glazes on individual objects can be compositionally heterogeneous (e.g., zoned).[19] Black lights are, however, indispensable for detecting slick repairs to damaged specimens.

Modern connoisseurs tend to be more objective than some of their predecessors who flourished at a time when folklore seemed to rule the day. Commonly, the opinions of certain enthusiasts were often accepted unchallenged simply because of the august source of the information. Regrettably, some factory sites were excavated without the supervision of professional archaeologists. As a consequence, in some instances, large quantities of sherds were removed from the ground with little in the way of documentation. Indeed, many of these sherds, where not casually dispersed among other collectors, reside in dusty basements, uncataloged or even unnumbered (or sharing the same cryptic number as dozens of other sherds), and so have limited value from the point of view of serious research. Fortunately, a quick review of the recent literature shows that the times are changing. Apart from "rescue digs" where archaeologists "save" sherds from bulldozers, such excavations are now conducted in a much more systematic manner, so that the significance of individual sherds can more fully be appreciated.

There are, of course, situations in which even well-documented potsherds can mislead. These include cases where circulating groundwater has modified the mineralogy and composition of the wares, or where sherds from old factory sites actually originated elsewhere; many factories used broken dishes made elsewhere in their ceramic pastes (this material was referred to as "grog"). In the first instance, glazed sherds can preferentially preserve their original compositions better than biscuit samples.[20] In the second instance, it is best to conduct analytical work on obvious wasters, particularly sagged samples, those that are still attached to kiln furniture or firebricks, or those with aesthetic characteristics (e.g., shape or decoration) or markings that are unequivocally associated with the factory from which they have been excavated.

The application of widely used analytical methods to these wares has shed new light on the history of the porcelain industry in Britain. Many of the traditional opinions—some so entrenched that they once approached dogma—have been objectively tested. For example, it has been demonstrated that kiln-firing losses at Nantgarw were largely related to difficulties in controlling kiln temperatures rather than any inherent deficiency in the paste.[21] Based on the analytical data for these wares, belated advice can nonetheless now be offered to William Billingsley, Nantgarw's proprietor, on how he could have rendered his paste more refractory, so that it would have generated less melt at the extreme kiln conditions at which it was often fired.[22]

It has also been shown that, despite claims to the contrary, Worcester's early proprietors did indeed experiment with novel pastes prior to acquiring Lund's Bristol factory.[23] This can only lead to a better appreciation of

early Worcester wares and the innovative individuals who created them. Similarly, the long-held belief that America's first domestic porcelain, produced in the early 1770s at the Bonnin and Morris factory in Philadelphia, is virtually indistinguishable from Bow has also been refuted.[24] Although Bonnin and Morris hired former Bow staff, they produced a distinct type of bone-ash porcelain. Unlike any other phosphatic ware that has been analyzed to date, this Philadelphia porcelain made use of small amounts of flint glass. This can be detected by the microprobe analysis of less than a milligram of material surgically removed from the unglazed base of any suspected Bonnin and Morris porcelain object.

Analytical data can also point to possible linkages between seemingly unrelated factories. For example, possible connections between the Limehouse and Brownlow Hill works is suggested by some of the wares (stone china; Si-Al-Ca rich porcelain) recovered from these sites. This inference is supported by the fact that a William Ball worked at both factories, although it is unclear whether or not this was one and the same individual.

For some inexplicable reason, it is largely collectors who appreciate antique porcelain; comparatively few archaeologists are interested in these wares. Perhaps this is due to the fact that the ceramic assemblages recovered from colonial archaeological sites are dominated by utilitarian wares (redware, stoneware, etc.). Despite this, subordinate quantities of porcelain artifacts are widespread at many domestic (e.g., houses), commercial (e.g., up-scale taverns), and military (e.g., officer's quarters) sites. These fragments are usually given a generic name (e.g., "British soft-paste porcelain," "Chinese export," etc.), and then disregarded. And yet, what better evidence is there for high-end social status than these lustrous bits of dishes lying beneath the ground? And how easily they can be traced to a specific factory, especially if they originate in Britain, data for porcelain made elsewhere (except perhaps oriental wares) being comparatively sparse at present.

The analysis of ceramic sherds from defunct factory sites has provided a comprehensive compositional fingerprint for many of the major British porcelain manufactories, and with a few exceptions, sherds from colonial sites can be convincingly linked to specific potworks. For example, Bow (London) and Christian/Pennington (Liverpool) porcelain has been identified at the Fortress of Louisbourg.[25] A fragment of the same type of Liverpool porcelain has also been recovered from the Bonnin and Morris factory site. The significance of the latter sherd is unclear. Either someone discarded their favorite teacup after it had been damaged, or perhaps this object was used as a template for designing some Bonnin and Morris porcelain. This is one question, however, that cannot be answered in the lab.

Conclusion

The microchemical analysis of all types of archaeological ceramics has revolutionized the interpretation of these wares. No longer is ephemeral connoisseurship required to identify pottery and porcelain artifacts. Instead, a more egalitarian situation has arisen whereby with a small budget the archaeologist can characterize the nature of even tiny fragments of undecorated

wares that would otherwise confound even the cognoscenti in this field. Comparing the analytical results with an ever-expanding database compiled from sherds from factory sites, the origin of these samples can often be convincingly determined.

The data can be used for much more than provenance studies. Armed with a rudimentary understanding of phase diagrams, many of which were constructed specifically for this purpose, details about technical difficulties faced by the manufacturers of early porcelain can be assessed in a quantitative manner. Predictions about melt fertility can be compared with measured amounts of the glass phase in the porcelain, and the composition of this phase places important constraints on maximum kiln temperatures. This type of information is crucially important to appreciating how manufacturers responded to the challenges presented by the nascent porcelain industry in Britain.

A wider understanding of these methods of analysis and the interpretation of the analytical data can readily be gained by undergraduate archaeology and ceramics students who elect to enroll in introductory physical chemistry, mineralogy, and igneous petrology courses. It is to be hoped that these types of courses will soon be routinely included in archaeological and ceramics arts curricula.

ACKNOWLEDGMENTS
Rob Hunter is thanked for providing the opportunity to present this review article in *Ceramics in America*. It is largely based on earlier work that was supported by Natural Sciences and Engineering Research Council, and Social Sciences and Humanities Research Council of Canada operating grants to the author. Thanks are also extended to the many museum curators and ceramics enthusiasts who generously made available sherds for chemical analysis, and to Rod Jellicoe for making available photographs of the porcelain objects.

1. J. Victor Owen, "Provenience of Eighteenth-Century British Porcelain Sherds from Sites 3B and 4E, Fortress of Louisbourg, Nova Scotia: Constraints from Mineralogy, Bulk Paste and Glaze Compositions," *Historical Archaeology* 35, no. 2 (2001): 108–21.

2. F. Hamer, and J. Hamer, *The Potter's Dictionary of Materials and Methods,* 4th ed. (London: A & C Black, 1997).

3. Harry Frost, personal communication, 1998.

4. J. Victor Owen, "Compositional and Mineralogical Distinctions Between Bonnin and Morris (Philadelphia, 1770–1772) Phosphatic Porcelain and Its Contemporary British Counterparts," *Geoarchaeology* (in press).

5. J. Victor Owen, and T. E. Day, "Assessing and Correcting the Effects of the Chemical Weathering of Potsherds: A Case Study Using Soft-Paste Porcelain Wasters from the Longton Hall (Staffordshire) Factory Site," *Geoarchaeology* 13 (1998): 265–86.

6. J. Victor Owen, B. Adams, and R. Stephenson, "Nicholas Crisp's 'porcellien': A Petrological Comparison of Sherds from the Vauxhall (London; c. 1751–1764) and Indeo Pottery (Bovey Tracey, Devonshire; c. 1767–1774) Factory Sites," *Geoarchaeology* 15 (2000): 43–78. Owen, "Provenience of Eighteenth-Century British Porcelain Sherds from Sites 3B and 4E, Fortress of Louisbourg, Nova Scotia."

7. M. Bimson, "The Composition of Vauxhall Porcelain," *Transactions of the English Ceramic Circle* 13, no. 3 (1989): 226–27. Owen, Adams, and Stephenson, "Nicholas Crisp's 'porcellien': A Petrological Comparison of Sherds."

8. J. Victor Owen, "Geochemistry of Phosphatic- and Silicious/Aluminous-Porcelain Sherds from the Coalport Factory Site," in D. Barker and W. Horton, *Post-Medieval Archeology* 33 (1999): 3–93, appendix, 82–87.

9. H. Eccles, and B. Rackham, *Analysed Specimens of English Porcelain* (London: Victoria and Albert Museum, 1922).

10. I. Freestone, "A Technical Study of Limehouse Ware" in D. Drakard, ed., *Limehouse Ware Revealed* (Beckenham, Kent: English Ceramic Circle, 1993), pp. 68–77. J. Victor Owen, "A Preliminary Assessment of the Geochemistry of Porcelain Sherds from the Limehouse Factory Site, London" in K. Tyler, and R. Stephenson, *The Limehouse Porcelain Manufactory,* MoLAS Monograph 6 (2000), pp. 61–63.

11. J. Victor Owen and P. Williams, "Compositional Constraints on the Provenance of a True-Porcelain Chocolate Mug from the Rockingham Inn (c. 1796–1833) Site, Bedford, Nova Scotia," *Canadian Journal of Archaeology* 23 (1999): 51–62.

12. J. Victor Owen and J. Sandon, "Petrological Characteristics of Gilbody, Pennington, and Christian/Pennington (18th-century Liverpool) Porcelains and Their Distinction from Some Contemporary Phosphatic and Magnesian/Plombian British Wares," *Journal of Archaeological Science* 25 (1998): 1131–47.

13. R. Philpotts and N. Wilson, "Application of Petrofabric and Phase Equilibria Analysis to the Study of a Potsherd," *Journal of Archeological Science* 21 (1994): 607–18.

14. O. P. Gosselain, "Bonfire of the Enquiries. Pottery Firing Temperatures in Archaeology: What For?" *Journal of Archeological Science* 19 (1992): 243–59.

15. J. Victor Owen and M. L. Morrison, "Sagged Nantgarw Porcelain (1813–1820): Casualty of Overfiring or a Fertile Paste?" *Geoarchaeology* 14 (1999): 313–32.

16. Ibid.

17. George Savage, *18th-Century English Porcelain* (London: Spring Books, 1964), pp. 56–62.

18. See Owen and Morrison, "Sagged Nantgarw Porcelain (1813–1820)."

19. J. Victor Owen and R. Barkla, "Compositional Characteristics of 18th-Century Derby Porcelains: Recipe Changes, Phase Transformations and Melt Fertility," *Journal of Archaeological Science* 24 (1997): 127–40.

20. J. Victor Owen and T. E. Day, "Assessing and Correcting the Effects of the Chemical Weathering of Potsherds: A Case Study Using Soft-paste Porcelain Wasters from the Longton Hall (Staffordshire) Factory Site," *Geoarchaeology* 13 (1998): 265–86.

21. Owen and Morrison, "Sagged Nantgraw Porcelain (1813–1820)."

22. J. Victor Owen, J. O. Wilstead, R. Williams, and T. E. Day, "A Tale of Two Cities: Compositional Characteristics of Some Nantgarw and Swansea Porcelains and Their Implications for Kiln Wastage," *Journal of Archeological Science* 25 (1998): 359–75.

23. J. Victor Owen, "On the Earliest Products (c. 1751–52) of the Worcester Porcelain Manufactory: Evidence from Sherds from the Warmstry House Site, England," *Historical Archaeology* 32 (1998): 60–72.

24. J. Victor Owen, "Compositional and Mineralogical Distinctions between Bonnin and Morris (Philadelphia, 1770–1772) Phosphatic Porcelain."

25. Owen, "Provenience of Eighteenth-Century British Porcelain Sherds from Sites 3B and 4E, Fortress of Louisbourg, Nova Scotia."

Figure 1 Ovington's China Warehouse, Brooklyn, New York, ca. 1875. (Courtesy, Susan Myers.) Note the display of parian in the window at right.

Ellen Paul Denker

Parian Porcelain
Statuary:
American Sculptors
and the Introduction
of Art in American
Ceramics

▼ D E V E L O P E D B Y English potters in the 1840s, parian porcelain statuary made sculpture available for the homes of the new, middle class in the same way that engravings duplicated famous paintings. The success of the infant industrial revolution in creating a more comfortable lifestyle for merchants and managers also provided these consumers with art for the home, a type of material culture previously owned only by the courtly class. Much like today, the desire for consumer goods was developed and encouraged by associating their ownership with the perception of a better life. During the nineteenth century, this life was defined as moral, educated, and enlightened. The proper Victorian family in its parlor was expected to be surrounded by trophies which showed its interest in literature, the fine arts, and travel.

The idea of making many copies of a single important work of art was well established by the time parian porcelain statuary came on the scene. Engravings of famous paintings had long been available, and any number of examples from the first half of the nineteenth century could be cited. Asher B. Durand's engraving of *Ariadne,* after the painting by John Vanderlyn, came on the market in 1835. The Portland Vase is another example. The Duchess of Portland created a stir by acquiring the original ancient cameo-glass vase from the Barberini Palace in the late 1700s. Wedgwood's stoneware copy soon followed and continued to be offered for many years into the nineteenth century in a variety of colors to coordinate with any interior. Historians call this the "commodification of art." For the companies that made and/or marketed the goods, this might be an appropriate characterization. For those who bought the wares, however, there were deeper meanings of identity and possession. The buyer of the copy also acquired the sensation of owning the original and shared its possession with any number of family, friends, and acquaintances who recognized its significance.

Sculpture, or its full-scale reproduction, was more difficult to own than prints or pottery because of its size, weight, cost, and scarcity. The development of parian porcelain statuary in England offered a new dimension for the parlor. Named after a type of marble, the fine white, unglazed parian porcelain suitably mimicked the ancient sculptural material. Sculpture, which had been reproduced only in engravings, was now available in the round, reduced in size but retaining its form and proportion. Many conditions came together to make parian porcelain statuary successful during the mid-nineteenth century.[1] Discoveries in clay chemistry and ceramic

technology in the pottery industry provided the fabric. The rise of the art union lotteries as purveyors of fine art helped to create the market. And the proliferation of art magazines encouraged, among other things, the development of English sculpture as an art form worthy of appreciation and support.

From the beginning, parian was marketed as an art material that would satisfy the tastes of the new middle class, and the English potteries produced subjects that appealed to these buyers—busts of royalty and important writers, politicians, and artists; reproductions of antique and contemporary sculpture; and, later, the sentimental Victorian subjects developed by factory modelers from popular literature and paintings.

English parian was available in America from the time of its introduction in England, and American sculptors soon took advantage of parian as a medium for promoting their skills and reaping some financial benefit from their talents (fig. 1). Eventually American manufacturers developed the materials and techniques and cultivated the artists to produce a home-grown product. Before the invention of parian ware, nearly all of the modeling for manufactured ceramics, particularly in England and America, was done by artisans trained through the apprentice system within the factories. With parian, however, ceramic manufacturers discovered the monetary rewards of attaching their production to fine art.

They also understood the benefits that could be drawn from employing artisans with a formal education in the arts. The importance of designers to the ceramic industry and the need for academies to train them began with the marriage of ceramic art and the parian industry. Although parian had largely passed from fashion by the late 1880s, its legacy in terms of the new attitudes toward art among manufacturers was only beginning to be felt in the ceramic industry. As schools of ceramic art and design increased in number and sophistication during the twentieth century, so did the impact on ceramics as one of the applied arts.

Parian's Technique
Figurines have long been part of the potter's repertoire, although a distinct fashion for them developed among the courtly class in the mid-eighteenth century. Important European potteries—Sevres, Meissen, Derby—made a variety of white (unglazed or biscuit) and decorated models to embellish banquet tables and palace mantels. By the early 1800s, figures in earthenware of mediocre quality were being turned out in great quantity from the Staffordshire potteries for the English middle class. But several prominent potteries such as Minton, Worcester, and Copeland & Garrett had continued to make the white biscuit figures and to search for a high-quality clay body that would resist the soiling that came from handling the unglazed surface.

At the same time, modelers and mold makers in the English industry had developed their crafts to the highest level. Although the chemistry of slip casting had been discovered in the previous century, the dynamics of modeling and mold making were greatly refined during the second quarter of the nineteenth century.

Most sculptural ceramic figures are extremely complex and cannot be accommodated by a single mold. The mold maker had to dissect the model into manageable parts that were later joined by the repairer when the slip-cast parts were in the green state. The joints between parts were carefully hidden and smoothed so that the viewer rarely noticed the number of pieces that had been combined to create the final figure.

Modelers were considered the most skilled of this group of craftsmen. Working in plaster or clay, they were required to copy an existing model so that the figure that resulted would have the proper proportions even after the fire had reduced the green clay by twelve to fifteen percent. The work of the modelers was greatly aided by Benjamin Cheverton's reducing machine (essentially a three-dimensional pantagraph) that was patented in 1844.[2] By improving the fidelity of these statuary reproductions to the originals, Cheverton's machine allowed parian porcelain to do for sculpture what engraving had done for painting—make facsimiles available for display, ornament, and study in the home.

Although there is still dispute over which pottery first introduced parian porcelain statuary, several English firms were making figures in this new material by 1845. Various names were used in the earliest years: "Statuary Porcelain" at Copeland & Garrett; "Parian" at Minton; and "Carrara" at Wedgwood. Both "Parian" and "Carrara" referred to the desirable marble, which the ceramic body was intended to imitate. By 1851, the term "Parian" was in general use. Formulas for the clay body itself were as numerous as were the potteries that made parian, but they all shared the basic ingredients of feldspar in concentrations of thirty to sixty-five percent, Cornish clay, and Cornish stone. Some recipes also included ball clay, flint glass, barium carbonate, or frit, but it was feldspar that gave parian its distinctive hardness, smooth surface, and pale creamy translucency.

The new material was hailed as being far more successful in duplicating the look and feel of marble than any previous biscuit body both in the way it transmitted light and in the detail possible from its fine texture. In 1851, the *Illustrated London News* reported that the "introduction of the comparatively new material of Parian for statuettes and ornaments generally, has given a feeling of art to those productions which the old bisque body could never have done. The rich transparent tone of the Parian, giving the reflected light and semi-opaque shadows of marble, contrasts so unmistakably with the grey looking tint and hard effect of the bisque, that no one can wonder that the latter is now completely superceded in England."[3] English sculptor and royal academician John Gibson, the first artist to give permission for his work to be translated into parian, declared that it was "the best material, next to Marble" when he was introduced to it on a tour of the Staffordshire potteries in 1845.[4]

Marketing English Sculpture through Parian
The happy alliance of artist, manufacturer, art magazine, and art union created the commercial success of parian porcelain statuary. Gibson's remark was made during a meeting arranged by the editor of the *Art Journal* that

included Gibson and several other sculptors, Thomas Battam of Copeland's staff, and agents of the Art Union of London. The meeting resulted in the production at Copeland's of fifty copies of Gibson's diploma work, *Narcissus,* for distribution as lottery prizes by the Art Union. By combining the morality of art with the suspense of a lottery, art unions satisfied both the middle-class desire for respectability and the ability to obtain it at relatively small cost.

The success of the art unions in popularizing contemporary British and European art was based largely on their ability to educate the public. The organizers recognized two types of persons who needed nurturing: "The first consists of those who, although possessed of taste are not wealthy; the other are those of ample means, but who . . . have hitherto evinced little interest in the progress of the arts and little taste for their productions."[5] The contemplation of art, it was believed, would lift both types to a higher moral plane. "The influence of the Fine Arts in humanizing and refining, in purifying the thoughts and raising the sources of gratification in man, is so universally felt and admitted, that it is hardly necessary now to urge it," noted the Art Union of London in 1840.[6]

In addition to patronizing the art unions, Victorian Britons were also attracted to fine art and parian through the regional, national, and international fairs held in London and other British centers, and by the attention focused on the annual academy exhibitions in England and Scotland. Much publicity in the popular and art presses was generated by the strong showings made by parian manufacturers at these exhibitions. The largest show of parian was made at the Great Exhibition, London, in 1851, where more than ten manufacturers mounted displays of the porcelain statuary.

The Greek Slave
Of all the contemporary sculpture that was reproduced in parian porcelain during this period, Hiram Powers' *Greek Slave* was peerless in terms of its own fame and in the recognition that it continued to draw from its many reproductions. In 1843, Powers (1805–1873), an American sculptor, executed the first *Greek Slave* and six full-size marble replicas that were produced by 1866. The chained maiden, meant to symbolize the young Christian women auctioned by the Turks during the Greek revolution, was shown first in London in 1845 and subsequently appeared at several international fairs and many galleries there and in the United States. One statue toured a number of American cities between 1847 and 1852, from New York to St. Louis and Detroit to New Orleans. As a result of its widespread renown, the statue engendered innumerable reviews and a fair number of poems extolling its spirituality and chastity despite, or perhaps because of, its naked and manacled form. "The grey-headed man, the youth, the matron, and the maid alike yield themselves to the magic of its power, and gaze upon it in silent and reverential admiration," observed a reporter for the *Courier and Enquirer* of the statue's exhibition in New York City in 1847.[7]

Reproductions of the *Greek Slave* in plaster, parian, bronze, crude marble, and alabaster in several reduced sizes were extraordinarily popular.

Figure 2 The Greek Slave, Minton and Co., Staffordshire, England, 1849. Parian. H. 14½". (Courtesy, Metropolitan Museum of Art, Gift of Mr. and Mrs. Russell E. Burke III, 1983.)

Writing in *Godey's Lady's Book*, Mrs. Merrifield advised that a plaster copy of the figure "should be found on the toilette of every young lady who is desirous of obtaining a knowledge of the proportions and beauties of the figure."[8] Several British potteries made small-scale copies, but the earliest and perhaps best was Minton's (fig. 2). Made originally for Summerly's Art Manufacturers, a marketing firm that promoted public taste by getting well-known artists to design common objects, the Minton version was first exhibited at the 1849 Birmingham exhibition. Copeland's copy appeared in 1852 and other versions followed. Consumers continued to buy replicas for many years. Despite the warnings of connoisseurs that the copies could never duplicate the original, the Victorian middle class did not care if the slave's thighs were a bit heavy or her head tilted too much to the left; the important consideration was whether the form was "sufficiently correct to study the general proportions of the figure."[9] Just owning a copy was enough to relive the dramatic moment of having seen the original or, for those who had not seen it, to embrace its reputation.

Parian Porcelain Statuary in America

Despite the fact that little in the way of parian porcelain statuary was made in America before 1870, there was plenty of parian to be had in the shops and markets on this side of the Atlantic Ocean. The art press generated most of the demand for it here, by manufacturers' exhibits at fairs, and in the shops of urban china and glass dealers. Both Minton and Copeland, for example, showed parian statuary at the New York Crystal Palace Exhibition of 1853. Both firms were awarded bronze medals for their parian, but it was Copeland's display that Horace Greeley described as having the "gems of their kind in the Exhibition."[10]

Prominent china and glass dealers in America's large cities were the primary purveyors of parian. Advertisements in newspapers and trade publications provide the most information on what was available here. Charles Ehrenfeldt of New York advertised "400 DIFFERENT FIGURES OF VARIOUS SIZES" by Copeland, Minton, and Wedgwood during the 1850s. His offerings included John Bell's *Miranda*, Hiram Powers' *Greek Slave*, a wide variety of political figures, popular personalities such as Jenny Lind, literary figures such as Lord Byron and Charles Dickens, and religious subjects.[11] In 1851, Tyndale and Mitchell, Philadelphia china and glass dealers, advertised James Wyatt's *Apollo*, J. J. Pradier's *Ondine*, Antonio Canova's *Hebe*, and Charles Cumberworth's *Indian Girl* and *Negress*, in addition to those subjects mentioned for Ehrenfeldt.[12]

The United States Pottery Company of Bennington, Vermont, under the direction of Christopher Webber Fenton also exhibited parian at the 1853 New York World's Fair (fig. 3). Although the largest proportion of this company's exhibit was earthenwares with mottled brown glazes (called Rockingham), which were the mainstay of the company's production, the firm also showed four figures, pitchers, a clock case, and a sugar bowl in parian porcelain. Most of the wares were said to be the work of English modelers John Harrison and Daniel Greatbach who immigrated to America

Figure 3 Figure of a poodle, attributed
to United States Pottery Company,
Bennington, Vermont, 1849–1858. Parian.
H. 8¾". (Private collection; photo,
Jay Lewis.)

Figure 4 Bust of Christopher Webber
Fenton, United States Pottery Company,
Bennington, Vermont, ca. 1853. Parian.
H. 14⁹⁄₁₆". (Collections of Bennington
Museum, Bennington, Vermont.)

during the 1840s from the Staffordshire potteries and worked in Bennington briefly. The pitchers are well-known today from the numerous marked examples that survive; however, the figures have yet to be identified with any certainty.[13] Unique figure groups, one mounted on the top of the company's display, and a bust of Fenton (fig. 4) attributed to Greatbach, were also included in the exhibit. These are preserved in the collection of the Bennington Museum (fig. 5).

American Sculptors

The enthusiasm for sculpture generated through the parian copies shown in exhibits at the regional, national, and international fairs that proliferated after 1845 was not lost on American sculptors. Even if little parian was actually made in America before 1870, American sculptors had their work translated into this material by factories in England. Hiram Powers' *Greek Slave* was highly successful in England where the product was developed. In Boston, on the other hand, between 1850 and 1880, retailers and entrepreneurs commissioned or purchased models of popular subjects from young, ambitious American sculptors such as Thomas Ball, Martin Milmore, and Daniel Chester French. Plaster models from these sculptors were sold to investors along with the rights to reproduce them. The investors then secured the copyright in the United States and arranged for

an English pottery or American foundry to make copies in porcelain or metal.

Thomas Ball (1819–1911) describes his experiences with reproducing small-scale sculpture in his autobiography.[14] Early on he tried to profit from the reproductions entirely on his own. However, he found the details of copyrighting and producing to be cumbersome and the fact of pirating to be discouraging. In 1853, on the eve of Daniel Webster's death, Ball modeled a small, reproducible figure of the statesman (fig. 6). "The first day it was seen," he later recalled, "I had the very tempting offer of five hundred dollars for the model and the right to multiply it. I accepted the offer with avidity, feeling relieved from any further responsibility. The shrewd art-dealer who bought it must have made five thousand dollars out of it, at the very least. But I could not have done it; so I never murmured, and was only too delighted at the success, and to receive later from the Charitable Mechanics' Association a first-class gold medal for it."[15] Ball must have been impressed with his relative success at this venture, and perhaps even discussed it frequently. Two of his students eventually followed the same track.

Martin Milmore (1844–1883) was apprenticed to Ball from 1858 to 1862 and became Boston's leading sculptor when Ball left for Italy. Between 1860 and 1865, Milmore modeled several pieces that were translated into parian, including a figure of Massachusetts governor John Andrew published by

Jones, McDuffee and Stratton, a Boston china and glass dealer (fig. 7). Busts of Governor Andrew and Abraham Lincoln are also signed by Milmore, but the publisher is unknown.

John Rogers (1829–1904) made his living by reproducing his own sculpture. Believing that sculpture should be understood and enjoyed, Rogers used American subject matter and made it in an inexpensive material in order to make sculpture available to many people. His subjects, rendered in profuse detail, were drawn from history, literature, domestic life, and the Civil War soldier's life. His 208 designs were reproduced in more than 80,000 plaster copies. Although all of his designs were made in plaster, a few have also been found in parian porcelain. *Wounded to the Rear – One More Shot* (fig. 8) and *The Wounded Scout* appear in the factory record of Robinson & Leadbeater, a pottery in Stoke-on-Trent, England, that specialized in parian production. The circumstances of the manufacture of these groups in England are currently unknown, but the assignment to

Figure 8 Wounded to the Rear: One More Shot, John Rogers, New York. ca. 1864. Parian. H. 18¾". (Courtesy, Strong Museum, Rochester, New York © 2002.)

Robinson & Leadbeater is based on the factory record of about 1885 now preserved in the Winterthur Museum library.[16]

Daniel Chester French (1850–1931) was also a student of Thomas Ball, working in the sculptor's studio in Italy beginning in 1876. Furthermore, French and Milmore were close friends. French's most vivid work, *The Angel of Death and the Sculptor* (1891–1892), is a memorial to Milmore, who died at a young age. Between 1871 and 1874, French, like Ball and Milmore before him, modeled several pieces that were translated into parian porcelain. However, French's contributions were not figures of historically important politicians, but rather sentimental ornaments suited to mid-Victorian tastes that favored sweet stories and anthropomorphic attributes. Subjects included owls, dogs, and scenes from popular fiction. Most of these groups also functioned as match safes. *Match Making,* published by Clark, Plympton & Company of Boston, features a pair of owls nuzzling softly on a branch. Its pendant, a single owl, was called *Reveries of a Bachelor.* Both were made by Robinson & Leadbeater of Stoke (shapes 249 and 249½). Similarly, *Imposing on Good Nature,* also produced by Robinson & Leadbeater (shape 230), shows a large lounging dog being pestered by a small dog. In its pendant, *Retribution* (shape 231), the large dog is standing and has pinned his tiny playmate to the floor. *Joe's Farewell,* also copyrighted by Clark, Plympton & Company and made by Robinson & Leadbeater (shape 235), interprets the passage in Charles Dickens' *Barnaby Rudge,* in which Joe Willet calls on Dolly Varden, with whom he was smitten, to say goodbye for an indefinite period of time (fig. 9). The similarity of this group in particular with the work of John Rogers was no accident.

Figure 9 Joe's Farewell: Dolly Varden and Joe Willett, Daniel Chester French, copyrighted by Clark, Plympton & Company and made by Robinson & Leadbeater, 1871–1874. Parian. H. 9¾". (Courtesy, Metropolitan Museum of Art, Gift of Mrs. Charles Beekman Bull in memory of her mother, Alice Hawke Reimer, 1957.)

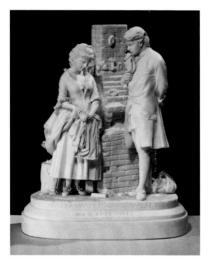

French openly admired Rogers' work and even promoted its historical and artistic importance in later years.[17]

The work of Henry F. Libby (1850–1933), a Boston dentist and amateur sculptor, can also be considered in this group. In the early days of his dental practice during the late 1870s, Libby modeled small sentimental sculpture groups and had them produced by Robinson & Leadbeater of Stoke.

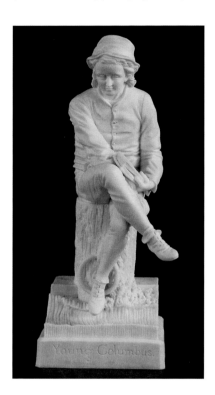

Among these are *Young Columbus* (fig. 10), which features the explorer as a boy dreamer, and *Conquering Jealousy,* dated 1878, which features a sweet young girl mediating between a large dog and a puppy.[18] After Libby's dental practice grew, he seems to have abandoned sculpture as a creative outlet. His interest turned to natural history, and in 1912 he founded the Libby Museum in Wolfeboro, New Hampshire.

American Sculptors Work in American Clay

The relationship established between sculptors and manufacturers for the production of parian porcelain statuary in mid-nineteenth-century England and Boston provided the model for the development of the art porcelain industry in the United States. Parian manufactured here in the 1870s was modeled mostly by American and European sculptors, although the reputations of these men today are based mostly on their work in clay. Ott & Brewer found Isaac Broome, the Union Porcelain Works hired Karl Mueller, John D. Parry modeled figures, and W. H. Edge modeled busts for the New York City Pottery.

A Canadian by birth, Isaac Broome (1835–1922) was trained in the United States at the Pennsylvania Academy of the Fine Arts and worked with Thomas Crawford on the statues for the pediment of the U.S. Capitol in 1855/56. In 1860, after having spent a few years in a studio in Rome, Broome became an academician at the Pennsylvania Academy and taught there until 1863. His assignment for Ott & Brewer of Trenton, New Jersey, was to create exhibition pieces in parian porcelain for the 1876 Centennial Exhibition in Philadelphia and models for smaller sculpture that could be purchased by the public. Large vases dedicated to baseball, fashion, and antiquity, busts of political leaders including George Washington, Abraham Lincoln, Ulysses Grant, Samuel Tilden, Thomas Hendricks, Rutherford Hayes, James Blaine and others, and brackets celebrating the centennial were among the more than twenty models that Broome created in the year or so before the fair when he was working in Ott & Brewer's shops.

Of these many models, the *Baseball Vase* is the most important (fig. 11). Western sculpture in general was already moving away from the classical style that had prevailed since the early 1800s, but the subject here is blatantly contemporary and entirely American. The National League had been formed in 1875 and the topic of baseball was on everyone's lips. The pair of covered vases that flanked Ott & Brewer's Philadelphia display in the ceramics area of the Manufacturers' Building attracted so much attention that one was moved to the Art Gallery of Memorial Hall a month after the fair opened in 1876 (figs. 12–15). This is the first American-made ceramic object that was officially given the status of art.

Karl Mueller's models for the Union Porcelain Works were more nostalgic in nature than Broome's. Mueller (1820–1887) and his brother, Nicholas, were trained in metalsmithing in Koblenz, Germany, and immigrated to America about 1850. In New York they modeled and cast small-scale sculpture and clock cases in metal. In 1874, Karl was hired to create models for Union Porcelain Works' display at the upcoming Centennial Exhibition.

Figure 11 Baseball Vase, designed and
modeled by Issac Broome, Ott & Brewer,
Trenton, New Jersey, 1875–1876. Parian.
H. 38¾". (Courtesy, Detroit Historical
Museum.)

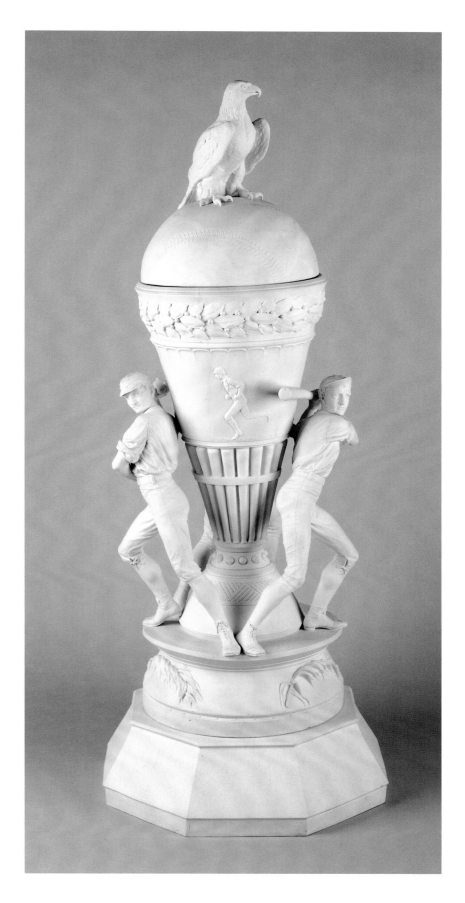

Figure 12 Photograph of the Ott &
Brewer display at the American Institute
Fair, New York City, 1877. (Private col-
lection.)

Figure 13 Broadside, Ott & Brewer's
Eutria Pottery Works, Trenton, New
Jersey, ca. 1876. (Collection of David and
Barbara Goldberg.)

Figure 14 Bust of *Elaine,* Lenox China, Trenton, New Jersey, 1914. Parian. H. 14¾". (Private collection; photo, Jay Lewis.) This bust, which appeared in the Ott & Brewer display illustrated in fig. 12, was designed and modeled by Issac Broome in 1876 and recast by him at Lenox in 1914.

Figure 15 *Figure of a Catcher,* modeled by Issac Broome, Ott & Brewer, Trenton, New Jersey, 1875–1876. Parian. H. 14⅞". (Private collection.)

Figure 16 *The Blacksmith,* Karl Mueller, Union Porcelain Works, Greenpoint, Brooklyn, New York, ca. 1876. Parian. H. 12". (Courtesy, Brooklyn Museum; photo, Schecter Lee.)

The Blacksmith is a larger version of the same figure that Mueller had patented in 1868 and produced in white metalxix (fig. 16). Like Rogers with his groups, Mueller in his portrayal of the blacksmith seeks to monumentalize the labor of the common American while recording the details of his life and craft.

James Carr (1820–1904) operated his New York City Pottery beginning in 1853, but did not make parian porcelain statuary until the early 1870s. John D. Parry (1845–1945), a native of Vermont and resident of Boston and Rome, modeled the seated figure of Charles Sumner in the early 1870s for Carr (fig. 17). He may also be the sculptor for the group *Meeting of Jacob and Rachel* (fig. 18), which won high praise when it was exhibited at the Centennial Exhibition in Philadelphia and the American Institute Fair the same year in New York City. In 1876, Carr employed a sculptor to develop

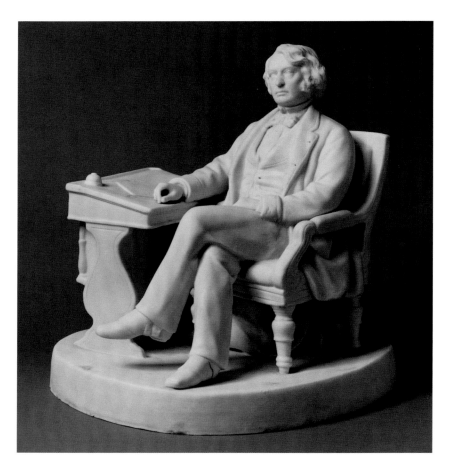

additional models for the Centennial Exhibition. W. H. Edge, previously
identified with the ceramic industry in Trenton, modeled busts for the dis-
play, including George Washington, Ulysses Grant, and perhaps Carr him-
self (figs. 19, 20). Carr's pottery received a gold medal for its parian at the
Centennial Exhibition, and subsequent exhibits of the pottery's parian
received similar high praise. Indeed, one writer in 1876 compared Carr's
work to Copeland's.[21]

Parian's Legacy

Thomas Ball and Daniel Chester French noted in their respective remem-
brances that good profits were made by entrepreneurs claiming a sculptor's
hand as the source for the figure or group. A Minton figure of *The Greek
Slave,* for example, was priced at £1.10s in 1917, but was produced at a cost
of 3/6d. Minton's *Dorothea,* which was enormously popular over a long
period of time, cost the consumer two guineas in London at the time when
most workers were bringing home wages of less than £1 per week.[22] Sim-
ilarly, Ott & Brewer asked china dealers to pay $250 in the 1880s for the
Baseball Vase, an enormous price in its day but still less than what the retail
customer would have been charged. It is probably safe to say that no one
ever paid this huge price, but the wholesale cost of $32.00 per dozen for
small busts of George Washington left plenty of room for profit while
making the sculpture available to a middle-class retail audience.

Figure 18 *Meeting of Jacob and Rachel,*
modeling attributed to J. D. Parry,
James Carr's New York City Pottery, 1876.
Parian. H. 22". (Collection of the Newark
Museum, Gift of Miss Sara Carr, 1924.)

Figure 19 Bust of *James Carr,* modeled
by W. H. Edge, James Carr's New York
City Pottery, ca. 1876. Parian. H. 21⅜".
(Collection of the Newark Museum, Gift
of Miss M. E. Clark, 1924.)

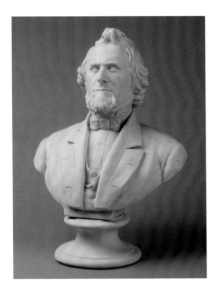

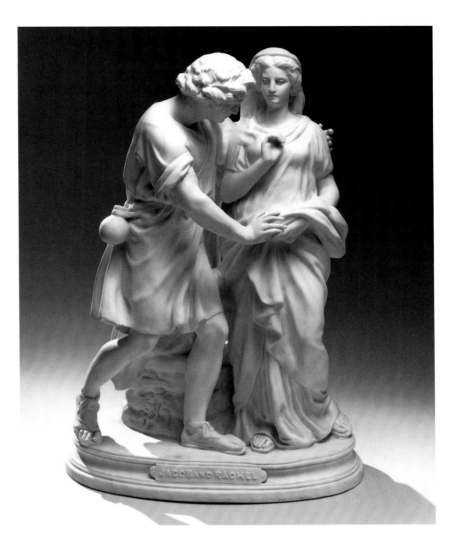

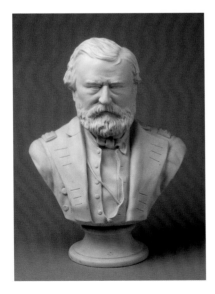

Figure 20 Bust of *Ulysses S. Grant,*
designed and modeled by W. H. Edge,
James Carr's New York City Pottery, 1876.
Parian. H. 18⁹⁄₁₆". (Courtesy, Metropolitan
Museum of Art; Purchase, Anonymous
Gift, 1968; photo, Schecter Lee.)

In America, the success of parian in terms of the publicity it generated
encouraged the development of the art porcelain industry. Until the cen-
tennial, American-made ceramics were notable primarily for their durability
and cheapness, first as redware pots, then as utilitarian stoneware and yel-
low ware, and finally as white ironstone tableware. Attempts to make finer
porcelain wares from the late eighteenth century on had been foiled by the
high cost of American labor unprotected by import duties on wares from
abroad. Furthermore, the reputations of English and French manufactur-
ers continued to plague American firms who often disguised the domestic
origin of their wares by imprinting them with marks that looked English.

When American sculptors began modeling for parian porcelain, the
subject matter they chose had a classically American character. Daniel
Webster, John Andrew, Charles Sumner, George Washington, Ulysses
Grant, and especially baseball were subjects of interest to many Ameri-
cans. Although there had been the stray figure of Washington sent over
from England by the Staffordshire potters, the wide array of American
politicians and popular subjects chosen by the American sculptors was far
more nationalistic.

The reaction to American parian was encouraging to the fledgling American pottery industry. Ott & Brewer, for example, went on to develop an American version of Irish Belleek in the early 1880s that established a reputation for fine art porcelain made in Trenton. The Willets Manufacturing Company expanded production there, and the success of both firms in marketing fine porcelain encouraged Walter Scott Lenox in 1889 to open the first studio for making and decorating art porcelain exclusively in the United States.[23]

The subjects and style of parian changed between 1845 and 1885 as sculpture developed from the early neoclassicism that favored ideal figures and antique replicas to the later Victorian preference for sentimental storytelling, but the medium did not survive changing ceramic fashions or the general movement toward owning original art and decorating with handmade objects. Trade advertisements of the 1880s favored majolica, a molded earthenware painted in glossy brightly colored glazes. Unlike white parian, majolica's colorful style incorporated all the popular Japanese motifs and naturalistic subjects that appealed to the fashionable homemaker.

At the same time, the late nineteenth-century desire for honest use of materials belied the idea central to parian's popularity, that clay could imitate marble that mimicked drapery. The aesthetic movement followed by the arts and crafts movement in England and America saw parian as one of the gew-gaws that was to be stripped from the parlor. The old idea that a reproduction represented the original work of art in a positive way passed from the scene, although there were at least a few who were sorry to see it disappear. "Why is it we get so few parian imitations of the works of the great masters now?" whined a commentator for the *London Pottery Gazette* in 1884. "We fear it is the patrons which are wanted, not the will or ability to do on the part of our manufacturers. One of the things aestheticism did for us was to make it vulgar to have copies in art. . . . It is a mistake to imagine that art only exists in the most cultured or the most wealthy. . . . Of all exclusiveness, exclusiveness in art is the most to be lamented."[24]

Parian porcelain statuary has been in the attic for more than a century, victim of the modern attitudes that give value to original products of the artist's hand, but not to objects that replicate, even faithfully, the finished work of art. Parian is not art and never was meant to be. But its character—the product of an alliance between artists and manufacturers—laid the foundations for the twentieth-century embrace of design as a democratic art form available to everyone and the century's active market for the work of studio ceramists.

1. For more on the background of English parian porcelain statuary, see Paul Atterbury, ed., *The Parian Phenomenon: A Survey of Victorian Parian Porcelain Statuary & Busts* (Somerset, Eng.: Richard Dennis, 1989).

2. See ibid., fig. 2, for an illustration of Cheverton's machine which could reduce or enlarge sculpture by use of a gearing system that united two pointers, one on the original work and the other on the material being used for the reduction or enlargement.

3. *Illustrated London News*, July 26, 1851.

4. Gibson was quoted on the title page of Copeland's illustrated catalog of parian published about 1848. See Atterbury, *Parian Phenomenon*, p.19.

5. *Art Union Journal* (1839), p. 20, quoted in Roger Smith, "The Art Unions," in Atterbury, *Parian Phenomenon*, p. 27. Art unions developed in Great Britain in the mid-1830s after art lotteries were outlawed. Based on successful German schemes, the art union offered subscribers works of contemporary British art as prizes awarded through annual drawings.

6. Art Union of London, *Annual Report* (1840), p. 10.

7. *Courier and Enquirer,* August 31, 1847, quoted in Samuel A. Robinson and William H. Gerdts, "The Greek Slave," *The Museum* 17, nos. 1 & 2 (new series, winter/spring 1965): 16. For more information on Powers' sculpture and its reverberations through nineteenth-century society, see also Linda Hyman, "The Greek Slave by Hiram Powers: High Art as Popular Culture," *Art Journal* 35, no. 3 (spring 1976): 216–23.

8. Mrs. Merrifield, "Dress as Fine Art," *Godey's Lady's Book* 47 (1853): 20.

9. Ibid.

10. Horace Greeley, *Art and Industry: As Represented in the Exhibition at the Crystal Palace. New York—1853–4* (New York: Redfield, 1853), p. 118.

11. Ehrenfeldt's advertisement appeared in *The Crayon,* an art journal published in New York City.

12. Tyndale and Mitchell's advertisement appeared in the *Philadelphia Art Union Reporter,* February 1851.

13. For more information on the parian products of the United States Pottery Company, see Deborah Anne Federhen and Ellen Paul Denker, "The Bennington Parian Project: An Analytical Reevaluation of the Bennington Museum Collection," *Antiques and the Arts Weekly* (October 1998). Greeley, *Art & Industry,* notes this company's parian as being "remarkably fine, especially in the form of pitchers" on p. 122.

14. Thomas Ball, *My Threescore Years and Ten: An Autobiography,* 2nd ed. (Boston: Roberts, 1892), pp. 141–42.

15. Ball, *My Threescore Years,* p. 142. The "shrewd art-dealer" to whom Ball refers was George Ward Nichols who had an art store in Boston at the time. Nichols is listed as the assignee of the Webster statue by Thomas Ball on August 9, 1853, in *Report of the Commissioner of Patents for the Year 1853* (Washington, D.C.: Beverly Tucker, Printer to the Senate, 1854), p. 89. Nichols later married Cincinnati socialite Maria Longworth, who founded the Rookwood Pottery in 1880, and is best known for his critical review of the Philadelphia Centennial Exhibition of 1876, *Art Education Applied to Industry* (New York: Harper & Brothers, Publishers, 1877).

16. *Wounded to the Rear* is shape 398 in the Robinson & Leadbeater factory record and *The Wounded Scout* is shape 549. Other Rogers groups in parian include *Checker Players, Camp Life: The Card Players, Union Refugees, Taking the Oath and Drawing Rations,* and *Courtship in Sleepy Hollow.* Perhaps they were also produced by Robinson & Leadbeater, which advertised in the *Crockery & Glass Journal* on December 28, 1882, that "new designs, by first-class American and other artists, are constantly being added."

17. For more on Rogers and his relationship with his contemporaries, see Michele H. Bogart, "Attitudes Toward Sculpture Reproductions in America 1850–1880" (Ph.D. diss., University of Chicago, 1979).

18. The Robinson & Leadbeater factory record shows *Conquering Jealousy* as shape 371 (p. 112) and *Young Columbus* as shape 321 (p. 43 112), Joseph Downs Library, Winterthur Museum. *Young Columbus* was copyrighted in 1876.

19. For illustrations of the design patent and the metal statuette, see Alice Cooney Frelinghuysen, *American Porcelain, 1770–1920* (New York: Metropolitan Museum of Art, 1989), p. 157.

20. Ibid., pp. 158–60.

21. "The American Institute," *Crockery & Glass Journal* (October 5, 1876). For more on Parry and Edge, see Caroline Hannah, "James Carr (1820–1904) and His New York City Pottery (1855–1889)" (masters thesis, Bard Graduate Center for Studies in the Decorative Arts, 2000), pp. 74–75, 89.

22. Atterbury, *Parian Phenomenon,* p. 10.

23. For more on W. S. Lenox and the development of Belleek in Trenton, see Ellen Paul Denker, *Lenox China: Celebrating a Century of Quality, 1889–1989* (Trenton, N.J.: New Jersey State Museum and Lenox China, 1989).

24. *London Pottery Gazette,* 1884

Figure 1 Medallion, Josiah Wedgwood, Staffordshire, England, ca. 1787. Jasperware. D. 1⅛". (Chipstone Foundation; photo, Gavin Ashworth.) Design of chained and kneeling slave in profile taken from the seal of the Society for the Abolition of the Slave Trade.

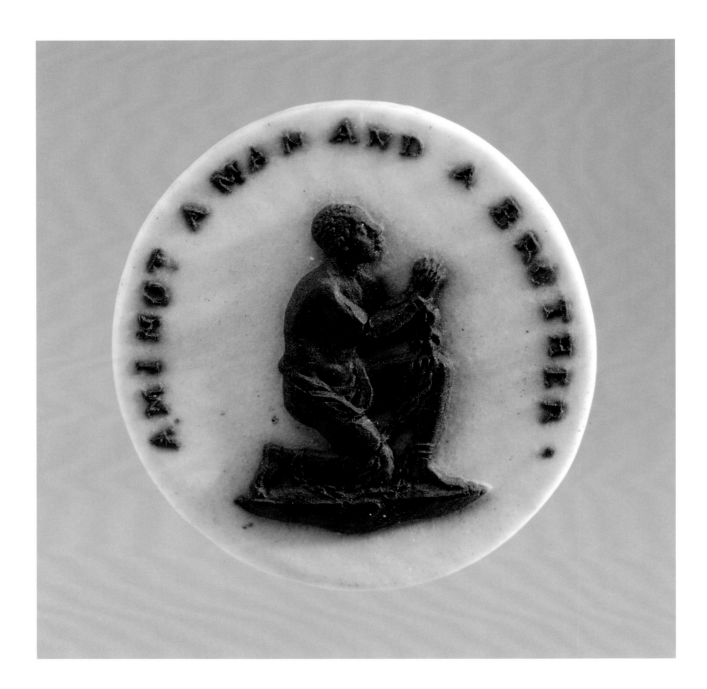

Sam Margolin

"And Freedom to the Slave": Antislavery Ceramics, 1787–1865

▼ I N F E B R U A R Y 1 7 8 8 Josiah Wedgwood sent the president of the Pennsylvania Society for the Abolition of Slavery "a few Cameos on a subject which is daily more and more taking possession of men's minds on this side of the Atlantic as well as with you." Accordingly, Wedgwood added, "it gives me great pleasure to be embarked on this occasion in the same great and good cause with you, Sir." The president of the Pennsylvania society was Benjamin Franklin and the "great and good cause" to which Wedgwood referred was the eradication of human bondage.[1]

The jasperware cameos featured the image of a kneeling, black male slave in chains, a design modeled by William Hackwood and adopted by the Society for the Abolition of the Slave Trade in 1787 for use in its seal (fig. 1). Wedgwood reproduced the image for the founding of the society and donated the cameos to friends and supporters of the cause.[2]

Wedgwood's dedication to the antislavery movement developed in the context of prevailing Enlightenment influences. He was closely associated with the Lunar Society of Birmingham, composed of men who shared not only a passion for scientific inquiry but also an interest in social and industrial progress. In 1773 society member Thomas Day published *The Dying Negro,* an epic poem which may have influenced Wedgwood to become actively involved in suppression of the slave trade.

Thomas Clarkson, one of Britain's leading abolitionists, indicated how the cameos came to be widely disseminated, publicly visible, and a valuable means of promoting the cause. Women, he reported, had them incorporated into bracelets and hairpins so that eventually "the taste for wearing them became general." The medallions were also set into boxes, and

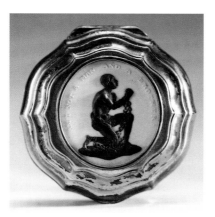

Figure 2 Medallion, Josiah Wedgwood, Staffordshire, England, ca. 1787. Jasperware and silver. D. 1⅞". (Collection of Rex Stark; photo, Gavin Ashworth.)

Figure 3 Patch box, England, ca. 1800. Painted enamel on metal. L. 1¾". (Collection of Rex Stark; photo, Gavin Ashworth.)

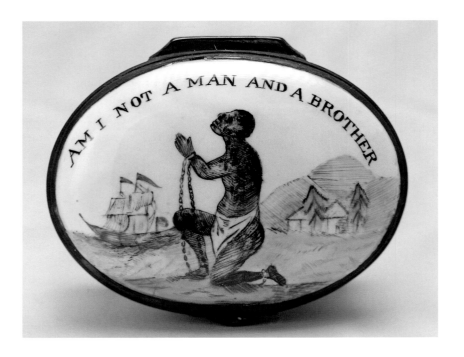

Figure 4 Halfpenny token, England, 1668. Copper. D. ⅞". (Collection of the author; photo, Gavin Ashworth.) Head of black youth representing the Black Boy Pub.

artisans applied the design to a variety of objects including plates, pitchers, patch and snuff boxes, tea caddies, and tokens (figs. 2, 3). "Thus fashion," observed Clarkson, "which usually confines itself to worthless things, was seen for once in the honourable office of promoting the cause of justice, humanity and freedom."[3]

African Images in English Society

Promoting the cause was a task made all the more difficult, however, by the less than complimentary manner in which blacks were often portrayed in Anglo-American culture. Much of the negative attitude derived from the specific and powerful meanings that English society associated with the word "black" well before the introduction of Africans to England in the 1550s. Some pre-sixteenth-century definitions in the *Oxford English Dictionary* including "deeply stained . . . dirty, malignant . . . foul, iniquitous, atrocious, horrible, wicked," exemplify decidedly negative connotations. Consistent with this view, Queen Elizabeth I sought to banish blacks from the kingdom in 1601, declaring her "discontent . . . at the great numbers of negars and Blackamoors which . . . are crept into this realm."[4] But the very fact that the population of Africans (whose immigration to the country was by no means voluntary) was increasing suggests that not everyone in England was repulsed by their presence. In fact, blacks were gaining popularity among the English gentry as domestic servants and status symbols, a fashion trend that continued throughout the seventeenth and most of the eighteenth centuries.

Contemporary paintings of English aristocrats often included black attendants, generally ascribing to the Africans a status comparable to that of household pets. These graphic representations generally depicted the servant either gazing earnestly at his or her white master or mistress or as a "mute background figure . . . unnoticed and unacknowledged . . . barely

more than a blob of black paint, a shadowy figure with no personality or expression."[5] The black servants portrayed in mid-eighteenth-century Staffordshire figural groups typically display unflattering, almost apelike characteristics: protruding lower jaw, low and massive brow, and exceptionally long arms (fig. 5). This diminished image of the black servant was further reinforced by the mass production of the late eighteenth-century transfer print of *The Tea Party* in which the features of the pet dog appear to have been rendered with greater care than those of the black houseboy (fig. 6).

Africans in English society appear to have been as much objects of curiosity and fascination as disdain, however. In addition to their appearance on trade cards, maps, and coats of arms, figures of African adults and children were employed on signboards, ubiquitous in eighteenth-century London, to advertise occupations as varied as those of cheesemongers, haberdashers, and oilmen.[6] The particular motifs of the blackamoor's head (usually in profile) and the black boy (or, occasionally, the black girl) have been identified as characteristic of the linen drapers and pewterers, respectively. Both designs also were widely used by tobacconists and public houses, or pubs, as mention of the "Black Boy in Bucklersbury" tavern in

Figure 5 Figural group, Staffordshire England, ca. 1760. Creamware. H. 5⅜". (Courtesy, Colonial Williamsburg Foundation.)

Ben Jonson's early seventeenth-century play *Bartholomew Fair* suggests (Act 1, scene 1).[7] Such images may not have been quite as omnipresent in America, but references such as the 1735 newspaper announcement of a Philadelphia merchant relocating to Market Street under "the sign of the Black Boy" indicate that they certainly existed (fig. 4).[8]

Figure 6 Cream jug, Staffordshire or Yorkshire, England, 1780–1790. Creamware. H. 4½". (Collection of the author; photo, Gavin Ashworth.) This jug, part of a larger tea service, has twisted strap handles with molded sprigs terminals and a black transfer print of *The Tea Party*.

Figure 7 Jug, England, ca. 1800. Pearl-ware. H. 9½". (Collection of the author; photo, Gavin Ashworth.) Armorial crest featuring blackamoor bust in profile.

Figure 8 Detail of the crest illustrated in figure 7.

Figure 9 Soup plate, France, ca. 1810. Porcelain. D. 9¾". (Collection of the author; photo, Gavin Ashworth.) Blackamoor head and legend "Asgre Lan Diogel ei Pherchen."

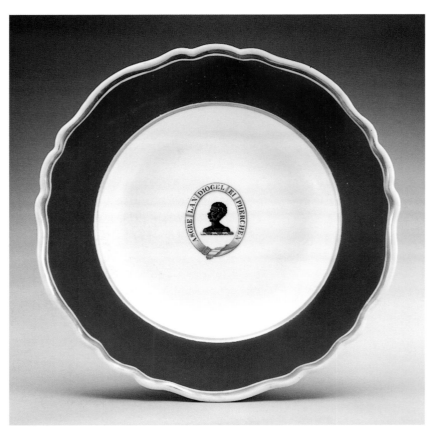

Figure 10 Detail of the soup plate illustrated in fig. 9. The Latin legend translates as "A pure conscience is a safeguard to its possessor."

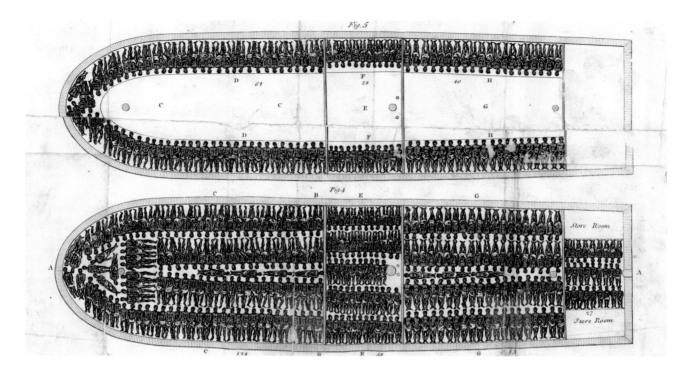

Figure 11 Detail of an engraving, from Thomas Clarkson's *History of the Abolition of the African Slave Trade,* London, 1807. Influential figures such as Thomas Clarkson were given the responsibility of collecting information to support the abolition of the slave trade. This included interviewing 20,000 sailors and obtaining equipment used on the slave ships such as iron handcuffs, leg-shackles, thumb screws, instruments for forcing open slaves' jaws, and branding irons. In 1787 he published his pamphlet, *A Summary View of the Slave Trade and of the Probable Consequences of Its Abolition.* After the abolishment of the British slave trade in 1807, Clarkson published his book *History of the Abolition of the African Slave Trade.*

While many of these representations were patronizing to various degrees, not all were inherently derogatory or condescending. The use of African images in conjunction with heraldic crests conveys a sense of dignity, even nobility, conforming to contemporary European notions of the "noble savage" (figs. 7–10). But whether portrayed as pet-like servants, quaintly exotic figures, or noble savages, such depictions of Africans in Anglo-American popular culture all failed to convey the harsh and often brutal realities of chattel slavery in America and the West Indies (fig. 11).

Abolition Images

To persuade others of the rightness of their cause, abolitionists first had to make a convincing case for the essential humanity of black people. Perhaps it was for this reason that the Society for the Abolition of the Slave Trade chose the specific wording "Am I Not a Man and a Brother" for use on its seal and, consequently, Wedgwood's cameo. Before Englishmen and Americans could regard slaves as brothers, they would first have to consider them human beings.

In the late eighteenth century, however, evangelical and Enlightenment influences gave rise to a growing impulse toward humanitarianism and a mood of sentimentality that produced greater empathy with the slave's plight.[9] Among the foremost literary efforts was William Cowper's seven-stanza poem *The Negro's Complaint,* cited by Clarkson as an influential popular work that spread throughout England "where it was sung as a ballad; and where it gave a plain account of the subject, with an appropriate feeling, to those who heard it."[10]

Employing a combination of visual imagery and verse, nineteenth-century British potters produced a variety of wares designed to arouse sympathy

Figure 12 Child's mug, England, ca. 1840. Whiteware. H. 2½". (Collection of Rex Stark; photo, Gavin Ashworth.) This enamel-colored black transfer print depicts the capture of native Africans by European slavers, along with the opening verse from William Cowper's *The Negro's Complaint:* "Forc'd from home and all its pleasures/ Afric's coast we left forlorn/To increase a stranger's treasures/O'er the raging billows borne."

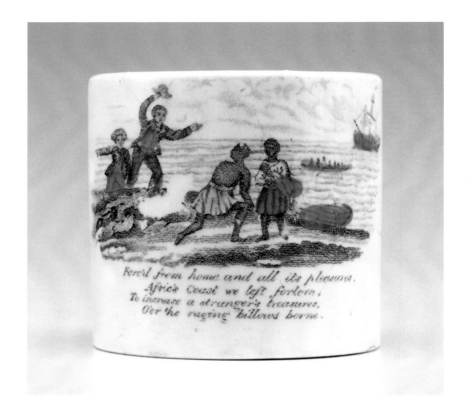

Figure 13 Jug, Staffordshire or Sunderland, ca. 1820. Pearlware. H. 4½". (Collection of Rex Stark; photo Gavin Ashworth.) This jug with copper and pink luster trim shows a transfer-printed variation of the Wedgwood plaque design. This one features a frontal view of a chained and seated slave, and verses from William Cowper's *The Negro's Complaint* on the other side. Note the reversal, most likely unintentional, of "I" and "Not" in the printed motto.

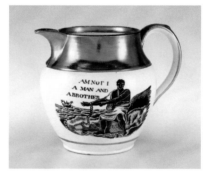

Figure 14 Detail of the reverse of the jug illustrated in fig. 13. This stanza from *The Negro's Complaint* reads (italics mine): "Slaves of gold, whose sordid dealings/ Tarnish all your boasted powers,/Prove that *you* have human feelings/Ere you proudly question ours!"

for the slave. Many themes were evoked, including depictions of the anguish of family separation and graphic portrayals of slavery's horrors (figs. 12–16). Other ceramic pieces reveal a more subtle approach to promoting the abolitionist cause. One strategy was to incorporate the message into the familiar, traditional form of the rhyming couplet commonly applied to English hollow ware (fig. 17). A popular verse that has its origins in the eighteenth century but was employed on later nineteenth-century earthenware proclaims:

> Health to the Sick
> Honour to the Brave
> Success attend true Love
> And Freedom to the Slave

Certain designs used by both British and other European potters not only aroused sympathy for slaves but also goaded supporters of the abolitionist

Figure 15 Figural group, France or England, ca. 1820. Porcelain. H. 6¼". (Collection of Rex Stark; photo, Gavin Ashworth.) A late eighteenth-century antislavery pamphlet by William Fox included a section on punishment in which a Royal Navy admiral attested that the flogging of slaves was much more severe than that administered to sailors aboard English men-of-war. More explicitly, an

English general asserted "there is no comparison between regimental flogging, which only cuts the skin, and the plantation, which cuts out the flesh."

Figure 16 Reverse view of the figural group illustrated in fig. 15.

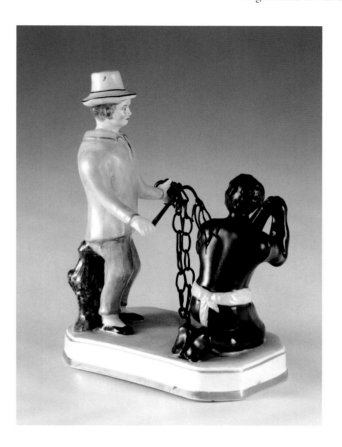

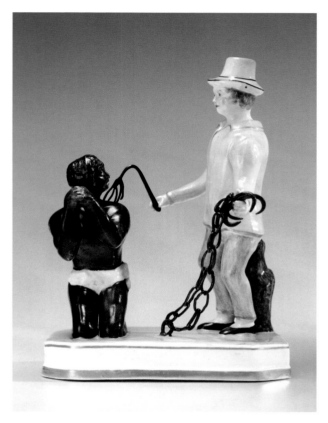

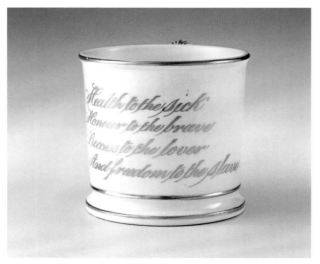

Figure 17 Mug, England, ca. 1850. Porcelain H. 3". (Collection of Rex Stark; photo, Gavin Ashworth.) In elaborate gold script: "Health to the Sick/ Honour to the Brave/Success to the Lover/ And Freedom to the Slave."

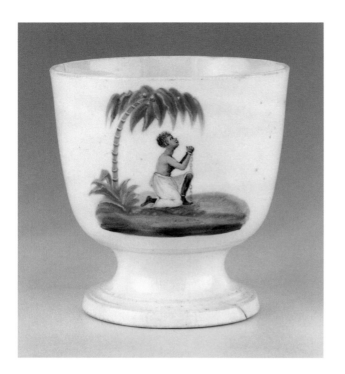

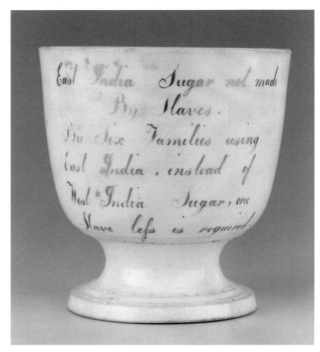

Figure 18 Sugar bowl, England, 1820–1830. Bone china. H. 4⅝". (Courtesy, Colonial Williamsburg Foundation.) The decoration of the kneeling slave in the tropical environment is enameled over the glaze suggesting that it may have been produced for a special anti-slavery fair or occasion.

Figure 19 Reverse of the sugar bowl illustrated in fig. 18. Legend reads: "East India Sugar not made/By Slaves/ By Six families using/East India, instead of/West India Sugar, one/Slave less is required." The wording represents a somewhat sanitized version of Fox's formulation that "A family that uses 5 lb. of sugar per week...will, by abstaining from the consumption 21 months, prevent the slavery or murder of one fellow creature" and tactfully omits the pamphleteer's more gruesome analogy "that in every pound of sugar used...we may be considered as consuming two ounces of human flesh."

cause to positive action. One option open to the average consumer was to refuse to purchase goods produced by slaves. William Fox's 1791 pamphlet, *An Address to the People of Great Britain on the Propriety of Abstaining from West India Sugar & Rum,* apparently provided the impetus for just such a campaign.[11] This early example of what came to be known as a "boycott" in the late nineteenth century is manifest in the injunction enameled on early nineteenth-century earthenware and bone china not to buy West Indian sugar that had been brought to market through the exploitation of slave labor (figs. 18, 19).

How persuasive were the boycott messages and the broader campaign? In a January 1792 letter to Wedgwood, Thomas Clarkson wrote that he had not traveled anywhere the Fox pamphlet "had been for any time in circulation, where it had not produced an astonishing effect."[12] That result, according to the abolitionist, consisted not only of "disposing the minds of such persons toward our cause, as we ourselves should have otherwise

Figure 20 Sugar bowl and cover, England, 1820–1830. Earthenware. H. 5". (Collection of Rex Stark; photo, Gavin Ashworth.) Transfer-printed image of the kneeling slave. This bowl would have been part of a larger tea service. A number of different ceramic forms were decorated with this transfer print, including teawares and dinnerwares.

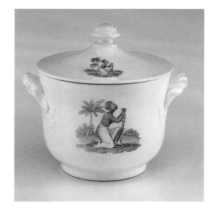

never reached," but also of significantly altering the buying habits of English consumers (fig. 20). In a postscript, Clarkson indicated that "25,000 Persons have left off Sugar & Rum" and that the "Sugar Revenue by Report has fallen off 200,000£ this Quarter."[13] Years later the abolitionist stated that among those "who had made this sacrifice to virtue . . . were all ranks and parties. Rich and poor, churchmen and dissenters." Clarkson estimated that the number of individuals in England who had forsworn the use of sugar as a matter of moral conviction amounted to "no fewer than three hundred thousand persons."[14]

Popular feeling eventually turned in favor of the abolitionists, but due largely to war with France and slave revolts in the West Indies in the late eighteenth century, it was some time before Parliament adopted legislation ending the slave trade and decades more until it abolished slavery in the British colonies altogether. Although the Commons voted to end the trade in 1792, full passage of the measure was blocked in the House of Lords where the influence of the West Indies plantation lobby was strong. Never-

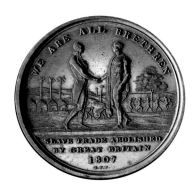

Figure 21 Token, England, 1807, copper. D. 1⅜". (Collection of the author; photo, Gavin Ashworth.) Inscribed: "SLAVE TRADE ABOLISHED BY GREAT BRITAIN 1807."

Figure 22 Reverse engraving on glass, London, 1807. (Courtesy, Colonial Williamsburg Foundation.) Published to commemorate the abolishment of the British slave trade, this depiction, rich in iconographic imagery, shows the figure of Africa casting a disapproving eye toward America who holds the images of Washington and Franklin.

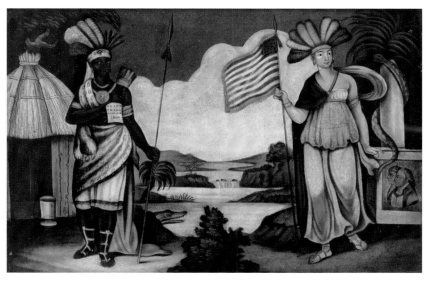

theless, Parliament managed to severely restrict the trade in 1806 and abolished it the following year (figs. 21, 22).

A number of ceramics honoring the acts of 1806–1807 were produced, although they generally celebrate the statutes in an oblique way. Reminis-

Figure 23 Jug, Liverpool, 1805–1810. Creamware. H. 8¼". (Collection of Rex Stark; photo, Gavin Ashworth.) The transfer on this jug is captioned: "Britannia Protecting the Africans."

Figure 24 Figure, Staffordshire, 1790–1810. Pearlware. H. 7". (Collection of Rex Stark; photo, Gavin Ashworth.) This early kneeling slave, hand enameled in high temperature underglaze colors, is holding a book inscribed "BLESS GOD THANK BRITON ME NO SLAVE." While not specifically identified as such, the early date of this ceramic figure must coincide with the British abolishment of the slave trade begun in 1792 and formally decreed in 1807.

cent of the portraits of African servants gazing ardently at their aristocratic English masters, the transfer print on a Liverpool creamware jug depicts a regal white female seated on a pedestal in a sheltering pose above two blacks with the legend "Britannia Protecting the Africans" printed beneath (fig. 23). This jug offers a glimpse of how ceramic manufacturers were responding to currents in the British social and political arena and the extent to which the slavery issue had become a cause célèbre in England. Among the most important ceramics produced at the time of the abolishment of the slave trade is a Staffordshire figure who gratefully declares "BLESS GOD THANK BRITON ME NO SLAVE" (fig. 24).

Although legislation prohibiting the slave trade protected free Africans from future abuses by British slavers, it did little to alleviate the suffering of those already in bondage. As former United States president and anti-slavery legislator John Quincy Adams reflected in 1838, "human reason cannot resist, nor can human sophistry refute the conclusion, that the essence of the crime consists not in the trade, but in the Slavery."[15] Recognizing the difficulty of overcoming the power of the West Indian lobby all at once, abolitionists sought to end slavery in stages: first by outlawing the slave trade, then allowing for a period of adjustment and retrenchment, and, finally, by abolishing slavery itself. That time came in 1833 when Parliament voted to abolish slavery throughout the British empire,

Figure 25 Figural group, possibly Staffordshire, early nineteenth century. Porcelain. H. 6⅝". (Collection of Rex Stark; photo, Gavin Ashworth.) In this figural group, a slave exults in freedom as broken chains and whip lie on the ground. An open Bible rests at Britannia's feet.

effective August 1 the following year. The legislation passed with a proviso that those currently enslaved above age six would undergo an additional term of indentured apprenticeship before complete freedom would be granted. Full emancipation actually took effect on August 1, 1838.[16]

The deliverance of 1838 consummated what has been described as England's "St. Paul-like conversion" from the nation responsible for the enslavement of more Africans than any other to one that styled itself a defender and liberator of blacks in bondage.[17] Conforming to the theme expressed on earlier wares, British artisans produced a variety of decorative pieces commemorating the empire's newly legislated benevolence. A commanding figural group features an exultant freed slave standing next to Britannia over broken shackles and a discarded whip (fig. 25). The skyward gaze of the liberated slave in all these pieces as well as the Bible at the feet of Britannia also suggest, however subtly, the machinations of a power higher than even England, a sentiment conveyed more explicitly by the "BLESS GOD" invocation in the previously mentioned figure's book (fig. 26).

Figure 26 Detail of the inscription on the book held by the kneeling figure illustrated in fig. 24.

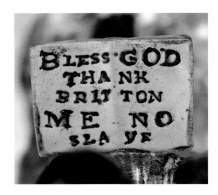

England's motivation in ending slavery and the slave trade was not entirely selfless. "Freedom," as James Walvin has pointedly observed, "meant free trade, free labour, the free movement of capital, in effect the freedom of an ascendant British economy to invest, exploit and control."[18] An intriguing commercial corollary to the antislavery movement, and one that assumed greater importance after the passage of British abolition

Figure 27 Plate, England, ca. 1840. Whiteware. D. 8". (Collection of Rex Stark; photo, Gavin Ashworth.) Molded daisy pattern rim with black transfer print advocating "Brotherhood and Free Trade with all the World."

Figure 28 Plate, France or England, ca. 1830. Porcelain. D. 9". (Collection of Rex Stark; photo, Gavin Ashworth.) Inscribed "Unfettered Intercourse between all Nations—The Best Security for Abundance and Peace."

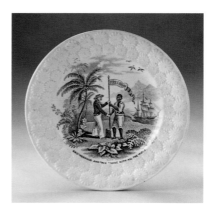

legislation, was the issue of international free trade. Intimately associated in some quarters with the struggle for human emancipation itself, the principle of free trade as it related broadly to slavery was articulated in a 1788 speech to Parliament by William Wilberforce. The prominent English abolitionist and politician provided both the moral and economic rationale for unrestricted commerce when he introduced a motion to end the slave trade by enjoining his colleagues to "make reparation to Africa as far as we can, by establishing trade upon true economic principles, and we shall soon find the rectitude of our conduct rewarded by the benefits of a regular and growing commerce."[19]

A printed white earthenware plate offers a graphic illustration of Wilberforce's vision (fig. 27). Entitled "Brotherhood and Free Trade with all the World," the design represents an ingenious twist on the familiar scene of the African native and slaver in the foreground, slave ship behind. In this image the design elements are similar, but the white and black figures are clearly portrayed as equals, shaking hands and jointly planting a banner of freedom on the shore of a symbolic new world. The three-masted vessel in the background no longer signifies the evils of the slave trade but the promise of unimpeded commerce that the legend below proclaims. Another plate offers a less egalitarian and more explicitly self-serving interpretation of the free trade doctrine. Iconic figures representing Asia, America, and Africa—the first two bearing gifts, the last in shackles on bended knee—attend a serene and seated Britannia within the legend "Unfettered Intercourse between all Nations—The Best Security for Abundance and Peace" (fig. 28).

American Abolition

One aspect of the free trade issue of particular concern to American abolitionists pertained to the English corn laws, statutes dating back to the fourteenth century that regulated the import and export of grain. Because they restricted English importation of American wheat while promoting that of cotton, the corn laws induced British consumers to patronize an agricultural enterprise that exploited slave labor at the expense of one that did not. The results, of course, proved injurious to the antislavery cause. As Philadelphia abolitionist Samuel Webb charged in an 1843 letter to his English counterparts, "*you* buy the slaveholder's cotton—you hire him to chain, to whip and to work his slaves to death! *You* stimulate him by your money—by your patronage—by your commerce!"[20]

Webb's letter serves as a stark reminder that, although England had legislated emancipation a decade earlier, abolitionists were still far from achieving success in the United States. Yet, as early as the late seventeenth century, Americans—especially Quakers and, later, Methodists—had been among the first and most outspoken opponents of slavery. In the 1770s several colonies went so far as to petition the home government to end or restrict the importation of slaves to America, efforts which the royal authorities—ironically in view of Britain's subsequent moralistic antislavery crusade—rejected. But the colonists soon were confronted with moral

inconsistencies of their own when British opponents of the Revolution sought to exploit the contradiction between America's rhetoric of freedom and its slaveholding. "How is it," asked Samuel Johnson after the Declaration of Independence, "that we hear the loudest yelps for liberty among the drivers of Negroes?"[21]

Although several states saw fit to abolish slavery within their borders during the first years of the Republic, and Congress, like Parliament, proscribed the slave trade in 1807 (effective the following year), the movement to emancipate slaves in America developed more slowly than in England. Despite the gradual dissolution of slavery in the North and successful legislative efforts such as the Northwest Ordinance of 1787 to restrict its westward expansion, slavery gained a firm foothold in the plantation states of the South.[22] Moreover, the commitment of such prominent activists as Benjamin Franklin notwithstanding, the efforts of the antislavery movement in the United States generally were scattered and ineffectual until the 1830s. The formation of the American Colonization Society in 1817, for example, actually may have done more to hinder than advance the cause. Proposing to transport free blacks from the United States and resettle them in Africa, the movement was opposed by many freedmen who considered America their home and criticized by abolitionists who saw colonization as a thinly veiled attempt to simply remove blacks from the nation altogether.

By the 1830s, however, American antislavery societies were expanding swiftly in number and influence. And in 1837 an event took place that profoundly affected the movement and resulted in the production of the first antislavery ceramics with explicitly American themes. The episode involved two highly charged issues, abolition and freedom of speech, and the fearless determination of newspaper editor Elijah P. Lovejoy to stand firm on both. An ordained Presbyterian minister and editor of a religious publication, the St. Louis *Observer,* Lovejoy was a somewhat reluctant participant in the abolitionist campaign. A "gradualist" who advocated a slow, cautious approach to emancipation, he occasionally defended slaveholders against what he regarded as false accusations. But in 1835, when antiabolitionist fervor erupted among the local populace, a citizen's group delivered to Lovejoy a resolution declaring "that the right of free discussion and freedom of speech exists under the constitution, but that . . . does not imply a moral right, on the part of Abolitionists, to freely discuss the question of slavery. . . . It is the agitation of a question too nearly allied to the vital interests of the slave-holding states to admit of public disputation." The resolution further condemned abolitionist activities as being "in the greatest degree seditious, and calculated to incite insurrection and anarchy, and ultimately, a disseverment of our prosperous union."[23]

Bristling at the attempt to silence him, Lovejoy's response was unequivocal. "I do, therefore," he wrote, "as an American citizen, and Christian patriot, and in the name of Liberty, and Law, and Religion, solemnly protest against all these attempts . . . to frown down the liberty of the press, and forbid the free expression of opinion. Under a deep sense of my obligations to my country, the church, and my God, I declare it to be my fixed

purpose to submit to no such dictation. And," he added, perhaps presaging future events, "I am prepared to abide the consequences." The consequences would be severe. Attacks on the newspaper, including the destruction of his printing press, forced Lovejoy to leave St. Louis in 1836 for Alton, Illinois, where his reception proved no more hospitable. Within a day of its arrival, Lovejoy's new press had been smashed and hurled into the Mississippi River, acts of destruction which would be repeated no less than four times in little over a year.[24]

In the final episode, Lovejoy was shot to death while defending his press against an angry mob on the night of November 7, 1837. Although the courageous editor barely receives mention in modern histories, John Quincy Adams wrote in 1838 that "the incidents which preceded and accompanied, and followed the catastrophe of Mr. Lovejoy's death have given a shock as of an earthquake throughout this continent, which will be felt in the most distant regions of the earth."[25] The events produced "a burst of indignation," reported the *Boston Recorder,* "which has not had its parallel in this country since the battle of Lexington in 1775."[26] Lovejoy's example inspired many to take up the abolitionist banner including celebrated activist Wendell Phillips, a young firebrand named John Brown, and Ohio attorney William Herndon who, in turn, influenced the views of his friend and law partner, Abraham Lincoln.[27]

Since Lovejoy became a martyr to proponents of both a free press and the antislavery movement, Staffordshire potters memorialized him in a white earthenware plate featuring design elements symbolic of each (fig. 29). Printed in light to medium blue, the central motif consists of the words of

Figure 29 Soup plate, Staffordshire, ca. 1840. Whiteware. D. 10½". (Collection of Rex Stark; photo, Gavin Ashworth.)

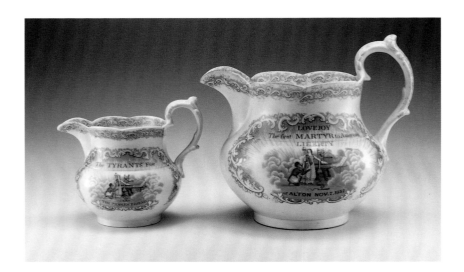

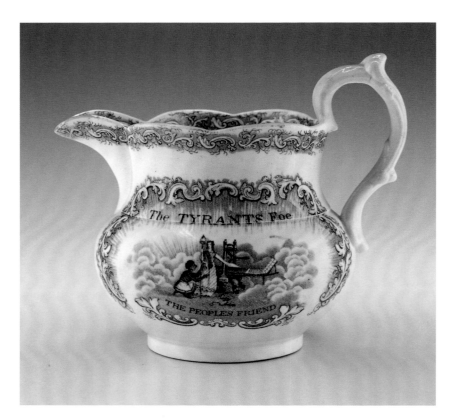

the First Amendment surrounded by a border with alternating cartouches and American eagles. The image in the main cartouche includes a slave kneeling at the feet of Liberty, shackles and whip lying in the foreground, and a printing press behind. Two variations of the inscription exist: "LOVEJOY The first MARTYR to American LIBERTY at ALTON NOV. 7, 1837" and "The TYRANTS Foe The Peoples Friend." Similar transfers were applied to other forms in tea and dinner services (figs. 30, 31). Donated by British abolitionists and shipped to New York to raise money through their sale for the American antislavery movement, the pieces became

extremely popular, so much so that forgers manufactured and passed off as originals reproductions fabricated in the late nineteenth century.[28]

The images on the First Amendment plate are almost as noteworthy for an element they omit as those they include. Since many of the antislavery pieces featuring the kneeling slave also contain some reference to God or religion, we might reasonably expect to see one here, particularly in view of Lovejoy's ordination as a minister and frequent invocations of God and church in resisting censorship. Certainly, precedent existed for the use of such imagery or messages in antislavery publications. Lovejoy's contemporary and fellow abolitionist William Lloyd Garrison, for example, prominently featured the image of Jesus Christ freeing a kneeling slave while rebuking a slavemaster in the masthead of his antislavery newspaper, *The Liberator*.

The role of religion in the debate over slavery was an ambivalent one. Ecclasiastical authorities, some perhaps less sensitive to moral than economic concerns, were by no means unanimous in supporting emancipation. Responding to a need to classify slaves for commercial purposes, England's Solicitor-General had determined in 1677 "that negroes ought to be esteemed goods and commodities within the Acts of Trade and Navigation."[29] Over fifty years later, British legal authorities determined that baptizing blacks did not change their status as slaves. Shortly thereafter, the Bishop of London endorsed both judgments, declaring that "Christianity, and the embracing of the Gospel, does not make the least alteration in Civil Property, or in any of the Duties which belong to Civil Relations."[30] Still, Christian clergymen could not easily dismiss the apparent contradiction of preaching love for fellow men while sanctioning their enslavement.

Advocates of slavery based their arguments mainly on "scientific truths" allegedly confirming black inferiority and biblical passages that appeared to justify human bondage.[31] South Carolina physician Josiah Nott offered an example of the former in an 1844 essay in which he maintained that "There is a marked difference between the heads of the Caucasian and the Negro, and there is a corresponding difference no less marked in their intellectual and moral qualities. . . . Their intellects are now as they have always been, as dark as their skins."[32] Defenders of slavery found further justification in biblical references to human bondage and, in particular, the apparent sanction of the institution by St. Paul who counseled: "Let each one remain in the calling in which he was called. Were you called as a slave? Do not let it bother you Let each one, brothers, remain with God in the state in which he was called."[33]

Slavery proponents still felt obliged to reconcile pious notions of love for all mankind with the subjugation of other human beings, however. They managed to do so by fusing assumptions of black inferiority with a version of Christian benevolence into a concept that has come to be known as "evangelical stewardship." Under this scheme, as expressed by a Virginia Baptist minister, "The guardianship and control of the black race, by the white, is an indispensable Christian duty, to which we must yet look, if we would secure the well-being of both races."[34] Although no ceramics explicitly advocating slavery have yet come to light, some are

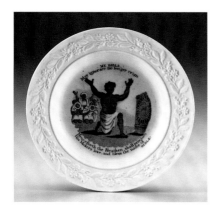

Figure 32 Child's plate, England, ca. 1820. Pearlware. D. 5". (Collection of the author; photo, Gavin Ashworth.) This blue transfer print extolling the virtues of "MY BIBLE" is derived from a color sheet published by William Darton, Jr. in 1812.

decidedly ambiguous on whether the duty of religion should have been to oppose bondage or encourage slaves to be content with their lot. A child's pearlware plate, for example, presents the image of a kneeling black with a group of peers in prayer behind (fig. 32). Taken from a color sheet by William Jolly and published by William Darton, Jr. in 1812, the inscription extolls the virtues of "MY BIBLE," but makes no mention of either slavery or emancipation.[35] Similarly, from a series of child's plates called "Flowers that Never Fade," one entitled "Piety" depicts two young white girls giving alms to a dark-skinned beggar within the inscription,

> While God regards the wise and fair
> The noble & the brave, He listens
> To the beggar's prayer, and the poor Negro slave.[36]

Little ambiguity is evident, however, in the ceramics that combine familiar antislavery imagery with relevant biblical text. Passages from the Old Testament especially were employed to draw the analogy between the suffering of the ancient Hebrews in Egypt and during the Babylonian Captivity and that of enslaved Africans in the eighteenth and nineteenth centuries. To accompany the text, some ceramic producers favored images of either the kneeling female or a slave mother holding her baby. A slender-necked vase (figs. 33, 34) displays the figure of a kneeling slave in chains on one side and, on the other, a verse from Ezekiel (22:29), a Jewish prophet during the sixth-century B.C.E. Babylonian exile:

Figure 33 Vase, France, ca. 1820. Porcelain. H. 4¾". (Collection of Rex Stark; photo, Gavin Ashworth.)

Figure 34 Detail of the inscription on the vase illustrated in fig. 33.

> The people of the land have
> used oppression and
> exercised robbery, and
> have vexed the poor and needy

Not included in the transfer are the ensuing lines of scripture in which God, speaking through Ezekiel, admonishes, "I have therefore poured out My indignation upon them; I will consume them with the fire of My fury. I will repay them for their conduct."[37] The implied threat to slaveowners would have been clear to the many in nineteenth-century England and America familiar with the biblical text. To those less conversant in scripture,

Figure 35 Sauceboat, France, ca. 1820. Porcelain. L. 5½". (Collection of Rex Stark; photo, Gavin Ashworth.) Black transfer print of a kneeling female slave in chains.

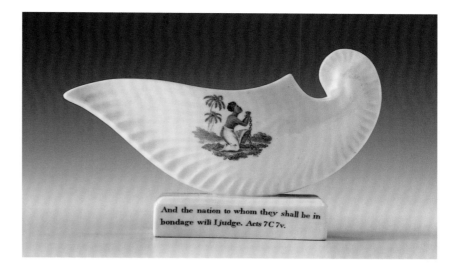

Figure 36 Dish, France, ca. 1820. Porcelain. L. 10". (Collection of Rex Stark; photo, Gavin Ashworth.)

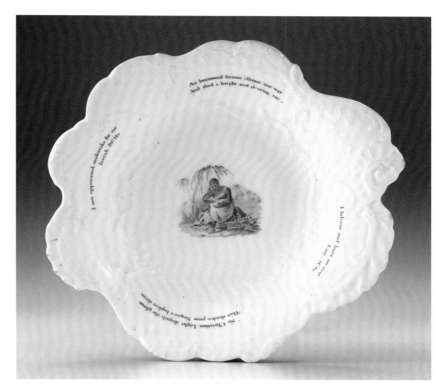

the New Testament legend on the base of a graceful sauceboat in the shape of a nautilus shell (fig. 35) delivered the same message more explicitly: "And the nation to whom they shall be in bondage will I judge."[38] A similar plate (fig. 36) combines the slave mother and baby image with Old Testament quotations from Isaiah 38:14 ("I am oppressed undertake for me") and Lamentations 5:5 ("I labour and have no rest") as well as the promise of Christian redemption:

> As borrowed beams illume our way
> And shed a bright and cheering ray
> So Christian Light dispels the gloom
> That shades poor Negro's hapless doom.[39]

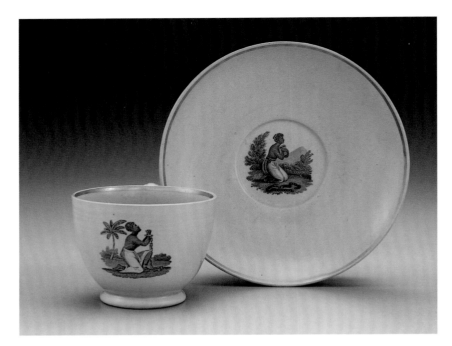

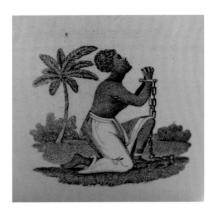

The message conveyed by a drabware cup and saucer is somewhat more obscure (fig. 37). The transfer print on the cup is that of the familiar female slave in chains (fig. 38), but the figure on the saucer, though similar, has broken chains and holds a Bible (fig. 39). Published in London in 1828, the image derives from an engraving which faces the title page of a pamphlet by Mary Dudley entitled *Scripture Evidence of the Sinfulness of Injustice and Oppression*. Predating English emancipation laws by half a dozen years, the engraving also bears the caption "This Book tell Man not to be cruel; Oh

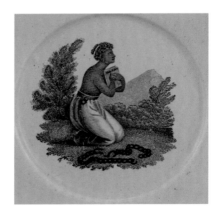

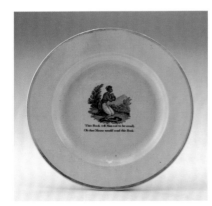

that Massa would read this Book," suggesting a liberation from bondage perhaps more spiritual than literal (fig. 40).[40]

The pamphlet's date of publication is also significant in that 1828 represents the year in which English abolitionists first introduced the kneeling female slave image as a counterpart to the male figure that Wedgwood had popularized. American activists soon adopted the motif as well. Newspaper editor Benjamin Lundy used it in the *The Genius of Universal Emancipation*

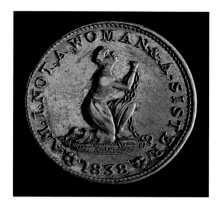

Figure 41 Token, United States, 1838. Copper. D. 1⅛". (Collection of the author; photo, Gavin Ashworth.) Kneeling and chained female slave with legend: "AM I NOT A WOMAN & A SISTER."

as early as 1830 followed by William Lloyd Garrison in *The Liberator* shortly thereafter.[41] In 1837 the American Anti-Slavery Society in New York commissioned a New Jersey firm to issue copper tokens featuring a kneeling slave with the legend "AM I NOT A WOMAN & A SISTER" (fig. 41).[42] The appearance of the female icon in Britain and the United States symbolized not only a growing awareness of the special vicissitudes that women suffered under slavery as victims of sexual exploitation but also recognition of the prominent role that women were playing in the antislavery movement.

That part was a singular one. Citing, among other evidence, a 1787 anti-slavery letter to a Manchester, England, newspaper that unequivocally associated the "Fair Sex" with the "Qualities of Humanity, Benevolence, and Compassion," historian Clare Midgley has concluded that "those moral qualities on which abolitionist commitment was based were . . . from the outset identified as especially feminine in nature."[43] The gender attribution of these traits combined with the development of the "separate spheres" ideology of the late eighteenth and early nineteenth centuries—a philosophy that specified business and political life as the male domain and domestic and family life as the female realm—to create unique functions for women within the antislavery community. Although women generally were barred before the 1830s from serving on abolitionist society committees, speaking out in public, or signing petitions, their decisions as the individuals primarily responsible for household purchases and consumption were critical to the success of such vital initiatives as the sugar boycott and abstention campaigns.[44]

Women also contributed by organizing and procuring goods for antislavery bazaars held to promote and raise funds for the cause. Items sold at the fairs, some produced by the women themselves, included ceramics, handicrafts, tokens, and textiles which bore images of kneeling male and female slaves.[45] To enlighten local communities and encourage attendance, fair managers displayed antislavery slogans on the walls of bazaars and on signs directing the public to the sites. Some of these, such as "Remember them that are in bonds," corresponded to maxims transfer printed on antislavery ceramics (figs. 42, 43).[46]

As profoundly as women influenced the antislavery movement, so, too, did the movement affect them. Advocating on behalf of oppressed members

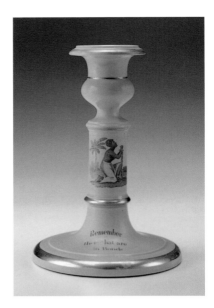

Figure 42 Candlestick, England, ca. 1830. Earthenware. H. 6¼". (Collection of Rex Stark; photo, Gavin Ashworth.) This unusual form has the transfer print of a kneeling female slave and the Bible verse: "Remember them that are in Bonds."

Figure 43 Detail of the gilt inscription on the base of the candlestick illustrated in fig. 42.

of their sex could not help but cause women to reflect on the gender inequalities of their own societies. As early as the 1790s, some, including Mary Wollstonecraft (who later wrote the novel *Frankenstein* under her married name Mary Shelley) were comparing their status in England to that of slaves and lamenting that few had "emancipated themselves from the galling yoke of sovereign man."[47] Even within the movement itself, female adherents had to tackle the "woman question," the debate over whether to permit the appointment and seating of women delegates at antislavery conventions.

The controversy came to a head in 1840 when female members of the American Anti-Slavery Society, who had already won the issue at home, were denied seats as delegates at the World Anti-Slavery Convention in London. Despite the setback, the leader of the American society, William Lloyd Garrison, concluded that the convention had "done more to bring up for the consideration of Europe the rights of women, than could have been accomplished in any other manner." And, looking back on the event a half century later, leading feminist Elizabeth Cady Stanton (who had attended the London conference on her honeymoon) declared that it "stung many women into new thought and action" and gave "rise to the movement for women's political equality both in England and the United States."[48]

Although the prevailing "separate spheres" ideology generally prevented them from assuming highly visible roles in promoting emancipation, some women exerted significant influence through their writings. These included not only those previously mentioned but a number of others, most notably Harriet Beecher Stowe who caused an international sensation with the publication of her novel, *Uncle Tom's Cabin,* in 1852. Practically an instant best seller in the United States and England, the book's huge commercial success induced potters to manufacture a plethora of items transfer printed with scenes from the text (some with captions in French and German) and even an image of the author herself (figs. 44–46).

Figure 44 Set of figures from *Uncle Tom's Cabin*, England, ca. 1855. Unglazed porcelain. H. of tallest: 3¼". (Collection of Rex Stark; photo, Gavin Ashworth.)

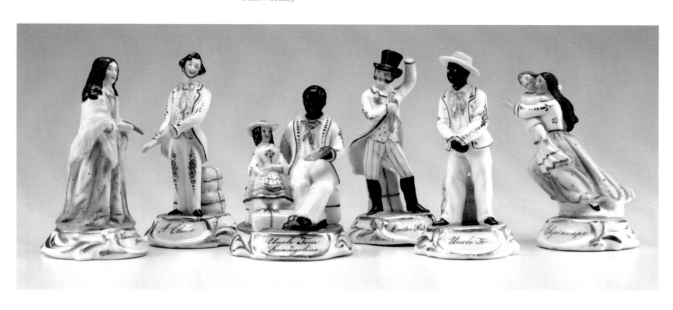

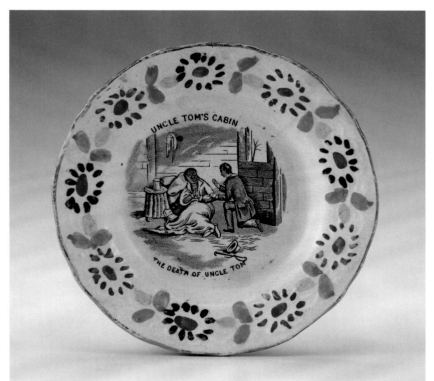

Figure 46 Plate, J. Vicellard, Bordeaux, France, ca. 1855. D. 8". (Collection of Rex Stark; photo, Gavin Ashworth.) A French version of the death of Uncle Tom.

Figure 45 Plate, probably Staffordshire, ca. 1855. Whiteware. D. 6 1/6". (Collection of Rex Stark; photo, Gavin Ashworth.) The printed scene shows "The Death of Uncle Tom."

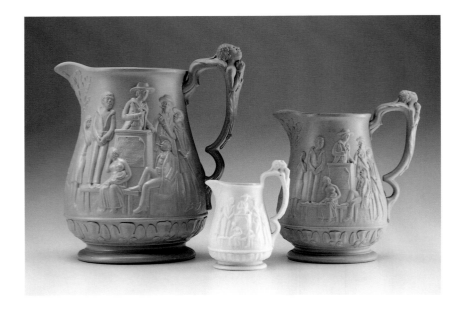

Figure 47 Pitchers, Ridgway & Abingdon, Staffordshire, 1855. Colored stoneware and parian. H. of tallest: 8". (Collection of Rex Stark; photo, Gavin Ashworth.) The molded images are taken from two scenes in *Uncle Tom's Cabin*, with the side shown depicting a slave auction. The three-dimensional handle shaped as a kneeling slave represents nearly seventy years use of that poignant image since the introduction of Wedgwood's medallion in 1787.

Figure 48 Reverse of the jug illustrated in fig. 47.

Probably the most distinctive pieces comprise a series of molded stoneware pitchers (figs. 47, 48) in various sizes produced by the Staffordshire firm of Ridgway and Abington, potters renowned in their time for "their very zealous ... praiseworthy, and ... successful efforts to improve the character of modelled ornament."[49] The jugs display two compelling episodes from the novel: the slave auction and fugitive slave Eliza escaping with her baby across the ice floes of the Ohio River. The precise source for each image is uncertain, but the auction scene is similar to several period print renditions. The depiction of Eliza on the ice most closely resembles the cover illustration of an undated but contemporary piece of sheet music titled "The Slave Mother."[50] In addition to the scenes on either side, the jug handle is decorated with the head and clasped hands of a slave (presumably Uncle Tom) in prayer, reminiscent of Wedgwood's cameo figure. Some of the pitchers are stamped on the base with a maker's mark and production dates as early as 1853, just one year after the book's publication. In addition to their artistic talents and technical skill, Ridgway and Abington, like other Staffordshire potters, were recognized for their ability to anticipate and react swiftly to public demand.[51]

Controversial in the 1850s, *Uncle Tom's Cabin* remains so today. Although some have praised Tom as a model of Christian faith, forbearance, and humility, others have disdained the character as excessively meek and docile. In the context of the mid-nineteenth century, Tom was an admirable figure, however, especially when compared with antiabolitionist caricatures of blacks that had been circulating in American society for several decades. In the wake of antislavery legislative successes, satirical broadsides that portrayed blacks graphically and in farcical text as "apish inferiors of whites" began to appear in the United States as early as 1815. Such images prefigured the minstrel show in which white performers in blackface diffused and perpetuated black stereotypes that lasted well into the twentieth century. [52]

Figure 49 Child's plate, England, ca. 1850. Whiteware. D. 5⅜". (Collection of the author; photo, Gavin Ashworth.) Enamel-colored black transfer print "JUMP JIM CROW," with molded rim.

Those stereotypes conform substantially to the figure of Sambo, "the typical plantation slave" defined by historian Stanley Elkins as "docile but irresponsible, loyal but lazy, his behavior...full of infantile silliness."[53] This symbolic character is implicit in the design of a whiteware plate entitled "JUMP JIM CROW," featuring a dancing black and a short rhyme describing his jig (fig. 49). The transfer print refers specifically to a white minstrel, Thomas Dartmouth Rice, who performed in blackface as Jim Crow at the Surrey Theater in England in 1836.[54] In his landmark study on late nineteenth- and twentieth-century American race relations, historian C. Vann Woodward maintains that "the origin of the term 'Jim Crow' applied to Negroes is lost in obscurity." Yet Woodward's identification of Rice as creator of a song and dance called "Jim Crow" in 1832 suggests that the minstrel character and the ceramic image represent two of the earliest documented uses of the term that would become synonymous with the system

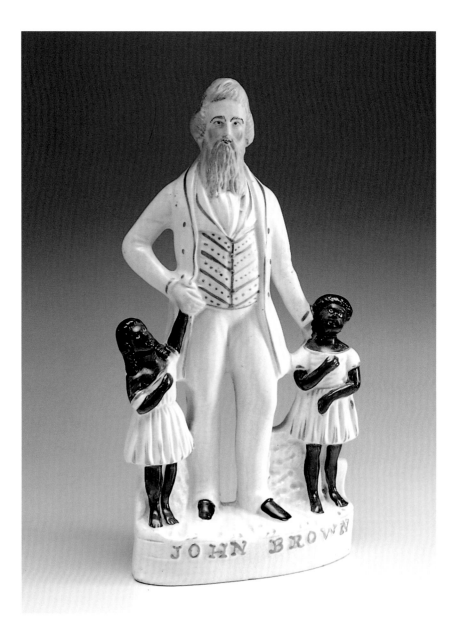

Figure 50 Figure, Staffordshire, ca. 1860. Whiteware. H. 11". (Collection of Rex Stark; photo, Gavin Ashworth.) The molded, hand-enameled figure of militant abolitionist John Brown contrasts sharply with the diminutive, adoring children.

of legal and de facto discrimination against blacks that prevailed throughout much of the American South in the century following Reconstruction.[55]

While it is tempting to dismiss such images as the products of racist minds, patronizing attitudes toward blacks were not restricted to slavery's defenders. Throughout the first half of the nineteenth century and even as the Civil War approached, the good intentions but condescension of some associated with the antislavery movement were apparent in various print and ceramic productions.[56] Reminiscent of eighteenth-century portraits of English aristocrats striking a benevolent and omniscient pose above the adoring gaze of their black servants and later ceramics featuring Britannia as protector and defender of Africans, a circa 1860 Staffordshire figure group features militant abolitionist John Brown affecting a similar stance with two black children (fig. 50).

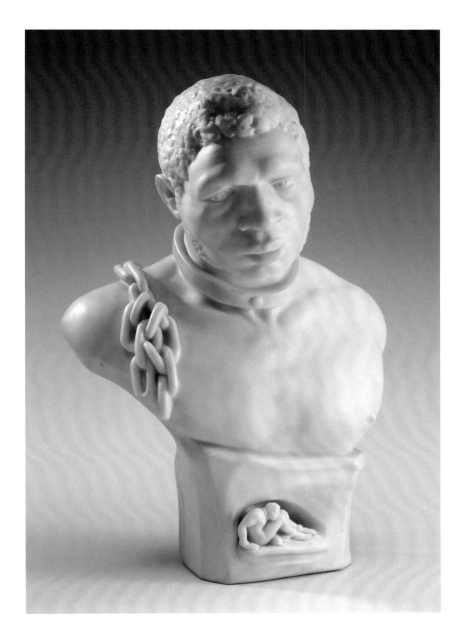

Figure 51 Bust, Copeland, Staffordshire, 1864. Parian. H. 9¾". (Collection of Rex Stark; photo, Gavin Ashworth.) This powerful sculptural expression of a chained slave with collar is among the most artistically-proficient and dramatic images of slavery. A confined full-body slave is represented in a recess on the base. The base is marked "Published May 1, 1864 Copeland."

Though sympathetic to the goals of emancipation, such creations nonetheless failed to grant blacks a full measure of humanity. The egalitarian sentiment was never entirely absent, however. Just as some early ceramic pieces portrayed blacks with sensitivity and without prejudice, so, too, does a remarkably realistic parian bust of a chained and collared slave produced by the Staffordshire firm of Copeland in 1864 convey the qualities of dignity, strength, and intelligence (fig. 51). The slave's eyes also reveal a deep sorrow based, it seems, not just on the suffering of an individual lifetime but the collective anguish of generations past and, perhaps, future as well. For, despite the ebullient optimism of Josiah Wedgwood's letter to Benjamin Franklin over seven decades earlier, freedom for the slave had yet to be achieved in America. And, even though Union victory in the Civil War would soon bring about emancipation, over a century of

desperation and struggle would yet ensue before the descendants of African slaves might enjoy full equality under the law.

ACKNOWLEDGMENTS

The author wishes to thank Rex Stark and the Colonial Williamsburg Foundation, especially curator Martha Katz-Hyman, for graciously allowing us to view and reproduce images from their outstanding collections.

1. *The Selected Letters of Josiah Wedgwood*, edited by Anne Finer and George Savage (London: Cory, Adams, and Mackay, 1965), p. 311; Robin Reilly, *Josiah Wedgwood 1730–1795* (London: Macmillan, 1992) p. 287.

2. Reilly, *Wedgwood*, p. 286.

3. Thomas Clarkson, *The History of the Rise, Progress, and Accomplishment of the Abolition of the African Slave-Trade by the British Parliament* (1808; reprint, London: Frank Cass & Co., 1968), p. 192.

4. David Dabydeen, *Hogarth's Blacks: Images of Blacks in Eighteenth-Century English Art* (Athens, Ga.: University of Georgia Press, 1987), pp. 21–26. See also Hugh Honour, *The Image of the Black in Western Art*, vol. 4, *From the American Revolution to World War I*, part 1, *Slaves and Liberators* (Cambridge: Harvard University Press, 1989).

5. Dabydeen, *Hogarth's Blacks*, p. 18.

6. Ibid.

7. Ambrose Heal, *The Signboards of Old London Shops: A Review of the Shop Signs employed by the London Tradesmen during the XVIIth and XVIIIth Centuries* (New York: Benjamin Blom, Inc., 1972), pp. 21–22. Jacob Larwood and John C. Hotten, *The History of Signboards, from the Earliest Times to the Present Day*, 6th ed. (London: John C. Hotten, n.d.), p. 432. Preface dated June 1866.

8. Phillip Lapansky, "Graphic Discord: Abolitionist and Antiabolitionist Images" in *The Abolitionist Sisterhood: Women's Political Culture in Antebellum America*, edited by Jean Fagan Yellin and John C. Van Horne (Ithaca, N.Y.: Cornell University Press, 1994), p. 216.

9. Winthrop D. Jordan, *The White Man's Burden: Historical Origins of Racism in the United States* (New York: Oxford University Press, 1982), pp. 142–43; Betty Fladeland, *Men and Brothers: Anglo-American Antislavery Cooperation* (Urbana: University of Illinois Press, 1972), p. 13.

10. Clarkson, *Abolition of the African Slave-Trade*, pp. 190–91.

11. William Fox, *An Address to the People; Correspondence of Josiah Wedgwood 1781–1794* (Didsbury, Manchester, Eng.: E. J. Morten Ltd, 1906), 3: 183.

12. Ibid., p. 183.

13. Ibid., pp. 184, 186.

14. Clarkson, *Abolition of the African Slave-Trade*, pp. 349–50.

15. Quoted in Joseph C. and Owen Lovejoy, *Memoir of the Rev. Elijah P. Lovejoy* (New York: Arno Press and The New York Times, 1969), p. 10.

16. James Walvin, *England, Slaves and Freedom, 1776–1838* (Jackson: University Press of Mississippi, 1986), pp. 165–66. A white earthenware plate is recorded featuring a blue transfer print of a black family celebrating, the flag of liberty waving in the background, all surrounded by the legend, "FREEDOM FIRST OF AUGUST 1838."

17. James Walvin, "British Abolitionism, 1787–1838" in *Transatlantic Slavery: Against Human Dignity*, edited by Anthony Tibbles (London: National Museums and Galleries on Merseyside, 1995), p. 91.

18. Ibid., p. 92.

19. John Pollock, *William Wilberforce: A Man Who Changed His Times* (Burke, Va.: The Trinity Forum, 1996), p. 16.

20. Quoted in Fladeland, *Men and Brothers*, p. 286.

21. Ibid., p. 25.

22. William W. Freehling, "The Founding Fathers and Slavery" in *American Negro Slavery: A Modern Reader*, edited by Allen Weinstein, Frank O. Gatell, and David Sarasohn (New York: Oxford University Press, 1979), pp. 9–13.

23. David W. Blight, "The Martyrdom of Elijah P. Lovejoy," *American History Illustrated* 12, no. 7 (1972): 21.

24. Ibid., pp. 21–22.

25. Quoted in Lovejoy, *Memoir,* p. 12.

26. Quoted in Henry Tanner, *The Martyrdom of Lovejoy: An Account of the Life, Trials and Perils of Rev. Elijah P. Lovejoy* (1881; reprint, New York: Augustus M. Kelley, 1971), p. 9.

27. Blight, "The Martyrdom of Elijah P. Lovejoy," p. 27.

28. Marian Klamkin, *American Patriotic and Political China* (New York: Scribner's Sons, 1973), pp. 102–4; Ellouise B. Larsen, *American Historical Views on Staffordshire China* (New York: Dover Publications, 1975), p. 242.

29. Walvin, *England, Slaves and Freedom,* p. 32.

30. Dabydeen, *Hogarth's Blacks,* p. 119.

31. *The Ideology of Slavery: Proslavery Thought in the Antebellum South, 1830–1860,* edited by Drew Gilpin Faust (Baton Rouge: Louisiana State University Press, 1981), pp. 10–12.

32. Josiah C. Nott, "Two Lectures on the Natural History of the Caucasian and Negro Races," in Faust, ed., *The Ideology of Slavery,* pp. 232–33.

33. I Corinthians 7:20–21, 24.

34. Thornton Stringfellow in Faust, ed., *The Ideology of Slavery,* p. 136.

35. Noel Riley, *Gifts for Good Children: The History of Children's China, Part One 1790–1890* (Ilminster, Somerset, Eng.: Richard Dennis, 1991), pp. 244–45.

36. Ibid., pp. 252, 253.

37. Ezekiel 22:31.

38. Acts 7:7.

39. Tibbles, *Transatlantic Slavery,* p. 93, fig. 180.

40. Clare Midgley, *Women Against Slavery: The British Campaigns, 1780–1870* (London and New York: Routledge, 1992), p. 100.

41. Lapansky, "Graphic Discord," pp. 205–6.

42. Russell Rulau, *Standard Catalogue of United States Tokens 1700–1900,* 2d ed. (Iola, Wisc.: Krause Publications, 1997), p. 91.

43. Midgley, *Women Against Slavery,* p. 20.

44. Ibid., pp. 20–24, 37, 94.

45. Lapansky, "Graphic Discord," p. 206; Fladeland, *Men and Brothers,* pp. 227–28.

46. Lee Chambers-Schiller, "'A Good Work among the People': The Political Culture of the Boston Antislavery Fair" in Yellin and Van Horne, *The Abolitionist Sisterhood,* p. 20.

47. Mary Wollstonecraft in Midgley, *Women Against Slavery,* p. 26.

48. Fladeland, *Men and Brothers,* pp. 264–65; Midgley, *Women Against Slavery,* pp. 160–62.

49. Quoted from *Art Union* magazine, December 1846, in Geoffrey A. Godden, *Ridgway Porcelains,* 2d ed. (Woodbridge, Suffolk, Eng.: Antique Collectors' Club, 1985), p. 164.

50. Music by George Linley, illustrated by J. Brandard; Stowe-Day Library, Harriet Beecher Stowe Center, Hartford, Conn.

51. Godden, *Ridgway Porcelains,* p. 160.

52. Lapansky, "Graphic Discord," pp. 216–17.

53. Stanley Elkins, *Slavery: A Problem in American Institutional and Intellectual Life* (Chicago: University of Chicago Press, 1968), p. 82.

54. Riley, *Gifts for Good Children,* p. 172.

55. C. Vann Woodward, *The Strange Career of Jim Crow,* 3d ed., rev. (New York: Oxford University Press, 1980), p. 7.

56. Lapansky, "Graphic Discord," pp. 211–12.

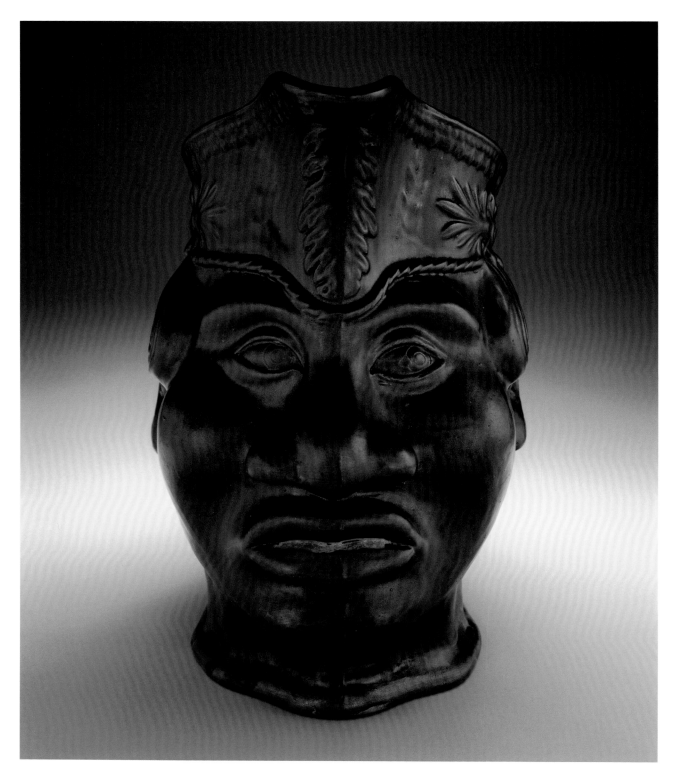

Figure 1 Pitcher, possibly Medford, Massachusetts, ca. 1840. Earthenware. H. 13". (Chipstone Foundation; photo, Gavin Ashworth.) This slip cast pitcher is one of four known. Two are impressed on the base with "MEDFORD" suggesting Medford, Massachusetts, as their place of manufacture. Nothing is known about the modeling of the original or the subsequent production of the molds. All of these jugs have a characteristic buff earthenware body with a thick Albany slip glaze that varies from shades of dark brown to almost black. The illusion of teeth is the result of scraping away the Albany slip to expose the buff color of the clay body.

*Jonathan Prown,
Glenn Adamson,
Katherine Hemple
Prown, and Robert
Hunter*

"The Very Man
for the Hour":
The Toussaint
L'Ouverture
Portrait Pitcher

▼ BROTHERS AND FRIENDS: *I am Toussaint L'Ouverture. My name is perhaps known to you. I have undertaken to avenge you. I want liberty and equality to reign throughout St. Domingue. I am working towards that end. Come and join me, brothers, and combat by our side for the same cause.*

Proclamation of August 29, 1793

The traditional curatorial approach to ceramic analysis prioritizes the identification of quantitative data: ware and glaze type, date of manufacture, place of origin, artistic style, subject, and authorship. These descriptive categories offer the typological stability upon which a neat ordering of the past can be constructed. But many artifacts, as well as the cultural contexts from which they emerge, are not so easily defined. In search of a more complex understanding of ceramic artifacts, many scholars have come to utilize different methodologies, including archaeology, anthropology, and material culture, which offer more intuitive understandings of the meanings, needs, and beliefs of the makers and original users. Although none of these analytical approaches can claim interpretive authority, they can be usefully combined. This essay merges a variety of strategies to help decipher a newly discovered group of mid-nineteenth century portrait pitchers which depict the famed Haitian leader Toussaint L'Ouverture and which symbolize the complexity of attitudes about race in American history (see fig. 1).[1]

Historian George F. Tyson, Jr. describes Toussaint, a former slave who led the first successful slave revolt in the Americas, as a mutable historical figure whose precise legacy is "obstructed by the fact that he has been all things to all men, from blood thirsty black savage to the greatest black man in history."[2] The portrait pitchers themselves similarly defy conventional understanding. Instead, they function as complex symbols that remain as potent today as at the time of their creation. To modern observers, the design is not only visually powerful but also offensive, distinguished by overtly racialized features that challenge contemporary sensibilities about appropriate representation and artistic license—reactions that are a significant part of coming to terms with this evocative object but necessarily shaped by our own historical context. A more thorough interpretation of this piece must also consider earlier historical contexts and, in particular, the racial ideologies that informed them.

When these pitchers were made in the 1840s, ideas about race were influenced by issues far more complex than the slavery debate; even the most

Figure 2 Mark Catesby, *Map of Carolina, Florida, and Bahama Islands with the Adjacent Parts,* London, 1754. (Private collection.)

Figure 3 Detail of the map illustrated in fig. 2 showing the island of Hispanola. Its aboriginal inhabitants originally knew the island as Haiti. The Spanish changed the name to Santo Domingo, and in 1697 the formal division of the island into Santo Domingo and Saint-Domingue took place. In 1804, Saint-Domingue ceased to exist and was renamed using the early term Haiti.

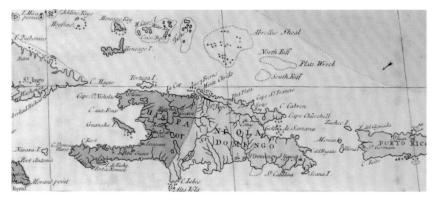

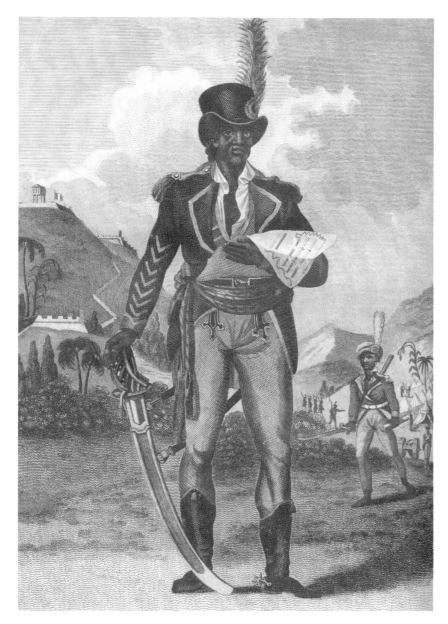

Figure 4 Marcus Rainsford, *Toussaint L'Ouverture*, London, 1805. (Courtesy, Archives & Special Collections, University of Miami Library.) This is the earliest known image of Toussaint L'Ouverture taken from sketches made by Marcus Rainsford. It appeared as an illustration in Rainsford's *An Historical Account Of The Black Empire Of Hayti: Comprehending A View Of The Principal Transactions In The Revolution Of Saint Domingo; With Its Ancient And Modern State*. Toussaint is represented as a dignified military leader with a sword in one hand and a battle map in the other.

Figure 5 Alexis Vincent, *Toussaint L'Ouverture*, Haiti, ca. 1970. Oil on canvas. (Private collection.) The image of Toussaint is commonly evoked by contemporary Haitian folk painters. Vincent's painting is reflective of the twentieth-century self-taught Haitian artists who began to make their contribution to Haitian life and cultural expression in the 1940s and 1950s. In this painting, Toussaint is depicted in a similar pose to the Marcus Rainsford engraving except that a commemorative scroll or proclamation has taken the place of the map.

vocal abolitionist sympathizers held diverse and ambivalent attitudes. Americans and European colonists in the Caribbean islands (figs. 2, 3) alike relied on complex and formulaic categories that could, for example, denote specific racial and legal identities of people down to $^{15}/_{16}$th white or black. Another compelling challenge in reading this pitcher is Toussaint L'Ouverture's intricate and even contradictory historical legacy—he has variously been remembered as either a heroic nation builder or as a complacent conspirator who did not effectively promote the cause of freedom (figs. 4, 5). The portrait on these pitchers similarly is hard to decipher. Although possibly meant to be an anti-slavery sympathizer's ennobling depiction of an important historical figure, the image clearly is associated with a derogatory engraved image created in 1837.

Figure 6 Detail of the impressed
"MEDFORD" stamp on the base of the
pitcher illustrated in fig. 8. (Private
collection; photo, Jay Lewis.)

A logical starting point for interpreting the pitchers' meaning is to consider the strongest piece of objective evidence: the stamped mark "Medford" found on the underside of two of the four pieces (fig. 6). The stamp
almost certainly suggests manufacture in Medford, Massachusetts, a town
on the Mystic River just north of Cambridge. Recent research by Electa
Kane Tritsch reveals that Medford's abundant sources of local clay allowed
it to become a major brick-making center during the middle and later part
of the nineteenth century. The adjacent towns of Charlestown and
Somerville also supported brick-making operations and several well known
ceramic manufactories. In the mid-eighteenth century, Medford may have
had a pottery business of its own that was run by the Tufts family, but
nothing is known of their production. That potting occurred in the mid-
nineteenth century is documented by a small group of simpler earthenware
pieces that similarly are marked "MEDFORD."[3]

The production of the Toussaint pitchers in Medford also relates to the
emergence of eastern Massachusetts as a leading center of abolitionist activity. The region was home to William Lloyd Garrison, Lydia Maria Child,
and Wendell Phillips, and several of the most influential abolitionist publications, including Garrison's *The Liberator,* the *National Philanthropist,*
and the *Massachusetts Abolitionist,* were produced in Boston. Also leading
the way were organizations such as the Massachusetts Emancipation
Society and the Boston Female Anti-Slavery Society (later the Massachusetts Female Emancipation Society). In addition to promoting abolitionist

ideology through the support of lectures and publications, the women's groups sponsored fairs that sold a wide range of art works, craft goods, and manufactured items to raise funds. A newspaper advertisement for a fair in 1840 notes that in addition to drawings, expensive cloth and clothes, and autographs by well known abolitionists, attendees could buy "elegant anti-slavery china, made for the occasion." Perhaps the Toussaint pitchers specifically were produced for this type of abolitionist fund raising event (fig. 7).[4]

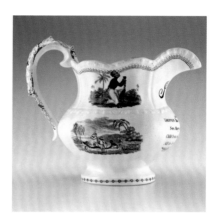

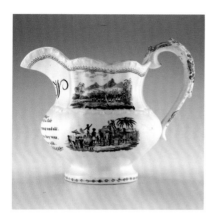

Figure 7 Pitcher, probably Staffordshire, England, ca. 1840. Earthenware. H. 6½". (Courtesy, Rex Stark; photo, Gavin Ashworth.) Inscribed with the initials "J.W." and the verse "DRIVEN like cattle to a fair; See they sell us, young and old. Child from mother too they tear, All for love of filthy gold." This rare transfer-printed jug made for the abolitionist market contains graphic scenes of slavery in the West Indies. Note the general overall shape, handle, and rim characteristic of ca. 1840 classical or Greek Revival styles in English and American pottery and porcelain.

One tantalizing, but currently unsustainable, attribution suggests that the pitchers were made in the Medford pottery that was opened circa 1838 by brothers John and Thomas Sables and their partner Job Clapp. That year all three men were listed as "all of Medford, Potters" on legal documents for their purchase of a group of former distillery buildings, which then became home to their pottery. Subsequent property sales over the next few years describe one or more of the men as "potters." In 1841 Thomas Sables, described as a potter, sold the "land, wharf, dwelling house, pottery and other buildings" to a Maine ship captain, a transaction that apparently marked the end of the Sables and Clapp pottery. The short life of the Sables and Clapp partnership probably reflects the men's diverse craft skills. In records both before and after the potting years, the three variously were recorded as housewrights, carpenters, and shipwrights—woodworking trades that, in theory, would have made the Sables and Clapp better suited to the production of slip-cast pottery than to wheel- or machine-turned work. One other intriguing clue is the Sables' unusual last name, which suggests that they may have been African-American. Nineteenth-century writers and lecturers used the word "sable" as a synonym for "black." An example of this usage is the British evangelist James Stephen's 1804 distinction between the "sable heroes of Haiti" and the "debased slaves" in other British colonies. [5]

A close look at the pitchers' formal elements suggests a number of additional facts about their origin, meaning, and function. All four are slip-cast earthenware, apparently formed in the same mold. There are minor variances in the manufacture of the pots, but nothing that would suggest production in different potteries. All are covered with a layer of lustrous

Figure 8 Pitcher, possibly Medford, Massachusetts, ca. 1840. Earthenware. H. 13". (Private collection; photo, Jay Lewis.) This example of the Toussaint L'Ouverture pitcher has an extremely dark brown, almost black, Albany slip. The outline of the eyes have been highlighted by scratching through the slip suggesting that although these pitchers were made from the same model, they could be individualized by the potter.

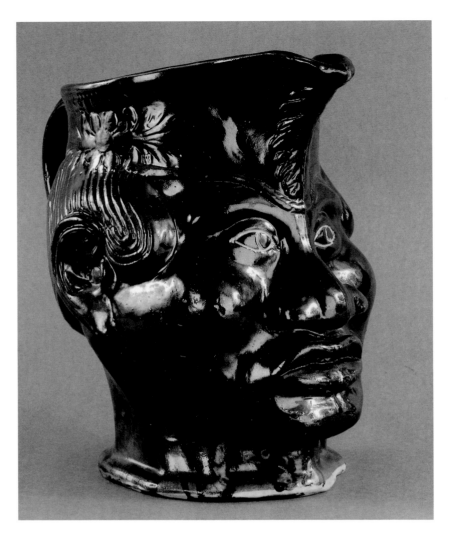

Figure 9 Detail of the unmarked base from pitcher illustrated in fig. 1. The fingerprints of the potter who dipped the pitcher in Albany slip have been recorded on its base.

Albany slip that ranges from a rich chocolate brown to near-black, colors which seem to have been deliberately chosen to suggest the skin tone of a person of African descent. The potter's close attention to the coloristic effects of the materials is evidenced by areas in which the glaze deliberately has been removed to reveal the off-white color of the body. Such sgraffito marks delineate the eyes on one example (fig. 8), and on another pitcher (see fig. 1) an unglazed patch was left in the mouth, perhaps indicating white teeth. The sculpting of the back and upper portion is much more flat and schematic than the sophisticated rendering of the face. That the pitchers were made to be functional as well as sculptural is indicated by the fact that they are glazed inside and out. Their pronounced baluster shapes likewise duplicate the form of more conventional ceramic water pitchers.

The front corner of the military hat conveniently serves as a spout, while the handle awkwardly protrudes from the back of the head. Among the curious inconsistencies on the pitchers is the design of the hat. Because of the fragility of the clay, the plume that would normally protrude upward from the front of a genuine tricorner hat instead surreally turns downward.

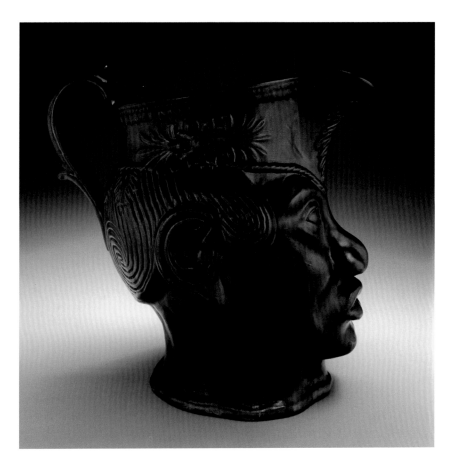

Figure 11 Ewer, Leeds, ca. 1790. England. Creamware. H. 11¼". (Chipstone Foundation; photo, Gavin Ashworth.) This late eighteenth-century ewer, inspired by antique Greek and Roman examples, exhibits molded frieze-like elements on the neck and body similar to the grammar of the design elements representing the military cap on the L'Ouverture pitcher.

Also, in order to provide additional stability to the pitchers, the maker pinched out the clay at the bottom to form a continuous foot—a fleshy protrusion that creates the uncomfortable feeling that the man has been decapitated. The casting line that vertically encircles the vessel, bisecting the face, could have easily been smoothed out but instead was left intact— evidence, perhaps, of large-scale production by relatively unskilled workers. Finally, the pitcher illustrated in figure 1 has four smudgy slip marks on the base that poignantly preserve the fingerprints of the potter and suggest a speed of manufacture that is difficult to reconcile with the object's sophisticated modeling (fig. 9). All of these inconsistencies suggest a collaboration between a skilled sculptor and a production-oriented potter.

Despite its unusual form, the overall design has much in common with the artistic conventions of classicism. The artist's fluency in the language of ancient ornamentation is evidenced by the geometric arrangement of stylized foliage along the top edge of the hat, which emulates the much more intricately decorated gold-thread trim tapes used on cloth military hats of this sort. When the pitcher is viewed from the side, the horizontally delineated lines of the hat create an unmistakably frieze-like passage, consistent with the classically inspired decoration of many late eighteenth- and early nineteenth-century pitchers (figs. 10, 11). Unlike other ceramic portrait pitchers made in this era, however, the careful rendering of the man's face mirrors the individuation and formal bearing associated with classical

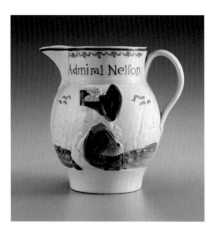

Figure 12 Jug, Staffordshire, England, ca. 1805. Pearlware. H. 6⅛". (Chipstone Foundation, Noël Hume Collection.) Drinking jugs and pitchers have been made to commemorate cultural heroes and promote political messages since antiquity. In the late eighteenth century, with the rise of the Staffordshire potteries, large quantities of molded commemorative wares were made for middle-class consumers in the Anglo-American market.

sculpture (fig. 12). Many of the facial details are fashioned with an apparent sensitivity to psychology, including subtle furrows that are cut into the forehead. The eyes shift slightly to one side, as if in expectation, and the mouth is parted, as though the man were on the brink of speech. Cords of muscle are carved into the neck, giving an impression of physical power (figs. 13, 14).

Figure 13 Pitcher, possibly Medford, Massachusetts, ca. 1840. Earthenware. H. 13". (Courtesy, Arthur Goldberg.) Also marked "MEDFORD," this pitcher has the illusion of teeth like the example shown in fig. 1.

Figure 14 Rear view of the pitcher illustrated in fig. 13. (Courtesy, Arthur Goldberg.)

Other features—notably the wildly exaggerated brow, nose, and lips, along with the incised whorled lines that form the hair—are not in keeping with the Touissant pitcher's more classical elements. When compared to the 1956 sculpture, *Negro Woman,* made by African-American artist Elizabeth Catlett (fig. 15), the pitcher's overwrought facial elements appear not only racialized—meant to depict, as objectively as possible, racial identity—but also racist—meant to indicate racial inferiority. Discerning the precise meaning of these elements in the context of nineteenth-century material culture remains difficult. Although a number of commemorative wares were produced (fig. 16), a search for visual comparisons immediately brings to mind the type of artifacts known among collectors as "black memorabilia"

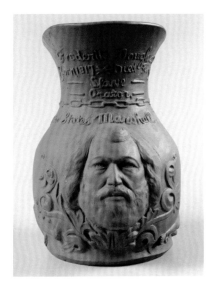

Figure 17 *Jolly Nigger Mechanical Bank,* J. & E. Stevens Co., Cromwell, Connecticut, patented March 14, 1892. Cast iron. H. 6". (Courtesy, Larry Vincent Buster, *The Art and History of Black Memorabilia* [New York; C. Potter, 2000]; photo, Kenneth Paul, Sr.)

Figure 18 Face jug, Edgefield, South Carolina, ca. 1860. Alkaline-glazed stoneware. H. 6". (Private collection.)

Figure 19 by Nelson Sizer and H. S. Drayton, A.M., M.D., *Heads and Faces and How to Study Them* (New York: Fowler & Wells Co., 1891.) (Chipstone Foundation.)

(fig. 17). In its portrait of a full head, the design of the Toussaint pitcher also recalls southern face jugs, which were made by both black and white potters and often gruesomely depict African-American faces (fig. 18). When the Medford pitchers were potted, however, manufacture of black memorabilia and face jugs had only just begun. Far more common at the time were images of African-Americans in print media, which often showed viscously stylized imagery. Motivated by racist assumptions, such depictions also reflected an emerging belief among whites in the pseudoscience of phrenology, with its obsessive grouping of physiological and racial archetypes (fig. 19). Phrenologists argued that Africans occupied the lowest position in the hierarchy of races. This assertion was defended by emphasizing such supposedly African characteristics as large lips, wide noses, and most tellingly, a jutting lower brow—a feature that implied a connection to simian physiology and introduced into popular vocabulary the term "lowbrow."[6]

The facial features on the Medford pitchers may be more accurately contextualized by establishing the specific identity of the subject as Toussaint L'Ouverture. To begin with, only a small number of black military figures might have been commemorated on a mid-nineteenth-century American artifact. Among the potential candidates is Crispus Attucks, the fugitive slave who in 1770 was the first American to die in the Boston Massacre. Thereafter he was hailed as a symbolic leader of the patriot cause and reemerged as a key historical figure in the rhetoric of abolitionists. However, Attucks was a sailor in Boston, not a soldier, and existing historical depictions do not show him wearing a military uniform or hat, so he seems an unlikely candidate. Another possibility is that the pitchers portray one of the small number of black troops who fought in the Revolutionary War. A Haitian regiment that battled alongside the colonists in Georgia, for example, included many subsequent leaders of the Haitian slave revolts. On the other hand, the majority of African-Americans in the Revolutionary War fought for the British and Loyalists. In 1775 Lord Dunmore, the last Royal Governor in Virginia, offered freedom to slaves who would fight for the British, a strategy that ultimately failed but that aroused the fear of many Virginians. The manumitted slave soldiers wore uniforms that were adorned with badges inscribed "Liberty to Slaves." But their story was not widely referenced by abolitionist writers and lecturers, so they too remain improbable candidates as the subject of the Medford pitchers. Haiti, on the other hand—along with the men who led its revolution at the end of the eighteenth century—occupied a prominent symbolic place in nineteenth-century American culture and remained at the center of debate among abolitionists and pro-slavery apologists alike. The most intriguing figure in the story of the Haitian revolution was Toussaint, who was, as Tyson suggests, "the very personification of its ideals and contradictions," an inspired yet messianic military and political genius who "molded the revolutionary army of slaves into an efficient, disciplined fighting unit; who defended the revolution by an astute mixture of statecraft and diplomacy; who restored economic stability to his ravaged country; who, through his personal achievements, inspired in his people, and in black people everywhere, a renewed sense of pride and purpose." For nineteenth-century Americans, Toussaint became the embodiment of the Haitian revolution and the various issues it brought to the forefront.[7]

A survey of the few surviving images of Toussaint not only supports the conclusion that he is the subject of the Medford pitchers but also offers some clues regarding the figures' exaggerated features. Although no life portraits of the former slave are known, several widely distributed engraved depictions were created from written descriptions offered by Haitian, British, French, and American contemporaries, descriptions that often are not complimentary (figs. 20–22). Among these are the comments of abolitionist Victor Schoelcher, who noted Toussaint's "repulsive ugliness and poor build."[8] Other commentators likewise drew on the language of phrenology and frequently remarked on his pronounced, jutting jaw.

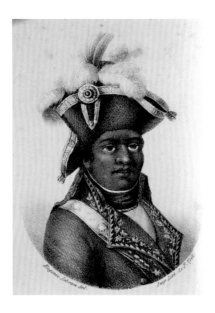

Figure 20 Eugenie Lebrum, *Toussaint L'Ouverture, General en chef à St. Domingue,* Paris, 1825. (Private collection.) This image of Toussaint appears as the frontispiece in a history of Napoleon Bonaparte's expedition in Haiti.

The most likely visual source for the design of the Toussaint pitchers is a lithograph created by French artist Nicolas Eustache Maurin for an 1832 portrait volume titled *Iconographie des Contemporains* (fig. 23). Maurin's portrait likewise was intended as an explicitly antagonistic caricature, accounting for what art historian Hugh Honour calls its "deformed, almost simian profile."[9] With an illegible signature added underneath the image to give it an air of authenticity, the lithograph became the most widely reproduced

Figure 21 *Toussaint L'Ouverture* from *Harper's New Monthly Magazine* 43, no. 253 (1871). (Private collection.) In contrast to the image portrayed in the 1838 *Penny Magazine,* this image, also after the Rainsford engraving, shows a young, almost boyish, Toussaint.

image of Toussaint. The modeling of the face on the Maurin engraving is comparable to that on the pitchers, as is the proportioning of the facial and decorative elements, including the hat and the parted lips. Additional shared elements include the protruding sidelong eyes, which correspond to period descriptions.

The early French biographer, Louis Dubroca, remarked on Toussaint's "dark and taciturn" disposition and his "rapid and penetrating" glances. Another early description refers to a relatively small man who lost his upper front teeth in battle, which may partially explain the large underbite shown in the engraving. Maurin's characterization of Toussaint is also

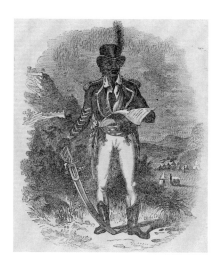

Figure 22 Engraving from *The Penny Magazine,* (London: Published by the Society for the Diffusion of Useful Knowledge, 1838). (Private collection.) This depiction of Toussaint L'Ouverture appeared on the cover of *Penny Magazine* in 1838. The magazine contained a wide range of informative illustrated articles and was aimed at the working class. The 1805 Rainsford engraving is the obvious source of this image although Toussaint's facial features have been given a much harsher look.

Figure 23 Nicolas Eustache Maurin, *Toussaint L'Ouverture,* from *Iconographie des Contemporains,* Paris, 1832. Lithograph. (Courtesy, Print & Picture Collection, Free Library of Philadelphia.) With its "ape-like" profile, this was the most frequently reproduced image of Toussaint during the period in which the portrait pitcher was modeled.

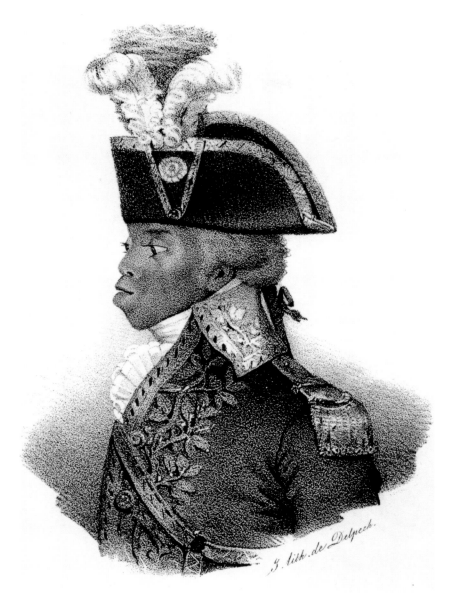

specifically linked to its production for a French audience.[10] More than any other Haitian leader, Toussaint and his followers supported the French colonial authorities through the revolution only to sever ties very late in the conflict. Humiliated not only by losing their most profitable colonial outpost but also by losing it to a native army led by an ex-slave, French leaders such as Napoleon Bonaparte portrayed Toussaint as a villainous traitor whose rise to power was only made possible by French support. The Maurin portrait drew on these attitudes to create a racist image of a diminished historical figure.[11]

The available evidence makes it possible to conclude with some certainty that the pitchers were based on the Maurin portrait of Toussaint and were likely made for the abolitionist market in eastern Massachusetts. But other, ultimately more important, interpretive questions remain, particularly in

regard to the Haitian subject matter and its potential meanings. In general, American interest in Haiti was linked to the fascinating details of the revolution itself, a mind-boggling series of cross-cultural and cross-racial revolts, alliances, and betrayals involving French, British, and Spanish colonizers and military leaders, and, of course, Haitians of every racial and social strain. African-Americans and abolitionist sympathizers could find much about the revolution that was inspiring. As historian Eugene Genovese notes, "as late as 1840 slaves in South Carolina were interpreting news from Haiti as a harbinger of their own liberation."[12] On the other hand, white Americans—especially those in the South—found much to fear in the occurrence of racial instability so close to home and in Toussaint's spectacular rise from slave to self-proclaimed "Life Governor" of the whole island of Hispaniola. To some, the Haitian revolution served as a potent symbolic reminder of the evils of slavery, but to most white Americans, the event functioned as a frightening reminder of the potentially violent consequences of slave revolt. In 1855 abolitionist William Wells Brown wrote, "Let the slave-holders in our Southern States tremble when they call to mind these events...that day is not distant when the revolutions of St. Domingo will be reenacted in South Carolina and Louisiana."[13]

Though much of the historical credit for the slave revolution should be shared by other influential leaders, such as Henri Christophe and Jean-Jacques Dessalines, Toussaint was the Haitian leader Americans—white and black, pro- and anti-slavery—came to know and in many cases to fear. He was widely embraced as a contradictory symbol of both the liberating and the destructive potential of slave revolt. According to nineteenth-century historian James Brewer Stewart, abolitionists hoped that "every plantation had its own Toussaint."[14] But other Americans remained fearful of the prospect of what was frequently portrayed as a racially-motivated bloodbath. Such fears were only fueled by the vehement rhetoric of southern pro-slavery ideologues, who in the aftermath of the Denmark Vesey and Nat Turner uprisings used the specter of revolt as an excuse for justifying increasingly brutal laws regulating slavery. In 1829 abolitionist David Walker published his widely distributed *Appeal to the Colored Citizens of the World,* which encouraged other African-Americans to read "the history particularly of Hayti, and see how they were butchered by the whites, and do you take warning."[15] Throughout the nineteenth century, cultural discourse surrounding the Haitian revolution centered on the possibility of a "race war," as abolitionists and pro-slavery apologists alike adopted increasingly militant rhetoric. The Toussaint pitchers may have functioned in a similar way, as symbols of both the promise and the threat posed by the Haitian revolution.[16]

For abolitionists in the 1840s, Haiti not only was the site of a watershed event in the fight against slavery but also a nation whose story could be used for their own strategic ends. Historian David Geggus notes that in the early nineteenth century "Haiti became both a political issue in itself and crucial test for ideas about race and about the future of colonial slavery."[17] In 1842 the Massachusetts chapter of the Anti-Slavery Society sent

leading abolitionists Maria Weston Chapman and her husband Henry Grafton Chapman to Haiti in the hopes of finding confirmation for the principle of black freedom. The pair returned with ebullient news regarding the Haitians' "intelligent acquaintance with the character of the anti-slavery men and measures of the United States."[18] One reason that the Chapmans may have visited Haiti was to evaluate it as a potential home for emancipated slaves. By the 1840s, the so-called "colonization" scheme had become an important, if controversial, part of the abolitionist crusade. Those favoring colonization argued that the slaves should be freed and "returned" to Africa despite the fact that by the mid-nineteenth century the vast majority were American-born. Though the colonization idea was initially promoted by African American activists, many whites soon embraced it enthusiastically.

The primary engine of the new movement was the American Colonization Society, dedicated to relocating the slaves to the African colony of Liberia. The organization achieved some success, providing for the transportation of over 15,000 African-Americans to Liberia over the course of the nineteenth century, with peaks in emigration during the 1840s and 1860s. But the Society had powerful opponents. William Lloyd Garrison, publisher of *The Liberator,* was a sworn enemy of the "colonizationalists," a group he blamed for diluting the anti-slavery message. Writing that the Society "rivets a thousand fetters where it breaks one," Garrision exposed the latent racism of the colonization movement, which tacitly held that America was better off without its black population.[19]

The plan to relocate people to Liberia also had logistical problems, and many adherents of the colonization movement thought that the proximity of Haiti might make it a better site for settlement. In an 1818 address in Philadelphia to the *American Convention for Promoting the Abolition of Slavery and Improving the Condition of the African Race,* Prince Saunders boldly declared that a return to the "paradise of the New World" was in "the best interests of the descendants of Africa."[20] Mid nineteenth-century Haitian leaders also generally welcomed the idea in hopes of rebuilding their war-decimated population and reviving some semblance of the nation's former economic stability and diplomatic connections, which effectively ended after the formation of a native government in 1804. King Henri Christophe even offered to defray the costs of transportation because he hoped that the colonization effort would help revive the country's trade-based economy on far more equitable terms than previously offered by the Spanish and French colonial authorities.[21] Although American fears about the island's unstable government ultimately discouraged the effort, the fantasy of Haitian colonization was never far from the center of abolitionist discourse—as late as 1863, President Lincoln signed a contract providing for an expatriate colony at Ile á Vache in Haiti, but the attempt proved disastrous due to the corruption of the white leaders of the project.[22]

In short, abolitionists viewed Haiti through a variety of rhetorical and political perspectives that were intended to serve a number of different ends. Abolitionist novels and histories similarly used Toussaint and his

country as symbols intended to serve various political and personal agen-
das. Especially notable is the fictional biography, *The Hour and the Man,*
published in 1843 by English novelist Harriet Martineau (fig. 24). Intro-
duced to his story by Maria Weston Chapman, Martineau recorded her
laudable, albeit self-serving, motivations for writing the book: "it flashed
across me that my subject must be the Haytian revolution, and Toussaint
my hero. Was ever any subject more splendid or fit than this for me and
my purposes?" The book, she continued, "will prove my first great work of
fiction. It admits of romance, it furnishes me with a story, it will do a world
of good to the slave question, it is heroic in its character, and it leaves me
English domestic life for a change hereafter."[23] Other abolitionists, such as
Wendell Phillips, were less interested in using Toussaint's legacy for per-
sonal gain than they were in using it to further their cause. In the 1850s,
Phillips began lecturing widely on Toussaint and his accomplishments. He
extolled Toussaint's military genius—which in the eyes of detractors was

Figure 26 Jacob Lawrence, *The Life of Toussaint L'Ouverture, No. 20: General Toussaint L'Ouverture, Statesman and military genius, esteemed by the Spaniards, feared by the English, dreaded by the French, hated by the planters and reverenced by the Blacks*, New York, 1938. Tempera on paper, 19" x 11½". (Amistad Research Center, Tulane University, New Orleans. Aaron Douglas Collection. Artwork © Gwendolyn Knight Lawrence, courtesy of the Jacob and Gwendolyn Lawrence Foundation.) *Toussaint L'Ouverture* was the first of Lawrence's many major series. Researched and created from 1937–1938, and completed when he was only twenty-one, the paintings thrust Lawrence onto the national art scene.

evidence of his "bloodthirsty," megalomaniacal ways—as proof of the intellectual capacity of the black race. To allay fears about white massacre by freed slaves, Phillips emphasized Toussaint's kind treatment of white land owners in Haiti. Phillips, like Martineau and other abolitionist thinkers, played an important role in furthering Toussaint's role as an iconographic figure who could be understood in a variety of ways.[24]

Ultimately, the Toussaint pitchers are as difficult to decipher as the diverse literary and historical depictions of the man and his world. Perhaps they are best understood in light of the famous series of the Haitian leader by artist Jacob Lawrence, painted in the late 1930s.[25] In this cycle of forty-one oil paintings, Lawrence depicts Toussaint in a variety of celebratory ways: as a daring warrior, riding into combat with sword drawn; as a studious intellectual; as a pathetic victim; and, in an image likely based on the 1832 Maurin lithograph, as a commanding general (figs. 25, 26). Lawrence never gives Toussaint definite facial features. Instead, he is a subject on whom viewers can project their own ideas about race and heroism, and the same is true for the Toussaint pitchers. The indeterminacy of Lawrence's depictions strikes at the heart of the historical legacy of Toussaint. The mid nineteenth-century American orator and colonization advocate James Theodore Holly declared that at the time of the Haitian revolution Toussaint was "the very man for the hour."[26] Ever since he has continued to fulfill this prophecy. The Toussaint pitchers symbolize the complexity of

race in mid-nineteenth century America and, in a very visceral way, arouse the sensitivity of modern viewers to America's legacy of slavery and racism. On one level, the pitchers embody the racist and stereotypical attitudes that allowed for the institution of slavery in America and the lingering subjugation of African-Americans ever since. On another, they can be read as an abolitionist's attempt at a more ennobling depiction of a historical figure widely admired by anti-slavery activists in Medford and elsewhere. In fact, the Toussaint pitchers embody both of these contradictory meanings—and until better evidence emerges, they will mirror the historical legacy of the great revolutionary himself and remain all things to all people.

1. The following—one of the more concise and understandable descriptions of the geographic names used to describe the lands that comprised the island now made up of Haiti and the Dominican Republic—appears in Rayford W. Logan, *Haiti and The Dominican Republic* (New York: Oxford University Press, 1968), p. 3: "Precise terminology will clarify much confusion about the island on which Haiti and the Dominican Republic are situated. The aboriginal Indians called it Quisqueya or Hayti, The Land of the Mountains. Columbus named it Española, later Anglicized to Hispaniola. Nomenclature became particularly confusing after Spain ceded the western part of the island to France in 1697. In this book, except in quotations, 'Hispaniola' means the whole island until 1697, 'Santo Domingo' means the Spanish colony before and after partition, and the Dominican Republic, the independent nation. Saint Domingue is the French colony from 1697 to 1804, and Haiti the independent nation." In an effort to bring clarity to this essay, which considers both pre-Revolutionary Saint Domingue and its post-Revolutionary incarnation as Haiti, the latter designation, which is more familiar to contemporary readers, will be used exclusively.

2. George F. Tyson, Jr., *Toussaint L'Ouverture* (Englewood Cliffs, N. J.: Prentice Hall, 1973), pp. 2–3.

3. Thanks to Electa Kane Tritsch for her considerable research into Boston-area abolitionist history, associated publications and advertisements, and records of ceramic production in Medford. For mention of Medford brick manufactories, see John Hayward, *A Gazeteer of Massachusetts* (Boston: John Hayward, 1846); James M. Usher, *History of the Town of Medford From 1630–1885* (Boston: Rand, Avery, & Co., 1886).

4. The quoted passage is in *The Massachusetts Abolitionist* 2, no. 43 (December 10, 1840). There is also mention in the Massachusetts Anti-Slavery Society Reports of Anti-Slavery Fairs with "bazaars" being staged during the 1840s at Boston's Faneuil Hall, as well as Salem, Fitchburg, Upton, Uxbridge, Milford, Hingham, Nantucket, Worcester, West Winfield, New Bedford, Weymouth, and elsewhere. The largest seems to have been an annual Christmas fair, held at Amory Hall and then at Faneuil Hall. In the 1843 report it is mentioned that the Christmas fair "was furnished from many towns in the State." On August 1, 1843, a celebration with a parade, banquet, and "an elegant collocation furnished by general contribution" was held in Dedham in honor of the anniversary of the emancipation of the West Indian slaves. The Dedham celebration is mentioned in *Twelfth Annual Report Presented to the Massachusetts Anti-Slavery Society,* January 24, 1844, pp. 44–45.

5. *Middlesex Deeds,* 384:118 and 408:515. Stephen's use of the term "sable," which originally appeared in *The Opportunity* (London, 1804), is quoted in David Geggus, "Haiti and the Abolitionists: Opinion, Propaganda and International Politics in Britain and France, 1804–1838," in David Richardson, editor, *Abolition and Its Aftermath: The Historical Context, 1790–1916* (London: Frank Cross, 1985), p. 115.

6. Lawrence W. Levine, *Highbrow/Lowbrow: The Emergence of Cultural Hierarchy in America* (Cambridge: Harvard University Press, 1988), pp. 1–22.

7. George F. Tyson, Jr., *Toussaint L'Ouverture,* pp. 1–2.

8. The physical descriptions of Toussaint noted in this paper, and many additional period references, appear in Tyson, pp. 89–154.

9. Hugh Honour, *The Image of the Black in Western Art,* vol. 4, *From the American Revolution to World War I,* part 1, *Slaves and Liberators* (Cambridge: Harvard University Press, 1989), p. 109.

10. David Geggus, "The Haitian Revolution," in Hilary Beckley and Verene Shephard,

Caribbean Slave Society and Economy: A Student Reader (Kingston, Jamaica: Ian Randle, 1991), p. 413.

11. The earliest known image of Toussaint was a hostile caricature, published in Francois Bonneville's *Portraits des Personnages Célèbres de la Révolution* (Paris, 1802); Bonneville also published a pamphlet attacking Toussaint and his "horrible crimes" in the same year. Tyson's book records most of the known period descriptions of Toussaint. Tyson, *Toussaint L'Ouverture*, pp. 132, 79. See also Honour, *The Image of the Black in Western Art*, pp. 105–9.

12. Eugene Genovese, *From Rebellion to Revolution: Afro-American Slave Revolts in the Making of the Modern World* (Baton Rouge: Louisiana State University Press, 1979), p. 95. Thanks to Susan V. Donaldson for this reference and for providing a copy of a lecture, entitled "Southern Narrative and Haitian Shadows."

13. William Wells Brown, *St. Domingo: Revolutions and Its Patriots* (Boston: Bela March, 1855), p. 32, quoted in Donaldson, "Southern Narrative."

14. James Brewer Stewart, *Wendell Phillips: Liberty's Hero* (Baton Rouge: Louisiana State University Press, 1986), pp. 104–5.

15. David Walker, *Appeal to the Colored Citizens of the World* (1829; reprint, University Park: Pennsylvania State University Press, 2000), p. 23.

16. Tyson, *Toussaint L'Ouverture*, p. 132.

17. Geggus in Richardson, ed., *Abolition and Its Aftermath,* p. 114.

18. *Eleventh Annual Report Presented to the Massachusetts Anti-Slavery Society by Its Board of Managers* (Jan. 25, 1843), p. 27. Five years previously, two men had been sent by the American Anti-Slavery Society on a similar trip to the free English-speaking islands of the West Indies, and they concluded that "the emancipated people are perceptibly rising on the scale of civilization, morals, and religion. Reason cannot fail to make its inferences in favor of two and a half millions of slaves in our republic." Horace Kimball and James A. Thome, *Emancipation in the West Indies: A Six Month Tour in Antigua, Barbadoes, and Jamaica, in the Year 1837* (New York: American Anti-Slavery Society, 1838).

19. On colonization, see P. J. Staudenraus, *The African Colonization Movement 1816–1865* (New York: Columbia University Press, 1961), pp. 82–87; Ludwell Lee Montague, *Haiti and the United States 1714–1938* (Durham, N.C.: Duke University Press, 1940); William Lloyd Garrison, *Thoughts on African Colonization* (Boston: Garrison and Knapp, 1832); G. B. Stebbins, *Facts and Opinions Touching the Real Origin, Character, and Influence of the American Colonization Society* (Boston: John P. Jewett & Co., 1853); Early Lee Fox, *The American Colonization Society 1817–1840* (Baltimore: Johns Hopkins Press, 1919).

20. Saunders is quoted in Alice M. Dunbar, *Masterpieces of Negro Eloquence* (New York: Bockery, 1914), p. 14.

21. Earl Leslie Griggs and Clifford H. Prator, *Henry Christophe – Thomas Clarkson: A Correspondence* (Berkeley: University of California Press, 1952), p. 68.

22. James Redpath, editor, *A Guide to Hayti* (Boston: Thayer & Eldridge, 1860); Staudenraus, *The African Colonization Movement*, pp. 244, 247.

23. Maria Weston Chapman, *Memorials of Harriet Martineau* (Boston: Houghton, Mifflin and Co., 1877), pp. 334–52; Harriet Martineau, *The Hour and the Man: A Historical Romance* (London: Edward Moxon, 1843). For more on Martineau see Adam Lively, *Masks: Blackness, Race and the Imagination* (London: Chatto & Windus, 1998), pp. 84–85.

24. Wendell Phillips, "Toussaint L'Ouverture," in Wendell Phillips, *Speeches, Lectures, and Letters* (Boston: Lee and Shepard, 1863), pp. 468–94; Maria Weston Chapman, *Memorials*, p. 352. For a competing but less frequently stated abolitionist use of the Haitian revolution, which presented the event as a cautionary tale about the inevitable violence created by slavery, see *An Essay on the Late Institution of the American Society for Colonizing the Free People of Color, of the United States* (Washington, 1820), pp. 33–59.

25. Peter T. Nesbett and Michelle DuBois, editors, *Over the Line: The Art and Life of Jacob Lawrence* (Seattle: University of Washington Press, 2000); Nesbett and Michelle DuBois, *Jacob Lawrence: Paintings, Drawings, and Murals (1935–1999), A Catalogue Raisonné* (Seattle: University of Washington Press, 2000), pp. 27ff. The cycle of paintings has also been used as the basis of a children's book, Walter Dean Myers' *Toussaint L'Ouverture :The Fight for Haiti's Freedom* (New York : Simon & Schuster Books for Young Readers, 1996).

26. James Theodore Holly, *A Vindication of the Capacity of the Negro Race for Self-Government, and Civilized Progress, as Demonstrated by the Events of the Haytian Revolution* (New Haven, Conn.: Afric-American Printing Co., 1857), p. 48.

Figure 1 Gustavus Hesselius, portrait of Stephen West, Sr. (1690–1752). Oil on canvas. (Private collection.) West acquired Rumney's Tavern in 1724. The portrait is superimposed on a detail of a delftware mermaid plate used at Rumney's Tavern.

Al Luckenbach

Ceramics from the Edward Rumney/ Stephen West Tavern, London Town, Maryland, Circa 1725

▼ WHEN STEPHEN WEST finally purchased the aging tavern in London Town, Maryland, he used part of his growing fortune to expand and upgrade the simple wooden structure. The year was 1724, and business was good (fig. 1). The tobacco seaport on the South River was thriving, and the tavern's location—along the principal north-south road in colonial Maryland—meant that a constant stream of hungry and thirsty travelers flowed past the front door (fig. 2).

The addition that West built nearly doubled the size of the business previously started by Edward Rumney along Scott Street a quarter century before. The new tavern complex also included the construction of an outbuilding with a larger, more stoutly constructed storage cellar. This rendered the collapsing earthen cellar under the old wing of Rumney's Tavern open to a new use.

Figure 2 John Greenwood, *Sea Captains Carousing in Surinam*, 1758. Oil on canvas. 37¾" x 75¼". (Courtesy, Saint Louis Art Museum.) Eighteenth-century prints and paintings have recorded numerous depictions of tavern life. These leave little doubt as to the large amounts of ceramics and glass that would succumb during a night of spirited revelry.

Figure 3 The Rumney/West cellar pit during the course of excavation with the contents of the eastern half removed. The once straight sides of the cellar were eroded away during its useful life. (Photo, Al Luckenbach.)

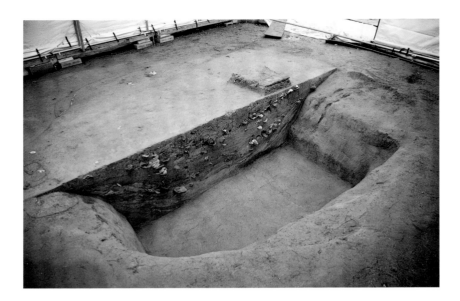

Within a few short years the constant detritus of daily tavern operation—the bones of cows, sheep, pigs, and fish, oyster shells, fireplace ashes, broken glassware, and ceramics—filled the old cellar pit (fig. 3). Nearly five feet of trash, deposited in numerous distinct layers, preserved evidence of tavern life in London Town around the year 1725. Thus, a once functioning cellar now served as a convenient repository for the tavern's refuse.

The remains clearly represent the serving end of the operation, as few utilitarian artifacts evidencing food preparation were present. The evidence of high status meals suggests that an elite clientele was frequenting the establishment. In addition, an impressive assemblage of broken glassware and ceramics was discarded in the fill. Nearly a hundred vessels were eventually recovered, many in a largely reconstructable state. This diverse collection contained not only the predictable mugs, plates, bowls, and chamber pots typical of a tavern locale, but also specialty items like a "pineapple bowl," tea bowls, coffee cups, and fragments of an early stoneware coffeepot.

Background

Towns did not form easily or naturally in the Chesapeake Bay environment. The many navigable rivers off the bay were settled by the middle of the seventeenth century with large numbers of planters engaged in the often-lucrative enterprise of growing tobacco. Tobacco plantations were clustered along these rivers, and each possessed its own wharf facility where the crops could be loaded for transport, and goods and merchandise off loaded in return. Indentured servants or slaves provided many of the manufactured items necessary for the plantation's operation in small-scale cottage industries. There was no need for towns.

Over the period 1667–1719 the legislative assembly of Maryland, like that of its neighbor Virginia, tried repeatedly to forcibly establish towns.[1] Not only did they perceive towns from the perspective of the modern seventeenth-century Englishman—as economic and social engines of society—but they also sought a solution to a more basic problem. Trade was being

conducted on such a geographically personal level that it was almost impossible to collect taxes. Forcing all trade to be conducted through legislative towns could solve this problem with the stroke of a pen.

In 1683, one such legislative act called for the formation of the Town of London on the South River in Anne Arundel County, Maryland. Unlike many such towns, which came to exist only on paper, or at best grew to support only a warehouse, tavern, and a few homes, London Town actually thrived. As the catch basin for a prosperous tobacco-growing region, the town became a thriving seaport. Unlike such well-known colonial towns as Williamsburg, St. Mary's City, and Annapolis, London Town seems to

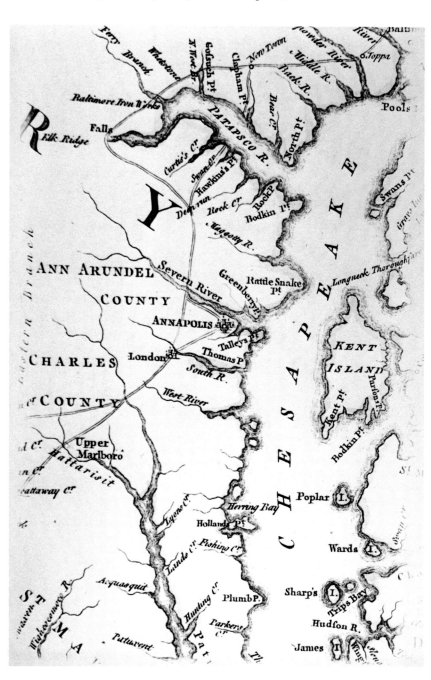

Figure 4 Detail of Joshua Fry and Peter Jefferson's *Map of the Most Inhabited part of Virginia, containing the whole province of Maryland with Part of Pensilvania, New Jersey and North Carolina.* 1754. (Courtesy, London Town Foundation.) This detail shows the important relationship of London Town, Maryland, to the colonial road system.

have owed little of its success to political centrality. Even when the Anne Arundel County courthouse, which had been located at London Town between 1684 and 1695, was moved to Annapolis, the town's status as an active port of trade did not seem to diminish, but rather continued to grow.

By the early decades of the eighteenth century, London Town had become perhaps the principal tobacco seaport in Maryland. Each year the tobacco fleet would gather on the South River in order to convoy their precious cargoes home. This fact alone had great significance for the nature of the town.

It is estimated from the known forty to fifty occupied lots that the town must have had a resident population that approached 300 during its heyday. But to this number must be added a fairly significant transient population. Not only was the tobacco fleet anchored off shore for weeks or months, awaiting a fickle crop (and leaving sailors with little more to do than wander the town), the planters from outlying areas had to arrive to conduct their business with factors and ship captains. Added to this was the fact that the principal north-south road in colonial Maryland ran through London Town and its ferries. A glance at a portion of the Jefferson and Fry map of 1751 (fig. 4) clearly indicates that, at least at this time, all roads led to London.

The exact cause of the eventual demise of London Town is clouded in the mists of time. One contributing factor may have been the removal of the tobacco inspection station in 1747. Just what would cause the Maryland Assembly to remove this important function from what must have still been one of the most important tobacco ports in the colony is unclear. Although river siltation has been suggested, or a change in salinity that fostered destructive marine worms, a more nefarious explanation involves the fact that a great many of the wealthiest citizens of London Town were relative newcomers from Scotland. Scottish factors, backed by banks and

Figure 5 A circa 1840 painting of London Town from across South River. (Courtesy, Edmondo Collection.) This view, looking south from the ferry master's house, shows a number of structures still surviving long past the town's heyday.

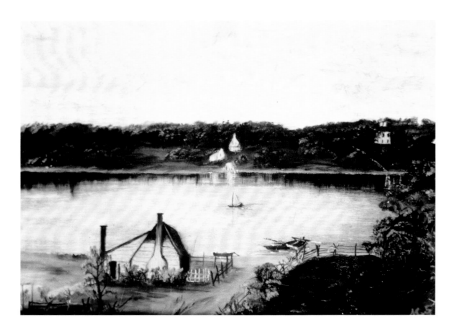

companies abroad, controlled much of the tobacco trade in the eighteenth century. Although not specifically recorded in this case, antipathy between these individuals and the native-born elite is well documented in the Chesapeake Region and may have led to competition.

What is quite clear is that the American Revolutionary War rang the final death knell. The British blockage of shipping clearly finished what was left of London Town as an economic hub (fig. 5). By the mid-1780s, the recorded land transactions dramatically demonstrate a combining of town lots into larger, agriculturally based farms. Perhaps a half dozen structures survived into the twentieth century. Today only two from the town period—one highly altered home on Larrimore's Point and the William Brown House and Tavern—still exist on the landscape.

London Town Today
Of the original 100-acre town, twenty-three acres are currently owned by Anne Arundel County, Maryland, and are used as a park. Operated by the London Town Foundation as "Historic London Town," the park today consists of beautiful woodland gardens and a single remaining structure from the town's heyday. The brick William Brown House and Tavern is a circa 1760 brick structure that once sat alongside the Rumney/West Tavern on Scott Street—today little more than an impressive, overgrown gully.

For a quarter century, the Brown House, filled with colonial period furnishings, and the idyllic, modern, woodland gardens were interpreted for visitors experiencing the park. Although a few of the more informed visitors knew that a town once existed, in point of fact, it was like interpreting the last standing structure in Williamsburg and largely ignoring the reality that it once sat in the middle of a bustling sea port (fig. 6).

All this changed rather abruptly with the commencement of large-scale archaeological excavations in 1995. The on-going investigation is a cooper-

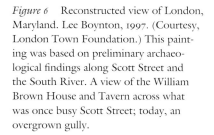

Figure 6 Reconstructed view of London, Maryland. Lee Boynton, 1997. (Courtesy, London Town Foundation.) This painting was based on preliminary archaeological findings along Scott Street and the South River. A view of the William Brown House and Tavern across what was once busy Scott Street; today, an overgrown gully.

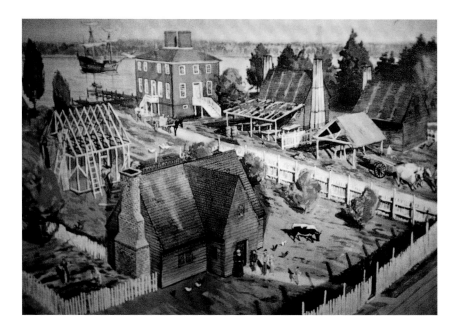

ative effort between Anne Arundel County's archaeological program, the London Town Foundation, and the county's Department of Recreation and Parks.[2] To conduct these excavations, the team of professional archaeologists, historians, and laboratory specialists that comprise Anne Arundel County's *Lost Towns Project* was augmented by hundreds of volunteers and students. Almost immediately, they began uncovering the remains of earthfast buildings[3] that once stood along Scott Street in the late seven-

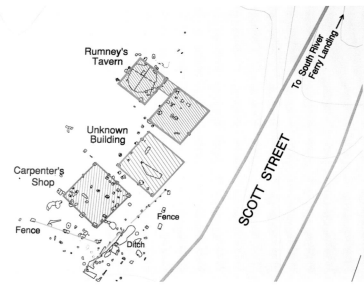

Figure 7 Drawing of the building footprints reconstructed from posthole patterns excavated along Scott Street. The area that has been archaeologically exposed so far is impressive for its dense, thoroughly urban layout.

teenth and early eighteenth centuries (fig. 7). Among those discovered was the site of a tavern operation that had apparently spanned nearly sixty years, from roughly 1690 to 1750. Located at this important nexus of sea born and land transportation for over half a century, the Rumney/West Tavern must have been a well-known locale to travelers of the colonial period.

The Rumney/West Tavern Complex

The *Lost Towns Project* began excavations at the Rumney/West Tavern in 1996. The team excavated the overlying plow zone in over sixty 5 by 5-foot squares, recovering artifacts, and troweling the underlying ground surface. These excavations revealed postholes delineating a 40 by 25-foot earthfast structure divided into two equal sections that apparently represented two rooms. Excavation of one of the 20 by 25 sections revealed the presence of a trash-filled cellar hole measuring approximately 18 by 16 feet at the surface, and 10 feet long at the base.

Over the next five years the 4.5-foot deep cellar deposit was dug in four quadrants. Careful observance of micro stratigraphy lead to the delineation of over forty separate levels of trash, clay, and fireplace ash in each quadrant (fig. 8).

Dating the deposit was attempted in several different ways. The presence and absence of ceramics is, of course, one of the most frequently used methods, but this only results in a broad range of possible dates (circa

Figure 8 The painstakingly careful excavations of the cellar, carried out over nearly five years, sometimes resembled an operating theater. Here, Lost Towns staff members can be seen working on a pig's jaw and one of three delftware plates bearing a pagoda motif. (Photo, Al Luckenbach.)

1680–1750). Tobacco pipes are also a mainstay of colonial archaeology in that they can provide specific chronological information. In this case, however, only one pipe was marked with the initials of a known maker, pipe maker William Manby (and his son, William), whose known period of output can be placed between 1689 and 1740.

A more novel approach involved a careful analysis of delftware decorative motifs recovered from the cellar. Eight separate motifs were compared to known, dated examples of delftware.[4] In this analysis, these eight motifs occurred ninety-two times on published dated examples with the average date being tabulated as the year 1723.8.[5] This result was viewed as highly significant since it corresponded to the historically documented date that the tavern transferred ownership from Edward Rumney to Steven West in 1724.

Various other studies, such as charcoal and pollen analyses, suggest that the cellar was filled with trash in a short period of time. When these indications are combined with the average date of 1723.8, West's acquisition of the property in 1724 can be argued as the principal stimulus for the cellar deposit. More supporting data comes from dated window leads recovered in the nearby plowzone. The 1725 dates appearing on some clearly suggest that West was remodeling the tavern complex. The current hypothesis, therefore, is that after a new cellar was built, West must have no longer required the older cellar for its original storage purposes. Once he decided to use it as a trash receptacle, the constant flow of debris from an active tavern operation rapidly filled the pit.

The Rumney/West cellar contents represent a classic archaeological time capsule. Particularly abundant information concerning diet was recovered from oyster shells, animal bones, fish scales, etc., and dietary practices were indicated by the remarkable ceramic and glassware assemblages (figs. 9, 10).[6] The range of ceramics types found are summarized and discussed below.

Figure 9 This view of the southwest quarter during excavation shows the popularity of oyster shells as tavern fare. Ceramic and wine bottle fragments, bricks, pig bones, and a barrel hoop complete the assemblage. (Photo, Al Luckenbach.)

Figure 10 Examples of glassware recovered from the Rumney/West cellar. (Photo, Gavin Ashworth.) A scent bottle and medicinal vials are in the foreground of this grouping. The wine bottles represent the stylistic extremes recovered from the deposit, ranging in date from approximately 1700 to 1725. The trumpet shaped wineglass was a unique find; fragments with knopped stems were more common. One faceted wine glass had the inscription "God Save King George" and is believed to date from the coronation of George I in 1714.

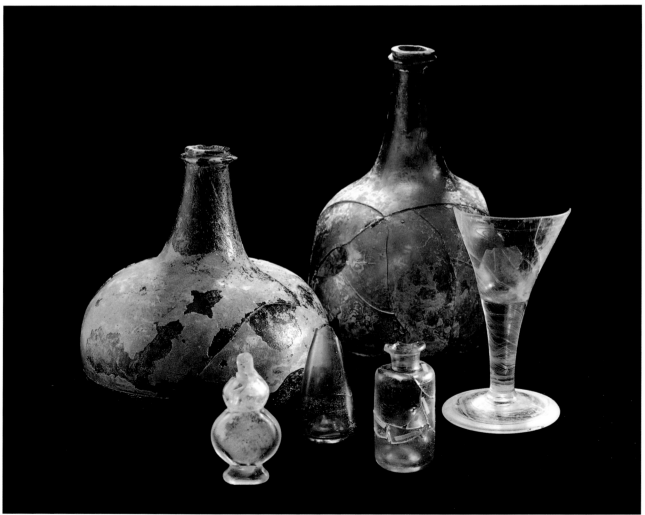

The Ceramics from the Rumney/West Tavern

Archaeologists have become particularly used to dealing with ceramics in a highly fragmented state—which theoretically is of little consequence, since all of the necessary informational data frequently remains with the sherd, no matter its size. The many volunteers who participate in the excavations of the *Lost Towns Project* are always impressed when a tiny chip of pottery can be determined to be, say, a tea bowl made in China in the early eighteenth century. However, intact vessels or those that can be reconstructed add an exciting dimension to any ceramic analysis.

One of the most notable aspects of the assemblage from the Rumney/West Tavern is the predominance of English ceramics. A single Chinese porcelain saucer and small fragments from perhaps as many as seven porcelain tea bowls, a Rhenish stoneware chamber pot, a Rhenish mug, and an example of what may be a Dutch buff-bodied earthenware brazier are all the "foreign" elements that are present. Thus, close to ninety percent of the nearly 198 vessels recovered were of English manufacture.

This lack of non-English ceramics is a dramatic contrast to other excavations by Anne Arundel County's *Lost Towns Project* at the 1649 Puritan settlements of Providence and Herrington. These contain examples of ceramics types from all over the world. Dutch ceramics are particularly well represented. As excavations at the Rumney/West Tavern continued, the contrast was quite distinct. The predominance of English wares at Rumney's was considered a reflection of the effectiveness of the Navigation Acts passed in 1651, 1660, and 1664. These acts forbid the importation of non-English goods (such as Dutch delft) to its colonies.

As is often the case in archaeology, however, this elegant explanation was dispelled by the results from other digs in the town. Notably, excavations at a circa 1700 cellar deposit located at the other end of the London Town peninsula recorded a large number of delftware vessels whose origins appear to be Holland, Portugal, and Italy—but none from England![7] More research is needed to better explain these discrepancies, as archaeology often provides more questions than answers.

Porcelain

The fine, well-made porcelain imported from China that was found was associated only with tea drinking vessels. A saucer painted in under-glaze blue and then enhanced with red enamel and gilt over-glaze decoration was the closest to a complete vessel found in the Rumney/West deposits. This was accompanied by a handful of tiny sherds representing tea bowls. A minimum vessel analysis reveals that apparently as many as seven different bowls are present (fig. 11). Unlike most ceramic types recovered from the Rumney/West cellar, relatively small fragments of these vessels were found.

Rhenish Stoneware

Although German salt-glazed stoneware is common from colonial period sites in the Chesapeake region, including elsewhere at London Town, only

Figure 11 Saucer and tea bowl fragments, China, ca. 1725. Porcelain. D. of saucer: 5". (Photo, Gavin Ashworth.) This export porcelain saucer, along with small fragments representing a number of porcelain cups, are clear indications of the fashionable consumption of tea at the Rumney/West Tavern.

Figure 12 Chamber pot, Germany, ca. 1725. Salt-glazed stoneware. H. 5". (Photo, Gavin Ashworth.) This utilitarian object was found in close association with a "mermaid" plate.

two examples were present in the Rumney/West cellar—a sturdy, well-decorated chamber pot (fig. 12), and a single, highly fragmented example of a typical incised Rhenish tavern mug. The chamber pot was discovered fairly high in the layers of trash, and in close association with a delftware "mermaid" plate. It would have represented a notable physical improvement over the fragile tin-glazed earthenware examples that were relatively common at Rumney's.

Figure 13 Mug, England, probably London, ca. 1720. Salt-glazed stoneware. H. 6½". (Photo, Gavin Ashworth.) This nearly complete example is one of a number of English brown stoneware mugs recovered. At least two bore the impressed "WR" excise stamp.

English Salt-glazed Stoneware

English brown and gray salt-glazed stoneware mugs, often called "Fulham" or "tavern mugs" by ceramics collectors are, as the name implies, a predictable find in a tavern assemblage. The Rumney/West cellar produced at least seven (and perhaps as many as nine) of these sturdy drinking vessels (fig. 13). Only two demonstrated the static "WR" excise mark.

Given that the earliest known dated example of English white salt-glazed stoneware is 1715, and that New World colonial archaeologists often use the start date of circa 1720, the presence of no less than ten vessels of white salt-glazed stoneware in this circa 1724–1725 deposit is most significant. The Rumney/West cellar is obviously a very early and well-dated context for this type of ceramic ware. Naturally, all specimens were of the earlier slip-dipped variety, and most possessed a brown rim caused by dipping into a manganese color. Four sturdy tavern mugs were included in this grouping (fig. 14), as well as a large and unusual handled pitcher (fig. 15). Interestingly, one small bowl form may in fact be a coffee cup (fig. 16).

Three tea bowls are among the white salt-glazed assemblage—one tea bowl and its saucer were recovered side by side in the same level (figs. 17, 18).

Figure 14 Mug, Staffordshire, ca. 1720. Salt-glazed stoneware. H. 6¼". (Photo, Gavin Ashworth.) Several Staffordshire white salt-glazed stoneware mugs were recovered. All had slip-dipped iron-oxide rims.

Figure 15 Pitcher fragment, England, ca. 1720. Salt-glazed stoneware. H. 7". (Photo, Gavin Ashworth.)

Figure 16 Bowl, Staffordshire, ca. 1720. Salt-glazed stoneware. H. 2½". (Photo, Gavin Ashworth.) This stoneware bowl and similarly sized delftware bowls may have been used as coffee cups.

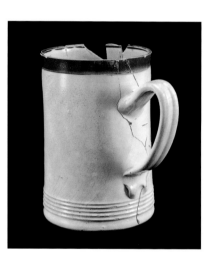
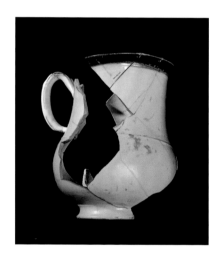
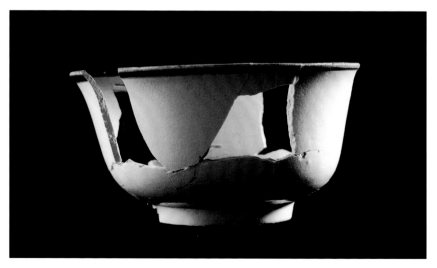

Figure 17 Tea bowl and saucer, Stafford-shire, ca. 1720. Salt-glazed stoneware. H. of tea bowl: 1½". (Photo, Gavin Ashworth.) These two objects were found lying side by side in the excavation.

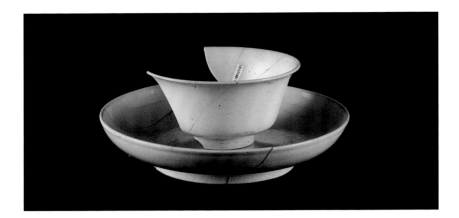

Figure 18 View of a single excavation level in the southwest quarter of the cellar. This image shows the white salt-glazed stoneware tea bowl and saucer lying amongst the remains of an English stoneware mug, wine bottle fragments, and oyster shells. (Photo, Al Luckenbach.)

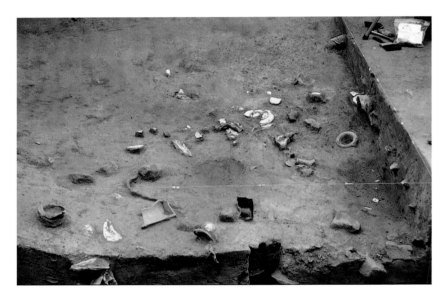

This particular example stresses the fact that these bowls are exquisite, thin-walled expressions of this early vessel form. While still not matching the ideal of porcelain, the superiority of the newly invented white salt-glazed over the delftware versions of this kind of delicate vessel seems well estab-lished at this early date.

Figure 19 Coffee pot fragments, England, ca. 1720. Lead-glazed stoneware. (Photo, Gavin Ashworth.) These English brown and off-white stoneware coffee pot fragments, including part of the handle and the acorn shaped finial from the lid, are taken as an indication of high status clientele in this circa 1725 context.

Figure 20 Mug, England, ca. 1720. Stoneware. H. 7¾". (Courtesy, Garry Atkins; photo, Gavin Ashworth.) An antique specimen of the lead-glazed stoneware represented by the coffee pot fragments illustrated in fig. 19.

Although the attribution of coffee cup for the one vessel is rather speculative,[8] what is not speculative is the presence in the Rumney/West trash of an English stoneware coffeepot. This particularly rare item by itself speaks volumes about the tavern and its clientele (figs. 19, 20).

The Rumney/West Tavern operated during a period in which Chesapeake society exhibited increasingly rigid social ranking.[9] This was also a period during which taverns and coffee houses became increasingly important settings in which English speakers on both sides of the Atlantic Ocean not only conducted business, but also created and critiqued fashions and fashionable behavior.[10] The fact that on the South River in colonial Maryland the town of London expressed such behavior by the mid-1720s is most notable.

Tin-glazed Earthenware (delftware)
The delftware plates recovered from the Rumney/West cellar are perhaps the most interesting vessel forms present in this type of ceramic. Except for a single example—a chinoiserie pattern with a foot ring—all were of a distinctive flat-based form usually attributed to London manufacture (fig. 21).

Figure 21 Profile of plate, London, ca. 1720. Tin-glazed earthenware. D. 8½". (Photo, Gavin Ashworth.) This low profile, lacking a foot ring, is typical of London manufacture. It was present on sixteen of seventeen excavated delftware plates.

Figure 22 Plates, London, ca. 1720. Tin-glazed earthenware. D. 8½". (Photo, Gavin Ashworth.) Two of the four "sunflower" plates recovered from the lowest levels of the cellar fill.

Figure 23 Plates, London, ca. 1725. Tin-glazed earthenware. D. 8½". (Photo, Gavin Ashworth.) These English versions of a Chinese pagoda motif appeared on three excavated examples.

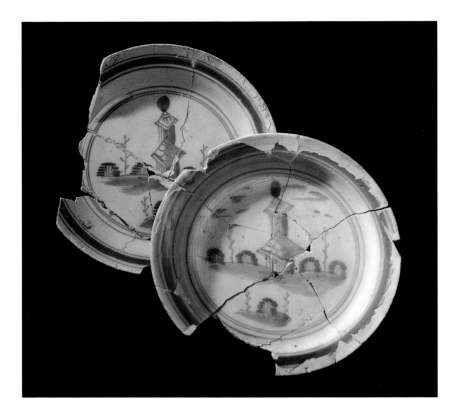

Most were decorated (twelve of seventeen), and all the decorated London plates had annular rings as border decoration. Intriguingly, "sets" of plates with identical decoration were recovered. Four examples were found which had a floral "sunflower" pattern (fig. 22), while three others displayed an impractical looking "pagoda" (fig. 23).

One of the first plates discovered at the beginning of the excavation in 1996 depicted a rather homely looking mermaid (figs. 24, 25). This "sea creature" as they are sometimes called in the literature, was eventually found on three of the annular ringed London vessels. Two different

Figure 24 A tin-glazed earthenware mermaid plate is shown here in situ during the first weeks of excavation. It was found intermingled with fragments of a Rhenish chamber pot (and the remains of meals), in the cellar's northeast quadrant. (Photo, Al Luckenbach.)

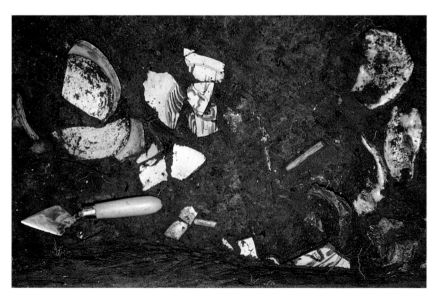

respected ceramic experts suggested that the presence of such plates might well be taken to indicate that the "Sign of the Mermaid" might have been the way the public denoted what we are calling here the Rumney/West Tavern.[11] This would appear to be appropriate in a seaport setting. Given that plans are underway for the eventual reconstruction of this building, the visage from this plate may once again swing from a wooden sign in front of the establishment.

But the London Town mermaid has not had to await the reconstructed building. As an indicator of the park's mission having expanded from the interpretation of the William Brown House and Tavern to that of the entire seaport, the mermaid has been employed for several years as the logo of the London Town Foundation that operates the historic facility. Despite her appearance, no one can dispute the mermaid's appropriate maritime connotations.

Figure 26 Tea bowls, England, ca. 1725. Tin-glazed earthenware. H. 1¾". (Photo, Gavin Ashworth.) These delft tea bowls vary slightly in size, a tribute to the lack of standardization during this early period. Although quite delicate and thin by tin-glazed earthenware standards, they are still thicker than what could be achieved with the newer, white salt-glazed stoneware.

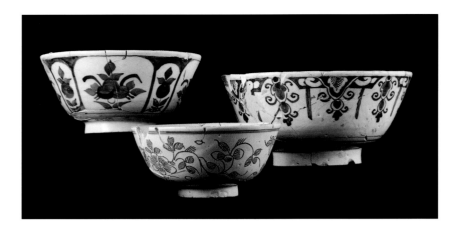

Figure 27 Bowls, England, ca. 1725. Tin-glazed earthenware. H. of tallest: 4½". (Photo, Gavin Ashworth.) Numerous delftware bowls attest to the popularity of punch at the Rumney/West establishment.

As has already been discussed, the Rumney/West Tavern appears to have served a wealthy clientele accustomed to dining using delftware and porcelain and, more importantly, engaging in social drinking of wines, punches, coffees, and teas. This is evident in the varied group of tin-glazed earthenware cups and bowls. A pair of matching tea bowls was recovered whose remarkably thin walls witness the attempt to reproduce the delicacy of porcelain in a difficult medium (fig. 26). Their painted border decoration corresponds to examples found at the Vauxhall pottery kiln site in London.[12]

A total of ten bowls was recovered, ranging in size from 4.5 to 7 inches (fig. 27). Although some of the smaller examples might be suspects for coffee cups, most, if not all, were undoubtedly for the consumption of alcohol. Interestingly, none of the large communal bowls often seen in contemporary paintings of tavern scenes were recovered. The small polychrome bowl in figure 27 is also a perfect match for a motif found at the Vauxhall production site,[13] while other, fragmentary bowls are evocative of the "sunflower" plates described earlier.

A delftware object of particular significance from the Rumney/West cellar is an unusual bowl possessing a central, pyramidal spike in its base (fig. 28). Similar vessels have been termed "pineapple bowls," assuming that such

Figure 28 Spiked bowl, England, ca. 1725. Tin-glazed earthenware. H. to top of spike: 1¼". (Photo, Gavin Ashworth.) This so-called "pineapple bowl" may have held butter or sugar instead. Note the interesting use-wear patterns that appear on all three edges of the pyramidal projection.

fruit (or limes, oranges, etc.) might be impaled on the spike to create an early form of rum punch. Other experts have considered alternative explanations to be preferable, such as butter or sugar containers. Regardless of its actual function, the vessel is clearly a rare and highly specialized item. At least two extant examples in museum collections are known, while three examples were recovered from the Vauxhall salvage excavations.[14] This first New World example speaks volumes for the kind of tavern operation involved along the South River in colonial Maryland.

The Rumney/West assemblage of tin-glazed earthenwares is rounded out by no less than five plain white chamber pots (fig. 29), and by three galley pots.

Figure 29 Chamber pot, England, ca. 1725. Tin-glazed earthenware. H. 4½". (Photo, Gavin Ashworth.)

Other Earthenwares

As stated, the low number of utilitarian, cooking types of vessels in the Rumney/West ceramic assemblage is striking. This implies that food preparation, or at least the disposal of its debris, occurred elsewhere. A single large jar of North Devon gravel-tempered ware is the only example recovered of this well-known, and sometimes abundant, redware ceramic type (fig. 30). This finding further reinforces the distinction between excavations at London Town and those at the earlier town of Providence where this coarse earthenware was present in numbers often approaching eighty percent. Other redware forms found at Rumney's included three jars, four milk pans, and a bowl. One example of a reconstructed jar is shown in figure 31. These lead-glazed redwares are so universal in construction and materials that they are extremely difficult to attribute to a source of production. Interestingly, historical documents indicate that a potter named John Wamsley was operating during this period, and was apparently located directly across the South River ferry from the Rumney/West Tavern. The possibility that these redwares could be Wamsley's products is most intriguing but unproven. Unfortunately, efforts by the *Lost Towns Project* to locate the pottery kiln site have been unsuccessful so far.

Figure 30 Jar, North Devon, England, ca. 1720. Gravel-tempered earthenware. H. 10⅜". (Photo, Gavin Ashworth.) Although gravel-tempered earthenwares from the North Devon area are very frequently encountered at seventeenth- and early eighteenth-century archaeological sites in Anne Arundel County, this example from Rumney's cellar is the most complete vessel yet recovered.

Figure 31 Jar, possibly Maryland, ca. 1725. Lead-glazed earthenware. H. 9⅜". (Photo, Gavin Ashworth.) This tall, redware jar is a candidate for being a local product. Documentary evidence indicates that a potter named John Wamsley was active on the opposite shore of the South River during this time period.

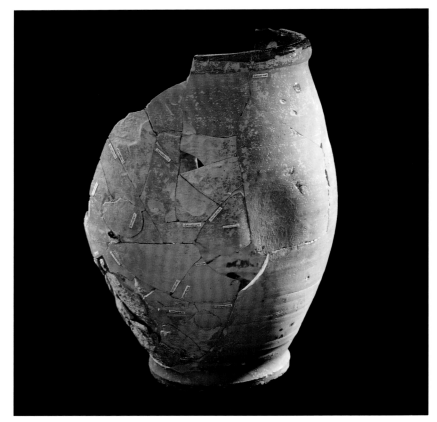

Also readily recognizable is a steep sided pan of buff-bodied material glazed with mottled manganese. It almost certainly was produced in the Staffordshire region of England (fig. 32), as was a single small cup with yellow and brown glaze recovered in fragmentary condition.

Finally, two probably Dutch products represent the only foreign earthenware from the assemblage. A pipkin and a highly fragmented brazier seem to match known Dutch forms (fig. 33).

Figure 32 Basin, Staffordshire, ca. 1720. Manganese-mottled earthenware. H. 4¼". (Photo, Gavin Ashworth.)

Figure 33 Pipkin, Holland, ca. 1700. Yellow-glazed earthenware. H. 2¾". (Photo, Gavin Ashworth.) Two buff-bodied yellow-glazed earthenware vessels were recovered with profiles matching Dutch forms.

Vessel Types

While the classification of ceramics by type provides a useful means of ordering and describing the contents of the Rumney/West cellar, it fails to adequately depict the overall functionality of the assemblage. For this reason archaeologists have come to increasingly rely on the functional classification of vessels, irrespective of type. While describing the numbers and percentages of bowls, plates, cups, etc. found during excavation has a certain utility in itself, it is the capacity to compare these results with data from elsewhere that greatly enhances the comprehension of their significance.

Fortunately, a body of such data exists from excavations done in Annapolis several years ago. Annapolis, which became the colonial capital of Maryland in 1695, sits on the Severn River, the next river system to the north of London Town. Although extensive excavations have been undertaken at the Providence settlement, precursor to Annapolis, this data falls at a chronological point (circa 1649–1680) too remote to provide any useful comparisons to the Rumney/West assemblage. However, the 1997 salvage excavation along Main Street in Annapolis conducted by R. C. Goodwin and Associates provides a perfect body of comparative data.[15]

The site called Freeman's Ordinary is ideal for a number of reasons. First, it was generally contemporaneous, containing wares from North Devon (1670s) to early white salt-glazed stoneware (1720s). Second, it is geographically proximate, being only three miles away as the crow flies, and like Rumney's, the Freeman's assemblage is urban in nature. Finally,

both ceramic assemblages show a fairly low presence of utilitarian ceramic vessels (other than chamber pots). This suggests that both are deposits generated from the serving end of the tavern operations and further indicates the utility of Freeman's as a comparison for the Rumney finds.[16]

Both taverns had significant numbers of wine bottles, wineglasses, mugs, and bowls, strong evidence of the amount of alcoholic consumption that occurred at both establishments. One difference is the prominence at Freeman's of large numbers of brass wires that once held stoppers on the wine bottles, a phenomenon not seen at Rumney's. The presence of a nearby Annapolis brewery in the late seventeenth century may provide the explanation for this, and it is speculated that the clientele at Freeman's was consuming more beer while Rumney's patrons drank wine.

Another difference is the presence of tea bowls, a coffee pot, and what might well be coffee cups at Rumney/West, but not at Freeman's Ordinary. If rum punch is the explanation for the "pineapple bowl" from Rumney's, then this constitutes another example of what would appear to be high status drinking.

Perhaps the most dramatic dichotomy between Freeman's and Rumney's is in dinner plates. Rumney's has numerous, often highly decorated plates, while Freeman's has none. Two explanations for this can be derived from the missing parts of any such archaeological assemblage—that which was not thrown away or which otherwise does not survive. Wooden trenchers, for example, would not be preserved to be excavated except in the most unusual of circumstances, circumstances not present at either of these two cellars.

A second explanation also involves plates made of materials not discarded for archaeologists to recover such as pewter. During the colonial period, pewter was a valuable metal that was easily reprocessed into other forms. As a consequence, it was not generally thrown away, and not generally recovered on most archaeological sites of the period. Rumney and Freeman's are not exceptions in this regard.[17]

So, were the missing plates from Freeman's wooden or pewter, or did they exist at all? While the answer may never be known with certainty, a number of evidentiary lines indicate that Freeman's was serving a clientele of lower social status than Rumney's—and would therefore be more likely to have been using wooden trenchers.

One has already been mentioned, the possible beer/wine dichotomy, and the tea/coffee drinking which occurred only at Rumney's. Historical documents provide another. Records indicate that workmen employed in building the new state house in 1697 were staying at Freeman's. If Freeman's Ordinary was accommodating a clientele of laborers, it probably would not also have had elite customers. Finally, a number of artifacts reinforce this conclusion. These include higher status items such as a scent bottle (see fig. 10), a highly decorative sword hanger, and such unique ceramic finds as the "pineapple" bowl found at Rumney's.

Figure 34 School children help screen plow zone soils for artifacts. (Photo, Al Luckenbach).

Summary

The ceramic assemblage recovered from the Rumney/West Tavern is unusual both for its extensive nature and for its well-preserved and datable context. Together with the analyses of its floral and faunal remains, it provides a remarkably detailed look at upscale tavern life in London Town, Maryland, circa 1725. The utility of such an assemblage for other comparative archaeological studies is of the highest order.

But surprisingly, the greatest contribution that this archaeological assemblage and its excavations have made may not lie in the artifacts or the technical aspects of historical archaeology, but in the public's awareness and personal participation in the recovery of the past. The *Lost Towns Project* is a public and educational program (fig. 34). Hundreds of volunteers assisted the professional staff in the excavations, lab processing, research, and analyses involving the Rumney/West Tavern complex. Thousands of school children visited the excavations as they occurred under our white tent.

Figure 35 Profile of the cellar fill at the halfway point of excavation. A life-sized version of this illustration has now been mounted in Rumney's cellar as a permanent exhibit. (Illustration, Severn Graphics.)

As the most visible archaeological feature at the park, the excavations proceeded slowly—not just for the normal, careful scientific reasons. Five years of painstaking excavations occurred before the last cultural deposit was removed, but this length of time was partly because of the importance of the excavation as an educational tool.

Edward Rumney and Stephen West's tavern continues to educate. Today, the site is a permanent exhibit centered around a single life-sized photograph of the deposits as they appeared at the half-way point of the excavations (fig. 35). Over 5,000 school children alone visit each year. After two and a half centuries, the tavern still draws a crowd.

1. For further information, see John W. Reps, *Tidewater Towns: City Planning in Colonial Virginia and Maryland* (Williamsburg, Va.: Colonial Williamsburg Foundation, 1972).

2. Other institutions providing assistance include the Anne Arundel County Trust for Preservation, the Maryland Historical Trust, the National Park Service, the Kaplan Foundation, and the National Geographic Society. Architectural research support has been provided by the Colonial Williamsburg Foundation.

3. In earthfast construction, the principal structural members of a building are set directly into the ground. For further information, see Cary Carson, Norman F. Barka, William M. Kelso, Garry W. Stone, and Dell Upton, "Impermanent Architecture in the Southern American Colonies," *Winterthur Portfolio* 16, no. 2/3 (summer/autumn 1981): 135–96.

4. Louis L. Lipski, and Michael Archer, *Dated English Delftware: Tin-Glazed Earthenware 1600–1800* (London: Sotheby's, 1984).

5. Al Luckenbach and John Kille, "Delftware Motifs and the Dating of Rumney's Tavern, London Town, Maryland (ca. 1724)," *American Ceramic Circle* (in press).

6. Al Luckenbach and Patricia Dance, "Drink and Be Merry: Glass Vessels from Rumney's Tavern (18AN48), London Town, Maryland," *Maryland Archeology* 34, no. 2 (1998): 1–10.

7. Lisa Plumley and Al Luckenbach, "Tracing Larrimore Point Through Time: Excavations at 18AN1084," *Maryland Archeology* 36, no. 1 (2000): 11–24.

8. Jonathan Horne made this suggestion, partially based on the known presence of a coffee pot, and partially on the use of a similarly sized cup in a delft tile store front picture, *Dish of Coffee Boy.*

9. Allan Kulikoff, *Tobacco and Slaves: The Development of Southern Cultures in the Chesapeake, 1680–1800* (Chapel Hill: University of North Carolina Press, 1986.)

10. John Brewer, *The Pleasure of the Imagination: English Culture in the Eighteenth Century* (New York: Farrar, Straus and Giroux, 1997).

11. Ivor Noël Hume and Jonathan Horne both made this suggestion in independent personal communications.

12. Dennis Cockell, "Some Finds of Pottery at Vauxhall Cross, London," *English Ceramic Circle Transactions* 9, no. 2 (1974): 121, 129.

13. Ibid., p. 126.

14. Frank Britton, *London Delftware* (London: Jonathan Horne, 1986), p. 71.

15. April Fehr, Suzanne Sanders, Martha Williams, David Landon, Andrew Madsen, Kathleen Child and Michele Williams, "Cultural Resources Management Investigations for the Main Street Reconstruction Project, Annapolis, Anne Arundel County, Maryland," report to the City of Annapolis, 1997.

16. Al Luckenbach, Patricia Dance, and Carolyn Gryczkowski, "Taverns and Urban Life in the Early 18th-Century Chesapeake: A Comparison of Two Assemblages from Anne Arundel County, Maryland," paper presented at the Society for Historical Archaeology, Atlanta, Georgia, 1998.

17. Ann Smart Martin, "The Role of Pewter as Missing Artifact: Attitudes Towards Tablewares in Late-Eighteenth-Century Virginia," *Historical Archaeology* 23, no. 2 (1989): 1–27.

Robert F. Trent

Richard Schalck,
Stoneware Potter
of Marblehead,
Massachusetts

▼ DEPICTED INCREASINGLY *in my sculptural ceramic forms in stoneware is my love affair with the country of Mexico. Annual journeys to the south of that country inspire both my clay pieces as well as the work of Pamela Schalck, my wife and traveling companion. Confronted with the difficulties of setting up to work in clay while there, I chose instead to work in two dimensions. I have tried to bring back something of how I feel about this land in my drawings, paintings, and prints. My warm connection to this part of America, its people and its culture greatly influences my work. Each year I absorb great waves of inspiration from this enigmatic place, where the ancient and modern intertwine.*

As an artist and as a human being, I feel also a strong connection to the natural world with its endless perfection, and my work exhibits a powerful pun towards the textures and colors of nature. Yet it is also the alteration of our natural world both positively and negatively by the human animal that is of profound interest to me as an artist. In Mexico, the kaleidoscope of contrasts inspires me to see the beauty and fullness of life more clearly.[1]

Running parallel to the well-publicized commerce of art potters who actively pursue gallery and museum sales and publish articles in magazines is the quiet world of the utilitarian potter. The utilitarian potter makes a living running a business, regularly firing small kiln-loads for domestic consumption, and only pursuing artistic production as a sideline. These individuals, who are often viewed with disdain by the more academic art potters, rarely gain artistic recognition.

Stoneware potter Richard Schalck has produced major vessels and slab-built sculptures for almost thirty years, but not a single work by him is in a major museum collection. His natural reticence and distrust of manifestos are one reason for his relative obscurity, but Schalck also seems to feel that participation in gallery shows and marketing to museums gets in the way of his conceptualization and execution. His production of strong, functioning utilitarian pots is important to him, but he has not had an interest in industrial design, as such. He even shies away from giving his sculptural works titles even when they have strong associational motifs.

This article gives an overview of some representative examples of Schalck's individualistic work, but it by no means captures the full range of his nuanced and elusive nature. Schalck was born in 1940 in Morristown, New Jersey. In 1948, his family moved to East Boston. Schalck attended Dorchester High School (which had a progressive arts program by 1950s standards) and then Lynn English High School. He studied at

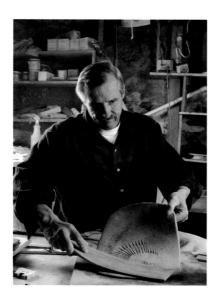

Figure 1 Richard Schalck at his basement workbench making "corrugated" slabs. Marblehead, Massachusetts, 2002. (Unless otherwise noted, all photography by Gavin Ashworth.)

Figure 2 Detail of signature on the base of a Schalck vessel.

Figure 3 A group of Schalck's utilitarian production.

Figure 4 The dragon logo of Schalck's Elm Street Pottery.

Massachusetts College of Art at the old Brookline Avenue campus from 1958 to 1962. While he took the regular MCA survey courses, including painting, drawing, and architecture, Schalck began to concentrate on ceramics in his sophomore year.

Three professors especially influenced Schalck's development. Charles E. Abbott was a superb technician in the Arts and Crafts tradition who stressed command of the medium, including bodies, glaze formulae, and firing temperatures. Russell Doucette was a strong mechanical engineer but also emphasized the history and beauty of Meso-American and Asian art, both of which have been fundamental to Schalck's work. Bill Wyman was a more expressionistic teacher who later achieved national recognition. He is remembered today for his self-portrait heads and temples in many museum collections. Wyman was a friend and colleague of Peter Voulkos, the California abstract expressionist potter who revived the rough, expressionistic style of the Mississippi Arts and Crafts potter George Ohr.

After graduation, Schalck worked as a union carpenter from 1963 to 1973. In that year he finally built a kiln in the carriage house of his wife's parent's house at 148 Elm Street in Marblehead. His first kilns were simple downdraft examples with arched chambers built of soft and fire brick and fired by gas. Schalck has always concentrated on stoneware, although he has made a certain amount of terra cotta. At school he had learned to make ceramics in electric-fired kilns that only reached cone 5 (approximately 2200 °F). Since true stoneware clays require higher temperatures, with his earliest experiments in making stoneware, Schalck had to resort to fluxing stoneware clays to melt at lower temperatures. Once he built his own gas-fired kiln, he began firing at higher temperatures.

The results of that first firing were uneven, but the strong technical background Schalck had received at MCA prompted him to overcome problems. He has rebuilt his kiln six times since 1973 as the rigors of high temperature firing have taken their toll. The last time he supplemented his own experience by bringing in a consultant who provided expertise on the relative sizes of the chamber and the flue, the position of the damper and burner, and insulation of the floor and roof.

Schalck has pursued a living making utilitarian pottery. Like many potters, he promoted his business locally at art fairs and shows or by demonstrating at festivals or in schools. He occasionally placed ads in the local newspaper, *The Marblehead Reporter*.[2] His initial forays into making what he refers to as "sculpture" was a 1975 castle, where he experimented with rough surface textures he calls "corrugations."

To create these sculptures, Schalck cuts slabs with a simple guitar-string arrangement. He then begins altering the slabs by working in grout and making corrugations with a tile or a wooden implement like a clothespin. The resultant patterns and relief are suggestive of fossilized trackways or patterns made by wave action, but their coarse texture gives them a strong sculptural quality, as though they were carved rather than incised. In 1976 Schalck created a composition of three slab-built groupings of creatures which he called "Family of," a rare exception to his use of titles for his

Figure 5 Richard Schalck, "Family of," 1976. Unglazed stoneware. H. of tallest: 23¾".

Figure 6 The artist with "Family of" at the bicentennial arts festival at Abbot Hall, Marblehead, 1976. (Courtesy, *Marblehead Reporter.*)

Figure 7 Richard Schalck, vessel, 1979. Partially-glazed stoneware. H. 28¾".

Figure 8 Richard Schalck, vessel, 1980. Unglazed stoneware. H. 18⅛".

Figure 9 Richard Schalck, vessel, 1980.
Partially glazed stoneware. H. 22½".

Figure 10 Richard Schalck, vessel, 1982.
Unglazed stoneware. H. 15¼".

Figure 11 Richard Schalck, vessel, 1991.
Glazed stoneware. H. 15".

works. These sculptures were first of what was an entire series stretching over twenty years.

The heavily-grogged stoneware clay Schalck uses, generally a brownish buff color, is usually sparingly glazed (if at all) in pale, mat glazes inspired by Song Dynasty wares. However, Schalck had little appreciation early in his career for vases in "antique" Asian-styles. Only later would he accept such forms as commissions for what he saw as a technical challenge, building them out of six or seven components.

His earliest work was hampered by the problems of stoneware construction and firing, including shrinkage, cracking, dunting, warping, and slumping. Schalck has used a variety of clay sources, although he notes that the number of supply houses has dwindled in recent years. Most of the stoneware clays he presently uses are from southern Appalachia. Schalck's usual stoneware body is mixed with grog in the form of pre-fired ground stoneware particles to which he has added other clays for color, but he usually sticks with a buff color. He uses a Bluebird pug mill (a motor-driven screw in a tube) to blend in both light- and dark-colored grog for color and texture. He then wedges the clay by hand on a board. In throwing vessels, Schalck uses both a kick wheel and a motor-driven Shimpo wheel with a variable speed pedal.

Figure 12 Richard Schalck, vessel, 1993.
Partially glazed stoneware. H. 17⅝".

Figure 13 Richard Schalck, "The Jed
Johnson Vase" (one of four), 1993.
Stoneware with Albany slip. H. 24⅝".
(Private collection.)

Figure 14 Richard Schalck, "The Pier at
Chicxulub Puerto," 1993. Watercolor and
ink on paper. 14" x 17".

Figure 15 Richard Schalck, "Fantasy
Drawing," Chicxulub, Puerto, 1992.
Watercolor and ink on paper. 17" x 14".

Figure 16 Richard Schalck, "Dogs of Chicxulub," 1995. Glazed stoneware. H. 3".

Figure 17 Details of the sculpture illustrated in fig. 16.

Figure 18 Richard Schalck, vessel, 1995. Glazed stoneware. H. 5½".

Figure 19 Richard Schalck, vessel, 1995.
Glazed stoneware. H. 7".

Most wares are fired in a gas-fired kiln twice, first a biscuit firing at cone 6 (1800°F) and second a glaze firing at cone 9–10 (2235 to 2381°F). Schalck has used a variety of slips made of locally dug clay or of pipe clay, which is porcellanous, but usually he employs only glazes. These are about 50–60% feldspar, but also include limestone, whiting, alumina, and white kaolin. Fluxes are borax, zinc, and barium. Colorants include iron, copper, cobalt, nickel, and occasionally wood ash. However, Schalck does not consider himself a glaze technician. He has ball-milled some pigments like Albany slip but prefers rougher grades of materials in their natural state.

Since 1988, Schalck and his wife Pamela have made annual trips to Mexico and have visited every Mexican state. He has funded these research trips by offering works by himself and his wife in return for subscriptions. In part, his choice of destinations was influenced by his teacher Russell Doucette, who emphasized the artistic achievements of the Olmec, Maya, and Aztec. Although Schalck has visited some traditional potters in Mexico, he concentrates on archeological sites and museums.

Although he recognizes the importance of artistic wares like those produced by Gorky Gonzales, they do not fundamentally interest him.[3] A definite artistic influence, however, was the landscape of the American Southwest, particularly desert mesas. To some extent the eroded slopes reinforced the motif of corrugated surfaces on some Schalck sculptures; several have steps or doorways that might be oblique references to pueblos.

Some direct Mexican motifs are seen in a series of fin pots and others that reflect feathers, fruits, and vegetables. In a few instances, Schalck has

Figure 20 Richard Schalck, vessel, 1993.
Glazed stoneware. H. 6½".

Figure 21 Detail of the vessel illustrated
in fig. 20.

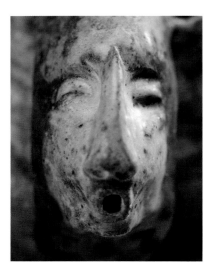

Figure 22 Richard Schalck, vessel, 1995.
Glazed stoneware. H. 3".

Figure 23 Richard Schalck, vessel, 1993. Glazed stoneware. H. 8⅜". (Collection of Pamela Schalck.)

Figure 24 Detail of the vessel illustrated in fig. 23.

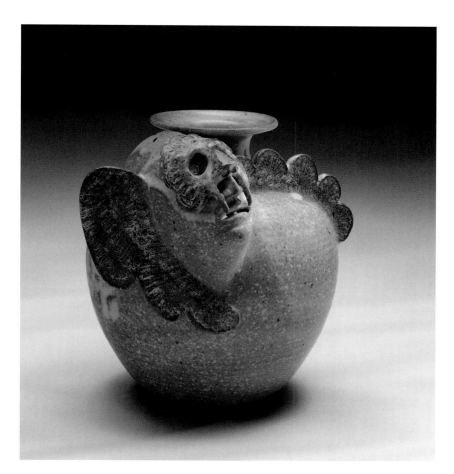

Figure 25 Richard Schalck, sculpture, 1993. Glazed stoneware. H. 7¼".

Figure 26 Richard Schalck, sculpture, 1994. Glazed stoneware. H. 10½".

Figure 27 Detail of the sculpture illustrated in fig. 26.

Figure 28 Richard Schalck, vessel, 1992. Glazed stoneware. H. 3⅞".

Figure 29 Top view of the vessel illustrated in fig. 28.

Figure 30 Richard Schalck, vessel, 1998.
Glazed stoneware. H. 9½".

Figure 31 Top view of a vessel by
Richard Schalck, 1997. Glazed stoneware.
W. 11¼".

Figure 32 Richard Schalck, vessel, 1995.
Glazed stoneware. H. 5". (Collection of
Chris and Merel Monaco.)

Figure 33 Richard Schalck, vessel, 1998.
Glazed stoneware. H. 6¾".

Figure 34 Richard Schalck, sculpture,
2000. Glazed stoneware. H. 15".

Figure 35 Richard Schalck, sculpture,
1999. Glazed stoneware. H. 11¾".

Figure 36 Richard Schalck, sculpture, 2000. Glazed stoneware. H. 13⅛".

Figure 37 Richard Schalck, sculpture, 2001. Glazed stoneware. H. 21¼".

Figure 38 Richard Schalck, downspout, 1990. Glazed stoneware. H. 18". (Private collection.)

Figure 39 Richard Schalck.

made sculptures incorporating tiny figures that quote Meso-American carvings. However, these rare break-outs of overt influence are far more common in the concept and landscape drawings that Schalck has executed on his trips. Several more recent sculptures are made of thinner slabs but are worked into bulbous, ambiguous forms that are puzzling and sometimes a bit threatening. These smoother forms with complex sprayed glazing represent a genuine formal departure, as well as a new psychological threshold for the artist.

It is difficult to predict what directions Schalck's production might take as the artist heads toward retirement from commercial production. The glare of public recognition attendant to articles like this might have any number of consequences for a practicing potter who has avoided it. However, one anticipates that Schalck might concentrate more and more on sculptures, perhaps moving into an overt Meso-American phase. The confrontation of his quiet personality with some of the extreme sacrificial aspects of historic Meso-American civilizations is tempered by his genuine regard for modern Mexicans. The only odd aspect of this is Schalck's apparent lack of a taste for incorporating the colors of the Mexican palette, another avenue he might explore in a mannered future phase.

1. Statement by Richard Schalck, May 1993, Abbot Public Library, Marblehead, Massachusetts.

2. Published newspaper accounts of Richard Schalck's works include *Boston Globe,* North Shore Supplement, September 2, 1987, p. 17b; *Boston Globe,* North Shore Supplement, July 10, 1983, pp. 16–17; *Salem Evening News,* September 29, 1987, pp. 1 and 9; *Salem Evening News,* January 4, 1995, p. 9; *Marblehead Reporter,* March 18, 1982, p. 15; *Marblehead Reporter,* June 22, 1977, pp. 19, 24.

3. See http://www.gorkypottery.com/

Figure 1 Mug, or gorge, attributed to John Dwight, Fulham, ca. 1675. Salt-glazed stoneware. H. 4". (All objects from the James Glenn Collection; photos, Gavin Ashworth.) This early example from John Dwight's stoneware manufactory in Fulham can be tightly dated by the manganese slip wash and the distinctive "rat-tail" terminal attachment of the handle. Dwight's patent of 1684 uses the term "gorge" to describe this globular mug form. Early examples of Dwight's stoneware production have been recovered from seventeenth-century American archaeological sites.

Figure 2 Mug, Frechen, Germany, 1660–1680. Salt-glazed stoneware. H. 5½". This mug with applied seal was recovered from the North Sea. The globular form and the shape can also be seen in silver and earthenware mugs of the period. Documentary and archaeological evidence suggest that similar forms were made in England as early as 1660. Characteristic of later English brown stoneware, the mug was dipped into an iron wash or slip before firing creating the rich brown mottled or freckled appearance.

James Glenn

Brown Mugs and Jugs: A Personal Foray into the Field of Collecting

▼ I HAVE ALWAYS had a fascination with the past and sought to understand it. If we could look into the past, look into our favorite period of history, what would we see? Would we be witnessing a pivotal historical event or simply peering into the everyday life of a commoner? As we walk through museums and visit historical sites, most of us would admit that it is irresistible to think of how life might have been lived at a different time.

Much of what we know of the past is based upon the historical records of major events and the lives of the most affluent and educated personalities. Although these are strong and vital components of understanding history, they provide an incomplete picture. To see the full picture, it is necessary to understand the history and everyday lives of the common people. If the major events and personalities are the framework of our history, it is the culture of the multitudes that is its substance. Unfortunately, ways to access their lives are few. But by studying commonplace objects

Figure 3 Mug, Westerwald, 1695–1702. Salt-glazed stoneware. H. 5¼". This example has an applied portrait medallion of King William III.

Figure 4 Mugs, London, 1700–1720. H. 4⅞" and H. 5⅜". The mug on the left is attributed to John Dwight's Fulham pottery and dates ca. 1703. It has an applied Britannia medallion and an "AR" excise mark below handle. For similar examples and further reading, see Chris Green, *John Dwight's Fulham Pottery Excavations 1971–1979* (London: English Heritage, 1999), pp. 134–35 example A, and for the medallion, see p. 269. The mug on the right is ca. 1720 and has the impressed excise mark "WR." These excise marks were required by a British Act to ensure standardization of capacities in the tavern trade of beer and ale. As the Act originated in 1700 during the reign of King William, the WR excise mark was typically used throughout the eighteenth century.

Figure 5 Mugs, Germany. Salt-glazed stoneware. *Left:* Impressed with "AR" cipher for Queen Anne (1702–1714). *Right:* Impressed with "GR" for King George I (1714–1727). H. 6".

that have survived and, more rarely, the writings of ordinary people, we are able to get a better sense of our cultural heritage.

The late seventeenth and early eighteenth centuries fall at the end of the Renaissance before the advent of industrialization that has so defined our life today. In the early part of the eighteenth century, life was still dominated by the strong traditions of the guild system. It was a period defined by the highest degree of human artisanship achieved without the advantages of complex machines. The time spent in labor to produce goods was of little regard—the emphasis was on the conservation of raw materials. Many of the goods recovered from that time show that great attention was paid to detail and artistry. The subtle but functionally unnecessary incised lines on the shoulder of a common utilitarian storage jar are but one example of this kind of detail.

Goods were meant to last long useful lives and to be enjoyed for their appearance. This touches all aspects of material production, including furniture, ironwork, leatherwork, and ceramics. But as industrialization

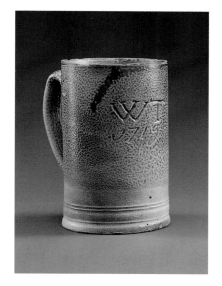
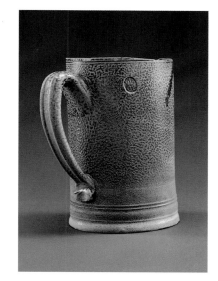

Figure 6 Mug, Bristol, 1719. Salt-glazed stoneware. H. 5½". An unusually early dated mug with an impressed "GR" excise mark in an oval. The GR marks appear to have been adopted only by stoneware manufacturers in Bristol.

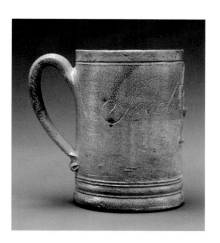
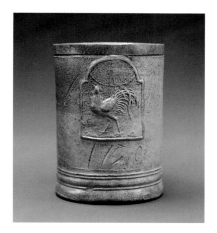

Figure 7 Mug, Fulham, 1750. Salt-glazed stoneware. H. 5⅛". A tavern mug inscribed "Jacob Morden 1750" with the sign of the rooster on its medallion.

emerged in the early nineteenth century, handmade goods begin to lose their artistry to mechanization and standardization. My collecting has been focused on gathering the humble objects used by many to try and piece together a picture of eighteenth-century life in England, as well as her American colonies.

The Beginnings of Collecting

I can never remember a time when I didn't collect. It began as an unconscious activity early in childhood. Like so many things in life, I didn't know where this passion would take me.

As a boy raised on the south side of Virginia, I found numerous Indian artifacts in almost every field and stream bed. American Civil War relics were constantly found near my mother's family farm, where Lee and Grant engaged in their last titanic struggle. I loved to comb through the wreckage of my father's eighteenth-century ancestral home that burned in 1932 and subsequently was abandoned. As these sites yielded various relics of the past, I was too young to understand their function or importance. Many were used as skipping stones in the nearby creek. As I grew older, I was filled with

Figure 8 A group of mugs with applied tavern signs, London. Salt-glazed stoneware. *Left:* H. 6¾". Quart tankard inscribed "Wm. Kemp in Wells, 1741" with the tavern medallion of the Golden Fleece with "WR" excise mark. *Middle:* Important quart tankard impressed using printer's type "JN. Cox Bromley 1756." This is the earliest recorded tankard using printer's type to impress its letters and date. Previously, the earliest recorded tankard using this method was dated 1758. (See Adrian Oswald, Robin J. C. Hildyard, and R. G. Hughes, *English Brown Stoneware* [London: Faber & Faber Limited, 198]), p. 43.) WR excise mark and the medallion of the "house of the rising sun." One other rising sun medallion is known on an eighteenth-century jug. *Right:* London quart salt-glazed stoneware tankard with the tavern sign "horses head" on its medallion. Printer's type impressed "Thomas Deall Egham 1768." WR excise mark.

excitement to notice the chipping that had fashioned the arrowheads and the finger impressions that molded the pottery sherds. I soon began saving everything I had previously been throwing away. Bullets, spurs, canteens, shrapnel, broken swords, and Indian relics began to adorn my room.

Whenever I found one of these field relics, I experienced a sense of awe. The thought that someone long ago had walked this very ground gave me an emotional link with the past that I had never experienced. The thought that I may be the only person to have seen these objects since they had been lost or cast aside by their owner overwhelmed me with excitement. These youthful experiences fueled my desire to collect. I was beginning to look through that window into the past, but there was much more to learn. For me collecting became a learning experience, rather than a mere function of assemblage.

Before I was in the first grade I became inspired by an uncle, who collected antique firearms. He gave me my first Civil War musket when I was six. At the age of eight, I purchased other relics, and at the age of ten, I bought my first primitive piece of furniture. It was an early Virginia pine chest held together with wrought nails and made with wooden hinges. Family members began to question my motives when I dragged this chest into my room with its two hundred years of soil and grime attached.

I was constantly inspired by the numerous trips to nearby Jamestown and Colonial Williamsburg. Some of my fondest memories were of playing on the cannon in front of the Magazine and walking through the houses that line Duke of Gloucester Street. I admired the reconstructed settlement at Jamestown. It was there that I first became interested in the architecture and the construction techniques our forefathers had used. My interest in early colonial life was strengthened by family trips to Boston, Massachusetts, and Charleston, South Carolina. I coerced my parents into stopping at every museum and antique shop that we passed. I never gave

Figure 9 Mugs. Salt-glazed stoneware. *Left:* Bristol, 1755. H. 6⅜". This mug is incised in freehand with "Thos. Carter at ye Green Dragon Zeals Green 1755" and has an impressed GR excise mark. It is the latest dated hand incised example in the collection. *Right:* London, 1766. H. 4¼". This pint mug is impressed with printer's type "Wm. Murrells Sulbery 1766" and has an impressed WR excise mark.

up the hope that I could convert them into collecting antiques, as their financial position could have afforded all of the great items that had captivated my attention. Unfortunately, I soon realized this was an undertaking I would have to assume myself. In contrast, my daughters Christie and Raleigh have taken more than an active interest in my collecting.

During this time every aspect of eighteenth-century life became fascinating to me. From politics to purses, textiles to tools, chamber music to military tactics, I wanted to understand the entire spectrum. I began to wonder about the people that made and used these objects. What were their lives like? Who were their families? What was their form of entertainment? What did they consume? What were their favorite foods? How did they travel? What was their sense of economy? How were their homes different from ours today? How did they cook? What kind of tools did they have? Where would they get them? At a very young age, I was filled with so many questions and had no idea where to find the answers. The history that I began to read as a young student did not address the majority of my questions.

Figure 10 A group of mugs, Germany. Salt-glazed stoneware. H. of tallest: 5⅝". Examples of tavern mugs of the type exported to England and the American colonies. Virtually all American archaeological sites dating between 1720 and 1760 contain fragments of such vessels.

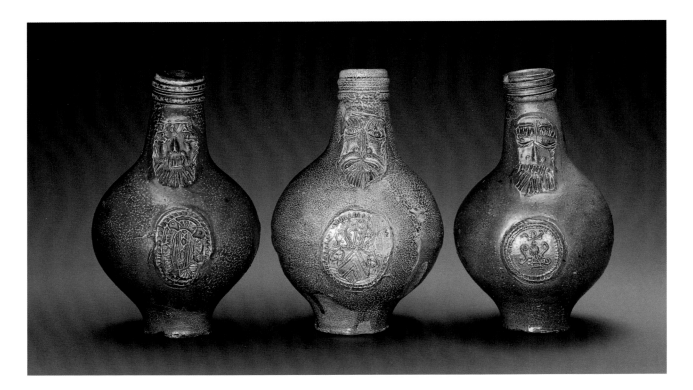

Figure 11 A group of bottles, Frechen, ca. 1680. Salt-glazed stoneware. H. of tallest: 9¼". During the seventeenth century, German "bellarmine" bottles were used throughout western Europe and North America as the containers of choice for wine, oil, and other liquids. Their ubiquitous presence is evidenced by numerous archaeological specimens found in Anglo-American contexts. These specimens are typical examples with the distinctive bearded mask and applied seals. The pronounced lips were used to fasten wires over the corks that sealed the bottles. Collectors commonly use the term bellarmine in referring to these bottles. In the period, the Germans called these jugs "bartmann" (bearded man) while the British used the term "grey beards."

Up to this point, the history I had studied was the typical assortment of dates, places, and important events. That began to change when I was invited to participate in an archaeological excavation with one of the state organizations. Being around the archaeologists and listening to their conversations, as they spoke of past finds as well as the ones they were uncovering, taught me not all questions where going to be answered by the text I had been reading in school. I realized I would need to do my own investigating and research.

During high school I became increasingly curious about the construction and development of objects as well as the people who made them. As much as I was gaining a view into the past, I was now trying to grasp some tactile historical experience by reproducing some of the pieces in my collection. Wonderful as it was to examine and place these pieces in their proper historical context, I wanted a deeper understanding of how people living in past centuries rose to the challenges of their limited technology. To test my own skills, I decided to reproduce an eighteenth-century Virginia-style long arm, well before a kit or mail order parts made building a facsimile easy.

I was also inspired by publications in archeology and other fields. From the underwater excavation of Port Royal, Jamaica, I drew many parallels between the findings there and my studies of colonial life in Virginia. I especially enjoyed publications interpreting the Williamsburg and Jamestown areas. At the same time I began to realize that exported colonial life from the European nations was somewhat homogenized no matter the location. The most enjoyable, inspiring, and influential writings were those by Ivor Noël Hume. He was the first in my experience who seemed to tell me what I wanted to know. Through him I learned that seemingly insignificant objects

Figure 12 A group of bottles, probably London, 1690–1720. Salt-glazed stoneware. H. of tallest: 9¼". English production of stoneware bottles began in earnest in the early eighteenth century. The smaller bottles were probably used for ale and other liquors. These were eventually supplanted by the production of glass bottles. Unlike mugs and tankards, stoneware bottles were usually fired without the benefit of saggers, being stacked tightly in the kiln. Where these bottles came into contact with each other is usually evident as circular spots or indentations on the shoulders and bellies. The name "Thomas" is incised in freehand script on the left and middle bottles.

Figure 13 Bottle, London, ca. 1725. Salt-glazed stoneware. H. 9". An elegant form in an everyday utilitarian object.

were in fact some of the strongest links to the past. His interpretive abilities, the way he was able to relate an unearthed object to its historical context, was unequaled. I became a fan of sorts, always waiting for the next book or article.

Other influential works included those by Wendell Garrett, Israel Sack, and Wallace Nutting. I soon found myself collecting references of all sorts, which began to form the nucleus of my personal historical library. I realized

Figure 15 Bottle, London, ca. 1725. Salt-glazed stoneware. H. 7⅝". The unique circular spot in this bottle is a result of its position in the kiln. The lack of salt-glaze within the circular area suggest that the bottle may have been resting horizontally on top of a mug or saggar.

Figure 14 Bottle, London, ca. 1725. Salt-glazed stoneware. H. 7¾".

that a library was one of the most important tools and assets for a collector. I would urge anyone who is just beginning to collect to read everything you can on your subject. Talk to everyone involved in your field of interest, take notes, photographs, make measured drawings whenever possible, and save it all.

During and after college, along with collecting, I began to reproduce many of the items in my collection as well as others I viewed in museums, an occupation that fascinated me. The idea was not merely to reproduce the antique object itself but to understand and experience the actual process that might have been used. This helped me gain greater insight as to how early artisans achieved their results. There were other implications. When determining whether or not an object was genuine, repaired, or a reproduction, knowing the original process gave vital clues not found in a text book or by merely viewing a piece from a distance in a museum.

While making these reproductions, I also found myself establishing a closer bond to the artisans of long ago. But if I were going to accomplish this task properly, I would need to make many of the tools of the period and to make them in period fashion. My projects were interrupted by my Wall Street training, and the usual activities consistent with business and family. Collecting, however, always remained my favorite pastime.

For many years, I have been affiliated with a number of organizations oriented towards my various historical interests. In many ways I have found my membership with them to be as useful in gathering information as the assembly of my own library. These organizations produce written works in the form of newsletters, bulletins, and books. Meeting and talking with members results in the cross-pollination of knowledge from a multitude of diverse sources.

I joined the Artist Blacksmith Association of North America and the Florida Artist Blacksmith's Association long after I had established my eighteenth-century style forge. Not all were as interested as was I in developing eighteenth-century items. However, there were always some within these organizations who wanted to share knowledge and skills. I produced

Figure 16 Ink bottles, London, 1780–1820. Salt-glazed stoneware. H. of tallest: 3½". These small bottles contained ink or pigments. The bottle on the left is impressed "SCOTT, 417 STRAND." John Scott was listed in the London Directory as "water Colourman to her Majesty" at this address from ca. 1790–1839.

Figure 17 Bottle, London, ca. 1780. Salt-glazed stoneware. H. 5½". This small bottle was reputedly found in a Connecticut house cellar.

Figure 18 Wine bottles, England. Glass. H. of tallest: 6". The sealed bottle is inscribed "Wm. Adams 1723" and was retrieved from an English river. The bottle on the right was found in an American river. Glass bottles, whose production began in the 1660s, quickly became the standard containers for wines and related alcoholic beverages. These early examples were free-blown with the final shape being dictated by the hand of the glassblower.

nails, locks, cooking utensils, furniture hardware, architectural hardware, woodworking tools, and smithing tools.

As I became fond of seventeenth- and eighteenth-century leatherwork, collecting once again turned into reproducing. These interests led to my membership in the Honourable Cordwainers Company. I produced leather jacks, buckets, bottles, and shoes of the period. Likewise, my furniture building and woodworking turned into another obsession. I joined the Society of Workers of Early American Trades, the Midwest Tool Collectors, and the Early Arts and Industry Association. The pursuit of collecting stoneware has led me to a membership in the most interesting Society for Post-Medieval Archaeology. Although I have yet to attend their meeting, the Society produces a wonderful annual publication that covers a variety of discoveries of interest to the ceramics collector.

Reasons for Collecting

There are many reasons why people collect and many approaches. My collecting has been eclectic; because I started collecting at such a young age, I had no preconceived notions. In collecting and preserving those hard-to-find pre-industrial goods from the seventeenth and eighteenth centuries, I have two criteria. One is the material object's place in history. The item must be judged as to how significant a role it played in the daily life of its time. The other is the history of the development of the object itself. It should have the qualities that exemplify one of the evolutionary processes

Figure 19 A group of wine bottles, England, 1740–1760. Glass. H. of tallest: 7½". These mid-eighteenth century examples were blown into a cylindrical mold in the early attempts to standardize the sizes and shapes of bottle. All three bottles have histories of being found in Virginia rivers.

in the development of its product type and class. I collect ceramics, metal, wooden and leather objects with emphasis on those used by or produced for the English and American markets during the first through third quarters of the eighteenth century. Occasionally I venture into the seventeenth century when I find objects that are necessary to explain the development of certain objects that came later or when the useful lives of the objects themselves extended into the eighteenth century.

My favorite area of ceramics is the brown stoneware first produced in the Rhineland then later produced in England. I am also keenly interested in early cobalt-decorated, Westerwald stoneware. These objects are subtle reminders of important physical changes in the way people lived. Their development facilitated the daily life of generations by making it easier to store, serve, and process foods and beverages. As necessary as they were to their time, they are relatively obscure today. They were not made for the courts of kings and queens and do not exemplify the highest art form of their day. They would most likely be found in a kitchen or a tavern, a part of the homescape of eighteenth-century life. Held in little regard, they were continuously used until destroyed or scrapped when replaced by new technologically advanced wares. As a result, these wares are relatively scarce and most of the information on them has come from archaeology.

The irony is that items made for the aristocracy were rare and expensive in their day and seldom used for their intended purpose. People would save, cherish, and gently hand them down to future generations, like any wonderful work of art. Many commemorate special events, dates, or regents. Today these objects can be easily found as long as your checkbook is nearby. Because the common and inexpensive brownwares of the day were

Figure 20 Bottle, Germany, 1720–1750. Salt-glazed stoneware. H. 17". Larger sized stoneware bottles were produced throughout the seventeenth and eighteenth centuries. This example has the applied bellarmine mask.

not considered heirlooms, they were not saved, hence the search for these pieces today is particularly difficult.

Collecting Salt-glazed Stoneware

I first noticed English salt-glazed brown stoneware at Colonial Williamsburg, early in life. I never forgot it. The interiors of many original and restored structures were stocked with various mugs and storage jars. These personal items were placed on tables or inconspicuously on shelves, as if the owner had just set them down. This intimate human aspect helped breath life into an inanimate setting. Much later in life I started collecting brownware. My collecting inclination was ignited when my friend antiquarian Bill Wensel gave me my first piece.

Brown stoneware is a highly fired clay body usually gray in color. After being thrown, these wares were dipped in an iron wash to create the brown appearance. They were then fired and glazed with salt. Unlike earthenwares, stoneware was so highly fired that the material became impervious to liquids.

The technique of stoneware manufacture was perfected sometime in the late thirteenth century, in the Rhineland of Germany. These wares were much more desirable than the porous and fragile earthenwares of their time. Stoneware vessels easily became the vessels of choice when compared to their wood, leather, horn, and earthenware counterparts.

The European market for the everyday stoneware vessels grew so rapidly that it became greatly profitable. Distribution networks reached far and wide, entering the English market in the fourteenth century and mostly dominating it by the late fifteenth century. Stoneware became so widely used in England that merchants were known to import and even stockpile vast quantities in warehouses. It was then distributed among local markets.[1]

Envious of German products and profits, English potters attempted to imitate these wares. Many failed, as the secrets to successful stoneware

Figure 21 Bottle, Germany, 1720–1750. Salt-glazed stoneware. H. 15". This bellarmine-type bottle was among several dozen German stoneware storage vessels recovered from the 1752 Dutch shipwreck *Geldermalsen*. At the time of its sinking in the East Indian Ocean, the *Geldermalsen* was bound for Europe carrying nearly 100,000 pieces of Chinese porcelain. These stoneware bottles appear to have been used as storage vessels for use by the ship's crew.

Figure 22 Bottle, Germany, 1750–1800. Salt-glazed stoneware. H. 18⅛". Incised "4." Generally, the bellarmine mask was not used after 1750.

production were closely guarded. If the process was going to be replicated, interested potters would have to discover it by numerous experiments. Although these experiments were well underway in England by the first half of the seventeenth century, the production of stoneware did not develop as quickly as that of delftware and gallipot. Toward the end of the century, the foreign monopoly was broken, and English brown stoneware was developed in London, Nottingham, Derbyshire, Burslem, and possibly Bristol.[2]

The first successful potter to do this on a commercial scale was John Dwight at his Fulham kilns. By the 1670s, Dwight's products were given credit for raising the standard of brown stoneware in England. He even began to produce copies of the blue and purple Westerwald wares. History generally regards Dwight as the "father" of English ceramics, and his success signaled the birth of the English ceramics industry.[3]

At first, English stoneware was produced in the same style and types as the German products they intended to imitate. Stoneware bottles were turned to the same shape as the German bellarmines. Medallions were applied to the center of the body and masks were applied to the neck. Mugs, which were short and globular, were turned with reeded necks and made with a pad base. By the early eighteenth century, the English freed themselves from these imitated German forms. Bottles lost their masks and medallions. Mugs and tankards were turned in cylindrical form, which remained the style throughout the rest of the century.[4]

The growth of the tavern business in England prompted huge demand for stoneware, both imported and locally made. This demand did not simply come from the British Isles alone. The British Empire was rapidly expanding over the world. There was an especially rapid rise in population in the North American colonies, resulting in an increased demand for

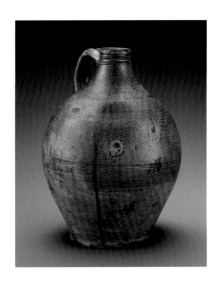

Figure 23 Bottle, England, probably Fulham, ca. 1720. Salt-glazed stoneware. H. 15¼". The large English bottles, although used as containers for ale and other drink, were more likely used for oils, varnishes, and paints. Production of these larger stoneware bottles continued throughout the eighteenth century and well into the nineteenth. Contact firing spots are readily evident on this bottle.

Figure 24 Detail of a hand print on the jug illustrated in fig. 23. The potter who dipped this jug into the iron wash, while marring his finished product, left an indelible mark for future generations. Although most potters remain anonymous, their fingerprints are common traces left on utilitarian stonewares and earthenware.

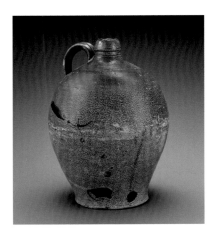

Figure 25 Bottle, London, ca. 1770. Salt-glazed stoneware. H. 13⅝".

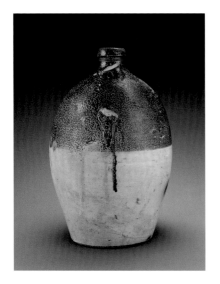 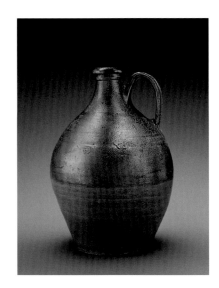

Figure 26 Bottle, England, probably Fulham, ca. 1740–1770. Salt-glazed stoneware. H. 16½". This example with its missing handle was reputedly found in the York River near Gloucester, Virginia.

Figure 27 Bottle, London, ca. 1725–1750. Salt-glazed stoneware. H. 14".

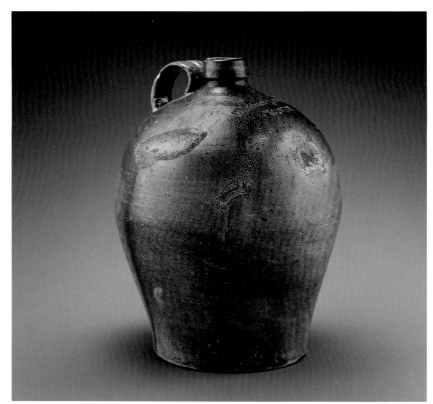

Figure 28 Bottle, Fulham, London, 1784–1805. Salt-glazed stoneware. H. 14⅜". Impressed "Brandram, Templeman & Jacque," a London firm of paint suppliers or "Colour Merchants." Several of these historically important jugs have been recorded in Virginia including two in the Colonial Williamsburg Collection. Research suggests that Brandram, Templeman & Jacque traded in Virginia and Maryland. A fragment of a similar jug was excavated at the Fulham pottery.

stoneware. Stoneware could be produced in quantity and at little relative expense. It has been found in tavern, domestic, and military archeological sites. Stoneware has always been a valuable tool for dating the finds of archaeologists. From the tremendous amounts of stoneware unearthed, it is obvious that it was an integral part of everyday life in the eighteenth century, just as pop bottles would be today.

The story of tankards and mugs of this period is of special interest to me. Most taverns had their signs painted and hung outside their establishments.

Figure 29 Detail of impressed mark on bottle illustrated in fig. 28.

Figure 30 Jar, London, ca. 1720. Salt-glazed stoneware. H. 7½". Jars like this served as storage containers for pickles, pastes, and other perishables.

Figure 31 Jars, London, 1720–1750. Salt-glazed stoneware. H. 6½" and 10⅛". These storage jars probably served many purposes, although they have been referred to as snuff jars.

Many had them copied and added as a medallion to the front of their tankards. These panels were applied to the tankard with a sprig mold. It was not uncommon for local patrons to carry home their beverages, and even though illiteracy was common, anyone could easily identify the tavern to which the tankard belonged.

Sometimes other information was placed on the tankard, such as dates, owners' names, and tavern locations. Tankards could exhibit one or all of these features. If the tankard were intended for commercial use, it would

Figure 32 Jar, probably London, ca. 1750. Salt-glazed stoneware. H. 8". The bulbous shape of this jar is unusual.

usually have an excise mark to indicate a full and proper measure of liquid sold. "The official English marks generally were incuse or stamped in relief with the cypher and crown within a borderless oval."[5]

Other marks on English brown stoneware, such as dates or inscriptions, were made using two distinctively different techniques. Up to the middle of the eighteenth century, marks were incised or scratched in by hand. Beginning in the second half of that century, marks were impressed using printer's type. As an example, the latest hand incised tankard in my collection is dated 1755, while the earliest printer's type impressed date reads 1756. This later specimen is the earliest known brown stoneware example to exhibit a printer's type date (see figs. 8, 9). Dated tankards and those with tavern signs applied as medallions to their bodies have been excavated in English and colonial American archaeological sites.

The gray-bodied Westerwald stoneware, with its blue cobalt decoration, continued to be made in the Rhineland and imported into England during the eighteenth century. "From about 1700, blue-gray Westerwald mugs, which combined the strength of stoneware with the decorative qualities of

Figure 33 Examples of reproductions of English brown salt-glazed stoneware, 1970–2000. H. of tallest: 8½". These stonewares represent contemporary products of American and English potters supplying the considerable reproduction market for historical sites, museum shops, and living history re-enactors.

Figure 34 Jug, Westerwald, 1691.
Salt-glazed stoneware. H. 11⅜". The
incised and applied decoration includes
a portrait medallion of King William and
Queen Mary dated 1691. The combined
use of cobalt and manganese on the body
is a characteristic of late seventeenth-
century Westerwald.

delftware, were specifically made for the English market."[6] Even though
the English industry was successfully producing stoneware in quantity,
demand made it necessary to continue purchasing German imports. This
was due to the ever-increasing growth of the tavern trade. Most were
adorned with a medallion containing the initials of the current monarch on
the English throne (WR King William; AR Queen Anne; GR King
George I, II, III). Infrequently a portrait of the monarch, including a date,
was applied to tankards and jugs, which were known to be imported until
the early nineteenth century.

Trying to date these pieces is not always as obvious as reading the applied
date. Dates on vessels can be commemorative. However, most evidence
indicates that the date is generally very close to the date of manufacture, if
not in fact the actual date of production.

Figure 35 Jug, Westerwald, 1702–1714. Salt-glazed stoneware. H. 8⅛". A large example impressed with "AR" (Anne Regina), the chipher of Queen Anne. Note that a small amount of manganese is used on the body decoration.

Figure 36 Jugs, Westerwald, 1724 and ca. 1740. Salt-glazed stoneware. H. 7⅜". The example on the left is dated. After about 1710, the use of manganese is generally restricted to the necks of Westerwald vessels.

Although I have a great passion for all the stoneware in my collection, be it storage jars, mugs, jugs, or tankards, the petite gorge or mug made by John Dwight around 1675 is my favorite (see fig. 1). This piece represents one of the earliest examples of the stoneware industry in England. As all collectors can appreciate the importance of this single item, it by no means completes the challenge and pursuit of other great objects.

Figure 37 Honey pot, Staffordshire, ca. 1700. Slipware. H. 5½". An early example of combed slipware with unusually fine patterning. Fragments of English slipware are among the most ceramic types found on American colonial archaeological sites and must have been used in nearly every household. The early slipwares of this type typically exhibit more care and better control in the application of the slip decoration than later examples.

Figure 38 Porringer, Staffordshire or Yorkshire, ca. 1730. Slipware H. 3¼". A later example where the quality of decoration is more debased than the example illustrated in fig. 37.

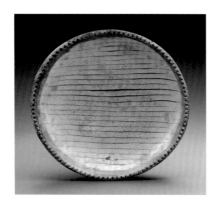

Figure 39 Dish, Staffordshire or Yorkshire, ca. 1750. Slipware. D. 11¼".

Figure 40 James Glenn.

I have tried, unsuccessfully, to acquire objects that were made in the factory of William Rogers of Yorktown, Virginia. Although the story of the Rogers factory is not well known by most collectors of ceramics, archaeological and historical research have documented it as the earliest and most important American stoneware manufactory. As the need arose for domestic suppliers, some potters attempted to take advantage of new colonial markets. William Rogers moved to the Virginia Colony where he made a wide range of earthenware and stoneware products in his Yorktown kilns from around 1720 to 1740 including brown stoneware tankards. Of the few that exist, some are almost indistinguishable from their English counterparts while others are distinctively more primitive. I have yet to find, much less acquire, an antique specimen of Rogers' stoneware.

If and when these utilitarian objects come up for sale, the same condition standards should not be applied to them as for other types of ceramics. Almost all of these pieces were damaged in some way during their useful life. They tell a story of hard use, and we are lucky to have any at all. No one should apologize for a small amount of restoration. In some ceramic circles, however, restoration can get out of hand. I have seen entire pieces almost completely fabricated from very little original material. I personally like those pieces that are completely untouched by the restorer's hand. I believe that the bumps and bruises tell the story of their great age. I am always amazed when people are induced to collect objects that are older than two centuries yet still want them to look freshly made. When restoration hides the record of use, something has been taken away from the object, its link to history broken.

In summary, I have found that the more common and useful the object, the better it represents the culture that produced and used it. Think of our modern world today. Which would best define our daily cultural life—a great work of ceramic art utilizing all our modern techniques of manufacturing? Or would it be the Coke bottle? I will let you decide.

1. Adrian Oswald, R.J.C. Hildyard, and R. G. Hughes, *English Brown Stoneware 1670–1900* (London: Faber and Faber Limited, 1982), p. 18; David Gainster, personal communication.
2. Ibid, pp. 18–19.
3. David Gaimster, *German Stoneware 1200–1900* (London: British Museum Press, 1997), p. 311.
4. Ibid., p. 312.
5. Malcom C. Watkins and Ivor Noël Hume, *The "Poor Potter" of Yorktown* (Washington, D.C.: Smithsonian Institution Press, 1967), p. 92.
6. Gaimster, *German Stoneware*, p. 312.

New Discoveries

Merry Abbitt Outlaw

New Discoveries— Introduction

CERAMICS PROJECT LAMENT AT THE END OF A LONG DAY:
I am poured out like water, and my bones are out of joint; my heart is like wax; it is melted in the midst of my bowels. My strength is dried up like a potsherd; and my tongue cleaveth to my jaws; and thou hast brought me into the dust of death.

Psalm 22: 14-15

▼ AS CURATORS OF archaeological collections for the Virginia Research Center for Archaeology, my colleague Beverly Straube and I had lightheartedly called ourselves "Mothers of Millions" because we were caretakers of millions of artifacts from all over the Commonwealth. Upon seeing the multitudes of ceramic sherds in need of proper curation—after decades of neglect in the cabinets at Jamestown after the 1930 National Park Service excavations—my "maternal" instincts toward potsherds flooded back. I immediately said yes to the task of helping to identify them.

A few days after I began organizing the sherds by provenance, ware types, dates, forms, and places of origin, I came upon the quotation cited above on a little note card handwritten by former Park Service curator J. Paul Hudson. And after closely examining and sorting thousands of thumbnail sized sherds a few weeks into the project, I knew just how Paul must have felt when he copied down that verse! But an innate love of ceramics made the job enjoyable and rewarding for me, and I was able to complete the project.

Again this year, most of the New Discoveries are the result of archaeological research. As the contributing authors worked with the hundreds, or even hundreds of thousands, of potsherds, they, too, may have felt at times their "strength . . . dried up like a potsherd." But their enthusiasm for and commitment to understanding our historic past made it possible for them to produce the important results reported in this issue of *Ceramics in America.*

This year, the New Discoveries are wide ranging in time, distance, ware type, and form. *La Vega* colonoware, from the sixteenth-century Concepción de la Vega in the Dominican Republic, illustrates the multi-cultural interaction of the American Indians, Spanish, and sometimes Africans, and speaks to the tragic enslavement and extinction of indigenous Caribbean peoples. From seventeenth-century archaeological contexts in Ferryland, Colony of Avalon, Newfoundland, elaborate Spanish *terra sigillata* specimens were recovered and are reported on. Also originating from the Iberian Peninsula in the seventeenth century is an important Portuguese faience

plate associated with the Lloyd family and bearing an armorial device from a site in Anne Arundel, Maryland.

Included this year are ceramic objects that were purely decorative to solely functional, as illustrated in articles about two vastly dissimilar caches of terra cotta objects: an assemblage of eighteenth-century flowerpots found in Williamsburg, Virginia; and an amazing collection of practice bombs from the First World War produced and recently discovered in New Jersey's clay district.

In addition to the terra cotta practice bombs from New Jersey, articles on American pottery manufacturing at two other east coast locations are included. One summarizes recent excavations at the first large production pottery in New England: the U. S. Pottery Co. (1847–1858) site in Bennington, Vermont. The other presents the continuing efforts to identify the works of Willie Hahn, and his son, Thomas, both of whom worked in the Old Edgefield, South Carolina, pottery tradition into the early twentieth century.

The National Park Service and the Association for the Preservation of Virginia Antiquities (APVA) separately own Jamestown Island, Virginia, the site of the first permanent English settlement in North America, and the colonial capital of Virginia until 1699. Archaeological testing of the island began in the late nineteenth century, and continued sporadically until 1993 when the APVA began *Jamestown Rediscovery*,™ the full-scale and continuing effort to rediscover John Smith's 1607 fort. Excavations of the island have produced the largest collections of seventeenth-century ceramics in America, and important new discoveries continue to be made there. This issue includes entries on two exciting ceramic finds unearthed at Jamestown; one was thrown away in the beginning of the seventeenth century, and the other was discarded at the end of the seventeenth century.

America's enduring ceramic links with England are demonstrated in three important research notes. In one, a surprising but disappointing connection is documented between Maryland judge Jeremiah Chase (1748–1828) and the Chelsea Porcelain Factory near London. Additionally reported are ceramics produced for the North American export market by three Tunstall, Staffordshire, manufacturers in the mid-nineteenth and early twentieth centuries. Finally, two recently discovered late eighteenth-century "vanity" dinner plates made in England for socially conscious American consumers are illustrated. As collectively presented in this year's New Discoveries, studies of our shared past by dedicated researchers in America and abroad have moved forward steadily, and as a result, our combined efforts to make the ceramic puzzle whole is continuing at a remarkable pace.

Kathleen Deagan

La Vega *Cerámica Indo-Hispano* — An Early Sixteenth-Century Caribbean Colono-ware

When Christopher Columbus established the town of Concepción de la Vega in 1498 to secure the rich, gold-bearing Cibao valley of Hispaniola, the powerful Taino chief Guarionéx and his people occupied the region. The gold of the Cibao valley, together with the large Taino population that would be exploited for labor in the gold fields, drew thousands of Spaniards to Concepción in the first decades of the sixteenth century, and it became America's first "boom town." The city was destroyed by an earthquake and abandoned in 1562.[1]

The Taino of the region did not survive to witness the destruction of Concepción. Epidemic disease, famine, warfare with the Spaniards, and forced labor after losing the war effectively wiped out the Taino population of central Hispaniola by the second decade of the sixteenth century. Labor was still required by the Spaniards, however, and in 1509 King Ferdinand permitted the enslavement of native peoples from other parts of the Caribbean. As a consequence, thousands of Native Americans from the Lesser Antilles, the Bahamas, Florida, and the mainland of Central America were captured and brought to Hispaniola to work in the Spanish mines and cities.

This desolate sequence of labor exploitation, extinction, and enslavement is reflected throughout the Caribbean in a variety of hybrid ceramic wares that incorporate Native American, Spanish, and sometimes African elements. These are known generally in the Spanish colonial areas as "*Cerámica de transculturación*,"[2] and perhaps the most remarkable of these have come from the site of Concepción de la Vega.

In 1976, Venezuelan archaeologist José Cruxent began excavating the site of Concepción de la Vega in the Dominican Republic under the auspices of the Dominican National Park Service. Among the enormous and very rich assemblage of European and Native American items from the gold mining center, he and colleagues Elpidio Ortega, José Gonzáles, and Manuel García-Arévalo recovered a large number of locally-made, hand built vessel fragments that combined circum-Caribbean native manufacturing and decorative traits with European and Native American forms. The most comprehensive treatment to date of these wares is that of Ortega and Fondeur, who refer to the ware as *Cerámica Indo-Hispano*.[3] Because of the general and broadly encompassing implications of the term *Cerámica Indo-Hispano*, however, we suggest that this particular variety be referred to as "*La Vega*."

In 1996 the University of Florida began a collaboration with the Dominican National Park Service to organize, clean, identify, and curate

the materials excavated from the site between 1976 and 1994. The assemblage includes 269,385 colonial period artifacts (both Spanish and Native American), and of these, 5,886 (three percent) are fragments of *La Vega* wares. They have come from both from the Spanish fort of Concepción de la Vega, and also from Spanish domestic contexts in the town.

Although European formal influence is evident, the great majority of examples are clearly non-European in inspiration and decoration. Three types of surface decoration dominate the assemblage, including solid red slip, *La Vega Rojo* (figs. 1, 2), (fifty-seven percent); red slip designs painted over a white slip ground, *La Vega Rojo y Blanco* (fig. 3), (thirty-one percent); and incised (sgraffito) designs on a white and/or red slip ground, *La Vega Esgrafiada* (fig. 4), (twelve percent). Ortega and Fondeur's study of paste for 876 of these sherds indicated that three percent of them appeared to have been thrown on a wheel, while the remainder were hand built using coils.[4]

Figure 1 *La Vega Rojo*, decorated vessels, early sixteenth century. (All illustrations unless otherwise noted, courtesy Florida Museum of Natural History; photos, James Quine.)

Figure 2 A selection of vessels decorated with *La Vega Rojo*, a solid red slip, early sixteenth century.

Figure 3 *La Vega Rojo y Blanco* decorated vessels, red slip designs painted over a white slip ground, early sixteenth century.

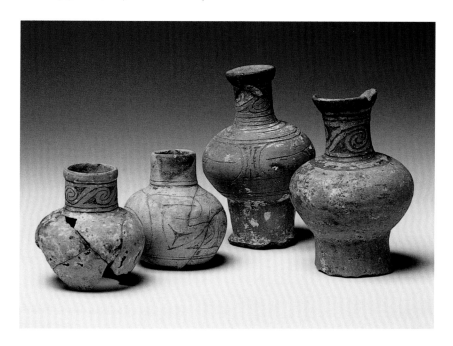

Figure 4 Forms decorated with *La Vega Esgrafiada,* or incised (sgraffito) designs, on a white and/or red slip ground, early sixteenth century.

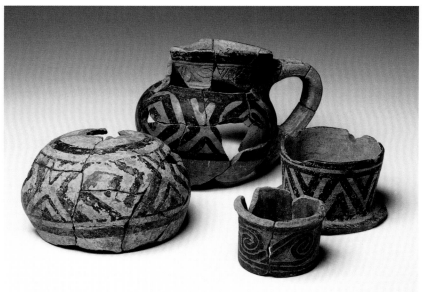

The red and white slip decoration has no known parallel in contemporary Taíno ceramics of Hispaniola. The decorative techniques and design motifs, however, are similar to some found in the indigenous pottery of Curacao, Panamá, and other parts of Central America. Studies are currently underway to systematically compare the *La Vega* wares to examples from other circum-Caribbean regions. Some vessel forms, such as pitchers, handled jugs, and candle holders, are clearly European in origin, while others,

Figure 5 Drawing: A–C *La Vega Rojo y Blanco* D: *La Vega Esgrafiada* on a white slip background E: *La Vega Esgrafiada* on a red and white slip background F: Bottle neck of *La Vega Rojo y Blanco* G. Bottle and jar mouths of *La Vega Esgrafiada*.

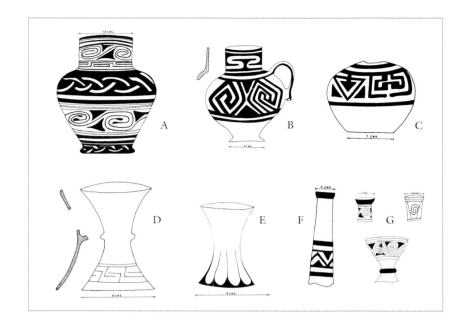

such as constricted-waist vases and pedestal pots, are reminiscent of those found in many parts of Central America (fig. 5).

Sherds from what appear to be *La Vega* ceramics have been found (although rarely) at several early sixteenth-century Spanish sites in Santo Domingo; however, they have not been reported so far from any other colonial sites in Hispaniola or elsewhere.[5] These *La Vega* ceramics fall clearly into the larger category of "colono-wares" found throughout the Americas that offer tangible expressions of multi-cultural interaction and exchange. Those from La Vega, however, also reflect the tragedy of enslavement and extinction of indigenous Caribbean peoples.

Kathleen Deagan
Florida Museum of Natural History
University of Florida
<kd@flmnh.ufl.edu>

1. Kathleen Deagan, Alfred Woods, Jeremy Cohen, and Pauline Kulstad, "Columbus's Forgotten City: Concepción de la Vega" <http://www.theweboftime.com/Issue-12/columbus.html>; Kathleen Deagan and José Cruxen, *Archaeology at La Isabela: America's First European Town, 1493–1498* (New Haven, Conn.: Yale University Press, 2002).

2. Kathleen Deagan, "The Archaeology of the Spanish Contact Period in the Circum-Caribbean Region," *Journal of World Prehistory* 2, no. 2 (1988): 187–233.

3. Elpidio Ortega and Carmen Fondeur, *Estudio de la cerámica del período Indo-Hispano de la antigua Concepción de la Vega* (Santo Domingo: Fundación Ortega-Álvarez.Série Científica 1, 1978).

4. Ibid., p. 22.

5. Manuel García Arévalo, "La arqueología Indo-Hispano en Santo Domingo," in *Unidades y variedades: ensayos en homenaje al José M. Cruxent,* edited by Erica Wagner and Alberta Zucchi (Caracas: Centro de Estudios Avanzados, 1978), pp. 116–17.

Beverly A. Straube

A Peacock's Flight . . . Across 100 Years

A tall cylindrical apothecary jar was recently recovered from a circa 1610 trash pit associated with the early English settlement at Jamestown, Virginia (fig. 1).[1] At first glance, it is difficult to see any relationship with the striking plumage of a peacock in its decoration. After all, aside from two manganese bands encircling the vessel, the palette is a monochromatic blue. Even the background tin glaze, which would normally provide a contrast in white, has a bluish cast, and the midgirth design—appearing like "scales with blobby dots," or maybe even fish eggs—is hardly representative of peacock feathers. Or is it? Perhaps examination of a decorative antecedent to the Jamestown jar, dating a century earlier, will make the association clearer.

A tin-glazed earthenware jar, in the National Museum of Nuremberg, is painted with overall scale-work similar to the Jamestown jar, although its palette is a very colorful orange-brown and blue (fig. 2). A product of Deruta, Italy, the vessel is known as an *albarello,* from the twelfth-century Islamic wares used to hold medicines, spices, scents, herbs, and other precious substances on pharmacy shelves. The tall slender *albarello* form is thought to have developed from sections of bamboo stalks, which served

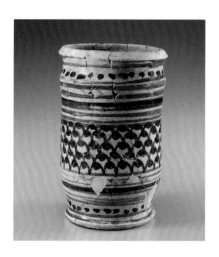

Figure 1 Apothecary jar, Aldgate or Low Countries, 1607–1610. Delftware. H. 7¼". (Courtesy, Association for the Preservation of Virginia Antiquities; photo, Gavin Ashworth.) Decorated with a stylized peacock feather motif. The jar was excavated by *Jamestown Rediscovery,*™ a project of the Association for the Preservation of Virginia Antiquities (APVA) at the site of James Fort (1607), the earliest permanent English settlement in the New World.

Figure 2 *Albarello,* Deruta, Italy, first quarter sixteenth century. Majolica. H. 12½". (Courtesy, Germanischen Nationalmuseum, Nuremberg.)

as the traditional Arabic container for medicines.[2] The cylindrical shape was also practical as it enabled the vessels to stand close together on apothecary shelves, and the constricted mid-section provided an easy hand-hold for handling the jars.[3]

The Jamestown apothecary jar has lost its "waist" and reflects the form's more rounded transfiguration as it was transmitted from Italy to the Low Countries and Britain in the sixteenth century. In these countries, the form came to be known as the gallipot, which either refers to galleys—the flat single-decked ships that traded Spanish and Italian tin-glazed earthenwares to the North—or to a derivative of an old Flemish word glei, meaning "porcelain clay."[4]

Apothecaries primarily used gallipots for the storage of ointments, drugs, and other medical preparations, but these vessels are also mentioned in sixteenth-century inventories and cookbooks as domestic storage containers for foodstuffs. Gallipots are particularly mentioned in conjunction with the storage of comfits (sugar-coated spices) and suckets (citrus peels and/or fruits conserved in syrup). This association probably developed because comfits and suckets were part of the Arabic confectionery that was introduced to the western world—along with the colorful apothecary jars—as medicine. Sugars and other spices were considered to be good for the digestion, and this was the primary reason for serving them as part of a meal.[5]

The use of tin glazing on pottery, which produced an opaque white ground for colorful decoration, is believed to have developed in the Near East in the ninth century as an imitation of Chinese porcelain.[6] During the Middle Ages, the technique spread along trading networks through the Islamic countries, including southern Spain, and eventually to Italy. Deruta, located south of the Apennines near Perugia, became an important center for the production of tin-glazed earthenware, or majolica, at the end of the fifteenth century. During this early time period, patterns from

Figure 3 Peacock feathers have provided decorative inspiration for centuries. The oldest known ornamental bird, the peacock figures largely in many cultures as a symbol of paradise or immortality. (Photo, Gavin Ashworth.)

Persian art as well as images on Chinese porcelain and designs borrowed from classical antiquity served as sources of decorative inspiration for the potters. The motif on the Deruta *albarello* is characteristic of Deruta wares during the first quarter of the sixteenth century and consists of a polychrome scale-work pattern, each scale with its central "eye."[7] This device is derived from Islamic interpretations of the upper tail of the peacock, which is marked with iridescent ocelli (fig. 3).

The Jamestown apothecary jar, which dates to the beginning of the seventeenth century, is a very stylized interpretation of the peacock design. At present, it cannot be visually determined if the jar is an early London product, possibly Aldgate, or was made in the Low Countries. Attribution is especially complicated by the fact that the Aldgate pottery, which operated from 1571 to about 1615, was comprised of Flemish potters who had emigrated from Antwerp. Compositional analysis using neutron activation has proved quite helpful in sorting out the tin-glazed products of the two countries.[8] It is hoped that a continuation of the scientific analysis of these wares, coupled with further study of the physical attributes, will lead to more secure attributions in the future. For now, the Jamestown apothecary jar represents the transmission of centuries of culture that followed the hot winds of the spice route through Asia and the Middle East, bringing aromatic spices, succulent citrus fruits, and mystical medicines to Europe's doors.

ACKNOWLEDGMENTS
The author thanks Ivor Noël Hume for pointing the way to Deruta.

Beverly A. Straube
Curator, *Jamestown Rediscovery,*™
Association for the Preservation of Virginia Antiquities (APVA)
Jamestown, Virginia
<bly@apva.org>

1. Beverly Straube, "European Ceramics in the New World: The Jamestown Example," in *Ceramics in America,* edited by Robert Hunter (Hanover, N.H.: University Press of New England for the Chipstone Foundation, 2001), pp. 47–71.

2. David Harris Cohen and Catherine Hess, *Looking at European Ceramics: A Guide to Technical Terms* (Malibu, Calif.: J. Paul Getty Museum in association with British Museum Press, 1993), p. 27.

3. Bernard Rackham, *Italian Maiolica* (London: Faber and Faber, 1952), p. 13.

4. Frank Britton, *London Delftware* (London: Jonathon Horne, 1987), p. 22.

5. C. Anne Wilson, "The Evolution of the Banquet Course: Some Medicinal, Culinary and Social Aspects," in *'Banquetting Stuffe,'* edited by C. Anne Wilson (Edinburg: Edinburg University Press, 1991), pp. 9–35.

6. Rackham, *Italian Maiolica,* p. 2.

7. Silvia Glaser, *Majolika* (Nuremberg: Germanisches Nationalmuseum, 2000), p. 200.

8. Michael Hughes and David Gaimster, "Neutron Activation Analyses of Maiolica from London, Norwich, the Low Countries and Italy," in *Maiolica in the North: The Archaeology of Tin-Glazed Earthenware in North-West Europe c. 1500–1600,* edited by David Gaimster. British Museum Occasional Paper Number 122 (London: British Museum, 1999), pp. 57–89.

James A. Tuck and Barry Gaulton

Terra Sigillata from a Seventeenth-Century Settlement in Newfoundland

Excavations at Ferryland, Newfoundland, over the past decade have revealed the remains of the Colony of Avalon, Lord Baltimore's first New World venture (1621–1637), and the succeeding Pool Plantation, presided over by Sir David Kirke, his wife Sara, and their sons between 1638 and 1696. Discoveries from the original settlement include parts of the waterfront, a stone warehouse with attached privy, the forge, a cobblestone street, and parts of the defensive works. A barn/byre, two dwellings, and the refuse midden from an upper class residence represent the latter, and longer, period of occupation.

The midden contained several tobacco pipes manufactured in the Chesapeake region during the seventeenth century and bearing the monogram "DK," almost certainly that of David Kirke who was proprietor of the Pool Plantation from 1638 until his death in 1654. However, the lowest layers of the deposit may pertain to Baltimore's occupation of the "mansion house." Among the more than one million artifacts recovered to date is a small collection of about 400 fine orange-bodied earthenware sherds pertaining to at least nine small vessels. Many of the fragments bear fine incised curvilinear geometric decorations formed by pairs of incised lines and picked out with a white slip. At least four types of vessel forms can now be recognized.

Three small bowls, three globes, two elaborate "handled pots," and a small jug or pitcher, represent these four distinct vessel forms. The fabric of all of the examples is fine and apparently untempered. The vessels are burnished on the exterior surfaces, and fired to a uniform bright orange color. No traces of color variation caused by the kiln environment are on any of the sherds.[1]

The bowls are small, shallow, and extremely thin walled. The most complete example (fig. 1) measures five inches in diameter and about two and

Figure 1 Side view of a small *terra sigillata* bowl, probably made in Estremoz, Portugal, in the early seventeenth century. D. 5". (All illustrations courtesy Department of Biology, Memorial University of Newfoundland; photos by Roy Ficken.)

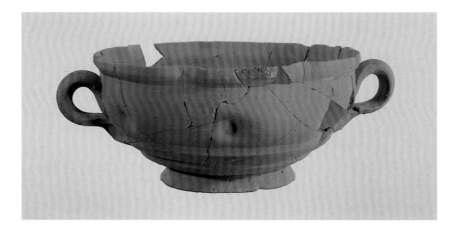

one half inches high. The rim is "frilled," and decoration consists of a geometric motif on the interior (fig. 2). Vertical handles extend from just below the rim to somewhat below the vessel midpoint. The second example has essentially the same form, but the decoration is confined to the exterior and consists of horizontal bands of curved lines above a lower

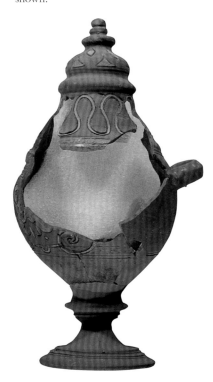

band of geometric and curving lines. The third specimen consists of a complete base, slightly thicker than the other specimens, and decorated only on the exterior.

The three globes were recently recognized when newly unearthed sherds joined bases of goblet-like vessels to finials that surmounted the closed bodies. A computer-generated illustration depicts a partial restoration of one such vessel (fig. 3). It stands about nine and one half inches high and is decorated on the exterior with a complex series of paired incisions filled with white slip. The finial is decorated with bands of incised triangles and diamonds, also filled with white slip. At least one horizontal handle remains just above the midpoint of the vessel. The presence of a second handle is uncertain. These unusual decorative pieces seem to have been thrown in two parts: the globes themselves, and the bases and foot rings. A cylinder on the base was inserted in a slightly larger cylinder on the globe and cemented with wet clay or slip. This resulted in an open base that allowed gases to escape during firing.

The largest and most elaborate vessels are of a peculiar globular form surmounted by a decorative finial. Although very fragmentary, enough sherds have been recovered to indicate that two such vessels are present. Two horizontal strap handles, one or more spouts, incised curvilinear and floral decorations picked out in white, and a molded face further decorate the vessels (fig. 4). They are similar to the "handled pots" illustrated by Jan Baart in his article on *terra sigillata* from the Low Countries.

The base of the small jug or pitcher (not illustrated here) is decorated with thumb impressions on the shoulder. The remnants of a handle attachment are in line with the decorative impressions.

The name for these ceramics, *terra sigillata,* is based on a 1632 inventory of the palace "Noordeinde" in The Hague. Some eighty-nine "pots, jugs and saucers . . . cups . . . and small pots" of "terre siglata" were arranged on three shelves. Portuguese scholars prefer the more generic term "fine redware," reserving *terra sigillata* for Roman ceramics. The Roman wares, however, are supposed to have been prototypes for the sixteenth- and seventeenth-century vessels. Such vessels may have been produced in a number of Portuguese centers, but the most elaborate, including those from Ferryland, were probably produced at Estremoz. Outside of Portugal, fragments of about sixty-four vessels have been recovered from some twenty-odd sites in the Low Countries.[2]

The Ferryland specimens were recovered from several areas on the site, primarily from the deep midden. A few sherds were recovered from the defensive ditch not far from the midden, some from the floor of the waterfront warehouse, and many more from an unusual deposit in a small stone-lined alcove in the inner face of the rampart. Artifacts associated with the *terra sigillata* include tobacco pipes dating from the 1630s and 1640s, including several from the Chesapeake bearing the "DK" monogram of Sir David Kirke. Pipes from the same craftsman were made for Walter Aston, of Virginia, in the 1640s. A bale seal from Charles I (1625–1649) further supports the other dates.

Figure 4 Fragments of large *terra sigillata* "handled pots," most likely made in Estremoz, Portugal, in the early seventeenth century. Measurements of the complete vessels are unknown. Note the complex incised decoration and the molded human face.

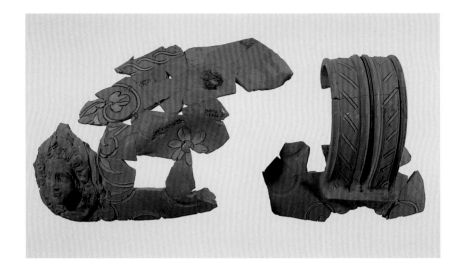

It is thought that the *terra sigillata* is not old enough to have belonged to the colony's first proprietor, George Calvert (Lord Baltimore), or his wife Joan. It seems more likely that the ceramics may have been among the possessions of Lady Sara Kirke, who arrived in 1638, or her sister, Lady Frances Hopkins, who arrived about 1650. *Terra sigillata* was clearly a high status item—Philip II of Spain bought several examples as gifts for his daughters in 1581. Both Lady Hopkins and Lady Kirke were of the gentry, and chances are good that one of them collected the exotic ceramics found more than 350 years after their arrival at Ferryland. Their occurrence at Ferryland is the first known in the New World; the authors, however, would welcome information about any other examples being found here.

James A. Tuck and Barry Gaulton
Archaeology Unit
Memorial University of Newfoundland
St. John's, Newfoundland, Canada
<bgaulton@morgan.ucs.mun.ca>

1. Barry Gaulton and Cathy Mathias, "Portuguese *Terra Sigillata* Earthenware Discovered at a 17th-Century Colonial Site in Ferryland, Newfoundland," *Avalon Chronicles* 3 (1998): 1–17, and Jan Baart, "*Terra Sigillata* from Estremoz, Portugal," in *Everyday and Exotic Pottery from Europe c. 650–1900,* edited by David Gaimster and Mark Redknap (Oxford: Oxbow Books, 1992), pp. 273–78.
2. Baart, "*Terra Sigillata* from Estremoz, Portugal," pp. 273–78.

Al Luckenbach

The Seventeenth-Century "Lloyd Plate" from the Broadneck Site in Maryland

The Anne Arundel, Maryland, Lost Towns Project is a long-term research and educational effort aimed at the archaeological rediscovery of a number of Chesapeake Bay colonial port towns that have disappeared from the landscape. The earliest of these was the first European settlement in the county—a place the inhabitants called "Providence" or "Severn," which was founded in 1649.[1] Over the last decade a total of eight sites have been located that can be associated with the Providence settlement.

The earliest of these is the Broadneck site, containing the remains of a "sill on the ground" building measuring approximately forty feet long and sixteen feet wide. A large earthen cellar, which once existed under the floorboards of the building, was excavated. The archaeological evidence suggests that the structure burned sometime in the 1650s. By that time, a number of interesting artifacts—such as a large iron pestle, an axe, a key, and a broken case bottle—had been deposited in the cellar along with a quantity of fireplace ash and food remains.

The short-term occupation of the site resulted in a fairly low overall artifact count. Ceramic finds included Rhenish brown salt-glazed stoneware, tin-glazed earthenware, Border ware, and redware. Interestingly, the site contained no examples of North Devon gravel-tempered earthenware, an extremely common ware type on all other Providence sites, sometimes reaching over eighty percent of the total ceramics recovered. The absence of this ceramic type is possibly due to the relatively early circa 1650 date assigned to the site's destruction. In the course of the cellar excavation, a pile of large sherds was uncovered that had been deliberately stacked on the original cellar floor (fig. 1). These proved to be the fragments of a Portuguese

Figure 1 Sherds of the Portuguese plate as found on the cellar floor. (Courtesy, Maryland Lost Towns Project.)

Figure 2 Plate, Portugal, tin-glazed earthenware, D. 10⅜". (Courtesy, Maryland Lost Towns Project; photo: Gavin Ashworth.)

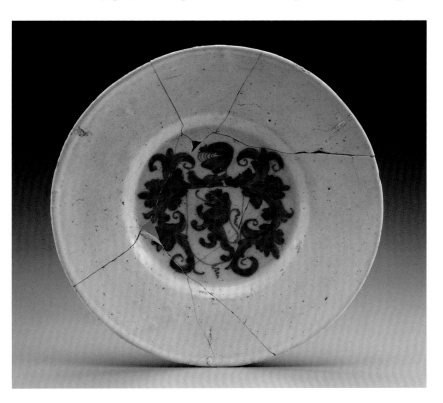

tin-glazed earthenware plate bearing a painted armorial device—a lion rampant surrounded by foliage and surmounted by a closed helmet (fig. 2). Intriguingly, the arms are an exact match for those of the Lloyd family— Edward Lloyd was the first "Commander" of the Providence settlement. Eventually the Lloyds became one of the wealthiest families in the Chesapeake—founding Wye Plantation on the Eastern Shore—and lent their family arms to the county seal of Talbot County, Maryland.

As intriguing as this association is, however, the discovery of virtually identical plates in such disparate places as New England, Amsterdam, and Brazil call such a specific familial association into doubt.[2] In fact, in the case of the Brazilian find, the armorial device is attributed to the Portuguese General of the Armada Francisco Correa da Silva! Although more research may yet decipher the relationship of the amorial plate to the Lloyd family, the Broadneck plate has been characterized as "unquestionably one of the most important examples of seventeenth-century tin-glazed earthenware yet found in America."[3] Today it is on permanent display at the Maryland State Archives in Annapolis, Maryland.

Al Luckenbach
Founder and Director
Maryland Lost Towns Project
<http://www.geocities.com/CollegePark/Square/6653/>
<alluck@aol.com>

1. Al Luckenbach, *Providence, 1649* (Annapolis: Maryland State Archives, Maryland Historical Trust, 1995).
2. Stephen R. Pendry, "Portuguese Tin-glazed Earthenware in Seventeenth-Century New England: a Preliminary Study," *Historical Archaeology* 33, no. 4 (1999). Jan Baart, *Portuguese Faiança, 1600–1660* (Amsterdam: Amsterdam Historich Museum, 1987). Ulysses Pernambucano de Mello, "The Shipwreck of the Galleon Sacramento," *International Journal of Nautical Archaeology* 8 (1979): 211–24.
3. Ivor Noël Hume, personal correspondence with author, 1991.

Merry Abbitt Outlaw

A Collection of Curious "Canns"

During the early 1980s, state archaeologists working on the William Drummond plantation site in James City County, Virginia, recovered two unusual cylindrical mugs or "canns" from circa 1690 archaeological contexts (fig. 1). Subsequently, two other examples that had been previously excavated were identified in the National Park Service archaeological collections at Jamestown (fig. 2). Unfortunately, these examples had been excavated decades earlier and information concerning their recovery had been lost. More recently, fragments of two more of these curious canns have been found in other nearby archaeological sites.[1]

Although stoneware vessels of this general form were manufactured in large quantities during the late seventeenth century, in and around London, these particular canns are unusual because they are earthenware. The clay body is very fine grained, red clay with small white flecks and frequent gray and orange streaks. The vessels were wheel thrown and trimmed on

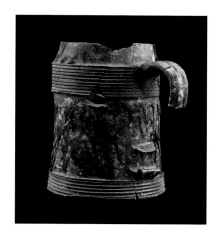

Figure 1 Mug or "cann," mottled slip decoration, England, ca. 1685–1695. Slipware. H. 4". (Courtesy, Virginia Department of Historic Resources and Jamestown Settlement, Jamestown-Yorktown Foundation; photo, Gavin Ashworth.)

the lathe resulting in an exquisitely thin product. Multiple horizontal reeded bands ornament the exterior just below the rim and above the base. Flattened and ovoid-sectioned with a central groove, their extruded vertical strap handles end at the bottom with a well-formed "squab"-terminal (fig. 3).[2]

The exterior of the canns were spattered all over with two or three colors before they were glazed, creating a "marbled" appearance. A thin matte and finely crazed lead glaze gives the fabric a reddish-brown appearance. The most intact example from Jamestown, although partly discolored from exposure to fire, is decorated with splashes of dark manganese appearing blackish brown, and a grayish white, possibly tin, oxide. The other Jamestown example is similarly decorated, but includes also a light cobalt blue, which is probably a mixture of cobalt and tin oxides. The Drummond site canns have splashes of manganese appearing brown, white, probably from tin oxide, and green from copper oxide.

These six vessels from the Jamestown environs comprise the only recorded examples of this ware. They appear to represent a rare and highly experimental period in English ceramic production. In the late seventeenth century, John Dwight of Fulham, and the Elers brothers of Staffordshire

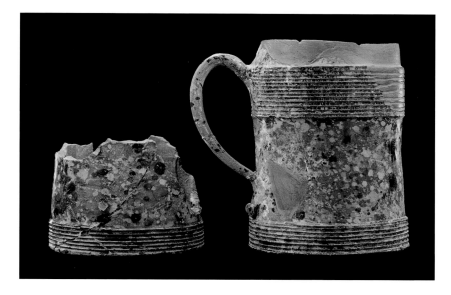

Figure 2 "Canns," mottled slip decoration, England, ca. 1685–1695. Slipware. (*Right*) H. 5". Catalog nos. COLO J 47308 (*left*) and COLO J 11806 (*right*). (Courtesy, National Park Service, Colonial National Historical Park; photo, Gavin Ashworth.)

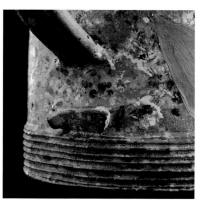

Figure 3 Detail of "squab" handle terminal, England, ca. 1685–1695. Slipware. COLO J 11806. (Courtesy, National Park Service, Colonial National Historical Park; photo, Gavin Ashworth.)

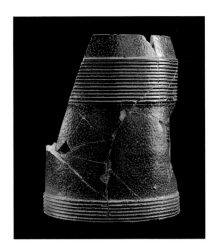

Figure 4 Mug, Fulham, England, ca. 1685–1695. Brown salt-glazed stoneware. H. 5". (Courtesy, Virginia Department of Historic Resources and Jamestown Settlement, Jamestown-Yorktown Foundation; photo, Gavin Ashworth.) Closely resembling the form of the mottled slipware "canns," this archaeological example also was found at the William Drummond site in James City County, Virginia.

and Vauxhall, are best known for their pottery experiments, as well as their legal disputes. In terms of form and skill of manufacture, the canns closely resemble John Dwight's brown stonewares produced after 1685, but do not match any of the known Fulham examples (fig. 4).[3] Furthermore, Dwight is not known to have worked in red earthenware. The canns are wheel thrown rather than slipcast, thus lessening the likelihood of the Elers' Staffordshire pottery as the source.[4]

During this period of experimental pottery manufacture, similar decorative techniques are demonstrated on other wares. For example, a unique gray salt-glazed stoneware Fulham gorge circa 1680 in the Victoria and Albert Museum is splashed with oxides of iron brown and cobalt blue. Also, some of Elers' red and brown stonewares are decorated with enameling, as evidenced on a brown teapot also in the Victoria and Albert Museum.[5] An important influence may have been the spattered cobalt technique known as *bleu Persan* or *bleu de Nevers* that was commonly used in the nearby London delftware factories during the 1680s, demonstrated by wasters found at Dwight's kiln site.[6]

On June 20, 1693, Dwight filed a lawsuit contending that one of his laborers, John Chandler, had been lured away and revealed secrets to the Elers of Fulham, as well as other potters working in Nottingham and Burslem.[7] In *John Dwight's Fulham Pottery Excavations 1971–79*, Chris Green states that Dwight employed "[a]t least one thrower of the highest abilities" from circa 1685 until 1695, and very guardedly conjectures that it was possibly Chandler, who worked there from 1683 to 1691.[8] The six earthenware canns found in and around Jamestown bear a strong resemblance to the Fulham stoneware mugs, suggesting a link with Dwight. Could they be examples of the unrecognized red stoneware Dwight is known to have produced?[9] Or did Chandler, whom Dwight sued for stealing secrets, share with others the sophisticated lathe turning technique employed in the manufacture of these six slip-decorated canns? If so, are they examples of the unidentified "browne muggs," made at Elers' London pottery at Vauxhall? Only time will tell, as we must await new research at other late seventeenth-century British pottery-manufacturing sites.

ACKNOWLEDGMENTS
I would like to thank David Riggs, Curator, and William Cahoon, Museum Technician, National Park Service, Colonial National Historical Park; and Thomas Davidson, Curator, Jamestown Settlement, Jamestown-Yorktown Foundation for making the vessels available for study and photography. For sharing their opinions of the curious canns, I would like to thank Robin Hildyard, Jonathan Horne, Garry Atkins, Chris Green, Robert Hunter, and Ivor Noël Hume.

Merry Outlaw
New Discoveries Editor
<Xkv8rs@aol.com>

1. "Cann" was a common seventeenth-century ceramic term for tankard. Chris Green, *John Dwight's Fulham Pottery Excavations 1971–79* (London: English Heritage, 1979), p. 63.

2. Green, *John Dwight's Fulham Pottery Excavations*, pp. 121–22.

3. Ibid.; Letter from Chris Green to Garry Atkins, 26 October 2001.

4. Gordon Elliot, *John and David Elers and their Contemporaries* (London: Jonathan Horne Publications, 1998), pp. 17–18.

5. Robin Hildyard, *Brown Muggs: English Brown Stoneware* (London: Victoria and Albert Museum, 1985), fig. 19, p. 37, fig. 48.

6. Green, *John Dwight's Fulham Pottery Excavations*, p. 67.

7. Ibid., p. 333.

8. Ibid., p. 118.

9. Ibid., pp. 128–29.

William Pittman
and
Robert Hunter

A Cache of
Eighteenth-
Century
Flowerpots in
Williamsburg

There is a paradox in material culture that the most common everyday objects in a given society are the ones least likely to survive the passage of time. Above ground anyway. Archaeologists can attest to the tremendous volume of crockery that bears little resemblance to the ceramics specimens preserved in the world's museums and private collections. Unfortunately, archaeologists usually are left with fragmentary examples to try to understand ceramic history, although occasionally an object is discovered nearly intact or one that can be pieced together from fragments. Outside of shipwreck cargoes, complete pots are rarely found in archaeological contexts.

A recent exception was the discovery of eighteen nearly complete earthenware flower pots in the excavation of a colonial cellar in Williamsburg,

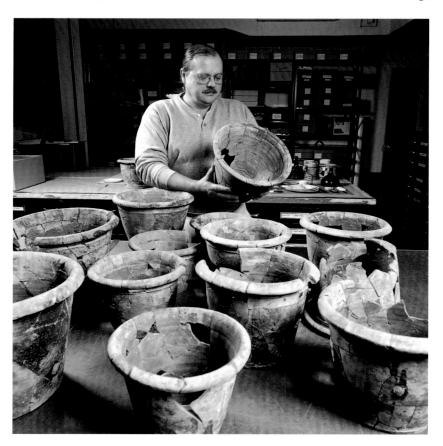

Figure 1 Reconstructed earthenware flowerpots being examined in Colonial Williamsburg's archaeological laboratory. (All illustrations courtesy Department of Archaeological Research, Colonial Williamsburg Foundation; photo, Gavin Ashworth.)

Virginia (fig. 1). Colonial Williamsburg's Department of Archaeological Research undertook the excavation in 1995 in advance of new construction on its property (fig. 2). The cellar was part of an imposing brick manor house built by John and Alice Page in 1662 on the outskirts of what was to become the town of Williamsburg in 1699.

Figure 2 View of archaeological excavation of the John Page House. (Photo, Department of Archaeological Research, Colonial Williamsburg Foundation.)

John Page was one of the most eminent men in the Virginia colony and appears to have maintained a well-landscaped plantation. He lived in the house until his death in 1692, and his wife lived in the house until her death in 1698. Ownership of the house remained in the family, although it is unclear who actually occupied the manor house. The last probable inhabitant was John Page III who may have resided there from 1718 until his death in 1727. Archaeological evidence suggests the house burned between 1725 and 1730, but it is unclear if this was before or after John Page III's death.

Houses that have burned filled with their contents, though tragic, can provide the best contextual information an archaeologist can hope for. They can provide a snapshot in time of the types and range of materials. The Page house is one of a handful of archaeologically excavated eighteenth-century burned house sites in colonial America. Sixty glass wine bottles, apparently full at the time of the house fire, were among the many artifacts recovered. Other household ceramics, probably having fallen from the floors above, were also recovered. These have been summarized elsewhere.[1]

Although frequently encountered in the excavation of colonial American sites, flowerpots are among the least documented ceramic forms. Archaeological research in the town of Williamsburg has revealed fragments of flowerpots on nearly every house lot. It is clear that they were plentiful and widely used.[2] The promotion of formal gardens was a direct import of the British practices particularly in the seventeenth and eighteenth centuries. The established gardens of Williamsburg and other prominent seats are well known, and the practice was considered a badge of rank for most Virginia gentlemen.[3]

At the time the Page house burned, the pots were being stored, possibly forgotten, in the cellar. The plainness of the pots combined with their English origin suggests that they were initially used to ship plants and young trees to the American colony. Precedence for this practice is well documented in the orders and shipping instructions of American gardeners to their London suppliers.[4]

The clay body of the pots has been identified as English, and they were possibly made in or near London. As most potters are creatures of habit, they tend to throw pots repeating the same forms or decorations. In many cases, these idiosyncrasies make it possible to separate the work of one potter from another simply by observing the distinctive way that rims are formed, handles are applied, or footrings are trimmed. All but one of the Page site flowerpots have strikingly similar characteristics, suggesting that one craftsman produced them.

They each have a distinctive raised v-shaped cordon, positioned below the rim on the exterior (fig. 3). The rim profiles are similar, being generally rounded in section, with a slightly flattened, down-angled upper surface. All the pots are flat bottomed and have sides that flare upward to the rims. The smallest size pots have a single, centrally positioned drain hole in their bases, while the medium- and large-size pots have three evenly spaced holes through the pot wall near the base, in addition to the central base hole (fig. 4). The potter formed all these drain holes by pushing through the pot walls from the outside inward. The odd pot in the group is a large example with a fully rounded rim, no raised exterior cordon, and only one central base drain hole that was fettled (trimmed) so that it is now impossible to determine from which direction the hole was formed. The base diameter of this lone example is larger than the average base diameter of the others in the assemblage.

The Page site flowerpots have been sorted into three groups based on their size and the number and location of the drainage holes. Five small

Figure 3 Flowerpots, England, possibly London, ca. 1700. Earthenware. H. of tallest: 10½". (Photo, Gavin Ashworth.) A comparison of the largest and the smallest pots.

Figure 4 A view of the drainage holes of earthenware flowerpots.

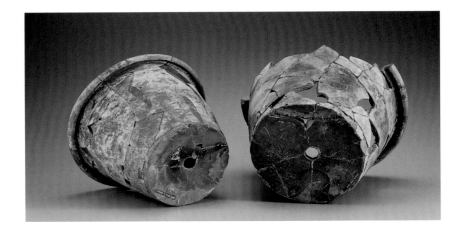

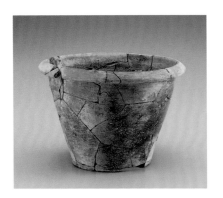

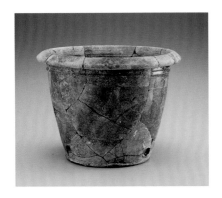

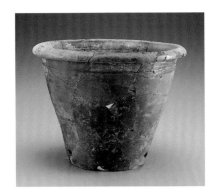

Figure 5 Flowerpot , England, possibly London, ca. 1700. Earthenware. H. 6⅞ ". (Photo, Gavin Ashworth.)

Figure 6 Flowerpot, England, possibly London, ca. 1700. Earthenware. H. 8¾". (Photo, Gavin Ashworth.)

Figure 7 Flowerpot, England, possibly London, ca. 1700. Earthenware. H. 10⅛". (Photo, Gavin Ashworth.)

size pots measure from 6⅞" to 7½" in height and range from 6⅞" to 7½" (maximum exterior diameter) at their rims (fig. 5). Nine pots comprise the medium size group, which measures from 8¾" to 9⅛" in height, with rim diameters from 11" to 12½" (fig. 6). The large size group contains three pots, the shortest being 10⅛" and the tallest 10¼", with rim diameters ranging from 12⅞" to 13½" (fig. 7).

Even though the fire that consumed the Page house discolored most of the surfaces of the pots, undamaged clay fabric survives in all of the specimens. The coarse earthenware clay body is a fairly homogenous, reddish-brown color with obvious sand inclusions. The flowerpots are unglazed except for random splashes of a clear lead-fluxed glaze on interior and exterior surfaces. Two of the medium size pots show scars in their glaze splashes where smaller pots (with base diameters of approximately 5") came in contact during firing. The pots fused together and had to be broken apart for use. Other smudges of thin glaze appear haphazardly on the exteriors under rims and on the bases of each pot in the assemblage.

Flowerpots are but one of many types of gardening evidence found on archaeological sites in Williamsburg; this assemblage is the largest group

of nearly complete flowerpots that has come to light thus far. Further analysis of the full range of gardening equipment, coupled with new analytical procedures being developed in the field of archaeobotany, will undoubtedly advance our understanding of eighteenth-century landscapes and horticulture.

William Pittman
Curator of Archaeological Collections
Colonial Williamsburg Foundation
<wpittman@cwf.org>

Robert Hunter
Editor, *Ceramics in America*
<CeramicJournal@aol.com>

1. John Metz, Jennifer Jones, Dwayne Pickett, and David Muraca, *"Upon the Palisao" and Other Stories of Place from Bruton Heights* (Williamsburg, Va.: Colonial Williamsburg Foundation, 1998).
2. Audrey Noël Hume, *Archaeology and the Colonial Gardner*, Colonial Williamsburg Foundation No. 7 (Williamsburg, Va.: Colonial Williamsburg Foundation, 1978).
3. Peter Martin, *The Pleasure Gardens of Virginia: from Jamestown to Jefferson* (Princeton, N.J.: Princeton University Press, 1991).
4. Ann Leighton, *American Gardens in the Eighteenth Century: "For Use or for Delight"* (Boston: Houghton Mifflin, 1976).

Stephen E. Patrick

The American Foundation of the Chelsea Porcelain Manufactory, 1745–1784

Joshua Johnson (1742–1802), an Annapolis merchant, traveled to London in 1773 (fig. 1). Johnson's letterbooks reveal that he was engaged by a number of his Annapolis neighbors to act on their behalf in business matters. One of those neighbors engaging his services was Jeremiah Townley Chase (1748–1828), the son of British émigrés from London (fig. 2).

Chase's mother died when he was five months old, and his father, Richard, followed when the boy was nine. As an adult, Chase read law and prepared for the bar, and later was appointed a Maryland state judge. At

Figure 1 Charles Bird King, *Joshua Johnson* (1742–1802), oil on canvas. (Courtesy, Smithsonian American Art Museum, Adams-Clement Collection, gift of Mary Louisa Clement in memory of her mother, Louisa Catherine Adams.) Johnson is the Annapolis merchant in London who researched Chase's claim on the Lawrence Street properties and broke the news about the pottery.

Figure 2 *Jeremiah Townley Chase* (1748–1828), attributed to Robert Edge Pine, ca. 1785, oil on canvas. (Courtesy, Maryland Historical Society, Baltimore, Maryland.) Chase is the American who failed to collect his rents in arrears on the Chelsea Porcelain Manufactory.

Figure 3 Houses in Lawrence Street, Chelsea, London, on the site of the Chelsea Porcelain Manufactory. (Photo, Stephen Patrick.)

Figure 4 Plaque describing the significance of the Chelsea factory in Lawrence Street. (Photo, Stephen Patrick.)

the age of twenty-four, in 1773, the young solicitor was becoming increasingly aware of his own legal history and the disposition of his father's estate when Chase was a child.

In surviving records, Chase apparently encountered a letter written by his father's cousin, London solicitor Sir William Halton, on December 10, 1747.[1] Sir William referred to London properties that had been given to Richard Chase from his mother's family, conveyed by settlement around 1720, and included an account of rents paid on houses owned in Wardour Street, Soho (figs. 3, 4). Jeremiah Chase had no prior knowledge of these properties in London, and most certainly had not seen any income. He engaged Johnson to investigate the matter. On December 23, 1775, as the American Revolution began to escalate, Johnson reported back from London, writing to Chase in Annapolis. He cataloged the frustrations he had encountered with various landlords, attorneys, bookkeepers, and clerks, and in the end, engaged a London attorney. He also produced new information: there were four more houses in the original Richard Chase estate. They were not in London proper, and thus his London attorney had traveled up the river to explore them. Johnson enclosed with his letter to Chase a copy of the attorney's report, which read in part:

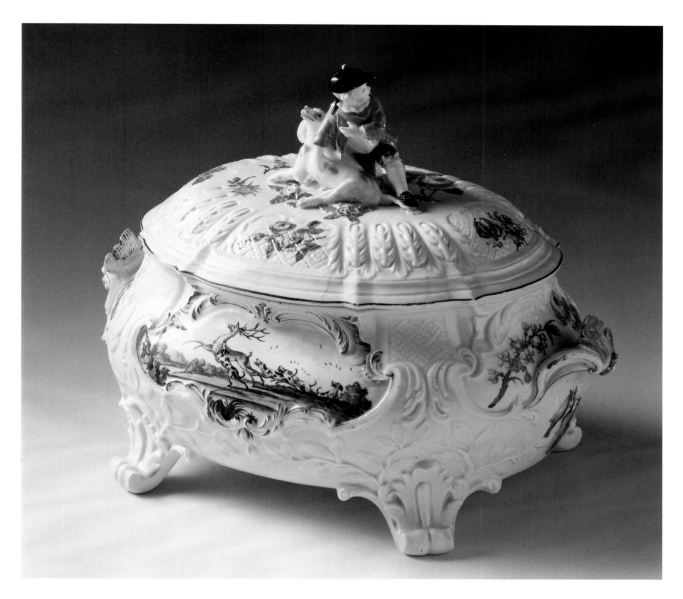

The four Houses at Chelsea are situate at the upper end of Lawrence Street near the church fronting the river Thames and were some years since occupied by the Proprietor of the Chelsea Porcelain Manufactory but are now in the occupation of Mrs. Friend (who inhabits the same house Dr. Smollet did). . . . The Name of Chase is well known to the Person from whom I gathered most of this Intelligence who has lived in Lawrence Street near 30 years and remembers seeing some old leases at the time the Estate was put up to Sale.[2]

After the war, Chase got some money from Wardour Street, but he failed to regain any claim to the Chelsea property, the first home of the celebrated porcelain manufacturer (fig. 5). The lack of documentation hindered him tremendously, and the sale and destruction of the houses in 1784 further frustrated his case, which he pursued into the 1790s. In a letter written in 1873, Judge Chase's granddaughter, Lucy Harwood, sadly noted, "Grand Pa seems to have had endless trouble with his *English estates*—his health was always delicate and as it became more infirm I imagine he let the

English affairs drop."[3] Judge Chase died in 1828, a few days shy of his eightieth birthday, never collecting on his Chelsea properties.

Stephen E. Patrick
Director, City of Bowie Museums
<spatrick@cityofbowie.org>

1. Sir William Halton to Richard Chase, December 10, 1747, Jeremiah T. Chase Papers, MS.278, Box 1, File 10, Maryland Historical Society, Baltimore, Maryland.
2. Joshua Johnson to Jeremiah T. Chase, Joshua Johnson Letterbook, vol. 2, Chancery Exhibits, Acc. 1508, Maryland Hall of Records, Maryland State Archives, Annapolis, Maryland.
3. Lucy Harwood to Col. Kimmel, Annapolis, September 29, 1873, Jeremiah T. Chase Papers, MS.278, Box 2, File 5, Maryland Historical Society, Baltimore, Maryland.

Joyce Hanes

Two Eighteenth-Century Vanity Plates

Figure 1 Plate, England, possibly Liverpool, ca. 1796. Pearlware. D. 8". (Collection of author; photo, Gavin Ashworth.) Inscribed in enamel "LABAN AND MARY FOLGER."

Two pearlware plates with apparent American connections have recently been found in New England. The first plate is eight inches in diameter and has a molded blue shell edge. Around the rim are transfers of various woodworkers' tools: a compass, a T-square, a ruler, a hammer, a chisel, and what appears to be feathers or quills (fig. 1). The center has the typical Masonic columns and archway, with symbolic figures on each column. Across the left-hand column is written "Virtue & Silence," and on the right hand column is "True Friendship." There is also something written on the arch, which is partly indecipherable. It says "...with Love." Under the arch are the names "LABAN AND MARY FOLGER," hand painted in black enamel.

The assumption is that this is a marriage plate, and research indicates

that Laban and Mary were married on October 11, 1796, in Gloucester, Massachusetts. The marriage was also filed on Nantucket (Laban's birthplace) and in Boston (Mary's birthplace). The pearlware body and style of the plate corresponds nicely with this time period. Laban was the son of Benjamin and Phebe (Worth) Folger, and records indicate that the family left Nantucket sometime before 1796. Mary was the daughter of Elijah and Eunice (Sargent) Mayhew of Boston, although Elijah was originally from Newburyport, Massachusetts. One would assume that Laban Folger was a man of some means to have had this plate, and possibly other pieces, made to order in England. His status as a Mason was obviously important to him. His death is recorded in Montreal, Canada, on April 19, 1810. Between his marriage and his death, no information could be found, nor any indication of children from the marriage. Mary died in Andover, Massachu-

Figure 2 Plate, England, possibly Liverpool, ca. 1794. Pearlware. D. 9⅞". (Collection of author; photo, Gavin Ashworth.) Inscribed in black transfer print "T & S DELANO."

setts, on May 3, 1817. We can only surmise that Laban may have been a "black sheep" and had taken off for Canada shortly after his marriage.

The second plate is just as much of a mystery. This plate is nine and seven-eighths inches and has a plain edge with hand painted blue flowers, squiggles, and leaves. In the center is a transfer wreath of wheat, grapes, and the initials and name "T & S DELANO" (fig. 2). This type of wreath is sometimes associated with the Masons. Delano is also a name connected to Nantucket. Records show that a Thomas Delano married Susannah Tallman in New Bedford, Massachusetts, on December 18, 1794. Thomas is listed as being "of Nantucket" at the time of the marriage. Thomas drowned in Buzzard's Bay, near New Bedford, on October 6, 1820. It is

possible that he was a fisherman. Susannah died on August 28, 1855, in New Bedford at age seventy-eight. Again, it is assumed that the plate was a marriage plate, and therefore was made in England in 1794.

We have not seen any other plates that match these, although it seems that if a transfer print was made for each of the plates, there would have been more pieces made. A search through books on transfer-printed English ceramics did not reveal transfers similar to those on the Folger plate, although there are many instances of transfer-printed designs with hand written names, especially from Liverpool.

Joyce Hanes
Hanes and Ruskin Antiques
<ljhanes@connix.com>

Jonathan Goodwin

American Export Wares Excavated in Tunstall, Stoke-on-Trent

Recent archaeological work in Tunstall has unearthed significant quantities of ceramics produced for the North American export market in the mid-nineteenth and early twentieth centuries. Waste dumps have been found which are attributable to three north Staffordshire manufacturers known to have had a sizeable interest in this trade. These finds are briefly discussed below.

Work on the demolition of the Woodland Works in Tunstall generated a pottery waste assemblage of John Wedg Wood, occupant of the factory from 1845 to 1857. Undecorated white granite ironstone-types, the ubiquitous American export ware of the mid-nineteenth century, dominate the assemblage and appear in a range of fluted tea and tableware forms (fig. 1). Transfer-printed wares are also present, with blue and flow-mulberry designs such as Geneva, Marble, and Peruvian, as are examples of factory-made slipware, shell-edged, polychrome painted and sponge-decorated

Figure 1 Undecorated ironstone forms from the Wood deposit, Tunstall, ca. 1850. Scale is in centimeters. (All illustrations courtesy Potteries Museum & Art Gallery.)

Figure 2 Printed earthenwares from the Wood deposit. *Left to right:* Peruvian, Geneva, and Marble; Tunstall, ca. 1845–1850. Scale is in centimeters.

Figure 3 Painted earthenwares from the Wood deposit, Tunstall, ca. 1847–1850. Scale is in centimeters.

earthenware (figs. 2, 3). Registration marks indicate a production date for the sherds of 1847 to 1850. Wood is notable in that he was one of the few local manufacturers whose output was almost totally devoted to supplying retail and wholesale outlets in North America.[1] Consequently, the wares from his factory group offer an important insight into the typical ceramic wants of the North American consumer in the middle years of the nineteenth century.

Figure 4 Fused earthenware dishes from the W.H. Grindley deposit, undecorated and with Lorne (center) and Beaufort printed designs; Tunstall, ca. 1847–1850.

Figure 5 Printed earthenwares from the Johnson Brothers deposit. *Left to right:* Richmond and St. Louis; Tunstall, ca. 1900–1912. Scale is in centimeters.

Up until the last few years, there has been a paucity of excavated evidence for the late nineteenth- and early twentieth-century production of American export wares. However, the recent discovery of two waste assemblages of W.H. Grindley & Co. and the firm of Johnson Brothers has helped to advance our understanding of this important, but often neglected period in the history of north Staffordshire's export trade with the United States. Both manufacturers ranked amongst the Potteries' "great 'American' firms" of the first quarter of the twentieth century, with a high percentage of either concern's output geared to supplying good quality durable earthenwares to a large North American consumer base.[2]

As with the Wood finds, the W. H. Grindley & Co. material was recovered from the site of the Woodland Works, home to the firm from 1891 until recent years. The finds consist of undecorated and transfer-printed earthenwares in a range of elaborately molded tea and tableware forms. The transfer-printed wares exhibit a number of flow-blue designs such as Beaufort, Portman, Melbourne, Syria, Keele, and Lorne (fig. 4). The styles of printed marks used suggest that the wares were made between 1915 and 1925.[3]

The Johnson Brothers assemblage is roughly contemporary with the Grindley material, dating to between 1900 and 1912, and was probably produced at the Alexandra Works, Tunstall, a short distance from where the sherds were found.[4] The two groups have clear similarities, with the Johnson Brothers wares displaying the same range of molded forms, both with and without printed decoration, that are obvious in the Grindley assemblage. Flow-blue patterns are once again prominent among the printed wares, with designs such as Richmond and St. Louis (fig. 5). The undecorated forms are restricted to wares of an ironstone-type body.

Jonathan Goodwin,
The Potteries Museum & Art Gallery
Bethesda Street

Hanley, Stoke-on-Trent
<jon.goodwin@stoke.gov.uk>

1. Neil Ewins, "Supplying the Present Wants of our Yankee Cousins: Staffordshire Ceramics and the American Market 1775–1880," *Journal of Ceramic History* 15 (1997): 60–71.

2. G. W. Rhead and F. A. Rhead, *Staffordshire Pots and Potters* (London: Hutchinson & Co., 1906), pp. 313–14.

3. G. A. Godden, *Encyclopaedia of British Pottery and Porcelain Marks* (London: Barrie & Jenkins, 1991), p. 294.

4. Cartographic sources show the area in which the sherds were discovered as open waste ground between 1900 and, at the very latest, 1912, at which point the modern street was laid down. The Johnson Brothers material must have been dumped here during this twelve-year period.

Catherine Zusy

Archaeology at the United States Pottery Company Site in Bennington, Vermont

For several weeks during 1997 and 1998, project director Catherine Zusy, archaeologists David Starbuck and Victor Rolando, and over seventy volunteers excavated at the U.S. Pottery Company (1847–1858) site in Bennington, Vermont. The goal of the project was to learn more about the production of Christopher Webber Fenton's pottery—the first large production pottery in New England and possibly the first in the nation to produce parian porcelain figures. While many have written about the factory and its products, there remains much confusion about what it made, especially in regard to parianware. The pottery marked little of its parian (no figures are known to be marked), published no illustrated price lists, and employed English designers who regularly copied English forms.

Figure 1 Miscellaneous ceramic fragments recovered from the U. S. Pottery Co. site during 1997 and 1998. *Top, left to right:* parian porcelain curtain tie-back, parian porcelain door plate. *Middle, left to right:* parian porcelain sailor boy with dog figurine, earthenware cow creamer. *Bottom, left to right:* yellow ware *fleur de lis.* (Courtesy, Bennington Museum; photo, Gavin Ashworth.)

Figure 2 Pitcher fragments of parian porcelain in the Lily of the Valley pattern recovered from the U. S. Pottery Co. site during 1997 and 1998. (Courtesy, Bennington Museum; photo, Gavin Ashworth.)

Bennington Elementary School now sits on top of the site of the former factory, so most pits were dug to the south of the school, blacktops, and playgrounds, just south of the 1853 wing of the pottery building. These excavations produced over 18,000 bits of kiln furniture, and more than 27,000 ceramic fragments were unearthed, including bisque earthenware (12,291); parian (8,488); Rockingham and flint enamel (3,139); yellow and white wares (2,017); and agateware (309). Most of the earthenware fragments were of forms previously documented as Bennington, of which there are many marked pieces of the firm's earthenware.

Over half of the parian shards could be identified as fragments of twelve documented Bennington parian pitcher designs: Pond Lily; Wild Rose; Tulip and Sunflower; Palm Tree or Paul and Virginia; Charter Oak; Arabesque; Cascade; Acanthus; Climbing Ivy; Flower and Vine; and Bird and Nest. Unknown variations of four of the pitchers— Charter Oak, Wild Rose, Ivy Vine, and Acanthus Leaf— were found, but not fragments of the documented pitchers Love and War and Snowdrop.

Fragments of a parian doorplate, doorplate letter, doorknob, curtain tieback and one figure (probably Sailor Boy and Dog) were found—all items listed on a company price list dated 1852, but not firmly identified until now (fig. 1). The 1852 price list is the last one extant for the company and the

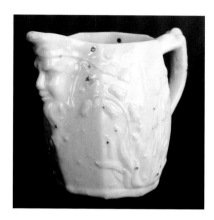

Figure 3 Pitcher, Lily of the Valley
pattern, U. S. Pottery Co., Bennington,
Vermont, 1853–1858. Parian porcelain.
H. 4½". (Private collection; photo, Jay
Lewis.) Upon hearing a description of
this newly discovered design, a prominent
American ceramic collector furnished this
photograph of the complete pitcher, now
confirmed to have been made at the U. S.
Pottery Co.

only one that includes parian, enumerating eleven figures in "parian marble."
The firm made parian statuettes, vases, and clockcases until at least 1856. Also
found were fragments of porcelain insulators and a blue and white cane han-
dle in the shape of the head of an old bearded man. Only one possible vase
fragment was unearthed, and no trinket box fragments were uncovered.

Perhaps of greatest interest was the discovery of 112 sherds of a small
paneled parian pitcher design not yet identified with Lily of the Valley
design (figs. 2, 3). Four other new earthenware forms were discovered: a
pitcher with *fleur de lis* design; a sugar bowl or teapot with foliage and
grape decoration; a hanging planter with acanthus leaf handles; and an
agateware form, probably a pitcher, with a double diamond decoration. In
addition, twelve designs previously only attributed to Bennington were
found: the parian objects noted above and, in earthenware, a hound-han-
dled pitcher, cow creamer, candlestick, candlestand, raspberry flask,
pedestal goblet, tumbler, and spittoon with shell decoration. Seventy-five
"mystery" fragments were also recovered, including over eighteen handles.

At least ten forms documented as products of the U.S. Pottery Com-
pany were not found, and only one or two fragments of the firm's
renowned hound-handled pitcher and cow creamer were. While these pre-
liminary excavations add to our knowledge of the factory's production,
they by no means complete it, as less than one percent of the four-acre site
was examined. Furthermore, the two schools that have subsequently been
erected there have disturbed the site, and it is likely that the factory was
dumping elsewhere as well. Future research including archaeology, histor-
ical research, and scientific study is needed to complete the story of the
United States Pottery Company.[1]

ACKNOWLEDGMENTS
The author wishes to thank the American Ceramic Circle for providing
major financial support for the 1998 excavations.

Catherine Zusy
Ceramics Specialist and Consultant
CathZusy@aol.com

1. Victor R. Rolando and Catherine Zusy, "Archeology at the United States Pottery Co.
Site in Bennington, Vermont," *The Journal of Vermont Archaeology* 3 (2000): 86–114.

Mark M. Newell

The Search Continues: New Insights into Old Edgefield Folk Potters

Figure 1 Jug, W. F. Hahn, Edgefield, South Carolina, 1883–1889. Stoneware with alkaline glaze. (Photo, Mark Newell.)

In the 1930s, recognizing that few potters who witnessed the closing years of the Old Edgefield folk pottery tradition remained, the Charleston Museum wittingly compiled information about the vanishing industry. Their efforts resulted in a few typewritten annotations and some very fine acquisitions for the museum's collections. Included in the accounts is an interview with George Fletcher, a potter from North Augusta, South Carolina, who, with his wheel and clay, came to Charleston to demonstrate the vanishing craft.

During his demonstrations, Fletcher recalled life as a turner in the last productive days of the stoneware potteries of the Old Edgefield District, and conveyed information about his fellow potters, including W. F. (Willie) Hahn, who was noted for his masterfully rendered beaded necks and bowl rims.[1] The museum collected vessels made by Hahn, and stamped "Trenton, SC" and "Augusta, GA." But other than his unmistakable skill and two places of work, little was known about W. F. Hahn for the next sixty years.

In the late 1980s, interest in Edgefield County's folk pottery traditions was renewed by avocational researchers, as well as by scholars at the McKissick Museum at the University of South Carolina, who had begun collecting histories and archival material on the subject. The museum's research resulted in *Great and Noble Jar,* the first major book on the potteries, by Cinda K. Baldwin. She wrote that a potter named Hahn worked at the John W. Siegler pottery established in 1853 on Shaw's Creek near Eureka, South Carolina, and that as recently as the 1980s, local residents claimed that Hahn worked there. She also noted that both W. F. Hahn and P. L. Hahn were working in Schultz Township after 1900, and that evidently W. F. Hahn had operated a pottery at Trenton before.[2]

In 1996, the Georgia Archaeological Institute (GAI) of Augusta began a re-assessment of these earlier findings surrounding Edgefield County's folk pottery traditions. GAI's program began in North Augusta, South Carolina, which is the present day location of Schultz Township on the Savannah River, opposite Augusta. Although in South Carolina, the area is clearly regarded as an extension of Augusta. Concurrently, much of Willie Hahn's history was uncovered in the Augusta city directories, archived at the Augusta-Richmond County Library. The accounts provided a glimpse of the fascinating bonds forged by the Edgefield potters through their social contact and working relationships.

As first reported in *Ceramics in America* (2001), a spectacular discovery of over 600 intact buried vessels was made on the Joseph Gregory Baynham pottery site near Eureka, South Carolina. Analysis of the stoneware vessels showed that, although clearly stamped "JGB," judging from their necks, William and Thomas Hahn undoubtedly turned a significant volume of the total deposit (figs. 1, 2).

Excavations also revealed that, beneath the Baynham occupation, a preceding pottery produced magnificently turned stonewares dating from at least 1862 to approximately 1872 (fig. 3). Exhibiting a clay body, style, and beautiful green alkaline glazes, these earlier vessels are vastly superior and

Figure 2 Jug, T. L. Hahn, Edgefield, South Carolina, 1883–1889. Stoneware with alkaline glaze. (Photo, Mark Newell.)

Figure 3 Jug, J. L. Miles, Edgefield, South Carolina, 1862–1872. Stoneware with alkaline glaze. (Photo, Mark Newell.)

Figure 4 Drawing illustrating neck treatment typical of W. F. Hahn. (Drawing, Christine Newell.)

Figure 5 Drawing illustrating neck treatment typical of T. L Hahn. (Drawing, Christine Newell.)

different from those of the Baynham era. They are believed to be from the pottery run by John Lewis Miles, the son of Lewis Miles, one of the most significant of the earlier Edgefield area potters.[3]

Both Hahns apparently worked for Joseph Baynham for six years before moving to Schultz Township in 1889. When he was fifty-one, W. F. Hahn established his Schultz Township pottery on the corners of West and Bluff Avenues in 1899. His twenty-eight-year-old son, Thomas L. Hahn, worked as a potter for the Southern Pottery Company in Schultz Township, also in the same year.[4] Two years after his father died in 1908, Thomas established his own pottery a few blocks from his father's old business on Railway Avenue in what had by then become North Augusta, South Carolina.

Since father and son were working at different potteries at the same time, GAI researchers surveyed local collections and compared the well-known "Hahn" beaded necks on vessels from the W. F. Hahn Pottery, Augusta works, and the Southern Pottery Company. A clear difference in potting techniques between father and son emerged. Necks produced by W. F. Hahn possess a distinct center ridge around the middle of the neck (fig. 4); necks turned by T. L. Hahn at Southern Pottery do not (fig. 5).

In an attempt to understand the differences, many Hahn-style vessels were reproduced in the GAI pottery laboratory. It was discovered that turning the neck with two extended fingers resulted in the "finger-ridge" on W. F. Hahn's vessels; the ridge was caused by the slight v-shape between the fingers. By using the side of the palm to lift up the neck, smooth elegant necks like the T. L. Hahn necks were duplicated. Later excavations of the 1908 T. L. Hahn pottery confirmed Thomas' distinctive style. Produced two years after W. F. Hahn's death, all of the necks recovered were smooth and showed no signs of the middle finger ridge. This discovery, coupled with the hands-on experimentation, led to new insights that allowed archaeologists to identify who turned what at the Baynham

pottery site. Also, based on archaeological evidence found there, W. F. Hahn apparently burned pottery at the old Miles kiln prior to Baynham's purchase of the property in the early 1870s.

Willie died in North Augusta in 1906 and was buried in Graniteville Cemetery next to his wife's family plot in Graniteville, South Carolina.[5] A few years later, his wife, Sarah, was buried next to him. Almost fifty years later, Tommy, who had become a prominent Augusta attorney by the time of his death, was laid next to him, as was Tommy's wife.

The role played by "Hahn" in the latter years of the Old Edgefield pottery tradition has two distinct faces: those of Willie and Tommy, as they are now affectionately known. Although a great deal more about the contribution of the Hahns to the Edgefield pottery tradition is known, one mystery remains: the Hahns' origin. That the elder Hahn may have come from Germany is just an assumption. Some collectors believe that Willie came from the Kirksey area where his name was Willie Horne, and that when he married Sally Durham from Graniteville, South Carolina, he changed his name to Hahn, a more socially prominent family name in the area. Is there any truth to the story? It is true that Horne and Hahn are considered interchangeable names in the area to this very day.

Mark M. Newell, Ph.D.
Director
Georgia Archaeological Institute
<mmnewell@yahoo.com>

1. Notes collected by "Miss L.M.B. and E.B.C.," Charleston Museum Archives, June 1930.

2. Cinda K. Baldwin, *Great and Noble Jar* (Athens, Ga.: University of Georgia Press, 1993).

3. Maloney City Directory, 1899, p. 403. On file at Augusta-Richmond County Library, Augusta, Ga.

4. South Carolina 1870 Census, Department of Archives and History, Columbia, S.C.

5. Graniteville Cemetery Association, Register of Burials, 1906, p. 20.

Richard Veit and
Mark Nonestied

Bombs Away!
Unearthing a
Cache of Terra
Cotta Practice
Bombs from the
First World War

Figure 1 This photograph shows several workmen standing in front of a machine used to press clay slabs into terra-cotta bombs, ca. 1918. Note the finished bombs on the table in the front center of the photograph and the extruded clay slabs stacked on the floor in the front right of the photograph. (Courtesy, Middlesex County Cultural and Heritage Commission.)

The Cornelius Low House/Middlesex County Museum, a project of the Middlesex County Cultural and Heritage Commission, researches and mounts exhibits pertinent to New Jersey history. Recently, while preparing for an upcoming exhibit titled "UnCommon Clay: New Jersey's Architectural Terra Cotta Industry," museum staff members Mark Nonestied, Hillary Murtha, and Guest Curator Richard Veit visited the sites of half a dozen terra cotta manufacturers in Middlesex County, New Jersey. These factories were active between the 1870s and 1960s, at a time when New Jersey led the nation in the production of architectural terra cotta. Through the cooperation of the property owners, access was gained to many sites that had previously been off limits to researchers. During a site visit in the fall of 2001 to the former Federal Seaboard Terra Cotta Corporation in Woodbridge Township, New Jersey, a large cache of terra cotta practice bombs was discovered. Although historians and archaeologists were aware that terra cotta practice bombs had been produced during the First World War, until this discovery it was thought that they had all been used and hence lost.

Figure 2 Women affixing fins to terra cotta dummy bombs on an assembly line at an unidentified New Jersey site, ca. 1918. (Courtesy, Middlesex County Cultural and Heritage Commission, Stephen Kermondy Donation.)

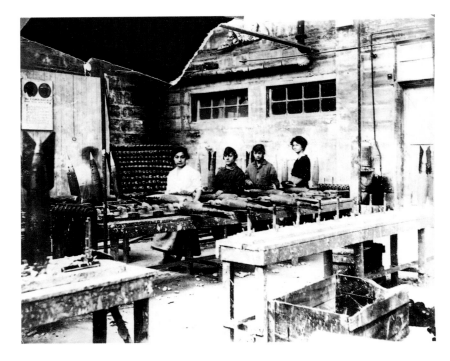

Figure 3 Workmen loading pallets of terra cotta practice bombs at the Atlantic Terra Cotta Company's Plant #1, Staten Island, New York, ca. 1918. (Courtesy, Staten Island Historical Society.)

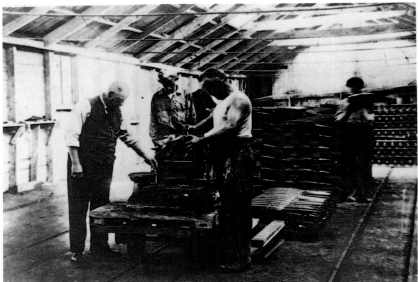

Architectural terra cotta is a versatile medium, which can be molded, sculpted, and glazed to imitate all sorts of materials. Turn of the century architects saw it as a superior building material that was long lasting, impervious to the elements, easily glazed, lighter and cheaper than stone.[1] Most of the architectural terra cotta produced in New Jersey's clay district was used as ornamental cladding on the first skyscrapers. In addition to architectural pieces, terra cotta workers made a variety of other items. These included colorful grave markers, hitching posts, carriage blocks, chimney pots, and statuary.[2] With good reason, terra cotta was known as the great imitator.

Perhaps the most unusual use of terra cotta was in the form of dummy or practice bombs. These were made and used during the First World War. With the United States' entry into World War I in April of 1917, there was a shift from the production of domestic goods to the manufacture of war-related materials. Responding to the shortage of architectural work and the need for military supplies, several terra cotta manufacturers, at the request of the United States Army Air Corps, began manufacturing terra cotta bombs. According to historian William McGinnis:

> Harry M. Gerns (of Federal Terra Cotta) was sent to Washington on request of the War Department. Major Burgardees asked whether practice bombs weighing about twenty pounds could be made. They were made at the Amboy plant from drawings furnished by the Major. An order was immediately placed for 500,000.[3]

At least four firms manufactured the practice bombs. They included two New Jersey firms, Federal Terra Cotta of Woodbridge and New Jersey

Figure 6 A sample of the 124 bombs recovered by the Middlesex County Cultural and Heritage Commission. (Photo, Mark Nonestied.) Note the unexcavated samples in the upper left corner of the photograph.

Figure 7 An intact terra cotta practice bomb. L. 25¾". (Photo, Gavin Ashworth.) Notice the coarse texture of the clay body. Apparently the bombs were hastily and rather sloppily manufactured.

Figure 8 Upright view of bomb illustrated in figure 7.

Terra Cotta of Perth Amboy, as well as the Atlantic Terra Cotta Company of Staten Island, and the American Terra Cotta Company of Illinois. The cache of bombs was found at the Federal Terra Cotta Company's Woodbridge factory. Historic photographs from that factory and others show the manufacturing process, including pressing the clay, assembling the bombs, and stacking them on pallets for shipment (figs. 1–3). A blueprint dated April 11, 1918, from the New Jersey Terra Cotta Company also depicts a bomb like those recovered in Woodbridge (fig. 4).

During a recent interview, centenarian William R. Crooks, the United States' oldest living military pilot, recalled using terra cotta practice bombs in flight school. Crooks, a World War I veteran, learned to fly in 1918. He stated that each of the planes carried four terra cotta practice bombs under their wings. The bombs were armed with shotgun shell firing mechanisms.[4] Susan Tunick, author of *Terra-Cotta Skyline*, cites George A. Berry III, the last owner of the American Terra Cotta Company, who "explained that these hollow-clay practice bombs . . . were filled with flour or powdered plaster, whichever was available. The spot where the bomb 'exploded'

would thus be covered with a white powder which was easily visible and helped to assess the accuracy of each drop."[5]

With the end of the war the market for terra cotta practice bombs dried up. The factories went back to manufacturing architectural elements. Upwards of a thousand stacked dummy bombs were abandoned next to a railroad siding at the Federal Seaboard factory. In 1941 the plant closed and a cardboard box manufacturer took over the factory. Overgrown with weeds, the bombs lay forgotten until their recent rediscovery.

During a site visit in October of 2001, museum staff along with members of the Woodbridge Historical Association toured the factory grounds. Along with architectural terra cotta, several strange conical terra cotta fragments were noted in a recently graded portion of the property (fig. 5). Hurried excavation revealed that these items were in fact the bodies of dummy bombs (fig. 6). Further investigation quickly revealed that upward of a thousand were located near a former rail line that serviced the factory. The bombs, stacked in courses of about eight feet high, made up a small embankment leading up to a former loading platform. The embankment measured about 150 feet in length, and one section also contained architectural terra cotta fragments. As the site is slated for redevelopment, the Woodbridge Historical Association with the Middlesex County Cultural and Heritage Commission carried out a systematic recovery of 124 bombs.

The practice bombs were made from coarse red terra cotta and appear to have been manufactured in two-piece molds as they show a seam running lengthwise up their sides. They measure twenty-five and three-fourths inches long, and five inches in diameter (figs. 7, 8). Each bomb weighs eighteen pounds. The bombs' tails were notched and grooved to accept fins. These unusual ceramic artifacts attest to the versatility of terra cotta, and also serve as grim reminders of the first use of aerial bombing during World War I.

ACKNOWLEDGMENTS
This research was made possible by the Middlesex County Cultural and Heritage Commission, a department of County Government, and the Middlesex County Board of Chosen Freeholders.

Richard Veit, Ph. D.
Director, Monmouth University Center for New Jersey History
Department of History and Anthropology, Monmouth University
West Long Branch, N.J.

Mark Nonestied
Assistant Curator, Middlesex County Museum
Middlesex County Cultural and Heritage Commission
New Brunswick, N.J.

1. Richard F. Veit, "Moving Beyond the Factory Gates: The Industrial Archaeology of New Jersey's Terra Cotta Industry," *IA: The Journal of the Society for Industrial Archaeology* 22, no. 2 (1999): 5–28.

2. Ibid., p. 19.

3. William C. McGinnis, *History of Perth Amboy, New Jersey 1651–1962* (Perth Amboy, N.J.: American Publishing Company, 1962), p. 11. McGinnis erroneously notes the company as Seaboard. In fact, it was Federal Terra Cotta, which merged with the South Amboy Terra Cotta Company and New Jersey Terra Cotta Company in 1928 to form Federal Seaboard Terra Cotta.

4. (http: www.af.mil/news/Oct2001/n200).

5. Susan Tunick, *Terra-Cotta Skyline* (Princeton, N.J.: Princeton Architectural Press, 1997), p. 113.

Book Reviews

Moira Vincentelli. *Women and Ceramics: Gendered Vessels*. Studies in Design and Material Culture. Manchester and New York: Manchester University Press, 2000. Distributed in the U.S. by St. Martin's Press. xii + 290 pp.; bw and color illus., bibliography, index. $35.00.

Ceramics are one of the most durable objects of material culture, and they reflect the aesthetic tastes of the societies in which they are produced and consumed. Because they are time and culture sensitive, they are widely employed by scholars to reconstruct histories of past and present societies. In *Women and Ceramics: Gendered Vessels,* Moira Vincentelli advances the thesis that women have been primary producers and consumers of ceramics. Her principal claim is that not only have women been left out of the history of this technology but also that their self identity and social status then, as now, are intertwined with its art and craft.

Vincentelli systematically reviews these claims by documenting women's contributions to the technical and aesthetic properties of ceramics, the techniques they have employed, and their long history of involvement in pottery production. Drawing on archaeological, ethno-archaeological, and ethnographic evidence, she engages in a broad-ranging discussion of the long-term history of ceramic production that begins with the world's earliest producers of ceramics and ends in the present. In this, the author is successful at presenting information on myriad and some little-known sources. But, perhaps because her undertaking is ambitious, coverage is not always even or complete, and the author fails to consider important scholarship that may have altered some of her conclusions. Nonetheless, scholars and others with interests in feminism, the history of women, ceramics, and technologies will find much that is original in both substantive and theoretical realms. In addition, the book is beautifully produced. It includes numerous illustrations and black-and-white photographs of potters at work in home and factory settings and pottery from a range of societies. Twelve color plates provide exquisite reminders of the aesthetic qualities of ceramics, even those used for the most mundane activities.

The book is divided into eleven chapters. Its basic premises are set out in chapters 1 through 3 and chapters 10 through 11. Chapters 4 through 9 describe case studies for the production and consumption contexts in which women have engaged in the craft as producers, business owners, collectors, writers, and teachers.

Vincentelli's theoretical position is drawn from structuralist, post-structuralist and French feminist theory, feminist archaeology, and her experiences as a university teacher of art history. The work is inspired by subject matter such as "women artists, gender and feminist issues, Welsh art, non-western art and material culture, and the applied arts" (p. 2) and new ways of thinking that have the potential to bring women and ceramics into the center of the art historian's image of craft as art. She is especially persuaded by developments in material culture studies in which objects can be viewed as "texts," as proposed in the works of the structuralist and post-structuralist theorists Michel Foucault, Roland Barthes, and Pierre Bourdieu. These works provide a basic structure with which to understand the power relations by which crafts and certain production techniques, such as hand building or ceramic decoration, have been assigned an inferior position to art. Closely allied to this position are the works of psychoanalytic theorist Jacques Lacan and French feminist thinkers who view language and culture as primary mechanisms by which the unconscious is shaped. The notion of *ecriture feminine* (feminine writing) developed by Julia Kristeva is seen as an oppositional mode to the prevailing patriarchal culture which is transmitted through language. The *ecriture feminine* assumes that a pre-symbolic phase of learning is aligned with the feminine. Taking these views an additional step, Vincentelli argues that "ceramics as made by women, and even more, as used by women can be mobilized to create meanings of solidarity or subversion in forms of visual ecriture feminine" (p. 4).

Vincentelli's interrogation of the visual *ecriture feminine* is embodied in the technical choices that she claims women have consistently made. She notes, for example, that although contemporary western and non-western women potters have used the potter's wheel and more efficient techniques in deference to today's world economies, many women potters have returned to techniques like hand building that have strong "feminine" associations that presumably reside in pre-symbolic phases of learning: "Coiling a pot is a rhythmical activity . . . [that] . . . requires smoothing and polishing and a delicate handling . . . [and] . . . is given a great deal of time. It is valued as a pleasurable activity and the polishing stones are treasured tools passed from mother to daughter" (p. 237). Speaking of the potter Magdalene Odundo (originally from Kenya, now in Britain), she states: "Her vessels make reference to the natural world—to bodies, nipples, gourds or stamens They exude a tactile and sensuous experience through beautiful burnished surfaces whose soft sheen speaks the loving attention that has created them" (p. 237). There is, therefore, a gendered component to women's ceramic production in this consistent embracing of technical practices that foster maximum closeness between the hand and the material. And finally, in a discussion of figurine production, she notes that figurines produced by women, because they "explore female sexuality and female symbolism," tend to cause distress among critics because these representations of female sexuality embodied in the very "practice of ceramics" replace the male with the female gaze, thus empowering the latter while destabilizing and undermining "patriarchal order" (p. 246).

Although some scholars would argue with Vincentelli's interpretations of these contemporary works, they would appreciate the rich array of case studies included in the book that document women's technical choices and their involvement in various aspects of ceramic production and consumption in both western and non-western societies. Some examples are based on reviews of the works of others, but the remaining are from the author's primary field of research. On the production side, they include women's participation, throughout a variety of historical periods, in work cooperatives, as independent artisans, and in industrial and traditional contexts, each of which demonstrates the ways in which women have contributed to ceramic history and technology. On the consumption side, five chapters are devoted to the collection and display of ceramics, workshop arrangements, promoters and patrons, writers and teachers, and running a business. These chapters demonstrate how women have influenced the development of ceramics as court patrons and as owners of shops and galleries, attesting to their intense involvement in determining the direction of aesthetics and the functions of ceramics.

Although, on the whole, Vincentelli provides a well-grounded history of the links between women and ceramics, the work is dependent upon broad generalizations. Some of these can be sustained in her discussions of contemporary potters and even her attempts to link them to the remote past, but in other instances, her argument breaks down. Indeed, many of the basic premises of the book rely on a selective reading of the archaeological literature and reviews and critiques of models employed by archaeologists. Included are discussions of early matriarchal theories, mythologies involving pottery production, and some case studies in which ceramic production has been attributed to women. Unfortunately, Vincentelli for the most part relies on outdated analyses and ignores the explosion of ceramic studies that focus on gender issues. When the works of feminist archaeologists are consulted, they seem to have been subject to a poor reading. As feminist archaeologists have shown, there has been a tendency in archaeology before the 1990s to associate women with lower status crafts. Status differences in crafts are based on modern categories in which technologies are ranked hierarchically and various arts and crafts or production techniques are assigned higher and lower value. These categories or hierarchies are then imposed on past societies. Along the same lines, feminist archaeologists are in general agreement that women's engagement in pottery production is defined by gender ideologies that are established within a particular cultural context and that, in past archaeological reconstructions, evolutionary biases have wrongly assumed that women ceased to produce ceramics when production moved from the household to barter- or market-based economies. These findings are very much in accord with Vincentelli's critique of the older archaeological literature; however, she parts company with feminist archaeologists when, based on her interpretations of contemporary works, she associates women with specific technical practices. Statements to the effect that certain "techniques and modes of production constitute a sufficiently distinct phenomenon to be designated

women's ceramic traditions" (p. 32) and "hand building, burnishing, painting, and bonfiring are never exclusively women's techniques, but they are predominantly so" (p. 35) simply cannot stand without attention to the specifics of time and place. Although Vincentelli's attempts to uncover basic structures that lie beneath exclusionary biases in which women's work has been accorded lower status are very much in line with recent attempts by archaeologists, her interpretations could not be more anathema to the works of feminist archaeologists who have avoided and vigorously argued against essentialist assumptions in which women's biology (or here psychology) is assumed to be aligned with some universal, natural, static, inevitable, and predictable sets of mind and body. More importantly, they would appear to contradict Vincentelli's own cautions concerning the kind of evolutionary thinking that has restricted our understanding of the contributions women have made in both the present and past.

That said, there is much grist for the mill, and although many, but not all, readers will disagree with Vincentell's interpretations, the examples and source material described in this book are a virtual treasure trove. Artisans not formerly known now take their place in the history of women and ceramics, as do the works of many contemporary studio and traditional potters. Thus, the book offers a partial remedy to a forgotten history and at the same time provides inspiration to women engaged in this and other artistic endeavors.

Rita P. Wright
New York University

David Gaimster, editor. *Maiolica in the North: The Archaeology of Tin-Glazed Earthenware in North-West Europe c. 1500–1600*. Occasional Paper No. 122. London: British Museum, 1999. 188 pp.; bw and color illus. £25 paperbound.

Any attempt to review a collection of papers delivered at a colloquium is akin to trying to shake hands with an octopus: one doesn't know with whom to begin or where to focus. Equally baffling is the readership enigma. In the field of commercial publishing the first questions asked are (1) who will want to read this book and (2) how many people will buy it? Subsidized publishing, on the other hand, is different. The book doesn't have to turn a profit, and if the readers are relatively few, at least they will be appreciative.

I had long supposed that the terms colloquium and symposium were synonymous, but there is a none-too-subtle distinction between them. According to Webster, the latter is a social gathering at which ideas are exchanged or where "specialists deliver short addresses on a topic or related topics." A colloquium, on the other hand, is a heavy-duty affair whose definition includes neither the words social nor short. The British Museum's invitation of March, 1997, brought together the top people in their related fields and lasted two full days.

As a title, *Maiolica in the North* has a somewhat chilling ring, but between this volume's pages lies an iceberg of information, a little of it on the surface and much more beneath. Compiled under the editorship of the British Museum's David Gaimster, sixteen authors combined to address a single century's production of one ceramic ware from a relatively small region. The result is a study in remarkable depth and of assured durability.

The tin-glazed wares manufactured in the South Netherlands were first brought to the attention of English-reading curators and collectors by Bernard Rackham in *Early Netherlandish Maiolica with Special Reference to the Tiles at the Vyne in Hampshire*. The tiles had been discovered in a garden of the Tudor house believed to have been built by Sir William Sandys, who had bought them while serving as Treasurer of Calais and who returned with them in 1522 or thereabouts. At an uncertain date in the nineteenth century, the discovered tiles were relaid in the Chapel at the Vyne, where they remain. Their importance to Rackham, and to John G. Hurst, who discussed them in his colloquium address, was simply stated: These were, and are, the earliest documented tin-glazed tiles found in England, and have a prefatory place in any discussion of the ware, no matter what its form.[1]

At the beginning of the sixteenth century, the shapes were few: vases with or without ring handles, some rather squat and ugly jugs, and waisted pharmaceutical *albarelli*. Logic dictates that most of the vases and jugs were imported prior to the Dissolution of the Monasteries in 1533, being decorated with the sacred YHS monogram peculiar to Catholicism. However, as John Hurst pointed out, the presence of so many fragmentary examples from secular sites may be evidence of private (even heretical?) devotion. Not until much later did Netherlandish production expand to include inferior copies of the elaborately decorated "faienza" dishes that were the glory of North Italian ceramic art in the latter years of the fifteenth century.

Growing collector interest in early English delftware that began in the late nineteenth century inevitably carried with it curiosity about the genesis of the decoration and the technology of the ware's manufacture— which, in truth, was Italian and not Dutch. It was out of that interest that Bernard Rackham's pioneering book was born. Two years earlier, in an equally seminal book, Rackham and his partner Herbert Read published *English Pottery* and in it addressed the Italian connection. They stated that "Research in archives and the yield of excavations have given us what we may probably regard as the truth of the matter." As the 1997 papers reveal, modern technology enables us to go much further, littering the way with the carcasses of hitherto sacred cows.[2]

In an editorial note, David Gaimster grapples with the all-too-familiar problem of misleading terminology and differentiates between style and place of origin. Here Netherlandish is retained to identify the sixteenth-century adaptation of Italian styles and technology into the Spanish Netherlands and the adjoining Dutch Republic. The Netherlands, on the other hand, refers only to the modern sovereignty so named. It can be argued, therefore, that tin-glazed wares produced in the modern Netherlands can fairly be called delftware (with a lowercase d unless attributable to Delft

itself), while similar wares produced in what is now Northern France should be called faience. In the sixteenth century, the northern maiolica industry flourished first in the vicinity of Antwerp, and it was from there, in 1567, that the first known maiolica potters emigrated to Norwich in East Anglia and sired the delftware industry that would dominate the tables of middle-class English households throughout the seventeenth century.

Since the Second World War, much more information has been garnered through archaeology, first as the result of German and Allied bombing, and subsequently by urban renewal programs both in Britain and in Western Europe. That diversity of sources is made manifest by the spread of contributors to this volume, e.g., Jan Baart in Amsterdam, Johan Veeckman on Antwerp, Alejandro Gutierrez at Southampton, John Allan on the West of England at Plymouth and Exeter, John Cotter at Colchester, plus the editor and others on finds from London.

This reviewer had what is now seen as the privilege (but then the unenviable task) of beginning salvage work on the building sites of post-war London, and there made the first archaeologically controlled recovery of a still important group of Netherlandish-type maiolica. Those three associated pieces came from a chalk-walled cellar on the site of what is now Gateway House on Queen Victoria Street. Consequently, their inclusion in this volume is cause for some small satisfaction—until one discovers that two of them lie among the nomenclaturic carcasses.

Of the three vessels, I followed Rackham in accepting the two small vases as Netherlandish while cautiously describing the jug as being of "Faenza style" on the evidence of a parallel in the Victoria and Albert Museum. One of the vases bore the sacred initials YHS already well known on similar, tin-glazed vases that featured a pair of ring handles. But this example differed, having what are best described as inverted-lobe handles. The second vase was decorated with a stylized peacock feather device and had the same handles. But regardless of their anomalous handles, I would continue to accept the vases as Netherlandish until NAA proved otherwise and the results were published in the colloquium's seminal paper, "De Nomine Jhesu...&c.," by Hugo Blake.[3]

NAA is not, as one colleague suggested, an acronym for Netherlands Automobile Association, but stands for Neutron Activation Analysis. That relatively new process is to ceramic clay what DNA testing is to innocents on death row. It compares the elements found in the body of one pot to those of another from a known kiln site, revealing beyond all argument whether both samples are or are not from the same source. The NAA matches for the Gateway House vases were found not in Antwerp, but in Northern Italy. In the course of the British Museum's extensive testing, many another hitherto Netherlandish vessel changed its nationality. The impact of this revelation provides the focus for most of the papers contained in this volume, as is indicated by the title of David Gaimster's introductory essay, "Maiolica in the North: The Shock of the New."

Needless to say, NAA is not limited to the re-classification of tin-glazed earthenwares of the sixteenth century. It can be applied to wares of every

clay composition and date and requires only that there be an anchoring data base of known origin. Although, in theory, NAA promises to solve most ceramic questions, in reality it is as yet limited to specific questions being asked by specialists who can thereby contribute to their laboratory's own research. In short, the process is not yet economically available to Aunt Mary, who wants to know whether her heirloom chamber pot really did come from Bideford as family tradition claimed.

That caveat aside, *Maiolica in the North: The Archaeology of Tin-Glazed Earthenware in North-West Europe c. 1500–1600* belongs in the library of every museum and collector having an interest in the evolution of delftware, maiolica, or faience. Four years after the last of the speakers left the podium, one dares to hope that someone among them will be moved to synthesize the colloquium's shared knowledge into a conventional book that can be read easily and with instruction by all who have an interest in these wares. To the archaeologist, however, the published papers make it very clear that the visual identification of ceramics based on style or osmosis is no longer acceptable. For the time being, at least, we are left fearing that we are wrong, yet helpless to be right. Within this narrow field alone, the class that for generations has been called Early Netherlandish Maiolica has suddenly become Italo-Netherlandish, meaning "we'll get back to you with one attribution or the other after we can afford to invest in Neutron Activation Analysis."

The British Museum Press stands tall among the few subsidized presses able to elegantly publish volumes whose sales do not offset the cost of production and distribution. That this is Number 122 in the Museum's series of Occasional Papers speaks eloquently for itself.

Ivor Noël Hume
Williamsburg, Virginia

1. Bernard Rackham, *Early Netherlandish Maiolica with Special Reference to the Tiles at the Vyne in Hampshire* (London: Geoffrey Bles, 1926).
2. Bernard Rackham and Herbert Read, *English Pottery* (New York: Charles Scribner's Sons, 1924), pp. 38–39.
3. Bernard Rackham, *Italian Maiolica* (London: Faber and Faber, 1952), fig. 27b.

Kieron Tyler and Roy Stephenson, with J. Victor Owen and Christopher Phillpotts. *The Limehouse Porcelain Manufactory: Excavations at 108–116 Narrow Street, London, 1990.* MoLAS Monograph 6. London: Museum of London Archaeology Service, 2000. x + 73 pp.; color illus., line drawings, glossary, index. £16.50.

Over the last thirty years, with the enactment of government legislation protecting archaeological resources in both the United States and Great Britain, hundreds of technical reports on salvage excavations have been written annually. Most of these reports and the resulting artifacts end up in government repositories, having only been reviewed by a few bureaucrats overseeing the compliance process. Much of the compiled historical

and archaeological information awaits rediscovery in the drawers and shelves of these government agencies.

Occasionally a technical monograph is made available through a limited publications series. Even more rarely, the results of a rescue excavation are so important that they catch the attention of a broad audience and receive the royal treatment of a glossy, full-color publication. Such is the case with the Museum of London's excavation of the Limehouse porcelain manufactory site in the east London borough of Tower Hamlets.

This important factory operated between 1745 and 1748, making it one of the earliest of the English porcelain endeavors. The history of English porcelain, in general, is of great interest to collectors, connoisseurs, economic historians, and students of ceramic innovations. The early attempts at making porcelain are of particular significance as the English factories conducted a tremendous amount of experimentation in the pursuit of marketable products.

The existence of the Limehouse porcelain factory came to light in 1928, when historical references to it were published. Products of the porcelain factory were not specifically identified until 1959, when the eminent porcelain scholar and collector, Dr. Bernard Watney, attributed a group of porcelain long held to be of Liverpool origin to the Limehouse factory. Although these identifications were made using the toolkit of the connoisseur, Dr. Watney provided well-reasoned arguments in his published paper.[1]

The actual physical remains of the factory lay undetected until the Museum of London's Department of Greater London Archaeology investigated the site in 1990 in advance of the proposed construction of the Limehouse Link road tunnel. The nature of the agreement between the archaeologists and the construction managers permitted eight weeks of investigation on the site, and the authors acknowledged that consequently much of the field research was done "under rescue conditions" (p. 1). These conditions are not unfamiliar to most archaeologists who work on development-driven projects, but the resulting well-designed and informative report is rare for the discipline.

The report consists of four chapters, a bibliography, eighteen data tables, and 127 color illustrations. The first chapter provides background information about the project, a geological and historical overview of the area, and a review of previous research on Limehouse porcelain. The second chapter details the excavation and reviews the features and structures found on the site prior to the construction of the porcelain factory. The report is mercifully concise in this section (at least for the porcelain aficionado), providing enough historical context for the reader to place the archaeological remains of the 1745–1748 porcelain manufactory within the other occupations and activity on the site beginning in the fifteenth century. The sequencing of site activities is presented in a straightforward technical manner with drawings and descriptions of features, deposits, and strata. This information is presented devoid of any sociocultural context for the finds or activities outside of the Limehouse porcelain factory period. The bibliographic references make it clear, however, that additional information is

readily available from the unpublished excavation reports and additional publications in progress.

The third chapter contains the primary information about the factory site, the kiln, and the porcelain products. The color photographs of the site and fragments are first rate. In an interesting collaboration, Phillips Fine Arts Auctioneers provided photographs of antique Limehouse porcelain examples from the catalogs of the recent Watney collection sales. It is hard to imagine historical archaeologists in the United States calling upon Christie's and Sotheby's auction houses to help illustrate their ceramic reports, although the effort might be mutually beneficial. Line drawings, a hallmark of British archaeological reports, are used in a limited but helpful fashion.

The primary value of chapter 3 lies in the juxtaposition of excavated sherds with extant porcelain examples. What is remarkable after all is said and done is that only 1,402 glazed and unglazed porcelain sherds and kiln furniture fragments were recovered from the excavation. The authors make considerable use of sherd weight in their tabulations—the entire 1,402 sherds weighed 10,385 grams, merely twenty-three pounds. From these sherds, at least thirty different forms were identified. A breakdown of forms encountered in the stratified proveniences is tabulated by number of sherds and weight. Unstratified porcelain finds also are classified by form.

Typologies of the painted and molded decoration are provided. Interestingly, the only decoration found on the site is underglaze blue painting. Extant Limehouse wares with colored enamels are known, however, suggesting that overglaze enameling was done elsewhere. Molded decorative motifs are also discussed and classified into eight basic types.

The porcelain information is generally descriptive, rather than analytical. It is difficult to interpret the tables without referring back to the plan drawings of the contexts in which the sherds were recovered. One weakness of the report is the limited discussion and presentation of data on the kiln structure. Although the photography of the kiln remains is excellent, an attempt at a detailed pictorial reconstruction would have been useful. This is particularly true for the discussion on parallel kiln construction from other excavated porcelain factories. It is hoped that this information will be presented in future reports.

The report by J. Victor Owen provides a glimpse of the rich potential of geochemical analysis of porcelain bodies, although only seven sherds were examined. The preliminary results suggest that at least two types of porcelain were made at the Limehouse factory. Although quite technical in nature, the discussion indicates the potential for understanding the compositional differences among other early English porcelain manufacturers.

The concluding chapter, eagerly awaited after the presentation of so much raw data, is disappointing, being only slightly more than two pages long. Leading off with Neil McKendrick's observation on the "china fever" that swept Europe in the mid-eighteenth century, the authors place the Limehouse factory example within a brief context of early English attempts to manufacture porcelain. From there, they offer tantalizing snippets for

further study of the Limehouse site. One observation links the architecture of the kiln to the porcelain technology employed in France, where successful porcelain manufacture had been ongoing for at least twenty years prior to the establishment of Limehouse.

In trying to make sense of the financial viability of the Limehouse factory, the authors propose the European model of factory sponsorship, with aristocratic, even royal, backers but offer no evidence to identify the potential investors in this early English factory. Although it is known that a Joseph Wilson and Company operated the factory, very little else is known. Identifying the economic underpinnings of the Limehouse factory seems a fruitful path for future researchers.

One statement reveals a surprising confession about the analysis of eighteenth-century domestic ceramic assemblages in England. Whereas research on colonial American sites has been ongoing for at least fifty years, relatively little attention has been paid to English domestic assemblages. One would initially suppose that the consumption of English porcelain is best understood by looking at its relationship to Chinese porcelain, Staffordshire white salt-glazed stoneware, and other English ceramic types in the homeland of its production. The authors, however, generally find an *absence* (emphasis mine) of English porcelain in their domestic sites. Although the situation is certainly not entirely dissimilar, English porcelain does exist, albeit in small quantities, in many American contexts, especially the domestic sites of the upper classes. Thus, as with the case of English pottery, American archaeological sites may ultimately provide the best contextual information for understanding economic and social factors related to ceramic consumption in the eighteenth-century Anglo-America world.

The Limehouse porcelain factory ultimately failed—an oft-told tale in both the porcelain and pottery industry. In some ways, its failure makes it a more tantalizing assignment for future research. In particular, the Limehouse story seems to share many parallels with the failed American china manufactory of Bonnin and Morris in Philadelphia. Only more research in the historical record can flesh out the stories of both porcelain factories.

The Limehouse porcelain manufactory site report is an essential resource for those interested in the history of English porcelain. The report presents this important information in a clear and concise manner. The quality of the photographs and printing is of the highest order and should serve as a model for all archaeological publications. Most importantly, the archaeologists have presented their information in a timely and usable fashion that porcelain scholars will be sure to reference for years to come.

Robert Hunter
Editor, *Ceramics in America*

1. Bernard Watney, "Four Groups of Porcelain, Possibly Liverpool: Parts I and II," *English Ceramic Circle Transactions* 4, no. 5 (1959): 13–25.

David A. Furniss, J. Richard Wagner, and Judith Wagner. *Adams Ceramics: Staffordshire Potters and Pots, 1779–1998.* Atglen, Pa.: Schiffer, 1999. 336 pp.; over 1,250 bw and color illus., appendices, bibliography, index. $79.95.

The Adams family of Staffordshire potters was an important force in the British ceramic industry from the late eighteenth century until well into the twentieth. Although other authors have researched the Adams family (e.g., Turner[1] and Nicholls[2]), this is the first comprehensive study. *Adams Ceramics: Staffordshire Potters and Pots, 1779–1998* combines a scholarly treatment of the history of the Adams potteries with a catalog of pieces and price guide. Using historical research, oral interviews, and ceramic products, the authors trace the history of the family and the various factories from the late eighteenth century and provide extensive footnotes.

Because the Adams factories focused for much of their existence on exporting the bulk of their production to the Americas and other foreign markets, the collaboration of authors from different geographic backgrounds is a key factor in the success of this study. David Furniss, who has been collecting and researching Adams ceramics in England for over a quarter of a century, provided a fairly comprehensive picture of Adams products for the period 1780 to 1835, but found few pieces in Britain dating from 1835 to 1900. American antique dealers Richard and Judith Wagner filled in the gap by tracing Adams products made for sale in the Americas, particularly transfer-printed wares and "Persian painted" wares.

Adams Ceramics is one of the few books that thoroughly treats a specific company's full range of products for both the home and export markets. As a rule, museums and reference materials that focus on the finest examples of a factory's production, ignoring the majority of the wares actually made by that factory, are of little use to an archaeologist trying to interpret the ceramics excavated from an isolated farmstead in the Missouri Ozarks or to a collector who is unable to afford the most expensive pieces. Staffordshire potters often made completely different lines of wares for sale to the home and to the export markets. Some lines (e.g., white granite, "ironstone" in collectors' parlance) were often so distinct that English collectors, ceramic historians, and museums, for example, were sometimes unfamiliar with wares exported to the Americas because they did not appear on the home market.

The material presented in chapter 1 is essential background for the rest of the book, although some of it is repeated in subsequent chapters. The authors trace the fortunes of the various branches of the family through the 1960s, when Williams Adams & Sons was taken over by Josiah Wedgwood Ltd. A useful chart of the male lineage of Adams master potters helps the reader keep track of all the master potters christened William. Information is provided on Adams family history, the various independent factories that they built or maintained, and the products for which they are best known. The authors' allusions to world economic history help the reader understand the fates of the Adams potteries as well as the rise and denouement of the Staffordshire ceramic industry in general.

Chapters 2 and 3, "Patterns and Context 1779–1917" and "Patterns and Context 1918–1998," comprise the majority of the book. In these chapters, the authors discuss the wares produced under a particular Adams master potter, primarily within the contexts of family and economic history. They then present an alphabetically arranged catalog of the various patterns that were made during the period in question (primarily on earthenware, but on small amounts of bone china items as well). Highlights of the pattern catalogs include later Adams products, particularly transfer-printed series such as "Birds of America," "Currier and Ives," "Dickens," Dr. Syntax revivals, and "Cries of London," and twentieth-century patterns on Micratex and Titian Ware bodies. The years covered in chapter 3 are a somewhat neglected period in ceramic history, and the authors are to be commended for not simply focusing on the early Adams years.

The catalogs are amply and beautifully illustrated, for the most part in color. The quality of the photographic reproductions in the book is in almost all cases excellent (however, it is unfortunate that many of the photographs included a clear plate stand; for example, the cover art on the dust jacket). In many cases, the maker's mark for an item is shown alongside it. Most images are photographs of flatware, with occasional images from company pattern books or advertisements, and a few engravings used as source prints for transfer-printed patterns.

In addition to the pattern name, catalog entries usually include measurements, descriptions of each item and applicable mark or marks, the factory with which the vessel is associated, and the date range for that factory. The dates given for a particular pattern are based on factory marks alone, although more specific dates from documents, archaeological sites (shipwrecks), and temporally sensitive styles are occasionally referenced. The reader attempting to define dates for a pattern is cautioned to refer to the text for additional information, instead of simply using the mark date.

Each illustrated catalog entry incorporates price information, apparently current as of the late 1990s. It was not clear how these prices were derived, nor how they were tied to the condition of the vessel. Including cost information in a book that could have a considerable shelf life seems counterproductive—what will happen when the prices are outdated? Separate price guides often accompany a book specializing in collector literature; with this strategy the publisher has the opportunity to print price updates from time to time.

An abbreviation key like that in chapter 4 would have been useful as well for chapters 2 and 3. Additionally, it is not always clear whether or not a pattern or color name has been assigned or attributed by collectors or was actually one used by the manufacturer. The authors allude to the difference between collectors' and manufacturers' terms on page 23, but this difference should have been stated explicitly at the outset. Some entries in the catalog are not really patterns at all, but the names of ceramic bodies, such as "white granite," "Calyx Ware," and "Royal Ivory," or specific lines, such as "Toys." The authors were no doubt faced with the dilemma of where to include this information, but the catalog

could simply have been titled more broadly. By and large, the authors' use of terminology follows preferred usage by contemporary ceramic historians, but their use of charger for platter, teapoy for tea cannister, white graniteware for white granite, and washstand set for toilet ware is open to question. There are a few gaps in the authors' knowledge of ceramic technology, e.g., their use of "transfer" for what is more properly referred to as a decal or lithotransfer, and the use of "overglaze decorated" to refer to bat-printed decoration.

Adams souvenir and commemorative patterns are presented in alphabetical order by importer and series in chapter 4. The best-documented years of souvenir and commemorative production were the mid-1890s through the 1960s. The discussion of the Adams' relationship with the American importer John H. Roth & Co. is a fascinating look at this aspect of the ceramic industry, which was often based on personal relationships between entrepreneurs but fraught with conflicts of interest inherent in the dealings between importer and manufacturer.

In chapter 5, the authors catalog known jasper, stoneware, basalt, and parian products of the Adams potteries in chronological order. Many of the pieces are from the Adams' family collection and the Potteries Museum and Art Gallery. Particularly interesting is the discussion of the reuse of Adams' eighteenth-century jasper molds in the twentieth century.

Chapter 6 is an amply illustrated discussion of characteristic makers' marks and backstamps used by the Adams factories, from the earliest impressed marks to printed marks used through the 1950s.

Useful information is provided in the five appendices included in the book: A, "Nineteenth century series"; B, "Adams and Meir Pattern Numbers" (John Meir bought Adams' Greengates Pottery in 1822); C, "The Scriven Report" (on child labor in the potteries); D, "Institutional and Hotel Ware" (by Ewart H. Edge); and E, "Museums with Adams' Holdings." Inexplicably, the latter included some but not all the institutions mentioned in the stoneware section of chapter 5.

The bibliography is extensive, but not all items listed as primary sources are documents produced by participants in an event or by eyewitnesses (e.g., bills of lading or invoices). It is unfortunate that the book does not contain a more thorough index, although the alphabetical pattern arrangement makes it easy to find patterns with known names.

This is one of the most scholarly books yet published by Schiffer, which is due in large part to the care taken by the authors themselves in writing and compiling their manuscript. Although the book could have benefited from more editorial support from the publisher, there are really very few errors given its length and scope. *Adams Ceramics* should be on the shelf of anyone interested in English ceramics, regardless of whether they are collectors, dealers, appraisers, historical archaeologists, or museum staff. A book such as this allows the reader to do much more than simply identify a piece. For those who are history-minded, production and distribution are put into the context of world politics and economics. For those primarily interested in the pots, it is possible to learn about the range of

shapes and decoration on Adams ware, what was deemed appropriate for various export markets, and stylistic influences and revivals. As noted on the dust cover, the "combined knowledge" of the authors truly "makes this the Adams book for all time."

Teresita Majewski
Statistical Research, Inc.

1. William Turner, ed., *William Adams, An Old English Potter* (London and Syracuse, N.Y.: Chapman and Hall and The Keramic Studio, 1904).

2. Robert Nicholls, comp., *Ten Generations of a Potting Family* (London: Percy Lund, 1931).

Andrew McGarva. *Country Pottery: Traditional Earthenware of Britain.* London: A & C Black, 2000. Preface by Michael Casson. 128 pp.; 66 bw and 105 color illus., glossary, bibliography, index. $60.00/£30.00.

Although common earthenware may be Britain's "hidden treasure," it has yet to fire the imagination of most museums and collectors. Overshadowed by whitewares with colorful decorations and elaborate forms, neglected and uncelebrated, it is sought only by the few who appreciate its sturdy, utilitarian beauty. "A continuation of tradition is less noticed than innovation or change," notes author Andrew McGarva (p. 12). In the diverse history of British ceramics, these wares rightly hold the lowest rank, for since the Middle Ages all British pottery types have sprung from these utilitarian earthenwares. As the country folk traditions of everyday brewing, cheese making, and baking declined steadily during the last century, so did the demand for common earthenwares. By the mid-twentieth century the true country way of life in Britain had vanished forever, and with it the country potters and their earthenware pots.

Makers of common earthenware over the centuries have rarely been the subject of notoriety. Contemporary records from the United States show that important as they were to their neighbors in providing wares necessary for everyday life, pottery makers could be considered a nuisance, with muddy yards, dangerous clay pits, and ever-smoking kilns.[1] Perhaps because of this perceived "nuisance" status, the inner workings and details of the everyday production in these shops were rarely recorded. Indeed, many individual potters compounded this lack of history by keeping their techniques and glazes a secret. As a result, ceramic research today often employs conjecture or the author's "best guess" as to exactly how these items were made.

A book has finally appeared that provides us with the missing link between modern potting methods and those techniques of the seventeenth, eighteenth, and nineteenth centuries often considered lost. Written from the unique perspective of a working potter, Andrew McGarva, the book thoroughly covers early pottery processes from training and wages to the eventual distribution and sale of pots produced. Michael Casson's preface accurately acknowledges the author's thorough understanding of his craft and the skills of traditional potters. The tiniest details, often overlooked by the casual observer, such as reaching for a "grab" of clay for

throwing, the length of the wareboard, or the mixing and application of slips and glazes, are described in a way only a potter could.

From the dedication to the final index entry, the foundation and strength of this book is clearly in its remarkable photographs. The inclusion of these photos makes this book indispensable to anyone interested in the study of common earthenware, not only of Britain but of Europe and the United States as well. This archive of photographs gives us an extremely rare glimpse into the shops, the yards, and even the kilns of potteries, which had all but disappeared by the mid-twentieth century.

A major inspiration for the book was the 1965 film, *Isaac Button, Country Potter,* by Robert Fornier and John Anderson. Chapter 6 is dedicated to this lone potter who worked the Soil Hill pottery from 1947 to 1964. The shop was located at Holmfield, between Halifax and Keighley, in Yorkshire. Typical of potters in shops making utilitarian ware, Mr. Button honed his skills and techniques to an amazing level. His standard bread crock required twenty-four pounds of clay and could be thrown in seventy seconds. Anyone who has centered and thrown even ten pounds of clay will quickly acknowledge that Button was a very skilled potter.

The twelve chapters cover all aspects of production and include clay preparation, tools, glazing, kiln setting, kiln types, and firing. Chapter 2 on training and wages begins by describing a fourteen-year-old's apprenticeship in the 1880s. Working a minimum of twelve hours a day, six days a week, a young lad could look forward to earning up to ten pence a week during the last of a five to eight year indenture. The big payoff was to become a journeyman. Moving on to another pottery, a journeyman enjoyed a change of scenery, and was introduced to new styles and techniques as well. Here he learned the importance of a high production rate, for all throwers were paid by how much they produced.

The payment system employed the use of a "cast" of pots. The number of pots per cast was determined by how much time was required to throw them. A cast would be sixty to seventy three-inch flowerpots, but only six twelve-inch pots. A good example is given of this system in operation before the First World War. Throwers at Fremington were paid four pence ha' penny per cast of sixty small flowerpots, which included making up their own balls of clay in preparation. This is where speed and dexterity paid off. A good thrower could produce two casts (120 pots) per hour, and finish the day with 1,000 pots drying on the racks. A few years later, with the introduction of the jolly machine (a machine in which a spinning mold forms the exterior of a hollow ware and a template shapes the interior), one man would be expected to turn 4,000 three-and one-half-inch pots in a day's time. Looking back from this age of carpal tunnel syndrome and other repetitive motion ailments, we may well wonder at these men who quietly plied their trade for forty or more years before slacking the pace and seeking retirement. Although we see it through the author's rather romanticized vision, we can still imagine the mind-numbing tedium and back-breaking labor of this work. The shops where these men worked were often dark and damp and subject to the ever-present danger of lead poisoning.

The author reveals not only production techniques, but also methods of digging and preparing clay, using a roulette wheel to decorate freshly thrown pots, throwing large pots in two sections, and unique methods for lifting large pots off the wheel. Throwing pots directly on the wheel head (as opposed to using removable bats) poses a great challenge when the time comes to remove a particularly large piece. This problem was solved at Soil Hill, as well as at other shops, by the use of a "lifting off stick" or "cow's rib." This beautifully simple tool was a slightly curved flat piece of wood about a foot long. While the hands went around the far side of the pot, the stick bridged the forearms and supported the near side. The pot was then cleanly lifted and moved without distortion and could be placed immediately on a wareboard for drying, saving at least one step in dealing with the throwing bat. Another trick for lifting bottle forms was to place a ball of clay over the mouth of the pot, sealing in air pressure which supports the piece from the inside and reduces the risk of deformation. Photographs illuminate many of the heretofore obscure details of this ware's production.

In the final chapter, Andrew McGarva takes a quick look at contemporary potters who, while not making reproductions of old pots, have been influenced by them and the men who made them. Here the author encourages us to "enjoy what is available today, rather than dwell on what has already gone" (p. 112). This sentiment may leave the modern-day antiquary a bit cold, but in truth modern pottery is the accumulated end product of all ceramics that have gone before.

Although a map is provided showing the locations of old country pottery sites that are mentioned in the text, an accompanying list of these shops with the names of the potters who worked in them and the dates of their operations would have been helpful to the reader.

Andrew McGarva has given us an important body of information in *Country Pottery*. Invaluable to the working potter, it also gives collectors a wide range of products to seek perimeters in which to conduct their search, and the student of ceramics a rich overview of the history of this common earthenware. Possibly the strongest point made by this book is that through the study and collection of these wonderful old pots, we can come to a new understanding and appreciation of "all makers of pots and pans; past, present, and future." In your library or on your coffee table, this book bears proud testament to a humble tradition.

Greg Shooner
Shooner American Redware
Oregonia, Ohio

1. Rose Marie Springman, *Around Mason, Ohio: A Story of Cincinnati* (Cincinnati, Ohio: C. J. Krehbiel, 1982), p. 43.

Regina Lee Blaszczyk. *Imagining Consumers: Design and Innovation from Wedgwood to Corning.* Studies in Industry and Society. Baltimore: Johns

Hopkins University Press, 2000. xiii+380 pp., 9 color plates, 51 b/w illustrations, notes, essay on sources, index. $45.95 hardbound; $22.50 paperback.

I was glad when Regina Blaszczyk's *Imagining Consumers: Design and Innovation from Wedgwood to Corning* was published because I had found a wealth of data on the Trenton pottery industry in her dissertation on which it is based. The book's focus on the market and consumers is a welcome relief from connoisseurship. Connoisseurs' definitions of beauty deny, states Blaszezyk, "the historical significance of commonplace items, the building blocks of popular culture" (p. 273). I can appreciate a mass-market paradigm that embraces common wares such as Fiesta that archaeologists and historians of popular culture cannot ignore.[1]

The case study technique examines product design, production, and marketing using the companies and products as units of analysis. Blaszczyk points out significant technological, economic, and cultural variables affecting the American ceramics and glass market under conditions of increased competition and falling prices. The studies range from flexible batch production as refined by Wedgwood during the late eighteenth century to the mass production of the twentieth century. The cases provide contrasting insights on the American market during a century of growth and marked technological change.

The process in which factory managers and art directors imagined their consumers was sometimes successful, as in the cases of Homer Laughlin's Fiesta and Corning Glass Works' Corning wares, and other times less successful, as in the cases of Corning's Pyrex and Kohler's Color wares. The central concept is that of fashion intermediaries providing feedback on product design and consumer wants. In the 1860s these fashion intermediaries included wholesale merchants, urban retailers, country store owners, and peddlers. Twentieth-century fashion intermediaries were designers, engineers, retailer buyers, advertising consultants, and home economists.

One of the fashion intermediaries for Homer Laughlin was Frederick Hurten Rhead, art director for the company from 1927–1942, who perceived a diverse American market stratified by class and who designed wares to suit this market. The English factory Wedgwood produced decorated creamware for the upper classes and plain creamware for the middle classes. As Rhead stated in 1931, "There is more than one personal taste" (p. 133). Taking an opposite view were art historians who believed in a unified aesthetic and tastemakers who saw only one customer: "a middlebrow who could be taught to appreciate upscale lines" (p. 251). By the 1920s, when working- and middle-class women comprised more than eighty percent of buyers of mass-manufactured goods, the consumers that many manufacturers tried to visualize were female.

Blaszczyk uses data from a wide variety of sources, particularly trade journals, industry publications, business records, and managerial oral histories. The superb documentation is thought-provoking in its detail. The dissertation's extensive footnotes are retained for the book, and the "Essay on Sources" is particularly useful for those researching American ceramics of

the late nineteenth and twentieth centuries. One of the author's strengths is her ability to highlight technological changes in the narrative, such as the 1930s shift in decorative techniques from decals to painting, silk screening, and bright solid-colored glazes. The black-and-white and color illustrations help to bring the narrative to life and benefit from the author's familiarity with not only company archives but also archives at the Smithsonian Institution's National Museum of American History, Dun & Bradstreet, Hagley Museum and Library, Winterthur Museum Library, the East Liverpool Museum of Ceramics, and other public and private institutions.

Chapters 2 through 5 deal primarily with ceramics. Chapter 2 describes Trenton china decorator Jesse Dean's experimentation with ceramic decals and photoceramics, china mania following the Centennial Exhibition, and the struggle between American potters and importers. Chapter 3 covers decal aesthetics and colored clays and glazes in the context of Homer Laughlin's and the Sebring family's competition for the mass retail trade, such as mail-order houses and five-and-dime stores. Chapter 4 describes the development of Homer Laughlin's Fiesta and other modern-style wares. Chapter 5 describes Kohler's attempt to persuade consumers to buy their colored sanitary plumbing lines, complicated by quality control problems with color matchings. The collaboration of Josiah Wedgwood and Thomas Bentley, the only English case, is treated briefly in the introduction and was not part of the author's dissertation. Additional chapters discuss the American table glass industry (chapter 1), the development of Pyrex ware (chapter 6), and the fortunes of the Sebring companies, Homer Laughlin, and Corning Glass Works in the Baby Boom era (chapter 7).

My criticisms are minor. At times when I became lost in the details of a company's history, I longed for synthesis, but this may not be a fair criticism of the case study approach, particularly since these are so well grounded in historical context. The addition of the Wedgwood case to the book helps to clarify the origins of the American manufacturers' factory structure and marketing methods, but this case is not documented with the depth of the other cases, making its placement in the introduction appropriate.

It is my pleasure to call this book to the attention of an interdisciplinary *Ceramics in America* audience. Fiesta and Corning Ware are important milestones in American tableware history as is the rise of casual dining in the twentieth-century United States. The case study approach lends itself to browsing through the book a chapter at a time. Even if you can't stand the sight of Fiesta ware, this book will teach you something about making and selling ceramics in America.

Amy C. Earls
Ceramics in America

1. Regina Lee Blaszczyk, "Imagining Consumers: Manufacturers and Markets in Ceramics and Glass, 1865–1965" (Ph.D. diss., University of Delaware, Newark, 1995). Those interested in the post–Civil War American market will want this dissertation for its chapter on the Homer Laughlin factory's conversion into the world's first mass-production tableware factory and for the data tables not used in the book.

Compiled by
Amy C. Earls

Checklist of
Articles, Books,
and Electronic
Resources on
Ceramics in
America Published
1998–2001

▼ THE FOLLOWING LIST includes publications about ceramics in America published in the years 1998, 1999, 2000, and the first half of 2001, as well as electronic resources on ceramics. As with last year's checklist, inclusion indicates a reference to ceramics made or used in America from the time of European colonization through the present day.

This year's bibliography contains a CD-ROM publication on the Belle Vue Pottery in Hull, England. Thirty-two printed and thirty-nine painted patterns from the pottery are illustrated with photographs or sketches. CD-ROM and website publishing are especially viable alternatives to the relatively expensive printed or photocopied color photographs so important to much ceramic identification in reports with small print runs, such as archaeological reports.

Most of the references were compiled through online library database searches. Databases used were *Online Computer Library Center's World Catalog First Search* and R. R. Bowker's *Books in Print* for books; ABC-CLIO's *America: History and Life* and also *Historical Abstracts* and H. W. Wilson's *Art Index* and *Art Bibliographies Modern* for journal articles; Research Libraries Group's *SCIPIO* for auction catalogs; University Microfilms, Inc.'s *ProQuest Digital Dissertations*; and Bard Graduate Center's library catalog. Selection was generally based on keyword and abstract searches. I have not tried to include all of the auction catalogs since the large auction houses sponsor regular sales in particular ceramics categories, and readers interested in those categories can subscribe to such publication series. I have tried to include shipwreck sales and significant private collections, but not all estate sales.

New in the checklist this year is the Electronics Resources list, which consists of websites for factories, collector organizations, museums, publications, etc. The electronics list is intended to be broad in scope, and consequently the websites vary widely in quality of presentation and technical accuracy. As with many popular collectibles books, however, the occasional lack of professional presentation may be compensated for by illustrations of marks, patterns, and shapes. Museum websites containing a wealth of useful information include the Ashmolean Museum's PotWeb and those of the Medalta Potteries Museum and The Potteries Museum and Art Gallery in Stoke-on-Trent. The Transferware Collectors Club is one of the best sites for transfer-printed patterns. Other particularly useful sites are gotheborg.com, the Dorchester Pottery Works records at the University of Massachusetts-Boston's Healey Library, and The Potteries (Stoke-on-Trent).

This year's list is weighted toward collectors sites, including both club websites and factory-sponsored club websites. Club websites may be for profit or nonprofit, but most contain dealer links and customer wants for buying and selling, and some provide their members' lists to other members to facilitate commercial contacts. Most sponsor conventions, auctions, and pottery shows and offer information in the form of newsletters, collector's guides, or other publications. Many offer virtual museum images of pots and their descriptions. Factory websites may offer virtual factory tours and limited edition products for their collectors club members as well as magazines and information for collectors of their discontinued products. Most auction houses provide auction schedules, catalogs, prices realized, and specialty departments for ceramics and glass or decorative arts. The online auction site, eBay, is an excellent source of images in a wide variety of ceramics categories.

The electronic resources list almost inevitably will be out of date by the time the journal is published some six to twelve months later. The volatility of the World Wide Web means that some addresses will change during the time that this journal is being produced. If the listed address does not locate a site, try searching using keywords. In the future, the electronic resources list may be maintained as part of the Chipstone Foundation's website: www.chipstone.org.

The checklist's scope is intended to be broad, and the burden is on the reader to examine and select the references and websites that may be of interest. Comments, suggestions, corrections, and additional references for 1998 through the present would be appreciated for subsequent volumes of the journal. Please address all communications to the Book and Exhibit Review Editor, *Ceramics in America*, P.O. Box 121, Florence, New Jersey, 08518, U.S.A. <trentonpots@yahoo.com>.

Adams, Brian, and Anthony Thomas. "Bovey Tracey Porcelain, 1767–1774—The Clues." *Northern Ceramic Society Newsletter,* no. 123 (2001): 34–44.

Adams, William H., and Sarah J. Boling. "Status and Ceramics for Planters and Slaves on Three Georgia Coastal Plantations." Reprinted in David Brauner, comp. *Approaches to Material Culture Research,* 2nd ed., pp. 111–38. California, Penn.: Society for Historical Archaeology, 2000.

Allen, J. R. L. "National Shipyard No. 2, Beachley, Gloucestershire: Some Ceramic Evidence from the First World War." *Post-Medieval Archaeology* 34 (2000): 203–6.

Amberes. *Schilderijen en grafik, oud-heden en kunstvoorwerpen, antieke en stijlmeubelen, tapijten, beeldhouw-werk en juwelen, luchters.* Auction catalog, Amberes, Antwerp, March 19, 2001. Antwerp: Amberes, 2001. (porcelain, delft.)

Arbace, Luciana. *Le ceramiche Cacciapuoti: da Napoli a Milano, 1870–1953: Faenza.* Exhibit catalog, Palazzo delle Esposizioni, September 16–October 29, 2000. Firenze: Olimpia, 2000.

Auctioneers Glerum. *Chinese and Japanese porcelain, silver and jewellery.* Auction catalog, Auctioneers Glerum, Amsterdam, November 21, 2000. Amsterdam: Auctioneers Glerum, 2000.

Austin, John C. "A Twentieth-Century Creamware Catalogue." *American Ceramic Circle Journal* 11 (2000): 32–51.

Ayers, John. *Chinese Ceramics in The Baur Collection,* vols. 1 and 2. Geneva: The Baur Collection, 1999.

Bailey, Michael V. "Early Pinxton Dealers and Retailers." *Northern Ceramic Society Journal* 17 (2000): 17–22.

Baochang, Geng. *Blue and White Porcelain with Underglazed Red,* Books 1–3. The Complete Collection of Treasures of The Palace Museum, vols. 34–36.

Beijing: Commercial Press, 2000.

Barker, Dennis. *Parian Ware.* Album 142. Princes Risborough, Bucks., England: Shire, 1998.

Beaudry, Mary, Janet Long, Henry M. Miller, Fraser D. Neiman, and Gary W. Stone. "A Vessel Typology for Early Chesapeake Ceramics: The Potomac Typological System." Reprinted in Brauner, *Approaches to Material Culture Research,* 2nd ed., 11–36.

Becker, Jerry. "The Stuff of Dreams: Inventing the Southwest: The Fred Harvey Company and Native American Arts: Denver Art Museum, Denver, Colorado, USA." *Hali* (January 1999): 90–91.

Bedell, John. "Archaeology and Probate Inventories in the Study of Eighteenth-Century Life." *Journal of Interdisciplinary History* 31, no. 2 (2000): 223–45.

Bentley, John W. "Turner-Type Stonewares." *Northern Ceramic Society Journal* 17 (2000): 79–105.

Besse, Xavier. "A Passion for Chinese Ceramics: The Story of the Ernest Grandidier Collection." *Orientations* 32, no. 1 (2001): 58–63.

Blackburn, Harry F. "'A Head of His Time.'" *Northern Ceramic Society Newsletter,* no. 122 (2001): 25–30.

Blair, Munroe. *Ceramic Water Closets.* Album 379. Princes Risborough, Bucks., England: Shire, 2000.

Blaszczyk, Regina Lee. "Style and Strategy: The Business of China Decorating, 1865–1900." *American Ceramic Circle Journal* 11 (2000): 1–31.

Bliss, Gill. *Practical Solutions for Potters: 100s of Your Top Questions with 1000s of Practical Solutions.* New York: Sterling, 1998.

Blumenfeld, Robert H. *Blanc de Chine: The Great Porcelain of China.* Berkeley, Calif.: Ten Speed Press, 2001.

Bonellie, Janet. "Mrs. Dignam's Pursuit." *Beaver* [Canada] 80, no. 3 (2000): 35–38. (Founding of the Women's Art Association of Canada.)

Bonhams. *Staffordshire Figures, Blue Printed Pottery and Other British Ceramics.* Auction catalog, Bonhams London, September 22, 1998. London: Bonhams, 1998.

Boos, Frank H., Gallery. *Fine Paintings, Furniture, Graphics, Decorative Arts, and American Glass.* Auction catalog, Frank H. Boos Gallery, Birmingham, February 10–11, 1999. Birmingham, Ala.: Frank H. Boos Gallery, 1999.

Boulay, Anthony du. "The Blue Porcelain Room, Fenton House: Lady Binning's Inheritance from Her Uncle, George Salting." *Oriental Art* 44, no. 2 (1998): 4–7.

Bower, Virginia, Josephine Hadley Knapp, Stephen Little, and Robert Wilson Torchia. *Decorative Arts: Part II, Far Eastern Ceramics and Paintings: Persian and Indian Rugs and Carpets.* Collections of the National Gallery of Art. Washington, D.C.: National Gallery of Art, 1998.

Boyer, Marie France. "House of Creil." *World of Interiors* (April 1999): 158–65.

Brauner, David R., comp. *Approaches to Material Culture Research for Historical Archaeologists: A Reader from Historical Archaeology.* 2nd ed. California, Penn.: Society for Historical Archaeology, 2000.

Brooks, Derek. *Belle Vue Pottery.* Swanland, E. Yorks., England: Derek Brooks, 2000. (CD-ROM available from author at bellevue_pottery@lineone.net or 40 West End, Swanland, E. Yorks., HU14 3PE, England.)

Brown, Jane. "The Bizarre Story of Clarice Cliff." *Garden Design* (December 1999/January 2000): 74–79.

Burleson, Mark. *The Ceramic Glaze Handbook: Materials, Techniques, Formulas.* New York: Lark Books, 2001.

Burrison, John A., *Brothers in Clay: The Story of Georgia Folk Pottery.* 1975. Reprint, Athens, Ga.: University of Georgia Press, 2001.

Butterfield and Butterfield. *Art Nouveau, Art Deco and Arts and Crafts.* Auction catalog, Butterfield and Butterfield, San Francisco, November 9, 1998. Los Angeles: Butterfield and Butterfield, 1998.

Butterfield and Butterfield and Butterfield and Dunning. *20th Century Decorative Arts, Including Prints, Posters and Paintings.* Auction catalog, Butterfield and Butterfield, Los Angeles, December 13–14, 1999. Los Angeles: Butterfield and Butterfield and Butterfield and Dunning, 1999.

Carney, Margaret. *The Binns Medalists.* Alfred, N.Y.: Schein-Joseph International Museum of Ceramic Art, 2000.

Carney, Margaret, Ron Kransler, and Wallace Higgins. *Glidden Pottery.* Exhibit catalog, Schein-Joseph International Museum of Ceramic Art, April 12–September 27, 2001. Alfred, N.Y.: Schein-Joseph International Museum of Ceramic Art, 2001.

Carswell, John. *Blue and White: Chinese Porcelain Around the World.* London: British Museum Press, 2000.

Carter, Tina. *Collectible Teapots.* Iola, Wisc.: Krause, 2000.

Chilton, Meredith. *Harlequin Unmasked: The Commedia dell'Arte and Porcelain Sculpture.* New Haven, Conn.: Yale University Press, 2001.

China and Porcelain Research Group, The. *The 2000–2005 World Outlook for China and Porcelain.* Strategic Planning Series. San Diego: Icon Group International, 2000.

Choi, Kee Il. "Hong Bowls and the Landscape of the China Trade." *The Magazine Antiques* (October 1999): 500–509.

Choi, Kee Il. "Japan and Design in Early Chinese Export Art." *The Magazine Antiques* (September 2000): 336–45.

Christie's. *The Aesthetic Interior: Featuring Nineteenth-Century Art and the Collection of Michael and Anne Ripley.* Auction catalog, Christie's East, March 13, 2001. New York: Christie's, 2001.

Christie's. *American Vision: Paintings and Decorative Arts.* Auction catalog, Christie's East, January 19, 2000. New York: Christie's, 2000.

Christie's. *Asian Ceramics and Works of Art.* Auction catalog, Christie's Amsterdam, May 8, 2001. Amsterdam: Christie's, 2001.

Christie's. *British and Continental Ceramics and Glass Including Paperweights.* Auction catalog, Christie's London, December 11, 2000. London: Christie's, 2000.

Christie's. *British and Continental Pottery.* Auction catalog, Christie's South Kensington, April 20, 2000. London: Christie's, 2000.

Christie's. *The British Interior: English Furniture, Ceramics, Paintings, Carpets and Chinese Export Porcelain.* Auction catalog, Christie's New York, January 25–26, 2000. New York: Christie's, 2000.

Christie's. *British Pottery Including Staffordshire Figures.* Auction catalog, Christie's South Kensington, October 21, 1999. London: Christie's, 1999.

Christie's. *Coleman Collection.* Auction catalog, Christie's New York, January 16, 1998. New York: Christie's, 1998.

Christie's. *The Collection of Mr. and Mrs. James L. Britton.* Auction catalog, Christie's New York, January 16, 1999. New York: Christie's, 1999.

Christie's. *The Dr Bodo Slingenberg Collection.* Auction catalog, Christie's Amsterdam, March 29, 2001. Amsterdam: Christie's, 2001.

Christie's. *European Ceramics, Dutch Delftware and Glass.* Auction catalog, Christie's Amsterdam, November 18, 1998. Amsterdam: Christie's, 1998.

Christie's. *Important American Furniture, Folk Art, and Chinese Export Porcelain.* Auction catalog, Christie's New York, October 14, 1999. New York: Christie's, 1999.

Christie's. *Important French and Continental Furniture, Porcelain*

and Carpets. Auction catalog, Christie's New York, May 24, 2000. New York: Christie's, 2000.

Christie's. *19th Century Ceramics.* Auction catalog, Christie's South Kensington, March 23, 2000. London: Christie's, 2000.

Christie's. *19th Century Furniture, Sculpture, Works of Art and Ceramics.* Auction catalog, Christie's, April 24, 2001. New York: Christie's, 2001.

Christie's. *The Principal Contents of Grimshaw Hall Knowle, West Midlands.* Auction catalog, Christie's London, March 8, 2000. London: Christie's, 2000.

Christie's. *The Roosevelt Era: Selections from the Private Collections of Franklin and Eleanor Roosevelt and Family.* Auction catalog, Christie's New York, February 14–15, 2001. New York: Christie's, 2001.

Christie's. *20th Century British Lustre Ceramics.* Auction catalog, Christie's South Kensington, March 3, 2000. London: Christie's, 2000.

Cincinnati Art Galleries. *Holiday Sale 1999: Featuring Fine Consignments from Many Collections, Including the Dick Sigafoose Collection.* Auction catalog, Cincinnati Art Galleries, November 7, 1999. Cincinnati: Cincinnati Art Galleries, 2000.

Cincinnati Art Galleries. *Holiday Sale 2000: Featuring Rookwood Pottery and Other Fine American and European Pottery, Including Rookwood from the Collection of Margaret Peck. Also Featuring Many Rare and Out of Print Reference Books Relating to Ceramics and Pottery.* Auction catalog, Cincinnati Art Galleries, November 5, 2000. Cincinnati: Cincinnati Art Galleries, 2000.

Cincinnati Art Galleries. *Rookwood IX and Keramics, 1999.* Auction catalog, Cincinnati Art Galleries, May 1999. Cincinnati: Cincinnati Art Galleries, 1999.

Claney, Jane. *Rockingham Ware in America, 1830–1930: An Exploration in Historical Archaeology and Material Culture Studies.* Ph.D.

diss., Program in American Civilization, University of Pennsylvania (Philadelphia), 2000.

Clark, Garth. "Murray and Leach: A Study in Contrasts." *Studio Potter* (June 1999): 21–27.

Cleggett, Mavis A. "A Worcester Dessert Service by Chamberlain." *The Magazine Antiques* (September 2000): 320–27.

Cliff, Stafford. *The English Archive of Design and Decoration.* London: Thames and Hudson, 1998.

Cockerill, John. "The North Shore Pottery, Stockton-on-Tees." *Northern Ceramic Society Journal* 17 (2000): 39–49.

Coignard, Jerome. "Londres: la revanche de l'art nouveau." *Connaissance des Arts* 570 (March 2000): 56–57.

Coleman Smith, Richard. "Digging up the Past." *Ceramic Review* (March/April 2001): 48–49.

Collector's Sales and Service. *Ceramics.* Auction catalog, Collector's Sales and Service, Middletown, R.I., August 18, 1998. Middletown, R.I.: Collector's Sales and Service, 1998.

Coltman, Viccy. "Sir William Hamilton's Vase Publications (1766–1776): A Case Study in the Reproduction and Dissemination of Antiquity." *Journal of Design History* 14, no. 1 (2001): 1–16.

Copeland, Alexandra. *An Artist's Travel Guide to the Ceramics Museums of Europe.* Cincinnati: Seven Hills Books, 1999.

Copeland, Robert. *Ceramic Bygones and Other Unusual Domestic Pottery.* Album 383. Princes Risborough, Bucks., England: Shire, 2000.

Coupe, Elizabeth R. *Collecting Burleigh Ware: A Photographic Guide to the Art Deco Tablewares of Burgess and Leigh.* Melton Mowbray: Letterbox, 1998.

Coutts, Howard. *The Art of Ceramics: European Ceramic Design, 1500–1830.* New Haven, Conn.: Yale University Press and Bard Graduate Center, 2001.

Craftsman Auctions. *Antiques from the American Arts and Crafts Movement.* Auction catalog, Craftsman Auctions, Pittsfield, May 14, 2000. Pittsfield, Mass.: Craftsman Auctions, 2000.

Creagh, D. C., and David A. Bradley. *Radiation in Art and Archeometry.* New York: Elsevier Science, 2000. (Article by P. Martinetto, M. Anne, E. Dooryhée, G. Tsoucaris, Ph. Walter. "Attribution of antique Chinese blue-and-white porcelains using energy dispersive x-ray fluorescence [EDXRF].")

D'Agliano, Andreina, Luca Melegati, and Fondazione Petro Accorsi. *I fragili lussi: porcellane di Meissen da musei e collezioni italiane.* Turin, Italy: Omega, 2001.

Dahlberg, Laurie V. *Victor Regnault, Louis Robert, and Photography at the Manufacture Impériale de Porcelaine de Sèvres, 1845–1865.* Ph.D. diss., Department of Art and Archaeology, Princeton University, 1999.

Dam, Jan Daniel van. "Van een verwaarloosd naar een nationaal product: het verzamelen van Delftse faience." *Bulletin van het Rijksmuseum* 49, no. 1 (2001): 72–83.

Deetz, James and Patricia S. *The Times of Their Lives: Life, Love and Death at Plymouth Colony.* New York: W. H. Freeman, 2000.

Delecretaz, Helen. *The Dragon's Journey: The Influence of Chinese and Japanese Porcelain on European Ceramics.* Exhibit catalog, Winnipeg Art Gallery, February 8–April 29, 2001. Winnipeg: Winnipeg Art Gallery, 2001.

DeLozier, Loretta. *Collector's Encyclopedia of Lefton China,* No. 3. Paducah, Ky.: Collector Books, 1999.

Del Vecchio, Mark. *Postmodern Ceramics.* New York: Thames and Hudson, 2001.

Den Blaauwen, Abraham L. *Meissen Porcelain in the Rijksmuseum.* Zwolle, Netherlands: Waanders, 2001.

De Rochebrune, Marie Laure.

"Charles Nicolas Dodin, Miniature Painter at Vincennes-Sèvres." *The Magazine Antiques* (October 2000): 524–33.

Dieringer, Ernie, and Bev Dieringer. *White Ironstone China: Plate Identification Guide, 1840–1890.* A Schiffer Book for Collectors. Atglen, Pa.: Schiffer, 2001.

Dieringer, Ernie, and Bev Dieringer. *White Ironstone Teapots: An Identification Guide.* A White Ironstone China Association, Inc. Publication. [Redding Ridge, Conn.]: White Ironstone China Association, Inc., [2001].

Dollen, B. L. and R. L. Dollen. *Collector's Encyclopedia of Red Wing Art Pottery: Identification and Values.* Paducah, Ky.: Collector Books, 2000.

Dommel, Darlene H., Arley Olson, and Bonnie Olson. "Charles Grantier, Dakota Artisan." *North Dakota History* 65, nos. 2–3 (1998): 26–32.

Doyle, William, Galleries. *Important English and Continental Furniture and Decorations, Old Master Paintings and Drawings.* Auction catalog, William Doyle Galleries, New York, January 26, 2000. New York: William Doyle Galleries, 2000.

Dubus, Michel, and Béatrice Pannequin. *La céramique française sous l'Empire: À travers l'enquête des préfets, 1805–1810.* Notes et documents des Musées de France 33. Paris: Éditions de la Réunion des musées nationaux, 1999.

Duke, Harvey. *Pottery and Porcelain.* Orlando, Fla.: House of Collectibles, 1999.

Du Mouchelles Art Galleries. *Auction at the Gallery, February 1998.* Auction catalog, Du Mouchelles Art Galleries, Detroit, February 13–15, 1998. Detroit, Mich.: Du Mouchelles Art Galleries, 1998.

Edmundson, Roger S. *A Bicentenary Exhibition of Thomas Rose's Coalport Porcelains, c. 1800–1814.* Coalbrookdale: Ironbridge Gorge Museum Trust, 2000.

Elliot-Bishop, James F. *Franciscan, Catalina, and Other Gladding, McBean Wares: Ceramic Table and Art Wares, 1873–1942.* Atglen, Pa.: Schiffer, 2001.

Emerson, Julie, Jennifer Chen, and Mimi Gardner Gates. *Porcelain Stories: From China to Europe.* Seattle: Seattle Art Museum and University of Washington Press, 2000.

Espinosa Martin, Carmen. "La Faiencerie de Choisy-le-Roi a traves de los modelos de Albert Ernest y Louis Robert Carrier de Belleuse en el Museo Lazaro Galdiano." *Goya* (January/February 2000): 35–43.

Estep, Keith. *The Best of Shaving Mugs.* A Schiffer Book for Collectors. Atglen, Pa.: Schiffer, 2001.

Étude Tajan. *Porcelaines de Chine, Compagnie des Indes, porcelaines françaises du XVIIIe et XIXe siècles, majoliques italiennes, faïences françaises du XVIIe et XVIIIe siècles.* Auction catalog, Espace Tajan, Paris, December 15, 1998. Paris: Étude Tajan, 1998.

Fairbanks, Jonathan L., Angela Fina, and Christopher Gustin, eds. *The Contemporary Potter: A Collection of the Best Original Work in Earthenware, Porcelain, and Stoneware.* Gloucester, Mass.: Rockport Publishers, 2000.

Falkenstien-Doyle, Cheri. "Cochiti Ceramic Figurines, 1880–1915: Possible Sources of Inspiration." *American Indian Art Magazine* 24, no. 4 (1999): 38–47.

Ferrin, Leslie. *Teapots Transformed: Exploration of an Object.* Madison, Wisc.: Guild Publishing, 2000.

Finlay, Robert. "The Pilgrim Art: The Culture of Porcelain in World History." *Journal of World History* 9, no. 2 (1998): 141–87.

Fournier, Robert. *Illustrated Dictionary of Practical Pottery.* 4th ed. Iola, Wisc.: Krause, 2000.

Francis, Peter. *Irish Delftware: An Illustrated History.* London: Jonathan Horne Productions, 2000.

Francis, Peter. *A Pottery by the Lagan: The Downshire Pottery Manufactory, Belfast, 1787–1806.* Belfast, N. Ireland, U.K.: Institute of Irish Studies, Queen's University Belfast, 2000.

Frelinghuysen, Alice Cooney. "Louis Comfort Tiffany at the Metropolitan Museum: Enamels and Ceramics." *The Metropolitan Museum of Art Bulletin* 56, no. 1 (1998): 76–81.

Frelinghuysen, Alice Cooney. "Louis Comfort Tiffany at the Metropolitan Museum: Laurelton Hall." *The Metropolitan Museum of Art Bulletin* 56, no. 1 (1998): 92–99.

French, Neal. *The Potter's Directory of Shape and Form.* Iola, Wisc.: Krause, 1998.

Fritz Nagel. *Tek Sing Treasures.* Auction catalog, Fritz Nagel, Stuttgart, November 17–25, 2000. Stuttgart: Fritz Nagel, 2000. (Shipwreck with Chinese porcelain.)

Furio, Joanne, George Ross, and Freddy Le Saux. *The Limoges Porcelain Box: From Snuff to Sentiments.* New York: Lake Warren Press, 1998.

Gallagher, Fiona. *Christie's Art Nouveau.* New York: Watson-Guptill, 2000.

Gaston, Mary Frank. *Collector's Encyclopedia of English China.* Paducah, Ky.: Collector, 2001.

Gibble, Patricia E. *Continuity, Change, and Ethnic Identity in 18th Century Pennsylvania Red Earthenware: An Archaeological and Ethnohistorical Study.* Ph.D. diss., Anthropology Department, American University (Washington, D.C.), 2001.

Gibson, Michael. *Lustreware.* Album 290. Princes Risborough, Bucks., England: Shire, 1999.

Goldstein, Doris. "Plunge into Poole. Poole Pottery Charms English Collectors, But It's Little-known in America." *Art and Antiques* 24, no. 7 (2001): 62–65.

Goldstein, Doris. "Rediscovering Liverpool Porcelain." *Art and Antiques* 23, no. 6 (2000): 62–66.

Goodfellow, Peter. "The Reuter Influence at The Vine Pottery, Stoke." *Northern Ceramic Society Newsletter*, no. 119 (2000): 43–46.

Goodfellow, Peter S. "The Goodfellow Factories in Burslem and Tunstall." *Northern Ceramic Society Journal* 17 (2000): 5–16.

Graham, Rev. Malcolm. *Cup and Saucer Land*. 1908. Reprint, Stoke-on-Trent, England: Staffordshire and Stoke on Trent Archive Service, 2000.

Grant, Diana. "Potters in the First Half of the 17th Century." *Northern Ceramic Society Newsletter*, no. 119 (2000): 49–51.

Graves, Alun R. "Ben Nicholson's Designs for Foley China." *The Burlington Magazine* (June 1998): 386–90.

Green, Nancy E., and Jessie Poesch. *Arthur Wesley Dow and American Arts and Crafts*. New York: Harry N. Abrams, Inc., 2000.

Greenhalgh, Paul, ed. *Art Nouveau: 1890–1914*. New York: Harry N. Abrams, 2000.

Griffin, John D. *The Don Pottery, 1801–1893*. Doncaster, Yorks., England: Doncaster Museum Service, 2001.

Griffin, Leonard. *Clarice Cliff: The Art of Bizarre, A Definitive Centenary Celebration*. London: Pavilion, 1999.

Guyatt, Mary. "The Wedgwood Slave Medallion: Values in Eighteenth-Century Design." *Journal of Design History* 13, no. 2 (2000): 93–105.

Hannah, Caroline M. *James Carr (1824–1904) and his New York City Pottery (1855–1889)*. Masters thesis, Bard Graduate Center for Studies in the Decorative Arts (New York), 2000.

Harran, Jim, and Susan Harran. *Dresden Porcelain Studios Identification and Value Guide*. Paducah, Ky.: Collector, 2001.

Harvey, Rebecca C. "Resemblance and Desire: Influences from the History of Whiteware." *Studio Potter* (June 1998): 29–32.

Haslam, Malcolm. "Between the Wars: British Studio Ceramics 1919–1939." *Crafts* (London, July/August 1998): 60–61.

Hayward, Anne. *The Alberta Pottery Industry, 1912–1990: A Social and Economic History*. Canadian Museum of Civilization, History Division Paper 50. Hull, Quebec: Canadian Museum of Civilization, 2001.

Hearn, Kathryn. "Jasper and the Potter." *Ceramic Review* (March/April 2001): 26–29.

Heckford, Brian, and Brian Jakes. *Hornsea Pottery 1949–89: Its People, Processes, and Products*. [Great Britain]: Hornsea Pottery Collectors and Research Society, 1998.

Held, Peter, ed. *A Ceramic Continuum: Fifty Years of the Archie Bray Influence*. Seattle and Helena, Mont.: University of Washington Press and Holter Museum of Art, 2001.

Henderson, James D. *Bohemian Decorated Porcelain*. A Schiffer Book for Collectors. Atglen, Pa.: Schiffer, 1999.

Hess, Catherine. *Maiolica in the Making: The Gentili/Barnabei Archive*. Los Angeles: Getty Research Institute for the History of Art and the Humanities, 1999.

Hewitt, Mark. "Tradition Is the Future." *Studio Potter* (June 2000): 14–16. (Wood-fired kilns.)

Hinton, Mark, and Oliver Impey. *Kensington Palace and the Porcelain of Queen Mary II: Essays in Association with the Exhibition China Mania, a Re-creation of Queen Mary II's Display of Oriental Porcelain at Kensington Palace in the 1690's*. London and Oxford: Christie's and The Ashmolean Museum, 1998.

Hluch, Kevin A. *The Art of Contemporary American Pottery*. Iola, Wisc.: Krause, 2001.

Hoffmeister, Dieter. *Meissener Porzellan des 18. Jahrhunderts: Katalog der Sammlung Hoffmeister*. Exhibit catalog, Museum für Kunst und Gewerbe, Hamburg, March 1999. Hamburg: [D. Hoffmeister], 1999.

Hôtel Drouot. *Porcelaines, faïences étrangères, faïences françaises....* Auction catalog, Hôtel Drouot, Paris, April 23, 2001. Paris: Hôtel Drouot, 2001.

Hôtel Drouot. *Succession X et à divers, 1ere vente: importante collection de céramiques du XVIIIe siècle, faïences européennes....* Auction catalog, Hôtel Drouot, Paris, May 31, 2001. Paris: Hôtel Drouot, 2001.

Hudgins, Lisa R. *Style and Commerce: The Charleston Ceramics Trade in the 1760s*. Masters thesis, Anthropology Department, University of South Carolina (Charleston, S.C.), 2000.

Hunter, Richard, William Liebeknecht, and Michael Tomkins with Harriet Kronick and Patricia Madrigal. *Archaeological Data Recovery at the Three Sites Along N.J. Route 34 (Cheesequake), Old Bridge Township, Middlesex County, New Jersey*. Report submitted to the Federal Highway Administration and New Jersey Department of Transportation, Bureau of Environmental Analysis by Hunter Research, Inc., Trenton, N.J. (Partial excavation of the Morgan stoneware kiln site.)

Hunter, Robert. "Pretty in Pink—Sunderland Luster." *Early American Life* (April 2001): 36–41.

Huxford, Bob and Sharon. *Collector's Encyclopedia of Fiesta: Plus Harlequin, Riviera, and Kitchen Kraft*. Paducah, Ky.: Collector, 2000.

Hyland, Peter. "'Hurra for the Railway': A Brief Review of British 'Railway Commemorative' Wares." *Northern Ceramic Society Newsletter*, no. 120 (2000): 15–23.

Jackson, Ian, ed. *Ceramic Ambitions and Strategic Directions: Perspectives on the UK Ceramics Industry Arising from a Series of Executive Seminars Organised by Staffordshire University Business School*. Stoke-on-Trent, Staffs., England: Staffordshire University Business School, 2000.

Jenkins, Steven. *Miller's Ceramics of the '50s and '60s: A Collector's Guide.* Tenterden: Miller's, 2001.

Johann, Stephan. "Die Porzellanstadt: Arita." *Keramik Magazin* (Germany; August/September 1999): 59–62.

Karlson, Norman. *American Art Tile: 1876–1941.* New York: Rizzoli, 1998.

Keighery, Michael. "CNC Milling." *Ceramics Technical* 7 (1998): 109–11. (Automated lathe technology.)

Kelly, Henry E., Arnold Kowalsky, and Dorothy Kowalsky. *Spongeware, 1835–1935: Makers, Marks and Patterns.* A Schiffer Book for Collectors. Atglen, Pa.: Schiffer, 2001.

Kenney, Douglas. "Ceramic Airbrushing: A Contemporary Approach." *Airbrush Action* (November/December 1998): 20–22.

Kerr, Ann. *Rosenthal: Excellence for All Times: Dinnerware, Accessories, Cutlery, Glass.* A Schiffer Book for Collectors. Atglen, Pa.: Schiffer, 1998.

Kerr, Rose. *Chinese Ceramics: Porcelain of the Qing Dynasty, 1644–1911.* London: V&A Enterprises, 1998.

Kerr, Rose. "What Were the Origins of Chinese Famille Rose?" *Orientations* (May 2000): 53–59.

Kowalsky, Arnold A. "The Alcocks: Their Earthenware, Ironstone, Stoneware and Granite Production." *Northern Ceramic Society Journal* 17 (2000): 23–38.

Krahl, Regina. *Dawn of the Yellow Earth: Ancient Chinese Ceramics from the Meiyintang Collection.* New York: China Institute Gallery, 2000.

Kramer, Miriam. "Irish Delftware." *The Magazine Antiques* (November 2000): 636–38.

Kuwayama, George. "Chinese Ceramics in Colonial Peru." *Oriental Art* 46, no. 1 (2000): 2–15.

Labacco, Ronald T. " 'The Playful Search for Beauty': Eva Zeisel's Life in Design." *Studies in the Decorative Arts* 8, no. 1 (2000/2001): 125–38.

LaPointe, Nancy F. "Medalta:
Continuing the Legacy of Fire." *Ceramics Monthly* (September 2001): 70–72.

Lauria, Jo, and Gretchen Adkins. *Color and Fire: Defining Moments in Studio Ceramics, 1950–2000: Selections from the Smits Collection and Related Works at the Los Angeles County Museum of Art.* Exhibit catalog, Los Angeles County Museum of Art and three other institutions, June 4, 2000–October 2, 2001. Los Angeles: Los Angeles County Museum of Art and Rizzoli, 2000.

Layre-Mathéus, Servane de, and Gwénaëlle Hamelin. *Faïences, poteries et terres vernissées du Perche et de ses confins, XIXe-XXe siècle: Beaumont-les-Autels, Bonnétable, Coudreceau.* Ceton, France: Amis du Perche, 2000.

Leath, Peter. *The Designs of Kathie Winkle: For James Broadhurst & Sons Ltd, 1958–1978.* Shepton Beauchamp, Somerset, England: Richard Dennis, 1999.

Ledger, Andrew P., comp. *European Competition, Trade, and Influence, 1786–1796: References from Original Documents.* Derby, England: Derby Museum and Art Gallery, 1998.

Lim, Kean Siew. *The Beauty of Chinese Yixing Teapots and the Finer Arts of Tea Drinking.* Singapore: Times Books International, dist. Art Media Resources, 2001.

Lungley, Martin. *Gardenware.* Marlborough, England: Crowood, 2000.

Mali, Millicent S. *CA, A French Faïence Breakthrough.* East Greenwich, R.I.: Millicent S. Mali, 2000.

Maneker, Roberta. "Make Mine Mocha." *Art and Antiques* (June 1998): 46–49.

Manna, Loris. *Gio Ponti: le maioliche.* Milano: Biblioteca di via del Senato, 2000.

Markin, Trevor. "Anthony Keeling and Company: Part 1, The Potworks and Partners, Edward Keeling and Samuel Perry." *Northern Ceramic Society Journal* 17 (2000): 51–78.

McAllister, Lisa S. *Collector's Guide to Feather Edge Stoneware: Identification and Values.* Paducah, Ky.: Collector, 2000.

McCarthy, Ruth. *Lefton China: Old and New.* A Schiffer Book for Collectors. Atglen, Pa.: Schiffer, 2001.

McCray, W. Patrick, and Teresita Majewski. "Appendix: Compositional Analysis of Ceramic Gorget Fragment from Fort Union (32WI17)." *Historical Archaeology* 34, no. 4 (2000): 117–21.

McLaren, Graham. *Ceramics of the 1960s.* Album 386. Princes Risborough, Bucks., England: Shire, 2001.

Medley, Margaret. *The Chinese Potter: A Practical History of Chinese Ceramics.* 1976. Reprint, New York: Phaidon, 1999.

Mellor, Maureen. *Pots and People (That Have Shaped the Heritage of Medieval and Later England).* Oxford, England: Ashmolean Museum, 1998.

Meinssen, Klaus. "The Top Ten Glaze Materials." *Ceramics Monthly* (November 2000): 100–103.

Miller, George L. "A Revised Set of CC Index Values for Classification and Economic Scaling of English Ceramics from 1787 to 1880." Reprinted in Brauner, *Approaches to Material Culture Research,* 2nd ed., 86–110.

Minchilli, Elizabeth H. *Deruta: A Tradition of Italian Ceramics.* San Francisco: Chronicle Books, 1998.

Molinaro, Joe. *A Pottery Tour of Kentucky.* Lexington, Ky.: Crystal Communications, 2000.

Molina-Rodriguez, Rafael. "A Dialogue with Lisa Orr." *Ceramics Monthly* (May 2000): 48–51.

Moody, Jennifer. "Carey's—Manufacturers of Earthenware, Ironstone and Bone China—1818–1842." *Northern Ceramic Society Newsletter,* no. 122 (2001): 37–47.

Moore, Peter. "Tilbury Fort: A Post-Medieval Fort and Its

Inhabitants." *Post-Medieval Archaeology* 34 (2000): 3–104.

Mueller, Shirley M. "Chinese Export Porcelain Curiosities." *Oriental Art* 46, no. 1 (2000): 16–27.

National Academy of Design, Caskey-Lees, and Sha-Dor. *The New York Ceramics Fair: Preview 2001.* Exhibit catalog, New York Ceramics Fair, January 17–21, 2001. New York: National Academy of Design, 2001.

"Ned Foltz: One of the Last Traditional Redware Potters." *Crafts Report* (May 1999): 53+.

Newman, Harold, and George Savage. *An Illustrated Dictionary of Ceramics.* New York: Thames and Hudson, 2000.

New Orleans Museum of Art Staff. *Imari: Japanese Porcelain for European Palaces, The Freda and Ralph Lupin Collection.* New Orleans: New Orleans Museum of Art, 1999.

Noël Hume, Ivor. *If These Pots Could Talk: Collecting 2,000 Years of British Household Pottery.* Hanover, N.H.: University Press of New England for the Chipstone Foundation, 2001.

Northeast Auctions, Hampton. *Painted Furniture and Folk Art, Art Pottery Including Dedham, Art Glass, Silver, Currier & Ives Prints, 200 Pieces of Parian Deaccessioned by the Bennington Museum* Auction catalog, Northeast Auctions, Hampton, March 20–21, 1999. Manchester, N.H.: Northeast Auctions, 1999.

O'Meara, Ellalou. *Traditional Printing on Ceramics, Glass and Enamel.* London: A. and C. Black, 2000.

Owen, J. Victor. "Provenience of Eighteenth-Century British Porcelain Sherds from Sites 3B and 4E, Fortress of Louisbourg, Nova Scotia: Constraints from Mineralogy, Bulk Paste, and Glaze Compositions." *Historical Archaeology* 35, no. 2 (2001): 108–21.

Owen, J. Victor, and Paul B. Williams. "Provenance of a True-Porcelain Chocolate Mug from the Rockingham Inn (c. 1796–1833) Site, Bedford, Nova Scotia: Constraints from Compositional Data." *Canadian Journal of Archaeology* 23, nos. 1–2 (1999): 51–62.

Owen, Nancy E. "On the Road to Rookwood: Women's Art and Culture in Cincinnati, 1870–1890." *Ohio Valley History* 1, no. 1 (2001): 4–18.

Pascoe, Joseph. "Australian Ceramics, 1800–1960: Toward a National Style." *Ceramics Monthly* (April 1999): 49–55.

Pattillo, Edward, and Robin McDonald. "Paris Porcelain in Antebellum Alabama." *Alabama Heritage* 58 (2000): 6–15.

Pearce, Jacqueline. "A Late 18th-Century Inn Clearance Assemblage from Uxbridge, Middlesex." *Post-Medieval Archaeology* 34 (2000): 144–86.

Pietsch, Ulrich. *Frühes Meissner Porzellan: Sammlung Carabelli.* Munich: Hirmer, 2000.

Perrin, Isabelle. *Les techniques céramiques de Bernard Palissy: Thèse pour l'obtention du grade de docteur de l'Université de Paris IV, discipline histoire de l'art, 1998.* Villeneuve d'Ascq, France: Presses universitaires du Septentrion, 2000.

Perry, Hamilton Darby. *Wedgwood Style.* New York: Welcome Rain Publishers, 2001.

Petrie, Kevin. "Water-based Ceramic Transfer Prints." *Printmaking Today* (U.K.) 8, no. 3 (1999): 31–32.

Phillips. *Decorative Arts.* Auction catalog, Phillips London, March 30, 1999. London: Phillips, 1999.

Phillips. *Design 1860–1945.* Auction catalog, Phillips Edinburgh, November 10, 2000. Edinburgh: Phillips, 2000.

Phillips. *Good British Ceramics and Glass.* Auction catalog, Phillips London, September 15, 1999. London: Phillips, 1999. (Includes The Roger Pomfret Collection of New Hall.)

Phillips. *Good British Ceramics and Glass.* Auction catalog, Phillips London, June 6, 2001. London: Phillips, 2001.

Phillips. *Late 19th and 20th Century Decorative Arts; Antique Furniture, Rugs, Clocks, Ceramics and Works of Art.* Auction catalog, Phillips Bath, September 13, 1999. Bath, England: Phillips, 1999.

Phillips. *The Norman Stretton Collection of Transfer-Printed Ceramics.* Auction catalog, Phillips London, February 21, 2001. London: Phillips, 2001.

Phillips. *Silver, Ceramics, Pictures, Works of Art, Clocks and Furniture.* Auction catalog, Phillips Ipswich, September 27–28, 2000. Ipswich, England: Phillips, 2000.

Phillips. *The Watney Collection, Part I.* Auction catalog, Phillips London, September 22, 1999. London: Phillips, 1999.

Phillips. *The Watney Collection, Part II.* Auction catalog, Phillips London, May 10, 2000. London: Phillips, 2000.

Phillips. *The Watney Collection, Part III.* Auction catalog, Phillips London, November 1, 2000. London: Phillips, 2000.

Phillips-Selkirk Galleries. *February Gallery Auction 1999.* Auction catalog, Phillips-Selkirk, St. Louis, February 13, 1999. St. Louis: Phillips-Selkirk, 1999.

Pierson, Stacey. "Women Owners' Marks on Chinese Porcelain: Two Cases." *Orientations* (November 1998): 51–54.

Pisano, Ronald G., Mary Ann Apicella, Linda H. Skalet. *The Tile Club and the Aesthetic Movement in America.* New York: Harry N. Abrams, Inc., 1999.

Plomp, Michiel C. "Leonaert Bramer (1596–1674) als ontwerper van decoratie op Delfts aardewerk." *Oud Holland* 113, no. 4 (1999): 197–216.

Porter, David. "Chinoiserie and the Aesthetics of Illegitimacy." *Studies in Eighteenth-Century Culture* 28 (1999): 27–54.

Racheter, Richard G. *Post '86 Fiesta: Identification and Value Guide.*

Paducah, Ky.: Collector, 2000.

Rago, David, and John Sollo. *Collecting Modern: A Guide to Mid-Century Studio Furniture and Ceramics.* Salt Lake City: Gibbs Smith, 2001.

Rago, David, and Suzanne Perrault. *American Art Pottery: Miller's Treasure or Not? How to Compare and Appraise.* London: Millers, 2001.

Rago, Thomas L. *Collector's Guide to Trenton Potteries.* A Schiffer Book for Collectors. Atglen, Pa.: Schiffer, 2001.

Rans, Jon, Nate Russell, and Glenn Ralston. *Zanesville Stoneware Company: Identification and Value.* Paducah, Ky.: Collector, 2001.

Ratheram, Terry. "A New Hall Plate, Chocolate Cup, Jug and Saucer." *Northern Ceramic Society Newsletter,* no. 119 (2000): 29–32.

Ray, Anthony. *English Delftware in the Ashmolean Museum.* Oxford, England: Ashmolean Museum, 2000.

Replacements, Ltd. *Noritake: Jewel of the Orient.* McLeansville, N.C.: Replacements, 2001.

Richards, Sarah. "'A True Siberia': Art in Service to Commerce in the Dresden Academy and the Meissen Drawing School, 1764–1836." *Journal of Design History* 11, no. 2 (1998): 109–26.

Ritchie's. *Fine Jewellery, Decorative Art and European and American Art.* Auction catalog, Ritchie's Toronto, November 22–25, 1999. Toronto: Ritchie's, 1999.

Roberts, Lois. "Underglaze Painting from South Yorkshire." *Northern Ceramic Society Newsletter,* no. 119 (2000): 15–17.

Rosen, Jean. *Les routes de la faïence en Bourgogne.* Dijon, France: Centre de culture scientifique, technique et industrielle de Bourgogne and Presses du réel, 2000.

Roth, Linda H., and Clare Le Corbeiller. *French Eighteenth-Century Porcelain at the Wadsworth Atheneum: The J. Pierpont Morgan Collection.* Hartford, Conn.:

Wadsworth Atheneum, 2000.

Runge, Robert, Jr. *Collector's Encyclopedia of Stangl Artware, Lamps, and Birds: Identification and Values.* Paducah, Ky.: Collector, 2001.

Saga Kenritsu Kyūshū Tōji Bunkakan. [*Kakiemon: The Whole Aspect of the Kakiemon Style.*] Exhibit catalog, Kyushu Ceramic Museum, Oct. 8–Nov. 14, 1999. Saga, Japan: Saga Kenritsu Kyūshū Tōji Bunkakan, 1999.

Saks, Bill. "If the Shoe/Slipper Fits—Wear It." *Northern Ceramic Society Newsletter,* no. 119 (2000): 25–28.

Samford, Patricia. "Dating English Printed Earthenwares." *Early American Life* (June 2001): 34–41.

Samford, Patricia. "Response to a Market: Dating English Underglaze Transfer-Printed Wares." Reprinted in Brauner, *Approaches to Material Culture Research,* 2nd ed., 56–85.

Sarsby, Jacqueline. "Pots of Life: Winchcombe Pottery, 1926–98: Cheltenham Art Gallery and Museum." *Crafts* (London, March/April 1999): 61–62.

Schollander, Wendell, and Wes Schollander. *Forgotten Elegance: The Art, Artifacts, and Peculiar History of Victorian and Edwardian Entertaining in America.* Westport, Conn.: Greenwood Publishing Group, 2001.

Schönfeld, Martin. "Was There a Western Inventor of Porcelain?" *Technology and Culture* 39, no. 4 (1998): 716–27.

Selkirk Galleries. *February Gallery Auction 1999.* Auction catalog, Selkirk Galleries St. Louis, February 13, 1999. St. Louis: Selkirk Galleries, 1999.

Selvage, Nancy. "Mimbres Pottery: Ceramic Traditions of Ancient and Modern Pueblo Potters from the American Southwest." *Studio Potter* (December 1999): 44–45.

Shackel, Paul A. *Archaeology and Created Memory: Public History in a National Park.* Contributions to Global Historical Archaeology. Norwell, Mass.: Kluwer

Academic/Plenum, 2000.

Shulsky, Linda R. "Philip II of Spain as Porcelain Collector." *Oriental Art* 44, no. 2 (1998): 51–54.

Skerry, Janine E. "Setting a Stylish Table." *The Magazine Antiques* (January 2001): 204–11.

Skinner, Robert W. *American Furniture and Decorative Arts: Featuring the Estate of Josephine I. Dawes Together with the Routhier Collection of Early American Glass and Mochaware from the Jonathan Rickard Collection.* Auction catalog, Skinner's, Bolton, Mass., March 11, 2001. Boston: Robert W. Skinner, 2001.

Sloan, C. G. *Estate Auction.* Auction catalog, C. G. Sloan, Miami, July 17, 1999. Miami: C. G. Sloan, 1999.

Smith, Roger C. "Pensacola's Tristán de Luna Shipwreck: A Look at the Archaeological Evidence." *Gulf South Historical Review* 14, no. 1 (1998): 21–30.

Snyder, Jeffrey B. *Marvelous Majolica: An Easy Reference and Price Guide.* A Schiffer Book for Collectors. Atglen, Pa.: Schiffer, 2001.

Snyder, Jeffrey B. *Pacific Pottery: Sunshine Tableware from the 1920s, '30s, and '40s . . . and more!* A Schiffer Book for Collectors. Atglen, Pa.: Schiffer, 2001.

Snyder, Jeffrey B., and Leslie J. Bockol. *Majolica: British, American and European Wares.* Rev. and exp. 2nd ed. A Schiffer Book for Collectors. Atglen, Pa.: Schiffer, 2001.

Sotheby's. *Applied Arts and Design since 1935.* Auction catalog, Sotheby's London, October 28, 1998. London: Sotheby's, 1998.

Sotheby's. *British Pottery and Porcelain.* Auction catalog, Sotheby's West Sussex, March 17, 1999. Summers Place, Billingshurst: Sotheby's, 1999.

Sotheby's. *A Celebration of the English Country House: Paintings, Sculpture, English Ceramics, Chinese Export Porcelain, Furniture and Decorations.* Auction catalog, Sotheby's,

April 19–20, 2001. New York: Sotheby's, 2001.

Sotheby's. *European Ceramics.* Auction catalog, Sotheby's London, November 8, 1999. London: Sotheby's, 1999.

Sotheby's. *European Ceramics, Glass, Silver, Vertu, and Portrait Miniatures.* Auction catalog, Sotheby's London, September 23–24, 2000. Amsterdam: Sotheby's, 2000.

Sotheby's. *Fine Chinese Ceramics and Works of Art: Including Chinese Export Porcelain.* Auction catalog, Sotheby's London, November 14, 2000. London: Sotheby's, 2000.

Sotheby's. *The Harriman Judd Collection: British Art Pottery.* Auction catalog, Sotheby's New York, January 22, 2001. New York: Sotheby's, 2001.

Sotheby's. *19th Century Furniture, Ceramics, Decorations, and Carpets.* Auction catalog, Sotheby's New York, November 3, 1999. New York: Sotheby's, 1999.

Sotheby's. *The Welsh Sale.* Auction catalog, Sotheby's London, October 19–20, 1999. London: Sotheby's, 1999.

Stern, Bill. *California Pottery: From Missions to Modernism.* San Francisco: Chronicle Books, 2001.

Sturm-Bednarczyk, Elisabeth, Claudia Jobst, and Wanda Zaleska. *Wiener Porzellan des Klassizismus: Die Ära Conrad von Sorgenthal, 1784–1805.* Vienna: Christian Brandstätter, 2000.

Sudderth, W. E., and Linda J. Darnell Hulvershorn. "The Rare Bone China Gorgets of Fort Union Trading Post National Historic Site, Williston, North Dakota." *Historical Archaeology* 34, no. 4 (2000): 102–17.

Sussman, Lynne. "British Military Tableware, 1760–1830." Reprinted in Brauner, *Approaches to Material Culture Research,* 2nd ed., 44–55.

Sussman, Lynne. "Changes in Pearlware Dinnerware, 1780–1830." Reprinted in Brauner, *Approaches to Material Culture Research,* 2nd ed., 37–43.

Sweet, Marvin. "The Yixing Effect." *Ceramics Monthly* (January 1999): 66–69.

Tennent, Norman H., ed. *The Conservation of Glass and Ceramics: Research, Practice, and Training.* London: James and James, 1999.

Terpstra, Karen. "An Archaeological Tour of South China." *Ceramics Monthly* (November 2000): 14–18.

Thomas, Tony. "The Watney Sale—Part 2." *Northern Ceramic Society Newsletter,* no. 119 (2000): 18–22.

Thompson, Amanda, and the California Heritage Museum. *Cerámica: Mexican Pottery of the 20th Century.* Atglen, Pa.: Schiffer, 2001.

Thornton, Dora. "Lustred Pottery from the Cantagalli Workshop: Its Sources and English Connections." *Apollo* (February 2000): 33–40.

Treadway Gallery and John Toomey Gallery. *The Modern Objects Price Guide: A Comprehensive Collection of Auction Results, 1991–1999.* Cincinnati: Treadway Gallery, 2000.

Tung, Wu. *Earth Transformed: Chinese Ceramics in the Museum of Fine Arts, Boston.* Boston: Museum of Fine Arts Publications, 2001.

Turner, Ian. *Candy Art Pottery: A History of Art Pottery Manufactured at the Candy & Co. Factory, Newton Abbot, Devon.* Melbourne, Derbys., England: Hillian Publications, 2000.

Twitchett, John. *Dictionary of Derby Porcelain.* Woodbridge, Suffolk, England: Antique Collectors Club, 2001.

Tyler, Kieron, and Roy Stephenson, with J. Victor Owen and Christopher Phillpotts. *The Limehouse Porcelain Manufactory: Excavations at 108–116 Narrow Street, London, 1990.* MoLAS Monograph 6. London: Museum of London Archaeology Service, 2000.

Valfre, Patrice. *Yixing: Teapots for Europe.* Poligny, France: Exotic Line, 2000.

Van Hook, Stephen J. *Discovering Dutch Delftware: Modern Delft and Makkum Pottery.* Alexandria, Va.: Glen Park Press, 1998.

van Lemmen, Hans. *Medieval Tiles.* Album 380. Princes Risborough, Bucks., England: Shire, 2000.

Van Patten, Joan F. *Collector's Encyclopedia of Nippon Porcelain: Identification and Values.* Paducah, Ky.: Collector, 2000.

von Dassow, Sumi. *Barrel, Pit, and Saggar Firing: A Collection of Articles from Ceramics Monthly.* Westerville, Ohio: American Ceramic Society, 2001.

Voorsanger, Catherine H., and John K. Howat. *Art and the Empire City: New York, 1825–1861.* New York and New Haven, Conn.: Metropolitan Museum of Art and Yale University Press, 2000.

Walker, Robert P. *Collecting Shelley Pottery.* Iola, Wisc.: Krause, 1998.

Warburton, Toni. "It's Only the Dish I Serve up My Craziness about Colour in." *Ceramics* no. 43 (2001): 44–51. (Color and function in the work of five ceramists.)

Waterbrook-Clyde, Keith, and Thomas Waterbrook-Clyde. *Distinctive Limoges Porcelain: Objets d'Art, Boxes, and Dinnerware.* A Schiffer Book for Collectors. Atglen, Pa.: Schiffer, 2001.

Waterbrook-Clyde, Keith, and Thomas Waterbrook-Clyde. *The Decorative Art of Limoges: Porcelain and Boxes.* A Schiffer Book for Collectors. Atglen, Pa.: Schiffer, 1999.

Wedgwood Society of New York. *Wedgwood Society of New York Auction.* Auction catalog, Wedgwood Museum at Sands Point Preserve, N.Y., October 25, 1998. Sands Point Preserve, N.Y.: Wedgwood Society of New York, 1998.

Weschler, Adam A. and Son. *Twentieth Century Decorative Works of Art: American and European Glass; Furniture; Decorative Arts and Lighting; Pottery, Silver and*

Metalwork, Sculpture. Auction catalog, Adam A. Weschler and Son, Washington, D.C., March 27, 1999. Washington, D.C.: Adam A. Weschler and Son, 1999.

Wheeler, Ron. *Winchcombe Pottery: The Cardew-Finch Tradition*. Oxford: White Cockade Publishing and Cheltenham Art Gallery and Museums, 1998.

Whiting, David. "Eleven British Potters: History and Invention." *Ceramics*, no. 35 (1999): 33–40.

Wilcoxen, Charlotte. "Dutch Fayence from a Seventeenth-Century Shipwreck." *American Ceramic Circle Journal* 11 (2000): 52–67.

Wilcoxen, Charlotte. "Seventeenth-century Portuguese *Faiança* and Its Presence in Colonial America." *Northeast Historical Archaeology* 28 (1999): 1–20.

Wilkie, Laurie A. "Culture Bought: Evidence of Creolization in the Consumer Goods of an Enslaved Bahamian Family." *Historical Archaeology* 34, no. 3 (2000): 10–26.

Wilkinson, Vega. *Copeland*. Album 306. Princes Risborough, Bucks., England: Shire, 1999.

Wilson, Timothy. "'Il papa delle antiche maioliche': C. D. E. Fortnum and the Study of Italian Maiolica." *Journal of the History of Collections* 11, no. 2 (1999): 203–18.

Wolf, Martha, and Frank Davenport. "Ubiquitous But Largely Anonymous, Bridgeless Willow." *Northern Ceramic Society Newsletter*, no. 121 (2001): 25–37.

Wood, Nigel. *Chinese Glazes: Their Origins, Chemistry, and Recreation*. London and Philadelphia: A. and C. Black and University of Pennsylvania Press, 1999.

Wright, Malcolm, and Margaret A. Skove. *Malcolm Wright: Functional Ceramics and Sculpture, April 14–June 25, 2000*. Fort Dodge, Iowa: Blanden Memorial Art Museum, 2000.

Electronic Resources

Website (prefaced by www. unless noted)	Description
acers.org	American Ceramic Society; publications, references; links to museums, techniques, etc.
AmArtPot.org	American Art Pottery Association; journal, book reviews, identification, scholarships
angelfire.com/ma/wsb	Wedgwood Society of Boston; newsletter, lectures
angelfire.com/ia/Pfaltzgraff	Pfaltzgraff collectors; newsletters for America and Folk Art patterns, images
ashmol.ox.ac.uk/PotWeb	Oxford University, Ashmolean Museum of Art and Archaeology; online catalog of the ceramic collections
aynsley.co.uk	Aynsley Fine English Bone China (factory); history, patterns
bauerpottery.com	Bauer Pottery collectors; publications, including catalog reprints; images, references, links to newsletter
belleek.ie	The Belleek Pottery Works Co., Ltd. (factory); sponsoring Belleek Collectors International Society; tour, museum, magazine
bgc.bard.edu	Bard Graduate Center for Studies in the Decorative Arts, Design, and Culture; publications, exhibits, academic and public programs, library
blueridgechina.com	Blue Ridge China; newsletter
bonhams.com	Bonhams & Brooks (auction house)
bossons.com	Bossons images, references
bossons.org	International Bossons Collectors Society; newsletter
britarch.ac.uk/spma	Society for Post-Medieval Archaeology; journal, newsletter, conferences
butterfields.com	Butterfield and Butterfield (auction house)
carltonware.co.uk	Carlton Ware Collectors Club; newsletter
ceramicart.com.au	Australian magazines, *Ceramics: Art and Perception* and *Ceramics Technical*

ceramicbooks.com	Bradshaw and Whelan ceramic reference books
ceramic-review.com	British magazine, *Ceramic Review*
ceramicsmuseum.alfred.edu	Schein-Joseph International Museum of Ceramic Art, Alfred University; publications, exhibits, lectures
ceramics.org	American Ceramic Society; *Ceramics Monthly, Pottery Making Illustrated*
chinaspecialties.com	China Specialties: Fiesta Collectors Quarterly and Hall China Collector Club newsletters; Fiesta, Hall China, Cat-tail, Hot-Oven, Luray Pastels limited editions
christies.com	Christie's (auction house); publications, searchable catalogs and auctions
cincinnatiartgalleries.com	Cincinnati Art Galleries (auction house); exhibits
cix.co.uk/~moshpit/hpcs	Honiton Pottery Collectors Society; history, images
claricecliff.com	Clarice Cliff Collectors Club; images, patterns and shapes, articles
cloverleaf.co.uk/cornish	Cloverleaf Group (T. G. Green factory); sponsoring Cornish Collectors Club
computerpro.com/~nemadji	Nemadji Pottery Collectors Club; history
cornishwarecafe.com	Cornishware Café; history of the T. G. Green Pottery
cowanpottery.org	Cowan Pottery Associates; history, marks, artists, shapes and designs, glazes, scholarships
craftsman-auctions.com	Craftsman Auctions
[no www.] decorativearts.library.wisc.edu	Digital Library for the Decorative Arts and Material Culture; documents, images (including The Chipstone Collection of American Decorative Arts), material culture at University of Wisconsin, links to resources
dedhampottery.com	Dedham Pottery Collectors Society; newsletter
DoyleNewYork.com	William Doyle Galleries (auction house)

ebay.com	ebay (online auctions)
elmnet.net/~coips	Collectors of Illinois Pottery and Stoneware; newsletter
englishporcelain.com	Roderick Jellicoe; publications, exhibits
fieldingscrowndevclub.com	Fieldings Crown Devon Collectors Club; magazine, references, help line
flash.net/~gemoore/nsapc	National Society of Arkansas Pottery Collectors; Camark Pottery images
flowblue.org	Flow Blue International Collector's Club; newsletter
fob.org.uk	Friends of Blue; images
frankoma.org	Frankoma Family Collectors Association; journal, history, images, glaze and color guide, reproductions, scholarships
gardinermuseum.on.ca	Gardiner Museum of Ceramic Art; exhibits, collections
gazette-drouot.com	la Gazette de l'Hôtel Drouot (auction house)
geocities.com/rodeodrive/6544	Maling Collectors' Society; newsletter, history, marks, dating, images
geocities.com/niloakpottery	Niloak Pottery; history, identification
gladdingmcbean.com	Gladding, McBean (factory); products (ornamental terra cotta, sewer pipe, roof tile), history
glerum.nl	Auctioneers Glerum
gosschina.com	Goss Collectors' Club; magazine
gotheborg.com	Chinese and Japanese porcelain types, marks, images, history, references
haegerpotteries.com	Haeger Potteries (factory); history
havilandcollectors.com	Haviland Collectors Internationale Foundation; newsletter, exhibits, archives, scholarships
historicalchina.com	William R. and Teresa F. Kurau (dealers)
hlcca.org	Homer Laughlin China Collectors Association; newsletter
hornseacollector.co.uk	Hornsea Pottery Collectors and Research Society; newsletter, lectures

hulldinnerware.com	America's Online Marketplace for Hull Pottery; identification, images
inform.umd.edu/EdRes /Colleges/ARHU/Depts/ AmericanStudies/MatCulture/Bib	transfer-printed ceramics bibliography
inter-services.com/HallChina	Hall China Collecting; tour
jonathanhorne.co.uk	Jonathan Horne; publications
ladymarion.co.uk	Belleek; marks, numbering system, references
lenox.com	Lenox, Inc. (factory); products, discontinued patterns
lib.umb.edu/archives/pot.html	Dorchester Pottery Works (Mass.) records, 1905–1961
lladro.com	Lladró (factory)
majolicasociety.com	Majolica International Society; newsletter; history, museum and reference links
manorpottery.co.uk	Bairstow Manor Pottery Ltd. (factory)
masonsironstonechina.com	Valerie Howard (dealer)
mccoypottery.com	Nelson McCoy, J. W. McCoy, and Brush McCoy Potteries; history, references
medalta.org	Medalta Potteries Museum/Clay Products Interpretive Center; tour, history, marks, newsletter
members.ozemail.com/au /~ceramic/ncs	Northern Ceramic Society; publications, lectures
members.tripod.com /~rosepast	Roseville's of the Past Pottery Club
mesda.org	Museum of Early Southern Decorative Arts; journal, newsletter, monographs
monticello.org/icjs /archaeology/daacs StylisticElementStudy.html	Monticello Digital Archaeological Archive of Chesapeake Slavery; painted ware stylistic element study
moorcroft.com or moorcroft.co.uk	Moorcroft Art Pottery (factory); marks, collectors club
nalcc.org	National Autumn Leaf Collectors Club; newsletter

nceca.net	National Council on Education for the Ceramic Arts; journal, newsletter, monographs, image database, programs, exhibits
nipponcollectorsclub.com	International Nippon Collectors Club; images, reproductions, marks, references
noritakecollectorsclub.co.uk or noritake.demon.co.uk	Noritake Collectors Club (Noritake and Nippon porcelain)
northeastauctions.com	Northeast Auctions
nyscc.alfred.edu	New York State College of Ceramics at Alfred University
nysl.nysed.gov:80/edocs /parks/dutchbib	An Annotated Bibliography of Selected Sources on the Archeology of Old World Dutch Material Culture in the 16th, 17th, and 18th Centuries
[no www.] ourworld.cs.com/_ht_a /TeaLeafIronstone	Tea Leaf Ironstone Club; history, decorative motifs, makers, shapes, references
paragonbook.com	Paragon Book Gallery; Oriental books
paragoncollector.org.uk	Paragon International Collectors Club (Paragon china); newsletter
patricianantiques.com /sfcc.html	San Francisco Ceramics Circle; lectures, seminar, Ceramics Study Center
phillips-auctions.com	Phillips de Pury and Luxembourg Auctioneers
pickardcollectors.org	Pickard China Collectors' Club; newsletter, convention, reference materials
pilkpotsoc.freeserve.co.uk	Pilkington's Lancastrian Pottery Society; history, images
poolepottery.co.uk	Poole Pottery (factory), sponsoring Poole Pottery Collectors Club; magazine, artists
preserve.org/fotc	Friends of Terra Cotta; publications
quimperclub.org	Quimper Club International; newsletter
ragoarts.com	David Rago Auctions; publications, *Style: 1900, The Modernism Magazine*

redwingcollectors.org	Red Wing Collectors Society; newsletter, history, images
replacements.com	Replacements, Ltd.; pattern identification (top 2000 patterns), vessel forms
royalbayreuth.com	Royal Bayreuth Collectors' Club; newsletter
royalchinacollectors.org	Currier & Ives Dinnerware Collectors (plus other Royal China Co. patterns); pattern identification, convention
royalcopenhagen.com	Royal Copenhagen Porcelain Manufactory (factory); products, artists, Blue Fluted pattern
royal-doulton.com	Royal Doulton Co. (factory; Minton, Royal Albert, Paragon, Beswick), sponsoring Royal Doulton International Collectors Club; newsletter, products
royal-worcester.co.uk	Royal Worcester (factory); history, products, museum, collectors society
rsprussia.com	International Association of RS Prussia Collectors; fakes and reproductions, publications, references
sha.org	Society for Historical Archaeology; searchable CD-ROM, *Historical Archaeology,* 1967–1989; 2-CD set, *Historical Archaeology,* 1967–1999
shelley.co.uk	Shelley Group (Shelley and Wileman pottery); images, history, marks
skinnerinc.com	Skinner Auctioneers
sloansauction.com	Sloan's Auctioneers
sothebys.com	Sotheby's (auctions); collecting guides, Sotheby's Institute of Art schools
spode.co.uk	Spode (factory); sponsoring The Spode Society collectors club, newsletter, history, pattern histories, matching patterns, references
staffordshires.com	Howards of Aberystwyth (dealer)
stanglpottery.org	Hill-Fulper-Stangl Museum (in a kiln at the former Stangl Pottery outlet), lectures, images of Stangl Pottery molds, saggers, and ware-boards

stanglfulper.com	Stangl/Fulper Collectors Club; newsletter, Stangl/Fulper Museum, lectures
stoke.gov.uk/museums	The Potteries Museum and Art Gallery; The Gladstone Pottery Museum; Etruria Industrial Museum; Ford Green Hall; publications, images, history, exhibits, collections (including the Enoch Wood archaeological collection)
studiopotter.org	magazine, *The Studio Potter;* newsletter, gallery, reviews
tajan.com	Étude Tajan (auction house)
thepotteries.org	Stoke-on-Trent pottery and potters, history, photographs, marks search
torquaypottery.com	Torquay Pottery Collectors Society; newsletter
totallyteapots.com	Totally Teapots (novelty teapots); newsletter
transcollectorsclub.org	Transferware Collectors Club; newsletter, images, marks of selected factories
treadwaygallery.com	Treadway Gallery/John Toomey Gallery (auction house); publications
vanbriggle.com	Van Briggle Pottery (factory); sponsoring Van Briggle Collector Society; catalog, tile and other products
vernonkilns.com	Vernon Kilns images, patterns, shapes and sizes, references
wade.co.uk	Wade Ceramics Ltd. (factory), sponsoring the Official International Wade Collectors Club
wedgwood.co.uk/society	Wedgwood (factory), sponsoring Wedgwood International Society
weschlers.com	Adam A. Weschler's and Sons, Inc. (auction house)
whiteironstonechina.com	White Ironstone China Association; newsletter
winterthur.org /index-museum.html	Winterthur Museum, Garden and Library; Campbell Collection of Soup Tureens
w-i-s.org	Wedgwood International Seminar; publications

willowcollectors.org	International Willow Collectors; references
worldcollectorsnet.com /francisjoseph	*Collecting Doulton & Beswick*
wsny.org	Wedgwood Society of New York; journal, *Ars Ceramica,* newsletter
zyworld.com/tggreen	T. G. Green Pottery/Cornish Ware (factory); history

Chipstone
Foundation
Publications

Order Form

Title	Code	Qty	Price
American Furniture 2002	AF2002	_____	$55
American Furniture 2001	AF2001	_____	$55
Back Issues Available 1994 – 2000	AFback	_____	$55
American Furniture – *2 year subscription*		_____	$100
American Furniture – *3 year subscription*		_____	$145
Ceramics in America 2002	CA2002	_____	$55
Ceramics in America 2001	CA2001	_____	$55
Ceramics in America – *2 year subscription*		_____	$100
Ceramics in America – *3 year subscription*		_____	$145
If These Pots Could Talk	IFTHCL	_____	$75
_____	_____	_____	_____
Shipping		_____	_____

U.S. Shipping $5.00 for first book; $1.25 for each additional book.
Foreign Shipping $6.50 for first book; $2.00 for each additional book.

TOTAL _____

Name _____

Tel _____

Address_____

City State ZIP _____

❏ Check payable to "UPNE"

Credit Card

❏ AMEX ❏ Discover ❏ Mastercard ❏ VISA

CC#_____ Expires _____

Please send to:
University Press of New England
37 Lafayette Street
Lebanon, NH 03766
University.Press@Dartmouth.edu
603/643-7110 • 800/421-1561 FAX 603/643-1540 www.upne.com